Praise for *STAR TREK: VOYAGER – A CELEBRATION*,
the companion volume and first in the series of *Celebration* books

Whether you are a casual viewer or know each episode by heart, STAR TREK: VOYAGER – A CELEBRATION *should delight you. Brimming with behind-the-scenes stories (only some of which I knew!), gorgeous photos and rare production design drawings, it gives a real sense of the creative individuals behind the show, as well as the familiar actors on-screen. I particularly enjoyed the "key episode" choices, spotlighted in chapters of their own. Cheers, Mr. Robinson, for a most welcome celebration. EMH out. [Sorry. Feeling a bit nostalgic.]*
Bob Picardo, The Doctor from *STAR TREK: VOYAGER*

The whole package is presented with much class. The book is beautiful and the prose is pristine. It opens up the show in an extraordinary way. And thanks for the Neelix chapter – you made me look intelligent and professional (which I am!)
Ethan Phillips, Neelix from *STAR TREK: VOYAGER*

Time travel is possible, and it does not necessitate a slingshot around the sun, nor does it call for an Atavachron. Here in this book, captured as if in amber, slices of STAR TREK: VOYAGER, *held in suspended animation, and when ingested through photonic dispersion, can cause your temporal lobe to vibrate at exactly the same frequency as high-energy, alpha-driven chronitons, and off you go...*
Doug Drexler, *STAR TREK* makeup artist, concept artist, and visual effects artist

This is the book VOYAGER fans have been waiting for! A terrific romp down memory lane with Captain Janeway and her crew.
Michael Sussman, writer/producer, *STAR TREK: VOYAGER & STAR TREK: ENTERPRISE*

STAR TREK: VOYAGER – A CELEBRATION *captures the spirit of the diverse personalities and talents that came together to create a series that touched audiences around the world. It's a reminder to all of us of a magic time in our lives and reveals things that I never knew.*
Dan Curry, *STAR TREK* visual effects producer

A delightful trip down memory lane. Those extraordinary years on VOYAGER, working alongside all those talented people, both in front of and behind the camera, were special, indeed. We are so proud to have been part of that amazing family, and for the opportunity – through your book – to take a trip down memory lane.
STAR TREK production veterans Michael Okuda (graphic designer) and Denise Okuda
(scenic artist and computer/video supervisor)

Finally, the definitive reference guide and companion for one of the most successful and beloved STAR TREK series ever, STAR TREK: VOYAGER. Ben Robinson and Mark Wright have done an incredible job looking back at this incredible series, while also conducting present-day interviews with almost everyone involved with the show, both in front of and behind the camera. A must-read for any STAR TREK fan.
David Zappone, producer of *For the Love of Spock* and *What We Left Behind: Looking Back at STAR TREK: DEEP SPACE NINE*

This is the landmark book for its series that fans have been waiting for. It's the ultimate love letter to the series in the words of those who created it – reading these visionaries taking us back through the development of the show and the characters is a real treat... It's the ultimate celebration for STAR TREK: VOYAGER fans, and the very best behind-the-scenes account ever created for the series.
C.J. Bunce, Borg.com

...a marvelous book, providing a thorough account of the show with a gorgeous presentation – and paired with [the] VOYAGER ILLUSTRATED HANDBOOK *makes a great return to the Delta Quadrant.*
Alex Perry, Trek Core

This book is a feast for VOYAGER fans. Even the most avid convention-goers will find stories they've never heard before – Ethan Phillips' tale of running into Robin Williams on the Paramount lot is a standout, as well as Bryan Fuller's recollection of a writer – a pal of Garrett Wang's – who kept pitching them stories starring Debbie Harry as "love personified."
Laurie Ulster, Trek Movie

The book is truly gorgeous, and includes some stunning images, from high-quality promotional shots to rare behind-the-scenes photos to early sketches and concept art. It even concludes with an episode guide with much better plot summaries than you'll find on NETFLIX. Plus, the way the book is organized means that you can pick it up every now and then to read a single chapter without missing anything from the bigger picture, or read it straight through (I would suggest taking your time if you choose this option – this isn't one to be speed-read). And there are so many new interviews and interesting tidbits, that it would also make a worthy addition to your TREK reference library.
Sue, Women at Warp

If you wanted a thorough, in-depth look at the show and everything that went into it, then this is certainly the book for you. Its mix of brilliant descriptions, full-color photographs, and memories is one to treasure, cherish, and enjoy from start to finish. It brings back the show to the minds of all those who watched it and to this day, miss its enjoyable stories, thrilling episodes and still marvel at its ties to THE NEXT GENERATION and DEEP SPACE NINE.
Carl Roberts, Future of the Force

General Editor: Ben Robinson
Development Manager: Jo Bourne
Writers: Ben Robinson and Ian Spelling
Designer: Stephen Scanlan
Sub-editor: Alice Peebles
Picture Researcher: Sue Jenkins

With thanks to the team at CBS: John Van Citters, Marian Cordry
and Risa Kessler

Published by **Hero Collector Books**, a division of Eaglemoss Ltd. 2021
Eaglemoss Ltd., Premier Place, 2 & A Half Devonshire Square,
EC2M 4UJ, LONDON, UK
Eaglemoss France, 144 Avenue Charles de Gaulle,
92200 NEUILLY-SUR-SEINE

ISBN 978-1-85875-990-6

Printed in China
10 9 8 7 6 5 4 3 2 1

PR7EN002BK

www.herocollector.com

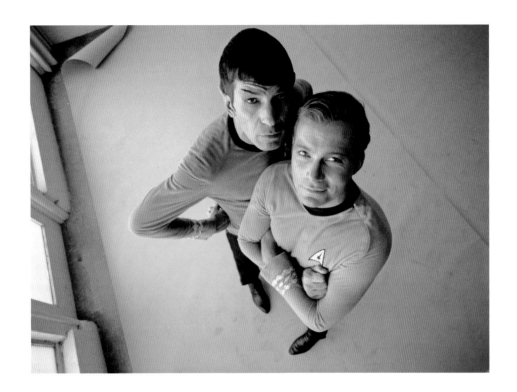

STAR TREK™
A CELEBRATION

CONTENTS

CONTENTS

SPECIAL THANKS

So many people to thank, so little space. Our shared appreciation starts with Gene Roddenberry, who created the show we all love so much, and extends to everyone who helped bring it to life and kept it alive all these years. That's cast and crew, guest stars and producers, and publicists and fan club presidents, as well as fanzine editors and authors, toymakers and magazine/book publishers, and more.

Specifically, we'd like to thank those cherished people still with us today who shared their memories: George Takei, Walter Koenig, Ralph Senensky, Joseph D'Agosta, Sandra Gimpel, Bobby Clark, April Tatro, Reuben Klamer, Andrea Dromm, Bjo and John Trimble, Maggie Thrett, Emmy Lou Crawford, Craig Thompson, Herb Dow, Devra Langsam, Stuart Hellinger, Eileen Becker Salmas, and Steven Rosenstein. Others whose input proved invaluable include James Cawley, Michael Okuda, Doug Drexler, Whoopi Goldberg, Chris Hunter, Brad Look, Daren Dochterman and Gerald Gurian.

This book wouldn't have been possible without Risa Kessler, John Van Citters, Marian Cordry, at CBS, all of whom have gone above and beyond the call of duty.

Ben would like to thank all of you who have ever bought a STAR TREK book, magazine, DVD, or model starship. You make it possible for us to do what we do and we really appreciate it. Enormous thanks are due to Jo Bourne and Alice Peebles who kept everything on track when our deadlines seemed impossible (they were impossible but thanks to them we did it anyway). I'd like to dedicate this book to the STAR TREK creators who are no longer with us, in particular, Bob Justman, Dorothy Fontana, Matt Jefferies, and Leonard Nimoy, who graciously gave me so much of their time and their memories.

Ian expresses his gratitude to everyone who pushed and prodded him on his journeys through life, journalism and STAR TREK. First, my family: Linda, Max, Jamie, and the Galaxy's best dog, Oreo, plus my mom, Janice, who always encouraged me to write and is surely super-proud. George Takei, Walter Koenig, James Doohan, Mark Lenard, Majel Barrett-Roddenberry, and Gene Roddenberry all – remarkably, graciously – spoke to me for my college newspaper, nudging me from fan to fledgling professional. Dave McDonnell trusted me to be Starlog's STAR TREK guy for decades and remains a dear friend. Thanks also to my many editors: Darryl Curtis, Gayden Wren, John Freeman and Nick Jones, and everyone in between. Special thanks as well to Bill Burke and my old team at StarTrek.com. And, lastly, thank you Ben Robinson for the honor of writing this book with you.

FOREWORD

When we told CBS about this book, the first question they asked was, 'How are you going to make a book about the original *STAR TREK* different? So much has been said already and there that aren't many people left to talk to...' We kept that question in mind as we wrote. We were always on the lookout for people who hadn't been interviewed and stories that hadn't been told, so we were delighted when we found out that Muhammad Ali visited the sets and that an apprentice editor named Herb Dow walked off with the Gorn costume, two boxes of tribbles and the three-foot model of the *Enterprise*. George Takei and Walter Koenig found time to take another look back, and thank you Ralph Senensky and Joe D'Agosta. You both have amazing memories and real insights.

The sheer volume of material that's been published about *STAR TREK* became part of the equation. The mission statement for the *Celebration* series is to give you "the best convention ever, in book form." Sadly, it's now impossible to reunite all of the *STAR TREK* cast and crew on stage, but between us we have talked to so many people. We reckon we must have done well over a hundred interviews with people who worked on the original series, including actors William Shatner, Leonard Nimoy, De Kelley, Jimmy Doohan, Nichelle Nichols, and Grace Lee Whitney, producers Gene Roddenberry, Bob Justman, John D.F. Black, John Meredyth Lucas, and Fred Freiberger, art director Matt Jefferies, prop master John Dwyer, story editor Dorothy Fontana, and countless guest stars. We were lucky enough to have talked to them, asked them questions and heard their stories. We've both been voracious readers, too, who have tracked down almost everything that's been published about the series. We've put all of that together to make the pages that follow.

Remarkably, we realized, there's never been an official book like this about the original *STAR TREK* – nothing filled with amazing images that covers the whole show. When you turn the page you'll find profiles of all the main characters, based around interviews with, and memos by, actors, writers and producers. Next is a series of chapters that deal with each of the main departments, which we hope will give you some idea of what went into making *STAR TREK*. We have focused on a dozen or so of the series' key episodes to discuss how they contributed to *STAR TREK*'s success. We're sure everyone will disagree about our choices. Throughout we've tried to unpick some of the myths and to give you a sense of what it was like to make *STAR TREK*. We hope that when you've read the whole book, you'll see the show in a new light, and have a real sense of the intelligence, the love, the care, and the people that went into making *STAR TREK* what it was.

WAGON TRAIN TO THE
STARS

STAR TREK BEGINS

The essence of *STAR TREK* stayed the same,
but Gene Roddenberry's first ideas provide a
fascinating glimpse of a different show.

STAR TREK was always meant to be something new, but at the same time, Gene Roddenberry was very clear it wouldn't be so new that it would be impractical. In the early 1960s, there was plenty of adult science fiction on air. *The Twilight Zone,* which ran from 1959 to 1964, was a big hit and it had been joined by *The Outer Limits,* which ran for two seasons between 1963 and 1965. But both those series had a problem: they were anthology shows. Every episode was different, without a regular cast, so every story stood or fell on its own merits. When Roddenberry started thinking about *STAR TREK* in 1963, he wanted to develop a format that combined this kind of storytelling with the kind of regular cast that viewers were familiar with on shows such as *Bonanza*, where the audience invested in the adventures of the Cartwright family.

In the pitch Roddenberry put together, he emphasized that there were bound to be millions of inhabited planets in the universe. He threw in the concept that there were parallel Earths, meaning that they would have evolved with human beings who had built societies that looked remarkably like the back lots

available at Hollywood's studios. These planets could be placed at any point in "human" evolution, so they could be the setting for stories about cultures like Ancient Egypt or the Westerns that dominated 1960s television. His idea was that a spaceship, originally led by Captain Robert April and his female first officer, Number One, would visit a different world, with its unique culture, every week. This way we'd have familiar characters to anchor the same kind of science-fiction stories people were watching on *The Twilight Zone*.

Roddenberry was keen to point out to network executives that this approach would make his series affordable. There was no need for monsters, costumes could be hired from the normal sources, and parallel Earths could be filmed on the back lot or even on sets that were left over from movies or other TV shows.

The ship and its crew drew inspiration from Isaac Asimov's *Foundation* novels – in which there are countless worlds inhabited by humans and linked up by a group of traders and a vast Galactic empire – and the 1956 movie, *Forbidden Planet*. Years later, Roddenberry was keen to play down these influences, but even if he was trying to do something different, memos from the time show that he was very aware of them.

The ship's mission is to "explore intelligence and social systems" that could pose a threat to Earth; carry out scientific investigation; provide assistance to Earth colonies; and –

almost certainly inspired by the *Foundation* novels – impose Federation law on commerce vessels and traders.

For all the science-fiction trappings, Roddenberry was keen to tell the networks that STAR TREK had a lot in common with more contemporary TV shows. His 1964 pitch document mentions *Gunsmoke* and *Dr. Kildare*, and famously describes the show as "*Wagon Train* to the stars." Whatever the future turned out to actually be like, the crew would be recognizable as men of 1966. "Science fiction," he wrote in the first version of the Writers' and Directors' Guide, "is no different from tales of the present or the past – our starship central characters and crew must be at least as believably motivated and as identifiable to the audience as characters we've all written into police stations, general hospitals, and Western towns."

That same document emphasizes that STAR TREK is an "action-adventure-drama." But, while he didn't put it in the pitch document, Roddenberry always wanted to use the show as a way of exploring ideas and commenting on society. Through science fiction, he could deal with difficult topics such as racism and slavery, and even grand themes, such as "what it meant to be human."

From the beginning, he intended to include an alien member of the crew – and one whose appearance would raise all sorts of questions. From the very first series outline, that alien was known as Spock. "The first view of him," the pitch says, "can

ABOVE: *Roddenberry's earliest attempts to sell STAR TREK emphasize how much of the show could be set in familiar locations. He promised it would be affordable, because they could use the studio back lot and hire costumes rather than make them. His first pitch lists stories set on a planet of 1930s' gangsters, Camelot and a planet that resembles America in 1964. This approach would end up being used for episodes such as 'The Return of the Archons' (above) and 'Miri.'*

ABOVE: STAR TREK's transporters were only invented later on. In the beginning, the plan was for the crew to land on the planets in small "recon rocket vehicles." The idea was that they would film one or two landing sequences and use them again and again.

be almost frightening – a face so heavy-lidded and satanic you might almost expect him to have a forked tail. Probably half-Martian, he has a slightly reddish complexion and semi-pointed ears. But strangely, Mr. Spock's quiet temperament is in in dramatic contrast to his satanic look."

In those early days, there was no mention of Spock being cold or logical. Those qualities were reserved for the ship's female first officer, Number One. In fact, one of *STAR TREK's* first writers, George Clayton Johnson, remembered that the emphasis was going to be on Spock looking like the devil, that he would have had red skin and possibly even a tail.

Years later, Roddenberry would decide that much of *STAR TREK's* success could be put down to its optimistic vision of the future and a belief that humanity would grow and get better. Back in the 1960s, his ideas were different. "You can," he wrote in the series bible, "project too optimistically. We want characters with any believable mixture of strength, weaknesses, and foibles."

Roddenberry's ideas would evolve, sometimes because he thought more deeply about things, sometimes for purely practical reasons, but the fundamentals of *STAR TREK* never changed. When he started to make the series, this is what he set out to do. When he wrote that first document in 1963 he had no idea how difficult it would be to get the series on air or how influential it would become…

ABOVE: One element of STAR TREK was in place from the beginning: Spock. But his character would change radically. In 1963, he was a half-Martian who looked like the devil, had a mesmeric effect on women, and was defined by his insatiable curiosity.

MAKING THE
CAGE
CREATING THE GALAXY

STAR TREK found a home at Desilu and NBC soon ordered a pilot, but the journey was only just beginning.

When Gene Roddenberry started work on *STAR TREK,* he would discuss his ideas with a few friends, including his secretary Dorothy Fontana and writer Sam Peeples, but whatever went on paper was solely up to him. That changed in April 1964 when he went for a meeting with Herb Solow, the head of production at Desilu, an independent studio that was owned by Lucille Ball. Desilu owned some significant studio facilities, but was relying on *The Lucy Show* to support itself. Solow had been brought in to ramp up the company's production arm and to sell shows to the TV networks. He remembered Roddenberry as being an awkward salesman, but there were a lot of things about *STAR TREK* he liked, in particular the way it used naval terms and concentrated on making science fiction feel contemporary, so he offered Roddenberry a deal.

The two men started work shaping Roddenberry's initial idea into something Solow could sell. The essence of *STAR TREK* was already in Roddenberry's original pitch, but together they added elements such as the captain's log and, in Solow's words, sharpened up the characters. Then, all-importantly, in May of

ABOVE: *Filming gets underway on the bridge of the Enterprise. Pato Guzman suggested that it should be circular and drew a quick pastel sketch, before he handed the task of designing it to Matt Jefferies.*

ABOVE: *Meg Wyllie as the Talosian Keeper. The script originally called for the Talosians to be crablike creatures, but this proved impractical. Instead ,Wah Chang designed prosthetics for their heads that pulsed when they were thinking.*

1964, Solow persuaded NBC to provide money for script development, and once they had approved the story, a pilot.

NBC agreed to buy a 90-minute story, on the grounds that if it didn't work, they could still screen it as a TV movie. It would also prove that Desilu, a company best known for making sitcoms, could handle a complicated production with visual effects and alien makeups.

The realities of production worried Solow. If *STAR TREK* was going to work, it would need a strong production team. The first order of the day was to design the ship. Desilu handed the task to a set designer named Matt Jefferies. Meanwhile, Lucy's regular production designer, Pato Guzman, started work on the sets, although he rapidly left and was replaced by Franz Bachelin. The visual effects work was handed to the Howard Anderson Company, which was based on the Desilu lot. The Andersons commissioned Richard Datin to build the *Enterprise* and Albert Whitlock Jr. to create the matte painting of Rigel VII. At Fontana's suggestion, Roddenberry brought in William Ware Theiss to design the costumes.

Solow wanted a film crew that had experience with science fiction. Bob Butler was brought in to direct and persuaded Bob Justman to come aboard as the first assistant director. His job would be to run the set and keep everything on schedule. Like Justman, a large cohort of the film company had worked together on the series *The Outer Limits*. He was joined by

makeup artist Fred Phillips, Wah Chang, whose Projects Unlimited provided the Talosian heads and various props, and Janos Prohaska, who would design and play the other aliens imprisoned in the Talosians' menagerie.

Originally Projects Unlimited was also supposed to provide Spock's ears, but the tests did not go well, and eventually Phillips sent Nimoy over to MGM, where an old friend solved the problem. Wah Chang's approach to the Talosians was much more successful. Although they were voiced by men, the production cast women. Wah fitted them with prosthetic heads that pulsed when they were communicating telepathically.

Casting went smoothly. Desilu was delighted to secure Jeffrey Hunter as Captain Pike, who they built a team around. Joseph D'Agosta, Roddenberry's casting director from *The Lieutenant*, helped out informally and several cast members were suggested by either Roddenberry or Butler. The pilot's major guest star was played by Susan Oliver, a widely admired actress who was much in demand.

'The Cage' was filmed at Desilu's 40 Acre back lot in Culver City, where the sets were built on Stages 15 and 16. Butler remembered being concerned that everything was "too clean" and pushed Roddenberry to dirty up the ship and costumes, but Roddenberry insisted that he wanted everything to look pristine. Butler also remembered that Roddenberry wanted the cast to play their roles in a very subdued, matter-of-fact

ABOVE: *Susan Oliver as Vina with Laurel Goodwin as Yeoman Colt. Oliver was an extraordinary woman who flew solo across the Atlantic. She found learning the choreography for the dance sequence the most challenging part of 'The Cage.'*

ABOVE: *Roddenberry always wanted the Enterprise to have a female first officer and wrote the part of Number One for Majel Barrett, who he would later marry. NBC, however, did not like her character and asked that she be dropped.*

way. But this made their performances flat, so Butler told them they should bring their normal approach to the work, giving it more intensity and a hint of melodrama. When it came to filming Vina's performance as the Orion slave girl, Butler was concerned that they were in danger or going too far, but Roddenberry pushed the erotic elements of the scene, suggesting that Theiss's original version of the costume could be more revealing.

Phillips was responsible for Vina's final transformation, an effect that involved clamping Susan Oliver's head in place, filming for a few seconds, then releasing her and adding more makeup, before clamping her head back in place and repeating the process.

Filming 'The Cage' was not an easy process. The soundproofing at Culver City was inadequate and the Desilu stages had been out of use so long that bees had nested in the rafters, which shut down production. In postproduction, Alexander Courage not only provided the music, but also created some of STAR TREK's most iconic sound effects, recording the 'whoosh' as the ship flies by the camera in the titles, and the sound made by the transporters. The effects shots took longer than hoped and 'The Cage' came in significantly over budget, but everybody was impressed by the results.

But NBC had a problem: Desilu had proved that they could deliver a complicated science-fiction show, but instead of having an example of an hour-long TV show, they effectively had a movie, with some extremely erotic elements, and a somewhat intellectual story. At the time, TV shows were sent out to the sales team who would show it to potential sponsors and advertisers. The NBC team felt that what they had couldn't be used for this purpose. In an unexpected and unusual move, they went back to Desilu and told them they wanted to have another go and they were prepared to fund another pilot…

ABOVE: *Leonard Nimoy and Cindy Robbins (who was up for the role of Yeoman Colt) during test shots for 'The Cage.'*

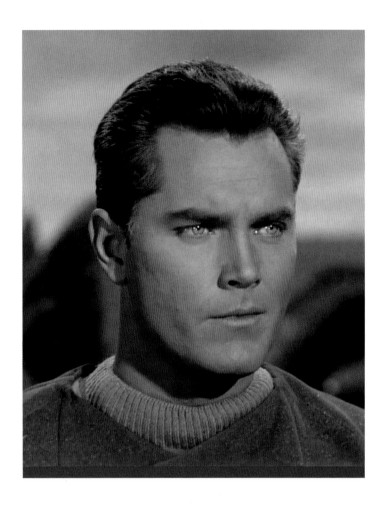

CAPTAIN PIKE

TORTURED COMMANDER

Pike was presented as a thoughtful man who felt the burdens of command. Roddenberry wanted more action, but his star left before he had a chance to rework his performance.

Jeffrey Hunter boldly left *STAR TREK*, and he did so by choice – sort of. His departure caught everyone off guard. The pilot shoot went well, he'd delivered a solid performance as Captain Christopher Pike, and Desilu Productions and NBC approved of Roddenberry retaining him for the second pilot. Hunter's wife, Dusty Bartlett, showed up solo for a screening of 'The Cage' that Roddenberry and producer Herb Solow arranged to be held in the Desilu screening room. Afterward, Bartlett dropped the bombshell that *STAR TREK* wasn't her husband's cup of tea and that, as a

movie star, he had no interest in returning for the second pilot.

Christopher Hunter, the son of Jeffrey Hunter and his first wife, the actress Barbara Rush, sat with his dad in a station wagon in 1964. The two chatted and, at a certain point, 12-year-old Chris asked his Dad, "What are you up to?" Jeffrey showed his son a script: *STAR TREK*. "I said, 'What's this?'" Christopher recalls. "He said, 'I'm a captain of a starship.' That was a big deal because, up until then, all we had was *Space Patrol, Rocky Jones, Space Ranger*, and one or two other shows. No one had ever heard of anything on this scale for TV. Nobody. I got real

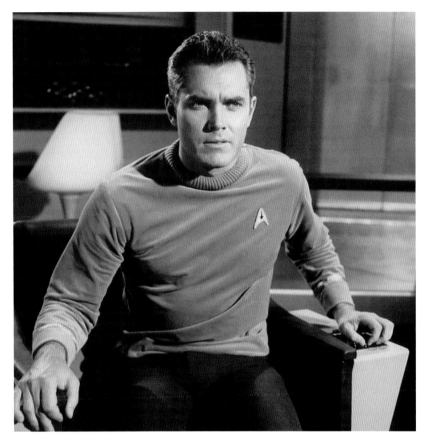

ABOVE: *The earliest versions of the Writers' and Directors' Guide emphasize the pressures on the captain. The executives at NBC felt that Hunter's performance was a little subdued but they wanted to keep him and it was his decision – or at least his wife's – not to return to shoot a second pilot.*

excited. Gut-wise, instinct-wise, I knew this was something real special. People tell me I was the first Trekker ever."

Hunter confirms that Bartlett put a stop to her husband's ongoing participation in *STAR TREK*. "I had a real evil stepmother… Evil," Hunter says of Bartlett. "She thought *STAR TREK* was a failure and that *STAR TREK* was beneath him. She went to Gene without my dad's knowledge and said, 'No, no. Your show didn't sell. Well, too bad. We gave it our shot. I know you're redoing it. Jeffrey Hunter isn't going to do your series.' Gene says, 'Please, we want Jeff back. Lucille Ball gave us the go-ahead.' She said, 'No, no. He's too good for this. He's a movie star.' My brother told me that when Dusty went to the screening, she didn't even tell Dad about it and went to them on her own. Gene said, 'We cannot deal with this woman. Forget it. We're going to go with Shatner.' That's why Dad didn't do it, but he loved the idea of it."

Pike lived on, first in the 'Menagerie' two-parter, with

Roddenberry fashioning an inventive framing device that allowed him to salvage some of Hunter's scenes from 'The Cage.' Decades later, long after Jeffrey Hunter died in 1969 at the age of 42, Bruce Greenwood portrayed the character in two of J.J. Abrams' reboot features. Anson Mount then stepped into the role for *STAR TREK: DISCOVERY*.

"I'm always amazed that people remember Dad, and remember Pike," Hunter says. "It's a big deal to people that the character existed, that he's canon. I thought Bruce did a really good job in the films, and then they brought Anson in to play Pike on *STAR TREK: DISCOVERY*. CBS asked me to go meet Anson at San Diego Comic-Con (in 2018), and I did. I told Anson, 'Buddy, you are the right guy. Dad and I are behind you.' During the talk they gave at Comic-Con in front of 6,000 people, Anson made me stand up and they put the spotlight on me. He said, 'Chris came down here to give me his support. It really means a lot to me that he did that.'"

NUMBER ONE

LOGICAL FIRST OFFICER

Roddenberry planned to give the *Enterprise* a female first officer who was cold and rational, but the character didn't survive from the first pilot.

S he is "never referred to as anything but Number One, this officer is female. Almost mysteriously female, in fact – slim and dark in a Nile Valley way, age uncertain, one of those women who will always look the same between years 20 to 50. An extraordinarily efficient officer, Number One enjoys playing it expressionless, cool – is probably Robert April's superior in detailed knowledge of the multiple equipment systems, departments, and crewmembers aboard the vessel. When Captain April leaves the craft, Number One moves up to Acting Commander" – from Gene Roddenberry's "*STAR TREK Is...*" breakdown, March 11, 1964.

Majel Barrett was already romantically involved with Roddenberry when he started formulating *STAR TREK*. Number One promised to be a game-changing character for the actress who played her, and the industry as a whole. A woman on the bridge! Second in command! Aloof yet sensual. Roddenberry created Number One for Barrett and cast her in the show's initial pilot, 'The Cage.'

"[Number One] is the first thing he wrote," recalled Barrett-Roddenberry, who married Roddenberry in 1969 and was with

him until he passed away in 1991. "He wrote that, then knew he would have the captain. He [also] wanted an alien. That's the way he wrote the parts. He knew what it was going to be, and soon as he got this framework, which, of course, was that there was a starship somewhere out there, working for the Federation, going on a five-year mission to explore new worlds and face things no one had ever faced before – that was the bone work of it. From there on in, there wasn't a whole lot to do but write episodes."

Beyond that introductory paragraph, Barrett knew little about Number One, who she was, how she functioned, what she liked, etc. Barrett took it upon herself to fill in the blanks. "To me, she was from a different planet where they actually numbered people," she said. "She was one of a litter, let's say. The only time they would breed was when they needed people. They would clone them and try to get as much intelligence into each one as they could. As they were growing up, they would take their place and be given a position according to their excellence, and she actually turned into Number One, and therefore went onto a starship. It was a way of life, just a manner of being, not doing anything particularly wonderful until she got there and met people. She was the one at the time who really didn't have any emotions. She was bred for excellence, that's all."

NBC rejected 'The Cage,' but allowed Roddenberry to try again, albeit with conditions. They wanted both Spock and Number One gone, among other demands. Roddenberry fought to keep Spock, but lost Number One. Barrett-Roddenberry shifted to recurring on the series as Nurse Chapel, a comparatively minor part. The Spock character absorbed at least two of Number One's defining attributes: being second in command and having a stern nature.

"Of course, I was disappointed," Barrett-Roddenberry admitted. "This was going to be a marvelous part. Can you imagine where the part would have gone if it had stayed in? And, strangely enough, nothing would have been affected. De's part wouldn't have been affected, and Leonard's part wouldn't have been affected. The captain's part wouldn't have been affected. There would have been one more person on the bridge. Every time I look back on that, I say, 'Oh, damn! What an opportunity.'"

ABOVE: *In Pike's absence, Number One takes control of the ship and the landing party. In 'The Cage,' the Talosians describe her as having a "superior mind" and tell Pike that she "would produce highly intelligent children. Although she seems to lack emotion, this is largely a pretense. She often has fantasies involving you."*

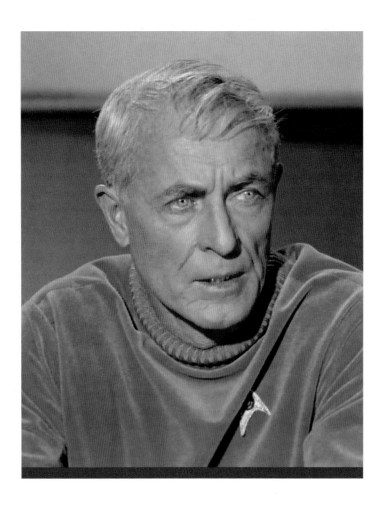

DR. BOYCE

DOCTOR AND BARTENDER

The *Enterprise*'s doctor was always meant to be an older man with a lot of experience, and in the beginning, he was going to be the captain's closest friend.

Ship's Doctor: "Phillip Boyce, an unlikely space traveler. At the age of fifty-one, he's worldly, humorously cynical, makes it a point to thoroughly enjoy his own weaknesses. Captain April's only real confidant, "Bones" Boyce considers himself the only realist aboard, measures each new landing in terms of relative annoyance, rather than excitement" – from Gene Roddenberry's "STAR TREK Is..." breakdown, March 11, 1964

Pop culture aficionados immediately associate John Hoyt with his late-career, long-running role as "Grandpa" Kanisky

on the sitcom *Gimme a Break!* It capped a fruitful acting run that encompassed several decades of performing on Broadway, in nightclubs, and in 125-plus films and television shows, including *When Worlds Collide*, *Spartacus*, *Cleopatra*, *The Outer Limits* ('I, Robot' with Leonard Nimoy), *Bonanza* (two episodes, including 'The Decision,' with DeForest Kelley as... a doctor), *Hogan's Heroes*, *Battlestar Galactica*, and *Desperately Seeking Susan*. He came oh-so-close, however, to adding an extended stay aboard the *Enterprise* to that impressive resume.

Hoyt was 59 when hired to costar in the first STAR TREK

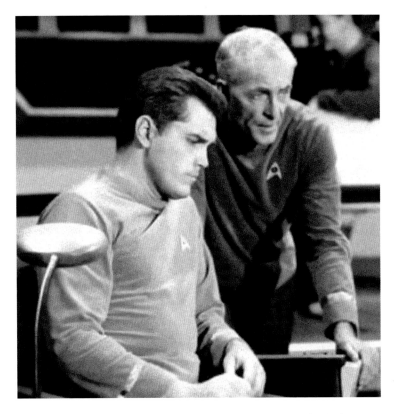

ABOVE: *Boyce was conceived of as the Captain's confidant and closest friend. When he senses Pike is troubled, he makes him a martini, because, as he says, "sometimes a man will tell his bartender things he'll never tell his doctor."*

pilot, 'The Cage.' He and Jeffrey Hunter shared agreeable chemistry, and Hoyt brought warmth and experience to his best line during a heart-to-heart between Pike and Dr. Boyce: "A man either lives life as it happens to him, meets it head-on, and licks it, or he turns his back on it and starts to wither away." NBC turned down 'The Cage'… and Hoyt, who was not asked back for the second pilot. He told *Starlog*'s Anthony Timpone in a 1986 interview that he initially believed he'd dodged a bullet. "I saw 'The Cage' in a projection room before it aired, and it was really a dog," he noted. "They spent far too much time on unimportant scenes. They had Susan Oliver, all painted green, doing a long dance. People at the screening departed in silence afterwards, and no one thought *STAR TREK* would come to anything. And look what happened."

The actor, however, soon realized he'd missed out on what evolved into an unprecedented phenomenon. "If I had been on the show all these years, I probably wouldn't be talking to you now, but relaxing on my yacht in the Mediterranean," he joked. "I was disappointed, though, that I wasn't called back. But I have a lot of company, since Leonard Nimoy was the only returnee. Even then, the set had a nice clubby feeling."

Hoyt, as noted, found himself too busy in the years after 'The Cage' to stew about it. He worked nonstop until a few years before his death in 1991 at the age of 85. He delivered his last performance in the series finale of *Gimme a Break!* in the spring of 1987. "It's amazing, isn't it, and at such a late stage," he enthused of his good luck landing the family comedy. "I like keeping busy. Satan finds work for idle hands."

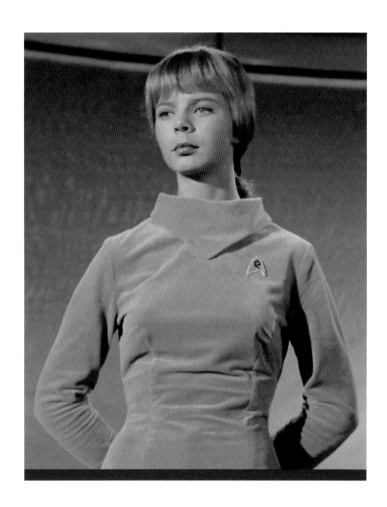

YEOMAN COLT

THE 'NEARLY' GIRL

In 'The Cage,' Laurel Goodwin played the Captain's Yeoman: at this point in history the character was a young, impressionable woman who admired the captain from a distance.

L aurel Goodwin had acted with Elvis Presley in *Girls! Girls! Girls!* and guest starred on *The Virginian*. While she foresaw no Emmys in her future for the role of Yeoman Colt – the captain's secretary, reporter, bookkeeper – she did envision, and wanted, a steady job. To that end, she performed to the best of her ability, and hoped it would lead to bigger and better things.

"Basically, it was playing the subservient role, and having a crush on the captain, and not trying to allow it to be picked up on so I could avoid getting into trouble, because you didn't do

that in a military setting," Goodwin says. "I wanted to play it right because, just being an actress and getting a job, it wasn't easy. The market was very, very tiny. Three networks. They made a lot of pilots, but only a few ever got picked up.

"*STAR TREK* was a bit different," she continues. "It had a great philosophy, and I thought the timing was perfect, that it was time for (something) semi-adventure, philosophical, a little deeper, because everyone was tired of detectives and cowboys."

The actress recalls a "wonderful" shoot. She and Nimoy "went way back." While under contract to Paramount, Goodwin

was sent to drama coach Jeff Corey, who had helped train Nimoy and later guest starred in 'The Cloud Minders' as High Advisor Plasus. "Leonard used to fill in when Jeff was working," she recalls, "and that's how I first met Leonard." Goodwin speaks glowingly of Jeffrey Hunter. "Oh, they just don't come any nicer or prettier," she enthuses. "The eyes were mesmerizing. He was just a wonderful, talented, charming person. Very easy to work with. He was a major star. There was no prima donna-ism. There was no ego nonsense. He was a very generous actor. He was one of the gang. It was like an ensemble, which was part of what appealed to me about the project."

Unfortunately, Goodwin's STAR TREK mission ended there. Hunter chose not to return for the second pilot, prompting NBC and Roddenberry to hire William Shatner and replace Colt with Yeoman Smith (Andrea Dromm), who also didn't make the cut long-term. So, Goodwin watched STAR TREK go on without her, first for three years on NBC, then into perpetuity. Though she acted a bit more (Get Smart, The Beverly Hillbillies, Mannix), coproduced the Burt Reynolds action-comedy Stroker Ace with her late husband, Walter Wood, and attended a couple of STAR TREK conventions, Goodwin's life might have been vastly different.

"No kidding," she says. "It was very painful. I, at that period of time, was going through a divorce. Not a pleasant divorce. So, yeah, I was devastated. Then I was good for a while. When the show came on with Shatner, I thought, 'Well, come on. Don't be sour grapes.' The thing that took the thorn out of my paw really was Leonard, because I was so pleased for him, and I knew this was going to give him some liquidation, that he could then do what he really wanted to do. I was very pleased with all of that."

Here, Goodwin makes a revelation. "And I had come up with [Spock's] pointed sideburns," she claims. "And a few other things. But that, very specifically. When I was in makeup, Leonard's going, 'You know, I've got to play this nonfeeling alien, and all that.' I said, 'Honey, trust me. When they get these ears right and they get that right, we get that look just right, you're gonna be the sex symbol of the '60s.' He brushed it off because he was a serious actor.

"So, even though I was crushed not to be on the show, I was delighted for Leonard. When the show started, not being sour grapes I took a look at it. The first moment that William Shatner walks on, I go, 'He's got Leonard's pointed sideburns.' That did it. I turned it off and never watched it again."

ABOVE: Laurel Goodwin (left) was disappointed not to win the role of the Captain's Yeoman. Colt doesn't play a major role in 'The Cage,' but would have been a regular feature on the show.

JOSE TYLER

ENTERPRISE NAVIGATOR

In Roddenberry's original plans, the *Enterprise*'s navigator was going to be a regular character. He started out as a Latino before evolving into Jose Tyler, played by Peter Duryea.

"Jose Ortegas, born in South America, is tall, handsome, about twenty-five and brilliant, but still in the process of maturing. He is full of both humor and Latin temperament. He fights a perpetual and highly personal battle with his instruments and calculators, suspecting that space, and probably God too, are engaged in a giant conspiracy to make his professional and personal life as difficult and uncomfortable as possible. Jose is painfully aware of the historical repute of Latinos as lovers – and is in danger of failing this ambition on a cosmic scale" – from Gene Roddenberry's "STAR TREK *Is...*" breakdown, March 11, 1964

By the time cameras rolled on 'The Cage,' the *Enterprise*'s navigator had lost his Latin-American roots; instead a young Peter Duryea had been cast as Jose Tyler. Duryea carved out his own career as an actor despite the large shadow of his famous father, Dan Duryea. Peter acted in such films and shows as *The Fugitive*, *The Outer Limits*, *Bewitched*, and *I Spy*. Turning up as Jose Tyler, the ship's navigator, in 'The Cage' reunited him with

director Robert Butler weeks after they'd worked together on an episode of *The Fugitive*. Duryea, however, didn't get the call to return when NBC ordered a second pilot.

"I was delighted to work with Gene Roddenberry, director Robert Butler, and an excellent crew and cast," Peter said in a 2013 interview (with *STAR TREK Magazine*). "The show took two weeks to make, and was incredibly innovative for the time. All of the actors really worked to establish characters that would withstand the test of time. We all had a sense that we were creating something new. Sure, there had been sci-fi before, but never had it been aimed at homes through a weekly television series. We introduced many new things: the sliding doors that opened as one approached, the communicators, complete with matte inserts of the people talking – and Spock's ears! Naturally, we were all devastated when we found it was too expensive to sell to the networks."

Following the death of his father in 1968, Peter began to long for something else, something more. He moved to British Columbia, Canada, in 1973 and spent more than 30 years working with his life and business partner, Janice Bryan. They produced documentaries with the goal of "bringing to light environmental issues, native culture, elder accomplishments, and positive community development initiatives." And with a friend, Alice Bruce, Duryea created the Guiding Hands Recreation Society, a nonprofit group that "educate[d] people about the value of nature and outdoor recreation in a healthy society."

Peter Duryea passed away on March 24, 2013, at the age of 73. He'd happily found peace long before then, once telling his adopted hometown's newspaper, the *Nelson Star*, "I really needed more in my life than just what I could see coming from [my acting] career. I need heart and I needed a community."

ABOVE: *Jose Tyler was one of the youngest members of the crew and would have been a regular member of landing parties. The character was dropped after 'The Cage,' but had some similarities to Chekov, who was introduced in the second season.*

TO BOLDLY GO

THE FIVE-YEAR MISSION

In the three years it was on network TV, the original *STAR TREK* laid the ground for everything that followed.

After NBC agreed to fund a second pilot, *STAR TREK* went back into production. At the network's request, Roddenberry dropped the character of Number One and agreed to downplay the importance of the alien, Mr. Spock. He took the opportunity to recast some of the characters, replacing John Hoyt with Paul Fix and Laurel Goodwin with Andrea Dromm. Everyone was happy with Jeffrey Hunter, but he decided not to return for the series, so Desilu turned to a young, rising star named William Shatner, and Captain Pike was replaced with Captain Kirk. Like its predecessor, the second pilot, 'Where No Man Has Gone Before,' was filmed at Desilu's Culver City lot – and this time *STAR TREK* sold.

With a firm order for 16 episodes, the production was relocated to Desilu's Gower Street studios, where the sets were rebuilt on Stage 9. Only the bridge survived the move and this was in bad condition, since it had been left exposed to the elements. Matt Jefferies, now established as the series' art director, designed and built all the sets he thought the show would need over the course of the season, giving the *Enterprise* a modular design that could be easily adapted to create new areas of the ship we hadn't seen before. Stage 10 would be used to build any alien worlds the scripts called for.

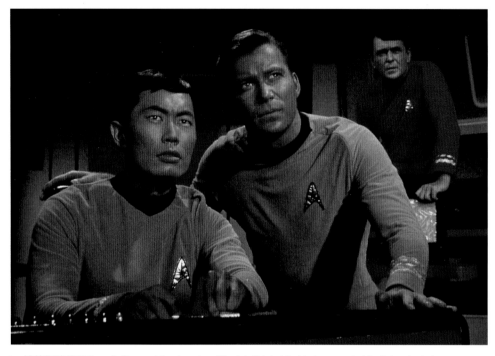

ABOVE: STAR TREK *was built around the character of Captain Kirk, but Roddenberry wanted the* Enterprise *to have a consistent crew, so he offered actors such as George Takei and James Doohan recurring roles, initially guaranteeing that they would appear in roughly half the episodes.*

The team that Roddenberry assembled was a combination of old-school Hollywood and people who were being given their first chance. Makeup artist Fred Phillips had worked on *The Wizard of Oz*. Linwood Dunn, whose company Film Effects of Hollywood would start to contribute effects shots, had worked on *King Kong*. In contrast, Bob Justman was promoted to become the series' associate producer and would be responsible for every aspect of the production and the show's budget. He recruited 35-year old Jerry Finnerman as the series' director of photography. Finnerman was a key member of the crew and his experimental approach to lighting with bright colors would play a major role in defining the look of the series.

A large cohort of the team were veterans of *The Outer Limits* and therefore had experience of science fiction, they included Justman, Phillips, propmaker Wah Chang and "monster performer" Janos Prohaska.

Joe D'Agosta accepted the job as Desilu's new head of casting, a position that hadn't existed before. Jim Rugg would contribute any practical effects that were needed, from explosions to flashing lights.

Before work could begin, Roddenberry needed scripts. He was keen to recruit as many science-fiction authors as possible, alongside experienced TV writers. He held parties and screenings to show them the second pilot before handing out story assignments. To help him manage the writing process, he brought in John D.F. Black, but at the beginning of that first year, Roddenberry would rewrite almost every script himself. Not all the writers were happy with the rewrites and there were often disagreements. Black would (mostly) side with the writers and when his contract came up for renewal, he chose the moment to leave.

In those early days *STAR TREK* was clearly a happy family. There may have been the odd spat and inevitably there were

people who didn't get along, but visitors to the set describe a happy place. Shatner was known for his humor and his charm, and Roddenberry would make a point of throwing parties for people's birthdays. There were so many birthdays in August that they were combined into one big party. Roddenberry was also fond of practical jokes and there are stories about him and Justman trying to convince Leonard Nimoy to have surgery on his ears to save money, or blowing up a massive weather balloon in story editor Steven Carabatsos's office. The general impression is of a professional but relaxed atmosphere, with everyone working hard and being glad that they were involved in a network TV show.

From the beginning it was clear that, despite the network's reservations, Spock was a compelling character and as soon as the episodes began to air, the public responded enthusiastically. However, STAR TREK had been designed as a vehicle for Captain Kirk. This was something that Roddenberry had to remind people of on more than one occasion. Only Shatner and Nimoy had contracts for every episode and were given credits before the titles. DeForest Kelley, Grace Lee Whitney,

and George Takei had contracts guaranteeing that they would appear in seven out of 13 episodes. James Doohan was contracted for five episodes. Nichelle Nichols didn't even have that and was only offered work when she was needed. Their roles were part of Roddenberry's desire to make the *Enterprise* feel like a real-world ship with a consistent crew, rather than part of an abortive plan to create an ensemble cast. As a result, many of the supporting cast and extras were called back time and time again (even if their characters were killed). Years after STAR TREK had been canceled, Roddenberry would talk about how much he wished he'd been able to explore the supporting characters further, but back then they would only work for one or two days an episode, while Shatner, Nimoy, and Kelley were normally needed throughout.

Toward the end of that first season, the STAR TREK formula started to fall into place. With the arrival of Gene Coon as the head writer, Roddenberry felt confident enough to step back and leave Coon and Justman to run the show on a day-to-day basis. Coon established a particular kind of light-hearted exchange between Kirk and Spock, and played up the

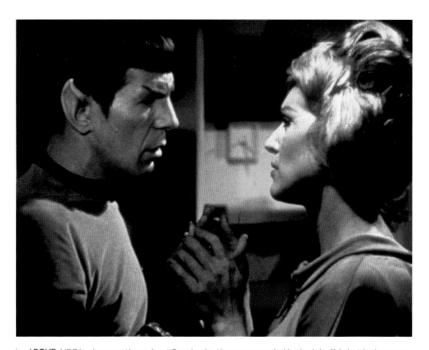

ABOVE: NBC had reservations about Spock, who they were worried looked devilish, but he became one of the series' – and television's – most popular characters. Leonard Nimoy realized this was happening when he saw the public response to Spock's loss of control in 'The Naked Time.'

conflict between Spock and McCoy. Familiar elements such as Starfleet, the United Federation of Planets, and the Klingons were all introduced during his tenure, and importantly, Dorothy Fontana joined him as the story editor. Working with Roddenberry, they created the *STAR TREK* that we know.

The show's ratings weren't great, but nor were they disastrous. Even if *STAR TREK* hadn't broken through, NBC hoped that with the team's support and a little more time, it would find a bigger audience. So as the series approached the end of the first season, NBC ordered four more episodes. In the end, they scaled that order back to three, but these would include 'Errand of Mercy,' which introduced the Klingons, and 'The City on the Edge of Forever,' which is widely regarded as *STAR TREK*'s finest installment. In March of 1967, they decided to bring the series back for a second season.

With *STAR TREK* renewed, Leonard Nimoy felt that Spock's popularity meant he was due for some recognition and demanded a pay rise. Negotiations were difficult, and at one point it looked as if *STAR TREK* might start its second season without Spock. Roddenberry and Coon even went as far as creating a replacement Vulcan science officer and offering the role to Lawrence Montaigne, but eventually, Desilu and Nimoy arrived at a deal.

This, however, raised an issue. Roddenberry was insistent that Shatner was the show's star and however popular Spock was, he was still a supporting character. For his part, Shatner was concerned that his position as the series' lead was being undermined by Spock's popularity. He was often unhappy about scripts making Kirk appear as if he was one step behind the super-intelligent Spock, and even having fewer lines. Because of his concerns, scripts were often reworked to shore up Kirk's role. Lines were taken away from other characters and given to the captain.

Roddenberry talked to his friend Isaac Asimov about the problem. The solution they came to was that Kirk and Spock should become inseparable. As Roddenberry wrote to Asimov, the approach would give the series one lead: "the team."

DeForest Kelley had only been given "featured" billing in the first season, but he too had established himself as a major part of the series and, at Bob Justman's suggestion,

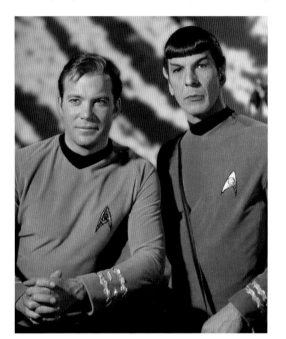

ABOVE: *As* STAR TREK *evolved, the show started to focus on Kirk and Spock. Roddenberry had them work together so closely that they started finishing one another's sentences, and audiences thought of them in the same breath.*

his name joined Shatner's and Nimoy's in the opening titles.

In an effort to attract a younger audience, Roddenberry decided to add a youthful new character, who was inspired by the popularity of Davy Jones in *The Monkees*. It was the height of the Cold War and Roddenberry wanted to make a point about humanity overcoming its differences in the future, so the new character, Ensign Pavel Chekov, would be Russian. Roddenberry even wrote a letter to the Russian state newspaper *Pravda* to tell them about it.

Ironically, Desilu's success was causing problems for the studio. Like *STAR TREK, Mission: Impossible* had been renewed for a second season, and it was being joined by *Mannix*. The company was spending a lot of money and was in danger of going bankrupt. As a result, *STAR TREK*'s budget was trimmed in the second season and, since the actors got pay rises, less money was available for production.

In order to make things run smoothly, the producers decided to institute a system whereby most episodes would be directed by one of two directors: Joseph Pevney and Marc Daniels, both of whom had proved themselves in the first season. Other directors, notably Ralph Senensky and Vincent McEveety, would step in to share the burden, but Pevney and Daniels between them directed 16 of the season's 26 episodes. At Shatner's suggestion, the producers provided the actors with a rehearsal table where they could run through the lines without needing to be on the stage.

Many people regard this as *STAR TREK*'s golden period. At the beginning of the season, Roddenberry's disagreements with the writers seemed to be a thing of the past, Coon and Fontana were turning out many of the series' best scripts, and new and important writers Norman Spinrad, Robert Bloch, and Jerome Bixby contributed stories. The writing and production staff was settled, too, and the art department was even strengthened by the arrival of prop master John Dwyer.

But it was a fragile balance. The show's ratings were marginal, the budgets were tight, and as a result so were the schedules. The pressure on Gene Coon was immense and in the middle of the season he decided to quit, handing his

producing and script-editing duties to John Meredyth Lucas, who had contributed the script for 'The Changeling.'

As the series approached the end of the second season, Roddenberry was concerned that it wouldn't be renewed. He encouraged a letter-writing campaign in the hope that it would pressure NBC into giving the show a third season. The renewal eventually came, but NBC had decided to move STAR TREK to the 10 o'clock slot on Friday nights. Everyone felt that would make it almost impossible to improve their ratings. Roddenberry's solution was to bring in a new producer: Fred Freiberger, while he himself devoted a lot of his energy to other projects.

By now STAR TREK had new owners. In 1967, Desilu had been sold to Gulf + Western, who merged it with Paramount, which they had bought the year before. The new regime instantly set about cutting costs. STAR TREK was an expensive show with what looked like a limited future, so its budgets were slashed. Freiberger had very different ideas from his predecessors about what would make the show successful. Some people had the perception that he didn't "get" STAR TREK and Leonard Nimoy, in particular, was unhappy that Spock was given more romantic storylines and unusual psychic powers.

The crew was losing key personnel, too. Dorothy Fontana left her job as story editor at the end of the second season. Jerry Finnerman moved on after 'The Empath' to work on a feature film. And, having been passed over for the producer's job and confronted with inadequate budgets, Bob Justman, who had been so important to the series, left in the middle of the third season.

The season would, however, include well-regarded episodes: the Klingons returned in 'Day of the Dove,' one of two episodes contributed by Jerome Bixby alongside 'Requiem for Methuselah'; and Joanne Linville played the Romulan Commander in 'The Enterprise Incident,' which Finnerman listed as one of his favorite episodes.

The ratings continued to decline, and this time the show would not be renewed. As they scattered to the winds, the cast and crew had different attitudes. For some, it was a relief that would allow them to seek out new opportunities; for others, it was the end of a nice job. But they all thought it was over, and when the last episode, 'Turnabout Intruder,' was broadcast, no one realized that STAR TREK's story was just beginning.

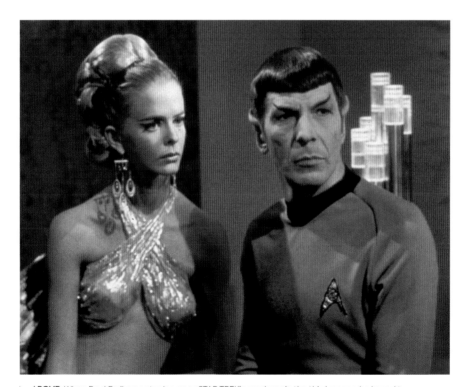

ABOVE: *When Fred Freiberger took over as STAR TREK's producer in the third season, he hoped to boost ratings by introducing more romance and exploiting Spock's character. Leonard Nimoy was very uncomfortable with this approach and felt that episodes such as 'The Cloud Minders,' where Spock is attracted to Droxine, betrayed the concept of the character.*

Desilu Productions Inc.

Inter-Department Communication

TO_____ GENE RODDENBERRY DATE___ AUGUST 1, 1966 ___

FROM_ BOB JUSTMAN ___ SUBJECT _ STANDARD OPENING
 NARRATION

Dear Gene:

It is important that you compose, without delay, our Standard
Opening Narration for Bill Shatner to record. It should run
about 15 seconds in length, as we discussed earlier.

 Regards,

 BOB

THE OPENING
NARRATION

With the first air date looming, an overworked Gene
Roddenberry sat down to write the epic narration with
a little help from his friends...

ugust 1, 1966, a little over five weeks before the *STAR TREK* season premiere on September 8, associate producer Bob Justman typed an already harrassed and overloaded Gene Roddenberry a memo urging him to write the show's opening narration. The main title visuals were ready, assembled with salvaged film from the two *STAR TREK* pilots, and new shots of the *Enterprise* in space. All they needed was 15 seconds of text.

Roddenberry sent a draft to Justman and another to head writer John D. F. Black, inviting comments and suggestions. Both men replied with their suggestions. "John was the one who first came up with the idea of incorporating writer Sam Peeples' second pilot title 'Where No Man Has Gone Before,'" recalled Justman, "And then everything ground to a screeching halt.

"Finally, on August 10, 1966, after phoning him at home the previous night to warn that we had just about run out of time, I sent Gene a final plea in memo form," remembered Justman. Roddenberry picked up the memos of August 2 with the suggested revisions, and wrote the final, famous words.

The same afternoon, Justman put in a call to William Shatner to meet him and Roddenberry on the dubbing stage. After a short rehearsal, he recorded the lines.

"His reading was superb," said Justman, "but after playing it back I felt disappointed. The narration didn't sound right. It seemed to lack importance." So Justman suggested that head sound mixer Eldon Ruberg add a 'reverb' effect to Shatner's voice. It worked. "We recorded another take and the results were perfect. Bill Shatner became Captain Kirk, the heroic starship commander of the future."

/2/66
STAR TREK
Opening narration

 This is the adventure of the United Space

Ship Enterprise. Assigned a five year galaxy

patrol, the bold crew of the giant starship

explores the excitement of strange new worlds,

uncharted civilizations and exotic people.

These are its voyages and its adventures . . .

ROUGH DRAFT 8/2/66
OPENING NARRATION - STAR TREK

 This is the story of the United Space Ship Enterprise.
Assigned a five year patrol of our galaxy, the giant starship
visits Earth colonies, regulates commerce, and explores
strange new worlds and civilizations. These are its voyages...
and its adventures.

Desilu Productions Inc.

Inter-Department Communication

TO GENE RODDENBERRY DATE August 2, 1966

FROM JOHN D. F. BLACK STAR TREK

 SUBJECT Opening Narration

Gene....

 Think the narration needs more drama.

 Follows an example of what I mean... *at about 15 to 17 seconds*

 KIRK'S VOICE
Space...the final frontier...endless...
silent...waiting. This is the story of
the United Space Ship Enterprise...its
mission...a five year patrol of the
galaxy...to seek out and contact all
alien life...to explore...to travel the
vast galaxy where no man has gone before
...a STAR TREK.

John D. F.

Desilu Productions Inc.

Inter-Department Communication

TO GENE RODDENBERRY DATE AUGUST 2, 1966

FROM BOB JUSTMAN STAR TREK

 SUBJECT OPENING NARRATION

Dear Gene:

Here are the words you should use for
our Standard TEASER Narration:

"This is the story of the Starship
Enterprise. It's mission: to advance
knowledge, contact alien life and
enforce intergalactic law ... to explore
the strange new worlds where no man has
gone before".

 Regards,

 BOB

STAR TREK

STANDARD OPENING NARRATION:

August 10, 1966:

Space ... the final frontier. These are the voyages of
the Starship Enterprise, its five-year mission.

 ... to explore strange new worlds

 ... to seek out new life and new civilizations

 ... to boldly go where no man has gone before.

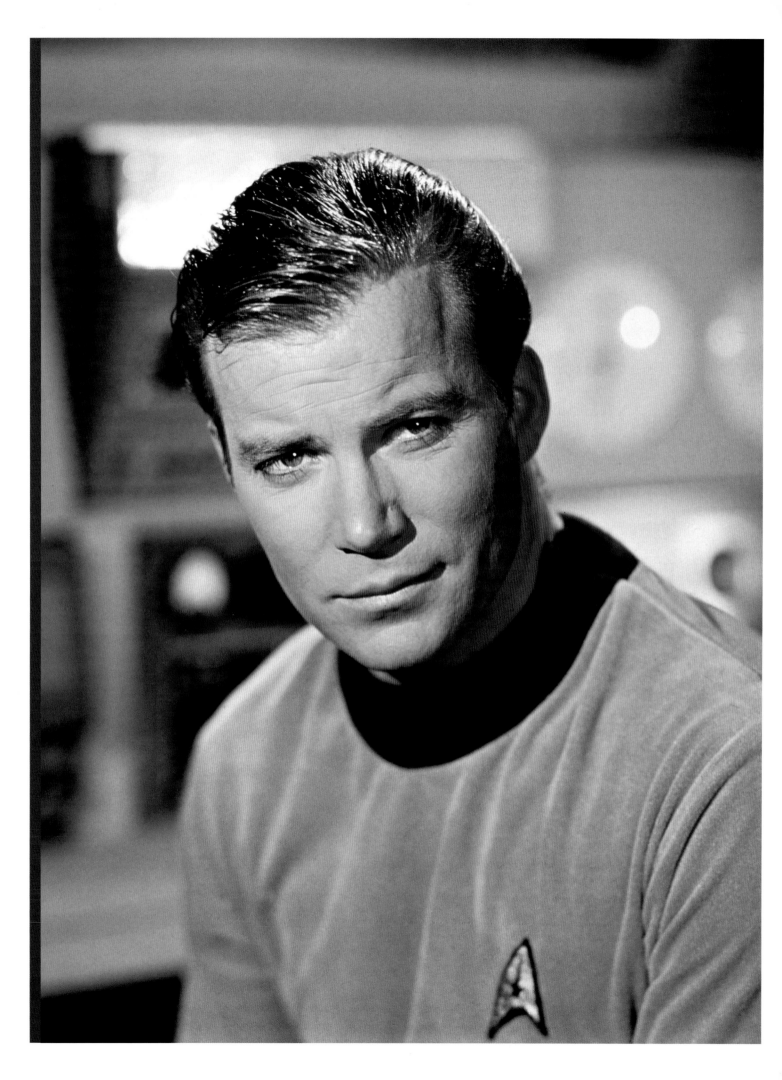

CAPTAIN KIRK
THE MYTHIC HERO

James T. Kirk was the model *STAR TREK* captain: brave, decisive, and commanding, but always human and compassionate. There is no question he was the star of the show.

"There is nothing else like *STAR TREK*," William Shatner marveled as he celebrated *STAR TREK*'s landmark 50th anniversary in 2016. "If there ever is something else like it, we'll all be long gone, because it will be 50 years from now. So, this is a unique phenomenon that I am very grateful to be a part of."

Likewise, there's nothing else like James Tiberius Kirk, captain of the *Starship Enterprise* – and there never will be again. Shatner spent portions of four decades playing the iconic character – part mythic hero, part philosopher, part man of action, and part lover – first for three seasons on *STAR TREK*, and then in seven feature films. He wrote Kirk-centric novels and not one, not two, but multiple memoirs (*STAR TREK Memories, STAR TREK Movie Memories, Get a Life!, Up Til Now*, and more). He voiced Kirk for *STAR TREK: THE ANIMATED SERIES* and several video games, directed a documentary, *The Captains*, in which he traded anecdotes with the men and woman who'd followed him as a *STAR TREK* commanding officer. It goes on and on: countless convention appearances, where he's answered thousands of questions from fans; touring one-man shows in which he revisited his career and Kirk; and too many promotional interviews to count.

For all of that, Shatner has always kept Kirk at arm's length. He appreciates the character. He knows what makes Jim tick. To a degree, after years of exploring the issue, he understands why fans embrace the character, whom he thinks of as a modern-day Alexander. But to Shatner, Kirk is a fictional creation, a role, a job, and a foot in the door to dabbling in other opportunities: author; talk show host; director; early Internet mogul; equestrian; commercial spokesman; songwriter; producer. And: charity event host; singer might be too strong a word, so let's go with recording artist; horse breeder; dog lover; father and grandfather.

As such, Shatner never internalized Kirk – or *STAR TREK* itself. He famously landed himself in hot water with the 'Get a Life!' convention sketch on *Saturday Night Live*. Kirk was a character, and he was the actor lucky enough to play it, which he did based on words written first by Gene Roddenberry, then Gene Coon and others. When necessary, he fought for Kirk to say this or do that, or to not say this or do that. He was

protective of the captain and his integrity. But make no mistake: Kirk is Kirk and Shatner is Shatner.

"The character of Captain Kirk is different because he is, in effect, a hero, and heroes are universal," Shatner said while promoting STAR TREK IV: THE VOYAGE HOME. "I never felt stifled in the series and I think any actor would have paid the management money to receive half the roles I've been asked to do. Certainly, for me, STAR TREK has been a means of international success as well as giving me some financial independence that would not have been there otherwise. It has affected a great deal of my life, and almost all of it has been good."

Shatner, in that same conversation, succinctly summed up why STAR TREK, at one point assessed as a failed series that lasted just three seasons, ultimately struck a nerve with millions of people worldwide. "I began to realize something was happening when people started calling me Captain Kirk everywhere I went," he noted. "It can be credited to the many elements that go to make up STAR TREK: the science fiction, the action/adventure, the family of characters, and that undetermined chemistry thing that makes a hit. STAR TREK reaches such a wide variety of fans."

It almost never happened.

STAR TREK's first pilot rolled camera in 1964, with Jeffrey Hunter taking the lead as Captain Christopher Pike, a character written by Roddenberry and depicted by Hunter as a serious man not entirely comfortable with his position's inherent tasks. "I'm tired of being responsible for 203 lives," he protests in 'The Cage.' "I'm tired of deciding which mission is too risky and which isn't. And who's going on the landing party and who doesn't. And who lives… and who dies." Pike also didn't care for women on his bridge. NBC nixed the pilot, but gave Gene Roddenberry another shot.

All involved believed, incorrectly, that Hunter would remain in the captain's chair for the second pilot and, hopefully, the ensuing series. Hunter quit, however, and Roddenberry took advantage of the opportunity to rethink the role of the captain. Thus, Pike gave way to Kirk in subsequent outlines and script

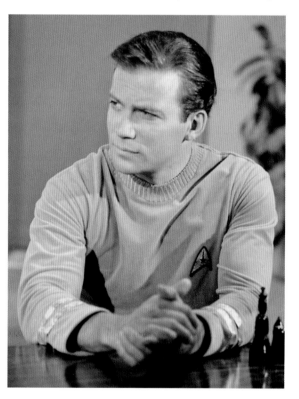

ABOVE: *William Shatner during the filming of 'Where No Man Has Gone Before.' Shatner always saw Kirk as an archetypal hero, but brought a certain degree of humor to the role, which had been lacking in 'The Cage.'*

revisions. "The character," producer Robert Justman told the Television Academy, "was an amalgam of Hamlet and Captain Horatio C. Hornblower."

Simultaneously, Roddenberry scoured Hollywood for his new leading man. Jack Lord, who went on to a long run with *Hawaii Five-O*, reportedly demanded a massive stake in the show and its profits to play Kirk. Roddenberry kept searching. Nothing was more important to *STAR TREK* than casting the captain. In the 1960s, casting the lead role in a TV series was very much about the qualities an actor brought to it. A character actor pretends they are someone else. A star pretends someone else is them. By this time, Shatner, was a star on the rise. He'd gained acclaim for stage performances in his native country, Canada, and for such films and television shows as *Alfred Hitchcock Presents*, *The Brothers Karamazov*, *The Twilight Zone*, *Judgment at Nuremberg*, *Alexander the Great*, *The Man from U.N.C.L.E.*, and *For the People*. He actually shared a scene in 'The Project Strigas Affair,' his *Man from U.N.C.L.E.* installment, with a fellow actor named Leonard Nimoy.

"So now Gene telephoned me, and at the time, I have to admit, I had no idea who he was," Shatner wrote in *STAR TREK Memories*. "But he told me about what was going on, and asked me to come to Los Angeles and watch the first pilot with him. And I remember as I watched it, I was impressed by a number of things. The green girl, and Leonard (who smiles… twice), and Majel Barrett as Number One, and I thought it was extremely innovative and extremely inventive. Gene then told me that NBC didn't put it on the air because they wanted him to recast it, rewrite it, and do a more action-packed, less thought-provoking pilot.

"At any rate, Gene explained that NBC saw something there that in their minds merited a second shot at creating a pilot episode," Shatner continued. "We talked at great length about the possibilities, potential drawbacks, and proposed direction of the series, and as we parted, I can remember Gene saying, 'You're my leading man.'"

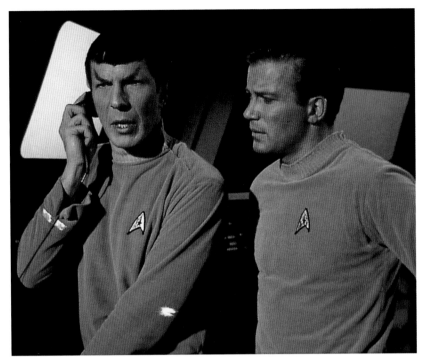

ABOVE: *Kirk's relationship with Spock would prove key to the series. The two men rapidly found a rhythm that allowed them to play off one another, and helped define their characters.*

The cast continued to coalesce around Shatner and the sole series regular retained from 'The Cage,' Nimoy. Production commenced in July, 1965, on 'Where No Man Has Gone Before.' NBC liked what it saw in the second pilot (which aired third), audiences did, too, and so began the *STAR TREK* juggernaut. Shatner quickly "found" the character, imbuing Kirk with heart, charm, a sense of adventure, more humor than Hunter had instilled in Pike, and a desire, most of the time, to do the right thing. He also… hit… upon… Kirk's… staccato… line… delivery, and humanized his dialogue. As the actor noted in one of his memoirs, he couldn't understand why anyone would say "Negative" when just a good old "No" would suffice – and sound more realistic.

And, crucially, Shatner hit his groove from the start with Nimoy and DeForest Kelley (who made his debut in 'The Corbomite Maneuver'), fashioning a dynamic that powered the entertaining and contentious Kirk-Spock-McCoy triumvirate for decades to come. Nimoy often noted that he recalibrated his performance as Spock in reaction to what Shatner delivered as Kirk. And the writers, recognizing the natural interplay between Shatner, Nimoy and Kelley, built up Dr. McCoy. We'll never know what might have happened if Paul Fix had stayed on as the ship's doctor, but could it possibly have paid off the way Kelley's casting did? Negative, or, rather… no.

Shatner, in an on-camera interview with the Television Academy, recalled the early days of *STAR TREK*. He'd routinely received 10 pages of script pages, often with two-page speeches, and then be handed the next day's 10 pages while

"We talked at great length about the possibilities… and as we parted, I can remember Gene saying, 'You're my leading man.'"

■ **William Shatner**

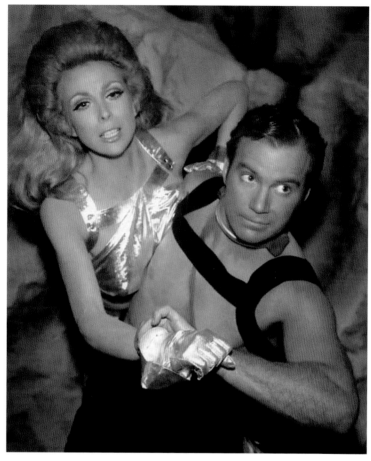

ABOVE: *Kirk wrestles with Shahna from 'The Gamesters of Triskelion.' The captain had a reputation as a fighter and a lover, but this was hardly uncommon for the lead in a 1960s TV show.*

still on set shooting the initial 10 pages. That never changed. It occurred, Shatner pointed out, when Roddenberry oversaw every detail in season one, when Gene Coon took over the day-to-day from the middle of season one to the middle of season two, and when others stepped in through to the end of the series. A day's shoot could last 10 hours or more and the only rehearsals were done hurriedly on stage.

Some days, Shatner might be asked to conduct interviews or participate in photoshoots, and those engagements might take place before, during, or after acting on set. Shatner's father passed away during production of 'The Devil in the Dark,' and his first marriage ended by the time the series wrapped for good. So, the actor stayed laser-focused on the tasks at hand: shooting a day's pages, playing Kirk, and as the leader on set, keeping the mood light with jokes and pranks. As a result, he remained blissfully oblivious to everything else around him, including any set romances or the myriad complaints of costars and guests about the way Kirk monopolized the lines and screen time.

"I knew nothing about any of the intrigues," Shatner explained. "I knew nothing about anything until years (later). Then the show was over. That's the end, and you go on to the next gig, and then suddenly there's intrigue, and I didn't know anything about it. I didn't know who was having affairs with who. I didn't have time!"

Addressing specific episodes in that same conversation, Shatner touched on a couple of his personal favorites. In 'The Enemy Within,' for example, a transporter glitch splits

Kirk into good and evil versions of himself, with the captain and those around him discovering that he needs both halves, in equal measure, to be the captain they all know and respect. "It was ultimately *The Fly*, wasn't it, in the transporter?" Shatner asked rhetorically. 'The good captain and the bad captain. I thought it was Jekyll and Hyde, with humanity. I wanted to do humanity. I wanted him to be human."

'Turnabout Intruder,' the final episode of the series, presented a similar challenge. Dr. Janice Lester (Sandra Smith) deploys a life-transfer device to possess Kirk's body and take control of the *Enterprise*. "It was fun," Shatner remembered. "The kick about that was reading the script and saying, 'A woman enters his body.' How do you do that? How do you act a woman entering your body? I think that was novel in the history of drama, and I had to fiddle around with that."

In *STAR TREK Memories*, Shatner called 'The Devil in the Dark' his favorite episode. "[It] was a terrific story," he opined. "Exciting, thought-provoking and intelligent, it contained all of the ingredients that made up our very best *STAR TREK*s. However, none of that stuff qualifies it as my favorite." Why it stood out to Shatner was the way the entire *STAR TREK* cast and crew rallied around him after he took the call relaying news of his father's death. Nimoy, he noted, made sure to be emotionally and physically close to his friend for the rest of the day, as did cinematographer Jerry Finnerman. "Between Leonard and Jerry, we were able to make it through that awful

Courtesy STAR TREK: Original Series Set Tour/James Cawley

ABOVE: *Shatner and Nimoy pose with a 3D chess set. Roddenberry liked the running gag that Spock would make logical moves, only to find that Kirk had defeated him by doing something unexpected.*

ABOVE: *Shatner takes a moment out to relax during the filming of 'The Naked Time.' His working day normally ran from 7 in the morning until just after 6 in the evening. After he had gone home he still had lines to learn for the next day and Shatner was in almost every scene.*

afternoon, and I was able to fly out that evening to my father, warmed by their love and affection. That's what makes this episode my favorite."

When *STAR TREK* was renewed for a second season, Roddenberry faced a dilemma: the show was built around Captain Kirk, but Spock had proved to be hugely popular and there was a danger that he could overshadow the captain. As Roddenberry wrote to his friend Isaac Asimov, "it's easy to give good situations and good lines to Spock." He went on to explain how important it was to make Kirk as strong as possible, but added that "the problem we generally find is this – if we play Kirk as a true ship commander, strong and hard, devoted to career and service, it too often makes him seem unlikable. On the other hand, if we play him too warm-hearted, friendly and so on, the attitude often is 'how did a guy like that get to be a ship commander?'"

As the series' leading man, Shatner was alive to the problem and made his concerns clear. It was important to him that Kirk be seen as the central character and not someone who waited for Spock to have the ideas. Scripts were often reworked to strengthen Kirk's role, and Roddenberry decided to make him and Spock inseparable. Even in the third season, Roddenberry was urging the writers to emphasize that Kirk was above all a commander, and shouldn't ever be seen to be seeking the "friendship and approval of his subordinates." For his part, Shatner was a strong presence on the set. One of *STAR TREK*'s most prolific directors, Joe Pevney, described him as being like a producer, who would orchestrate rehearsals and express definite opinions about how scenes should be staged.

STAR TREK concluded its run in 1969 and everyone moved on with their lives and careers. Shatner experienced peaks and valleys personally and professionally. Divorced in 1969, and

ABOVE: Shatner was known to be a joker on set and would often lighten the mood with a pun or an adlibbed line of dialogue that reduced the crew to tears of laughter.

All picturees courtesy STAR TREK: Original Series Set Tour/James Cowley

"He [Kirk] is also capable of fatigue and inclined to push himself beyond human limits, then condemn himself because he is not superhuman."

STAR TREK WRITERS' AND DIRECTORS' GUIDE

ABOVE: *Shatner often rode to work at the Desilu studios on his BSA motorbike. He remained a keen bike rider well into his 80s, when he rode a custom motorbike across America.*

with money tight, he lived in his pickup truck for a time in the early 1970s. TV guest spots and roles in such B-movies as *Kingdom of the Spiders* followed. Slowly and steadily, though, *STAR TREK* crept back into his life. He voiced Kirk for *THE ANIMATED SERIES*, attended a number of conventions, and signed on for the proposed *STAR TREK: PHASE II* series that morphed into *STAR TREK: THE MOTION PICTURE*. He never looked back after that, reprising his role as Kirk in the subsequent original-cast sequels, directing *STAR TREK V: THE FINAL FRONTIER*, and bade farewell to the character with his death scene in *STAR TREK GENERATIONS*.

Beyond the *STAR TREK* realm, Shatner branched out to host the reality show *Rescue 911*; star on the cop drama *T.J. Hooker*; write, produce, direct, and star in the *TekWar* sci-fi telemovies and series; and recur as The Big Giant Head on the comedy, *3rd Rock from the Sun*. A recurring role as the pompous, possibly Alzheimer's-afflicted lawyer Denny Crane on *The Practice* led to him coheadlining a spinoff, *Boston Legal,*

with James Spader and Candice Bergen. Shatner earned an Emmy nomination for *3rd Rock from the Sun* and took home the prize for both *The Practice* and *Boston Legal*.

And he kept going: *Miss Congeniality, $#*! My Dad Says, Hot in Cleveland, The Big Bang Theory,* and the feature, *Senior Moment.* Add to that the aforementioned albums, frequent convention appearances, additional fiction and nonfiction books, documentaries, horse-racing exploits, and more, and it amounts to a packed, even frenetic, and fulfilling life.

Leonard Nimoy announced his retirement in 2010, though he still accepted the occasional project when it fascinated him enough to do so. During a conversation in 2011, he commented on the state of his relationship with Shatner. "We're similar in a lot of ways, but on the other hand, very different," he observed. "He has this great need to be working, working, working, working, working. I've asked him at times why, and I'm not sure that we've ever really come to a very clear answer of why he wants to work so much and so hard. We're different. We're

different." Months later, in a separate interview, Shatner directly addressed Nimoy's comments and the question of why he keeps working, working, working. "I just have this opportunity to create so much stuff," he said simply and non-defensively. "I love it."

Shatner turned 90 on March 22, 2021. The great Carl Reiner titled his autobiography, *Too Busy to Die*. George Burns booked a 100th-birthday gig at a Las Vegas casino; he lived to 100, but had to cancel that show. Shatner keeps plowing forward, but he knows the final frontier awaits. "There's that ancient image of the guy with the beard and the scythe catching up to you on horseback," Shatner said when he turned 85. "It's that 'Don't look over your shoulder, they may be gaining on you' sort of thing. The omnipresence of death is there now, that wasn't there in prior years.

"I'm very much aware [of my age], although, my God, I'm telling you, I feel so good and so healthy," he concluded. "I ache a little, but I keep thinking that's because I'm lifting too many weights."

ABOVE: *Shatner poses with some brightly colored food during the reception scene in 'Journey to Babel.' Shatner was always amused by the more outlandish elements of STAR TREK.*

IN COMMAND

From his earliest notes about *STAR TREK*, Gene Roddenberry, emphasized the weight of command. The character of Captain Robert April was described as "A colorfully complex personality, he is capable of action and decision which can verge on the heroic – and at the same time lives a continual battle with self-doubt and the loneliness of command." Roddenberry's experiences with Jeffrey Hunter and Pike on 'The Cage,' coupled with Shatner's casting on 'Where No Man Has Gone Before,' led him to shift the emphasis. By the time he wrote the Writers' and Directors' Guide, Kirk evolved into "a complex personality capable of action and decision which can verge on the heroic – and at the same time live a command. Essentially a warm friendly man – driven rather than driving." Any references to self-doubt were tempered, and instead, his greatest weaknesses likely stemmed from "an almost compulsive" sense of compassion and a willingness to work too hard." As the guide read, "He is also capable of fatigue and inclined to push himself beyond human limits, then condemn himself because he is not superhuman."

SEASON 1

PILOT EPISODE

AIR DATE: SEPTEMBER 22, 1966

Written by Samuel A. Peeples

Directed by James Goldstone

Synopsis: After the *Enterprise* leaves the Galaxy, one of the crewmembers starts to exhibit remarkable powers. Captain Kirk has to accept that his former friend is now a danger to everyone and must be stopped.

WHERE NO MAN HAS GONE BEFORE

STAR TREK's second pilot introduced Captain Kirk and made Spock logical. In the story, they are confronted by a man who gains godlike powers and reveals his inner darkness.

Gene Roddenberry had been given another chance. After NBC saw 'The Cage,' they agreed to fund a second pilot, but there were conditions and unforeseen problems. NBC reasoned that *STAR TREK* already had sets and costumes, so the budget for the new pilot was only a third of what they had provided for its predecessor. This meant that most of the action would have to be filmed on the *Enterprise* sets.

More seriously, *STAR TREK*'s leading man,

Jeffrey Hunter, wanted out. His wife attended a screening of 'The Cage' and reported that he wasn't interested in doing a science-fiction show. Desilu tried offering Hunter more

RIGHT: Kirk tries to persuade Dr. Dehner that Gary Mitchell cannot be trusted with the vast powers he has gained.

money, but it made no difference. Instead, they started a search for a new leading man. They approached Jack Lord, who would become famous for his role on *Hawaii Five-O*, but he asked for part-ownership of the show, so Roddenberry and Desilu turned him down. William Shatner, who was regarded as a hot property, became available after the show he was in – *For the People* – had been canceled. He was flown out to L.A. where Desilu screened 'The Cage' for him and he agreed to come aboard.

Meanwhile, Roddenberry was working on new scripts. He wrote up an idea of his own, 'The Omega Glory,' while Stephen Kandel worked on a story idea about a planet with an extremely hierarchical military society. When this didn't work out, Roddenberry had him develop one of the ideas from the original *STAR TREK* pitch document about a trader and some women who are "destined for a far-off colony." Finally, Sam Peeples contributed an idea about a man who becomes evil after he acquires godlike powers. The early drafts of the story were called 'Esper' and involved a colonist rather than a member of Kirk's crew, let alone one of his closest friends. All three

stories would eventually get made, but NBC chose Peeples' script.

To direct the pilot, Roddenberry and Desilu brought in James Goldstone, who had worked with Roddenberry on *The Lieutenant*, and he brought the director of photography with him. Ernest Haller had plenty of experience of working on Desilu's Culver City stages because he had filmed *Gone With the Wind* there. He won an Oscar for his work on that film and had six other nominations under his belt. He was only available because he had retired and knew Goldstone.

Goldstone, Roddenberry, and Peeples would all contribute to the script, playing up the action elements to keep NBC happy and heightening the sexual attraction between Gary Mitchell and Dr. Elizabeth Dehner.

Matt Jefferies stepped up to become the art director, reworking the bridge set so that more of it could be removed to make filming easier. Bob Justman returned as first assistant director and accepted the additional responsibilities of associate producer.

For the key role of Gary Mitchell, Roddenberry called on Gary Lockwood who had starred in *The Lieutenant*. It almost didn't

happen because Lockwood had accepted his role in *2001: A Space Odyssey*, but he managed to squeeze the pilot in before reporting to work on Kubrick's feature. For *STAR TREK*, he was joined by a 28-year-old Sally Kellerman, who had already appeared

> **"In less time than that, he will have attained powers we can't understand and can't cope with. Soon we'll be not only useless to him, but actually an annoyance."**
> **Spock**

alongside him in an episode of *The Kraft Suspense Theatre*.

Roddenberry wanted to round out the ship's supporting cast with characters who could reappear whenever the stories needed them. James Doohan was chosen as the ship's engineer, who Doohan suggested should be a Scotsman. George Takei was cast as "ship's physicist" Sulu, and would only make the move to the helm when *STAR TREK* went to series.

In order to make Lockwood and Kellerman's eyes glow, the production decided to use scleral contact lenses, which cover the entire eye rather than just the pupil. In order to make them silver, the optician sandwiched tin foil between two lenses, leaving a small hole that the actor could look through. Lockwood, however, remembered that he could barely see a thing and Kellerman told a story about him having particular difficulty in the scene where they pick the fruit.

As far as possible, the team reused the effects shots that had been created for the first pilot, with the Howard Anderson Company adding footage of the *Enterprise* crossing the Galactic barrier. Goldstone was frustrated by how long he had to wait for the opticals. He had finished his original cut of the episode long before they arrived and had to return to Desilu to complete his editing chores at night – but this time everything worked. NBC liked the pilot and ordered *STAR TREK* to go into production.

Courtesy Gerald Gurian

RIGHT: *The cameras roll on the first day of filming 'Where No Man Has Gone Before' – the first time that William Shatner ever played Captain Kirk.*

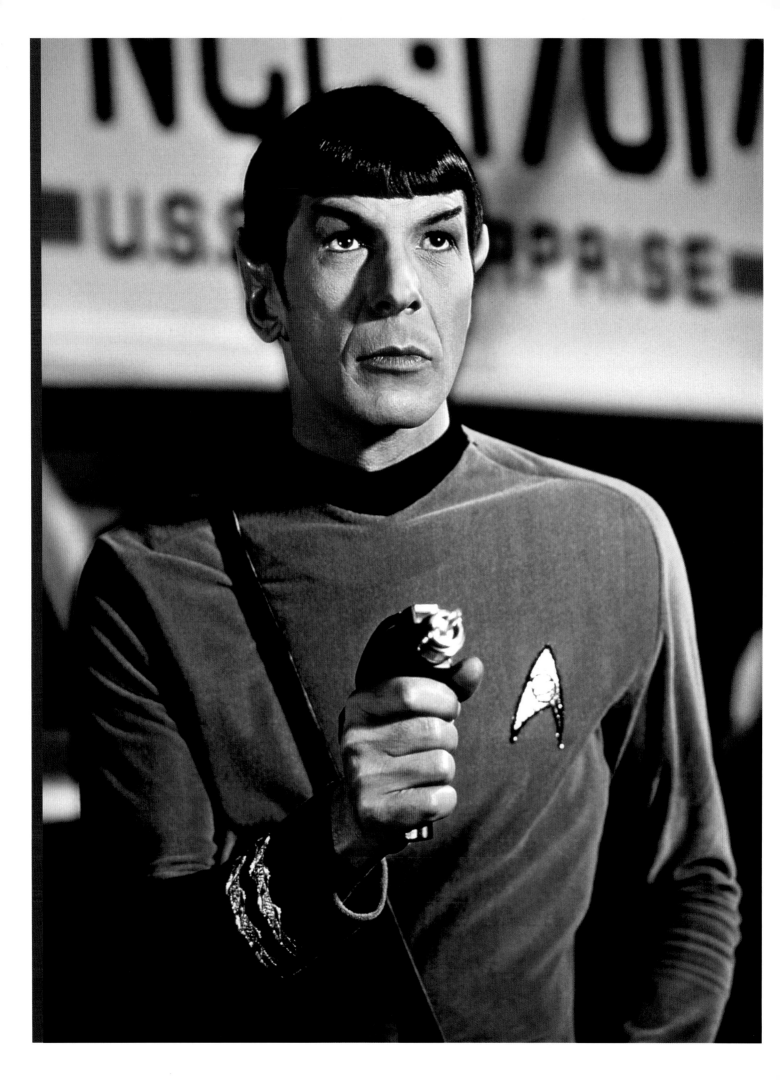

S P O C K

DIVIDED NATURE

The *Enterprise*'s half-human, half-Vulcan science officer was
STAR TREK's most enduring creation: an alien who provided a
unique insight into what it means to be human.

Leonard Nimoy took Spock seriously. He wanted to make sure that the character was never trivialized or cartoonish, that he was thoroughly thought out and developed, and that he belonged to an interesting culture. In short, that he was more than a pair of ears. From the beginning he was protective of his *alter ego*, "The character," Nimoy said, "has to depend on the kindness of the actor. The actor can do damage or be protective. I felt particularly that way with Spock, because I think Spock could easily become cartoonish or silly. I was offered vast amounts of money to do things like ride around in circuses and come flying in on a wire or something, and that's the kind of thing that I avoided."

When you talked to Nimoy about Spock, he would be very specific and considered in his responses. He felt proprietorial and protective about the character, and it's clear that rather than just delivering the lines he was given, he played a major role in defining Spock and Vulcans in general. He wasn't humorless about it – far from it; he would often laugh, but there was always a seriousness of purpose.

When Nimoy was first offered the role, Spock was a very different character. The original *STAR TREK* pitch document says that Spock is "probably half-Martian," and goes on to describe him in distinctly devilish terms with a "satanic" face and "semi-pointed ears." He is the closest to being the captain's equal "physically and emotionally, as a commander of men." He has a "quiet temperament," but there is no reference to him being logical. In fact, his defining characteristic is an intense curiosity that has the potential to get him into trouble. In that early pitch, he wasn't even the *Enterprise*'s science officer. Instead, he was the first lieutenant with responsibility for supervising all the ship's functions. By the time Roddenberry had written a complete script for 'The Cage,' that at least had changed and Spock was clearly identified as the ship's science officer. The script adds that he has a "gentle manner and tone" and speaks carefully, with the "almost British accent of one who has learned the language in textbooks." This was the character that Nimoy signed on to play and where the evolution of Spock began.

Roddenberry always had Nimoy in mind for the role. He'd been impressed with him when Nimoy had made a guest appearance on *The Lieutenant* (the first show Roddenberry had produced). In Nimoy's autobiography, *I Am Spock*, he remembered discussing the character with Roddenberry who, he wrote, was "adamant about one thing: Spock had to be obviously extraterrestrial." Nimoy liked science fiction and he could see that Roddenberry was serious and wanted to make Spock a fully-realized dramatic character. He was worried about the ears and the red skin, though. In 1964, the idea of regular work was very appealing, so he accepted the job, albeit with a degree of nervousness. "There was," he said, "the concern about whether or not this character was going to be a joke, or whether the character should be taken seriously."

Roddenberry's insistence about Spock's alien nature was the key to the character. When *STAR TREK* was being developed, Dorothy Fontana was still working as Roddenberry's secretary. She saw all the scripts and remembered being intrigued by Spock. "He was alien," she recalled. "He would bring an outsider's view not only to the stories, but the characters he was involved with. He would provide an alien look at the captain, the doctor, the voyages they were on, the people they met, and maybe a quirky take on the problem."

Exactly how alien Spock would be was still up for debate. George Clayton Johnson, who wrote one of *STAR TREK*'s earliest episodes, remembered Roddenberry telling him that Spock might have had a plate in his stomach that he used to receive energy. When it came down to it, Spock's appearance would be dictated by practical concerns. "They actually tried some red makeup on Leonard, but it didn't photograph well in the black and white," Fontana remembered. As a result, Spock's skin tone was changed to a pale, yellow color. The ears would prove problematic. The early versions were crude and stuck straight out from the side of Nimoy's head, and the problem was only resolved when Fred Phillips ignored his budget and marched Nimoy over to MGM where Charlie Schram created soft latex prosthetics that could be applied easily. "Leonard," Fontana continued, "always tells the story of how Roddenberry would come over and smooth his hair down into his bangs, and that's how the haircut evolved."

The idea that Spock was the *Enterprise*'s first lieutenant informed Nimoy's early performances. He declaims his dialogue loudly and clearly, making sure that everyone can hear him. In 'The Cage,' he even smiles. The character only started to evolve when NBC rejected *STAR TREK*'s first pilot. In Roddenberry's original concept, the ship's female first officer, Number One, was the cold and logical one. This is what the script says when the crew are surprised by their captain's orders: "Although both Mister Spock and Jose show some concern at this, there is no reaction from Number One. She turns back to the ship's controls, almost glacier-like in her imperturbability and precision. From time to time we'll wonder just how much female exists under that icy façade."

From here on in, it was Spock who would be icy, precise, and imperturbable. The process began in the second pilot, when Spock calmly suggests that they must strand Gary Mitchell on a remote planet. By the time *STAR TREK* went into full-time production in 1966, the Writers' and Directors' Guide describes him as displaying "an incapacity for emotion and an almost computer-like logical kind of mind. On his own planet, to show emotion is considered the grossest of sins… We will suspect occasionally his half-human heredity results in some feelings, but he will make every effort to hide his 'weakness.'"

ABOVE: *The Spock who appears in the first pilot, 'The Cage,' was very different from the one we would come to know. The look is there, although it would be refined, but the character smiles and speaks loudly, and although we can see that he is alien, it is far from clear what this means in practice.*

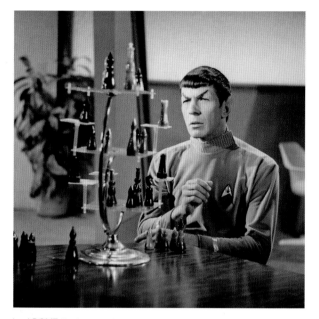

ABOVE: *By the time the second pilot was filmed, Spock's character was starting to take shape. Having been given Number One's emotionless traits, when Kirk beats him at chess, he professes not to understand the feeling of irritation, something Kirk suspects might not be true.*

However clear Roddenberry's intentions were, a lot of the detail still had to be filled in. Nimoy, the writers and directors would all play a major role in defining Spock. Nimoy always said that a key piece of the puzzle fell into place when they were filming the first regular episode. In 'The Corbomite Maneuver' when Balok's ship first appears on screen, Spock's response is not surprise or alarm, but fascination. As Nimoy told the Television Academy, the rest of the crew responded to the different threats posed by Balok with increasing alarm. At first, Nimoy said, he was "caught up in that energy," but then Joseph Sargent made a suggestion. "The director gave me a brilliant note. He said, 'Be different, be the scientist, be detached. See it as something that is a curiosity rather than a threat'…a big chunk of the character was born right there."

From now on, Nimoy would always apply that same thought to Spock, playing him as calm and dispassionate whatever was

happening. Years later, he would say that Shatner's performance played a significant role in this. Actors often feed off one another, trying to find the differences between their characters so they can give their scenes an energy. Jeffrey Hunter had been a very restrained performer who internalized his emotions, Shatner's Kirk was more expansive, and this gave Nimoy the chance to scale back his own performance.

The writers saw this in Nimoy's performance and would then write that kind of behaviour into their scripts. The first dozen or so scripts, however, were produced before anyone had seen anything other than the two pilots, so only a handful of people knew how Spock was evolving.

Nimoy was always keen to contribute ideas to the script and his character. In the third regular episode to be filmed, he introduced the Vulcan neck pinch. "It was a way of avoiding physical combat, frankly," he remembered, adding that he

"The director gave me a brilliant note. He said, 'Be different, be the scientist, be detached.'"

■ Leonard Nimoy

> *"I asked for a scene in which I could sort of do battle with myself and try to get control of this emotional outburst..."*
>
> ■ **Leonard Nimoy**

didn't like the idea that Spock could be drawn into fist fights. " I thought this is wrong, this is silly for this character to have to do this. When I was asked to hit someone on the head – in this case it was Kirk in 'The Enemy Within,' I was supposed to hit him on the head with my phaser – I devised the neck pinch to do it instead. Clean, simple, interesting, intriguing, magical, mysterious, much more entertaining I think than simply a hit on the head."

Two episodes later in 'The Naked Time,' the crew lost all their inhibitions due to an alien compound and Nimoy made another suggestion. "There was a germ," he recalled, "brought onboard that was passed hand to hand, which caused people to lose their emotional defenses. People started acting out fantasies and acting out emotions that had been suppressed. All the writer had given me as Spock was to be wandering around the hallways of the *Enterprise* crying – just simply crying, about nothing in particular, just walking around crying. Then he passes an elevator door and some fool comes out of the elevator carrying a pot of paint and a paintbrush and paints a mustache on Spock. And Spock goes off crying, now wearing a painted mustache. It was all kind of silly, and I thought 'Well, you know, there's no point to it, and it's not going to tell us anything, or inform us, or educate us, or touch us in any way.' Spock crying in itself is disturbing I suppose, but it's not really enlightening or illuminating or touching, really. So, I asked for a scene in which I could sort of do battle with myself and try to get control of this emotional outburst, and to verbally express what the battle was about, which was logic versus emotion.

"I simply said, 'Let me walk into a room and talk this out. I'm a scientist... I love my mother... $C = 2\pi r$. I'm trying to spout scientific definitions, equations, and so forth, which will give me a literal grip on my brain. At the same time I want to express

ABOVE: *Athouhgh he tried to subdue his emotions, Nimoy was far from humorless and in one famous blooper he ended the scene by sticking a lollipop in his mouth.*

All pictures courtesy STAR TREK: Original Series Set Tour/James Cawley

ABOVE: *Nimoy poses with an oversized spear from the episode 'The Galileo Seven,' a story that focused on his character's weaknesses when put in a position of command.*

this dichotomy – I have emotions, I feel things, and all of that.' It was a terribly important scene for me and I think a terribly important episode for Spock, and it was one that I asked for. After some resistance, because producers aren't particularly pleased about actors who create scenes for themselves, it was finally given to me. I think it was an important episode. I think it was an important scene."

Nimoy would identify this as the moment when Spock really caught the public's imagination. For the first time, Spock's inner conflict was on display. "You had a hint of what was there," Fontana said, "a hint of the agony that was buried deep underneath." For Nimoy, that internal conflict made the character interesting. "That was the intriguing aspect of the character that made me want to play the role," he said, "this

internal schism, this internal complexity of the character. Otherwise, the character would be rather superficial and dull."

The ninth regular episode to be filmed, 'Dagger of the Mind,' introduced the Vulcan mind-meld. Nimoy was happy with it because he felt it was more interesting than some kind of truth beam, which is what had appeared in earlier versions of the script. With its introduction, the essential elements of Spock's character were all in place.

Spock's inner conflict would be revisited in 'This Side of Paradise.' This time Dorothy Fontana would explore his potential for happiness and how tragic it was that he couldn't embrace it. At first Nimoy was resistant to giving Spock a love story. The idea was first mentioned to him halfway into the season and he felt that he was just beginning to understand the character.

ABOVE: *Nimoy had the idea that Vulcans were a very hand-focused people, and often used his hands to indicate Spock's state of mind. They also played a role in the neck pinch and the mind-meld, and in moments of intimacy.*

Gene Coon had taken control of the writing team at around the same point. Nimoy would describe him as *"STAR TREK's secret weapon."* The needling relationship between Spock and McCoy had been mentioned in Roddenberry's original notes, but it was Coon who would develop the idea that Kirk, Spock, and McCoy formed a triangle, with Spock offering logical advice, McCoy providing an emotional counterbalance, and Kirk making the final decision. Coon also brought more humor to the series, which Nimoy approved of, as long as it was grounded in Spock's character.

Spock was clearly *STAR TREK's* breakout character and Nimoy started to receive a huge amount of fan mail and acclaim. In March of 1967, the National Space Club invited him to a dinner alongside the Vice President and Mercury astronaut,

John Glenn. In the spring of 1967, he agreed to appear in costume with the ears at a parade in Medford, Oregon. The crowds were so large that he feared for people's safety and swore never to make another public appearance in character. He was frequently featured in magazine articles, many of which focused on the idea that Spock was sexy. Isaac Asimov contributed an article to *TV Guide* called 'Mr Spock is Dreamy.' When the first season wrapped, Dot Records signed Nimoy to make an album called *Mr. Spock's Music From Outer Space.*

Spock was famous, but for all his popularity Nimoy was still being paid as a supporting character and felt he wasn't being treated with much respect. He didn't even have a phone in his trailer. After talking to his agent, he decided that Spock's popularity meant that his contract was not appropriate and

unless it was renegotiated, he would not return for the second season. Desilu reluctantly agreed. This would establish a pattern that would be repeated in later years. Roddenberry and Paramount were keen to say that Nimoy didn't want to return when they were trying to revive STAR TREK in the '70s. Not so, he insisted. It was more that he felt they never made him a realistic offer. Nimoy was both intensely protective of the character and had a realistic sense of his own value. Ultimately, this combination would lead to him becoming a producer and director of the STAR TREK movies.

In 1967, Nimoy was glad to have a pay rise and to be back at work. When NBC had seen Spock's popularity, they had pushed for more episodes that focused on him. This resulted in one of the early season-two episodes, 'Amok Time,' in which Spock returned to Vulcan and we discovered that Vulcans are more complicated than they appear. Ted Sturgeon's script revealed that once every seven years these deeply logical people lost all control and were overcome with an urge to return home and take a mate.

'Amok Time' introduced the famous Vulcan greeting. Sturgeon wrote the lines 'Live Long and Prosper,' but director Joe Pevney and Nimoy contributed the Vulcan salute with the middle fingers split to form a V. Pevney remembered saying

that they should come up with some Vulcan business, and Nimoy suggested the salute based on a blessing used by Jewish priests that he had surreptitiously glimpsed as a child.

Nimoy loved the idea that Vulcans were very hand-focused, and when Mark Lenard and Jane Wyatt guested as his parents a few episodes later, he suggested that they think about something along these lines. The result was that Vulcans "kiss" by touching fingers.

Nimoy's desire to protect Spock often meant that he would visit the writers after receiving a script, sometimes to make suggestions, but other times to express concern. "I had," he said, "to prevent liberties being taken, writers playing fast and loose with the Spock character because it was convenient." He was particularly concerned about Spock's psychic powers becoming stronger because it helped to solve a story problem. A mind-meld was one thing, but in 'A Taste of Armageddon,' Spock focuses his telepathic powers to make a guard open a door. In 'By Any Other Name,' he makes telepathic contact with the Kelvans. Roddenberry himself called for these powers in 'The Omega Glory,' when he had Spock influence the mind of one of the Yangs.

Nimoy was not a fan of these scenes. "The idea," he said, "of Spock's capabilities had to be protected so that they would

ABOVE: Nimoy and director Joe Pevney developed the famous Vulcan salute as an alternative to a handshake. Nimoy based it on a gesture of blessing made by Jewish priests who used their hands to make the shape of the Hebrew letter, Shin.

| **ABOVE:** Nimoy in makeup but with his hair brushed back, posing with his Buick in the Desilu parking lot.

remain valuable. There were times when I thought that Spock's ability to mind-meld with another individual to pick up vital plot information was becoming too expedient and was being used as a kind of very simple device to solve plot problems too often. I would complain about it. One time they had Spock actually reading someone else's mind through a wall. I did it, but I thought 'We're not going to do that again.' It's just pushing the envelope too far and making less value of the incident."

Nimoy would find himself arguing with Roddenberry and to a lesser extent, Coon, both of whom were under pressure to get the scripts out and weren't keen on taking time to rewrite them. He would often enlist Bob Justman as an ally, who would find himself trying to persuade Roddenberry that the actor had a point. "I had confrontations with Roddenberry," Nimoy remembered. "I would usually find some benefit would come out of the confrontation. Sometimes reluctant, sometimes in a surprising way, and sometimes flat out agreement: 'Yes, we should do this.' So, at least I knew that I was dealing with somebody who understood what I was saying, but may have found they had a difference of opinion."

Nimoy would find STAR TREK's third and final season more challenging. With the show facing an uncertain future, Roddenberry stepped away, handing producing duties over to Fred Freiberger. By now Nimoy's allies Coon, Fontana, and Justman had left and he felt he had to look after Spock on his own. "Producers very often leave," he reflected, "and the writers leave, and the directors leave, and the person who is left to take care of the character is the actor. The character in a sense, if you can personify the character as a living individual, is stuck with the actor who plays him and has to depend on that person."

Freiberger was under pressure to improve STAR TREK's ratings. He knew that Spock was the most popular element of the show and that they needed to do better with a female audience. Part of his approach was to put Spock in more romantic situations and play up the show's more fantastical elements. Nimoy felt that too often this resulted in episodes that betrayed the fundamental ideas behind the show.

"The final year of the series was very difficult," Nimoy said. "Roddenberry was gone and we were dealing with people who simply didn't have a grasp of the show and the characters. The feeling was that we [the actors] didn't know what it was going to take, that we the actors didn't understand. At least, the message I got was 'You don't understand what it's going to take. What we're going to do to the series to make it successful.' Their feeling when they came aboard was that 'We know what's wrong with the show, and we know how to fix it.' I was very unsuccessful in dealing with all of that."

It didn't help that Roddenberry was keen to make extra money by exploiting STAR TREK's potential for merchandise.

In 'Is There In Truth No Beauty?,' Nimoy found himself with a scene featuring the IDIC medallion, something Roddenberry had designed with the express intention of selling to fans. As Freiberger remembered, the first he heard about it was when he was called to the set. "I went down, and Shatner and Nimoy were refusing to do the scene. They said, 'Gene's trying to sell merchandise. We don't want to do this medallion thing.' So, I called him up and said, 'Gene, we have a mutiny on our hands… They won't do the scene. Can we change it?' He went down to the set, and I think they decided to have Nimoy do the speech, and cut it down quite a bit."

In his memoirs, Nimoy remembered his frustration. He fully approved of the ideals behind the IDIC symbol (the letters stand for Infinite Diversity in Infinite Combinations), but he felt deeply uncomfortable about being used to sell merchandise.

He was even more frustrated by Freiberger's belief that the integrity and consistency of the characters were less important than action and romance. As Nimoy explained, he felt their philosophies were fundamentally at odds. "My frustration," he said, "would be with a producer who didn't have a clue what I was talking about. Would say 'No, no, no,' because they simply didn't get it. If Roddenberry and I disagreed, I was fine with that. But there were times when I had the other and that was infuriating."

Nimoy was so unhappy that he admitted to being relieved when *STAR TREK* wasn't picked up for a fourth season. In the years that followed, his relationship with Spock would sometimes be difficult. At least at first, *STAR TREK* seemed to be a failure but Nimoy would forever be known as Spock. But he never lost his affection for the Vulcan *alter ego* he had done so much to shape. Wherever he went, he was recognized as Spock. People, he recounted, would frequently stop him on the street and "say nice things." It was he said, "a very lovely thing."

When asked why he thought Spock had been so successful, he would invariably say that there was something about the character that embodied a universal truth. "He was, if you'll pardon me, so human really – caught between trying to maintain a balance between emotion and logic, and I think we all are. I think there are times when we say, 'Wait just a moment, let's stop and think about what we're doing here. Let's stop and think logically about the steps we're taking. That's a perfect example of how humans go through the process constantly. We deal with our spouses, we deal with our children, we deal with our parents, we deal with business relationships in these ways. The question is how much of it should be ruled by what we feel and how much of it should be ruled by what we think and know." That, he smiled, was what Spock was all about.

Courtesy Gerald Gurian

EMOTIONAL RESTRAINT

Nimoy famously made an effort to stay in character while he was filming. The effort of slipping in and out of an emotionless Vulcan state was tiring and he felt it would affect his performances, so he was careful to maintain a restrained and subdued presence. That didn't mean he didn't laugh. There are plenty of bloopers that show him cracking up, but on the whole he kept himself under control, and the other cast members and guest stars often remarked on how self contained and serious he was.

Up to this point, Nimoy had seen himself as someone who enjoyed playing passionate characters, but now he recognized the value of minimalism. He realized that if he made himself still and quiet, when he did something as simple as raising an eyebrow it made a real impact. Nimoy told the Television Academy that he was in character as Spock so much of the time that he actually started to take on some of his traits, which he found enjoyable and comforting. "By osmosis I picked it up… a cumulative number of hours I was Spock more than I was Nimoy, so my character gradually shifted."

DR. PIPER

THE SECOND DOCTOR

When *STAR TREK* returned for the second pilot, it had a new Chief Medical Officer, an experienced hand who had a lot in common with an "old country doctor."

here are prolific actors – and then there's Paul Fix. Fix, pardon the pun, was a fixture in movies and television, starting with silent films in the mid-1920s and ending in 1981 with a guest spot on *Quincy, M.E.* In between, he amassed more than 300 credits, most notably 27 films with his good friend, John Wayne, as well as *Adventures of Superman*, *The Rifleman* (on which he enjoyed a recurring role), *The Bad Seed*, *Giant* (James Dean's final, posthumously released film, with Fix as the father of Elizabeth Taylor's character), *To Kill a Mockingbird* (in which he shared scenes

with Gregory Peck, grandfather of Ethan Peck, *STAR TREK*'s current Spock on *DISCOVERY* and *STRANGE NEW WORLDS*), *The Twilight Zone*, *Pat Garrett and Billy the Kid*, *The Six Million Dollar Man*, and *Battlestar Galactica*.

Fix also counted among his output two other notable enterprises: *STAR TREK* and *Night of the Lepus*. He played Dr. Mark Piper in the second *STAR TREK* pilot, 'Where No Man Has Gone Before.' Roddenberry was already keen on casting DeForest Kelley as the ship's doctor, but director James Goldstone persuaded him to go with Fix instead. Roddenberry

had described the character as "an old country doctor," exactly the kind of role Fix was known for playing.

An NBC brochure describes Fix's character as "the oldest and most experienced space traveler aboard the *Enterprise*. As head of the ship's Medical Department, Piper is responsible for the mental and physical health of the crew. His evaluation of the reaction of the men to the pressures of intergalactic space travel and the strange flora and fauna encountered on the planets visited will have a vital bearing on the conduct of each mission."

Piper doesn't have much to do in 'Where No Man Has Gone Before' – he doesn't even have a dozen lines. But Roddenberry reportedly regarded Fix as a weak link, so decided not to bring him back for more, at long last securing first-choice DeForest Kelley to play the ship's medic. Years later, Dorothy Fontana and the episode's writer Samuel Peeples both reported that Roddenberry thought that Fix was a little too old, since he

wanted every member of the crew to be capable of physical action. Fix was 64 when he filmed the second pilot and Fontana remembered that Roddenberry wanted a "younger, more vigorous doctor." Viewers were likely thrown for a loop when Fix made his sole appearance as Dr. Piper, because they had already seen Kelley as Dr. McCoy in 'The Man Trap' and 'Charlie X,' which aired in advance of 'Where No Man Has Gone Before.'

As for Fix's other notable credit? *Night of the Lepus*, released in 1972, was a decadently cheesy sci-fi horror thriller starring Janet Leigh, Stuart Whitman, and Rory Calhoun, plus... DeForest Kelley. In it, Fix and Kelley even join forces to battle mutant, rampaging rabbits. One can only hope and pray that Fix and Kelley grabbed a drink some night during production, and conversed about their lives, extensive careers, and *STAR TREK* common denominator. Oh, to have been a fly on the wall for that.

ABOVE: *Roddenberry always intended the ship's doctor to be a regular character, but in 'Where No Man Has Gone Before', most of the medical dialogue is given to Dr. Dehner and Piper's role is played down. Fix was cast by the episode's director James Goldstone, and Roddenberry ultimately decided he wasn't right for the role.*

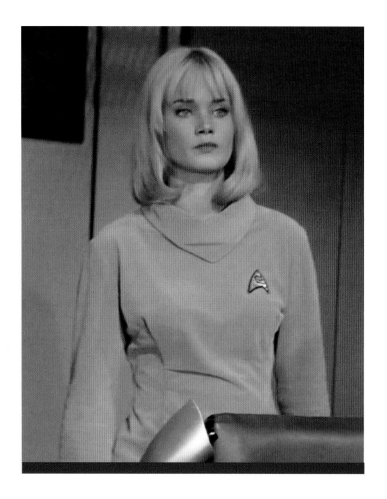

YEOMAN SMITH

MODEL OFFICER

Roddenberry always wanted the captain's yeoman to be an attractive young woman. If it hadn't been for a better offer, she could have been played by actress and model Andrea Dromm.

" **Y**EOMAN SMITH, who has drawn the important assignment of secretary to the Captain on her first mission in deep space, is easily the most popular member of Kirk's staff. A capable secretary and efficient dispenser of instant coffee, she also provides a welcome change of scenery for eyes that have spent long hours scanning the vast reaches of space" – from NBC's 'Advance Information on 1966–1967 Programming' brochure, featuring Captain Kirk and Yeoman Smith on the cover.

"I think it's very nice, very flattering, that fans still want to hear about my experience on *STAR TREK* or ask for my autograph," enthuses Andrea Dromm, who, over the course of four days in July 1965, played Yeoman Smith in 'Where No Man Has Gone Before.' "It's 56 years ago now, but I have no problem with that. If people want to hear from me or about me, that's great, because I did other things besides *STAR TREK*. I modeled. I was in *The Russians Are Coming, The Russians Are Coming*. So, it's all good."

ABOVE: *In the 1960s Andrea Dromm was a successful model and Yeoman Smith was her first TV acting role. She accepted another job before* STAR TREK *was picked up to series so wasn't available and the part was recast.*

Dromm, who lives in New York and is long retired, can't recall how she wound up on *STAR TREK*. She assumes that she met with Gene Roddenberry and likely casting director Joe D'Agosta, both of whom no doubt noticed the blue-eyed blonde's striking looks. "I was a model, and I guess they wanted some cute little girl, though I don't know for sure. And I got the job."

STAR TREK marked her first professional acting job. Gary Lockwood, who guest starred as Gary Mitchell, helped show Dromm the ropes. "I had done commercials for Clairol and National Airlines, and I'd done some plays, but I hadn't done dramatic acting for a television show before," she says. "Gary was really very good to me. There was a point when the ship was shaking and I didn't know what to do. They said, 'Simulate it,' which I didn't really understand. He showed me and just made me more comfortable. And Shatner… How am I going to say anything about Shatner? I do remember Bill saying, 'If I don't get this role…' He needed that job to work out."

Dromm reconnected with Shatner a few years ago, when she and a girlfriend bought VIP tickets to a performance of his one-man show, 'Shatner's World.' VIPs participated in a quick meet and greet with the actor after the show. "I thought it was important to follow up," Dromm notes. "We saw him, and at the meet and greet he took pictures with us, and he was pleasant. I'm not even sure he really remembered who I was, but we talked for a minute, and he was very nice."

After wrapping the second pilot, Dromm faced a decision: hope that NBC ordered *STAR TREK* to series AND that she'd be retained as Smith, or accept a supporting role in the big-screen comedy, *The Russians Are Coming, The Russians Are Coming*. She chose the movie, and harbors no regrets about her choice.

"My mother was Russian and I related to that whole Russian angle," Dromm says. "So, I opted out of *STAR TREK*. Also, no one knew how big *STAR TREK* was going to be. *STAR TREK* could hold me for six months, but they could also drop me anyway. They didn't have to sign me if they didn't want to. So, I did the movie. I don't have any regrets. It's great that *STAR TREK* became as big as it is, but I wasn't a sci-fi fan, and I wouldn't have been a Trekkie. I was in it, but I wasn't *of* it. And I never followed the shows and movies. I'm happy that people related to *STAR TREK* and got so into it, and that I had my small role in the pilot, but I just had to go on with my career. That's what I did. And I'm OK with that."

LIEUTENANT ALDEN

BEFORE UHURA

In *STAR TREK*'s second pilot, the *Enterprise* had a Black communications officer, but it wasn't Lieutenant Uhura. It was Lieutenant Alden, a male officer played by Lloyd Haynes.

loyd Haynes made a single appearance as Lieutenant Alden, a communications officer on the *Enterprise* bridge, in 'Where No Man Has Gone Before' – and then was never seen again. There's been next to nothing written about how or why Haynes won the role... or lost it, but he featured prominently in NBC's promotional brochure for *STAR TREK,* jammed between "Engineer Officer Scott" and "Physicist Sulu." The brochure had this to say about Haynes' character: "Communications Officer Alden refuses to be awed by the demanding task of establishing and maintaining

contact across vast distances. One of the youngest members of Kirk's staff, he also is one of this talented group's most respected technicians." When *STAR TREK* entered regular production, however, Haynes and Alden were dropped. Nichelle Nichols joined the cast as Uhura, assuming the communications officer's seat, and *STAR TREK* never looked back.

"Hiring anybody of color was not only not an issue on *STAR TREK,* it was what Gene expected," explains casting director Joseph D'Agosta. "I remember Lloyd Haynes well, and I don't recall considering him a [possible series] regular. He was

popular on the guest star circuit. Gene did like to have recognizable crewmembers in the smaller parts that were neither contract nor recurring characters with prenegotiated sliding deals."

When cast as Alden, Haynes, who hailed from South Bend, Indiana, was a Marine, athlete, pilot, actor, and musician, with just a single TV credit: an episode of *The F.B.I.* He never looked back, either. After *STAR TREK*, he guested on *Batman*, *The Green Hornet*, *Tarzan*, and *Julia*, and acted alongside Rock Hudson in the film *Ice Station Zebra*. He then secured his place in television history with *Room 222*, which ran from 1969 to 1974. Haynes starred as Pete Dixon, a Black teacher at an integrated school. In 1970, he earned an Emmy Award nomination in the Outstanding Continued Performance by an Actor in a Leading Role in a Comedy Series category.

After *Room 222*, Haynes continued to act, but more intermittently and with less societal impact. He added to his resume *The Greatest*, *Dynasty*, *Hart to Hart*, *T.J. Hooker*, *Hotel*, and *General Hospital*. The long-running soap opera would turn out to be Haynes' final credit, as he succumbed to lung cancer on December 31, 1986. At the time of his death, Haynes left behind his third wife, actress Carolyn Haynes, their four-year-old daughter, his mother and four sisters. He was only 52 years old. In 2017, Carolyn Haynes published his biography, *The Lloyd Haynes Story: A Remarkable Journey to Stardom*, honoring her late husband, whom she called Sonny.

"My dearest Sonny, an ambitious man, and often tormented soul led a profound life of perseverance and stayed resolute in his efforts to make life better than he found it. I believe he accomplished just that. Through all life's difficulties, that youthful mental energy remained the same until the last moment of his dynamic life and helped me to face the days ahead. What can I add except to say, I was, am, and always will be immensely proud of him, grateful for the privilege of a view-beyond-compare, and endless love."

ABOVE: *Haynes takes a break during filming for 'Where No Man Has Gone Before.' Exactly why his character was replaced is unclear, but when STAR TREK went to series, Alden was replaced with Lieutenant Uhura.*

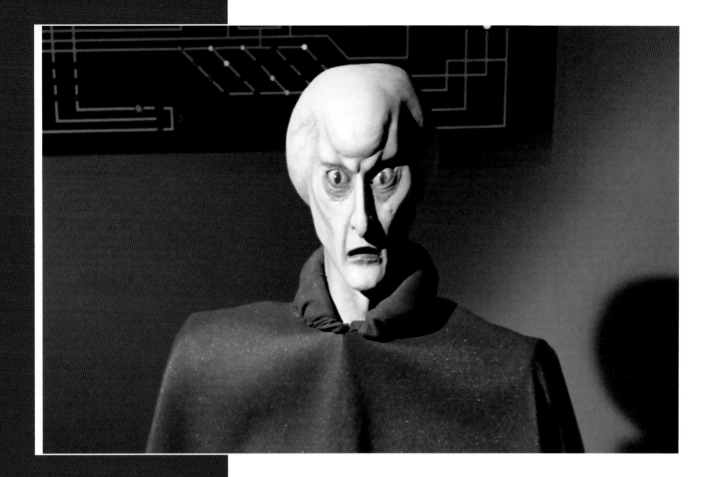

SEASON 1

EPISODE 10

AIR DATE: NOVEMBER 10, 1966

Teleplay by Jerry Sohl

Directed by Joseph Sargent

Synopsis: The *Enterprise* is caught and condemned by a massive alien ship and its seemingly fearsome commander, who turns out to be a charming, tranya-loving being.

THE CORBOMITE MANEUVER

The first episode of *STAR TREK*'s regular production run introduced new costumes and new characters and, in a happy accident, started to define Mr. Spock.

The first regular episode of the series produced after the two pilots, 'The Corbomite Maneuver' was the first to be filmed at Desilu's Gower Street studios. It introduced several series regulars, redefined others, and made major strides in establishing Spock's character. With *STAR TREK* greenlit to series, the bridge set was brought over from Desilu's Culver City lot and reassembled by Matt Jefferies' team, who also started building the rest of the ship.

RIGHT: Roddenberry was always looking for ways to make characters seem alien. In this case, he cast the seven-year-old Clint Howard as Balok.

The script for 'The Corbomite Maneuver' was written by science-fiction veteran Jerry Sohl and designed to be as easy to film as

possible. Almost all the action takes place on the *Enterprise* bridge, with only a brief move to Balok's ship, *The Fesarius*, at the end.

The show would feature three important new characters: Dr. McCoy, Yeoman Rand,

> Spock: "Has it occurred to you that there's a certain... inefficiency in constantly questioning me on things you've already made up your mind about?" Kirk: "It gives me emotional security."

and Uhura. In each case, Roddenberry would bring in actors he had worked with before, and who, in the cases of DeForest Kelley and Nichelle Nichols, he was close to personally. McCoy's character was clearly still being developed as he is extremely argumentative rather than lovably irascible. He isn't the only character who behaves unusually. Spock loses his cool, even shouting several times. And, in

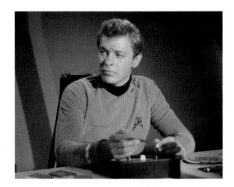

ABOVE: *The story emphasizes* STAR TREK's *belief that it's important to understand rather than fear the unknown, a storyline that is played out through the navigator Bailey, played by Anthony Call.*

a bit of character background business that would be revised later on, dialogue suggests that the Vulcan's parents are dead.

The episode's protagonist, Balok, was played by Clint Howard, who was just seven years old on his *STAR TREK* debut. As Roddenberry would do several times, he had someone else (this time Ted Cassidy) provide the voice to create the impression that Balok was truly alien. After flirting with the idea of having Howard also play the menacing version of Balok, Sohl and the producers hit

on the idea of using a puppet head, which Wah Chang was brought in to create.

Like the characters, the costumes were still evolving. The three divisional colors were introduced for the first time, but the shirt collars were a work in progress and were far wider than they would be on the final versions. The episode saw the first appearance of the minidress, although Uhura wears gold instead of red.

Several major moments with long-lasting ramifications occur in 'The Corbomite Maneuver.' George Takei's Sulu shifts from ship's physicist to helmsman. The shot in which he whirls around, looks over his shoulder, and reacts to Kirk would be recycled repeatedly through the series. Dr. McCoy utters the first of his many "I'm a doctor, not a..." gripes when he asks, "What am I, a doctor or a moon shuttle conductor?" Kirk's now-iconic "Space: the final frontier" monologue was written for the opening credits.

Associate producer John Black remembered recommending that Joseph Sargent should be brought in to direct. He was joined by director of photography Jerry Finnerman, who would play a major role in creating *STAR TREK*'s look by using a lot of color on Matt Jefferies' plain walls.

According to Robert Justman, cameras began to roll on 'The Corbomite Maneuver' at precisely 8:22am on Tuesday, May 24, 1966.

On the second day's filming, Sargent suggested to Leonard Nimoy that Spock not respond in fear to his initial glimpse of Balok's ship. The script already had his line

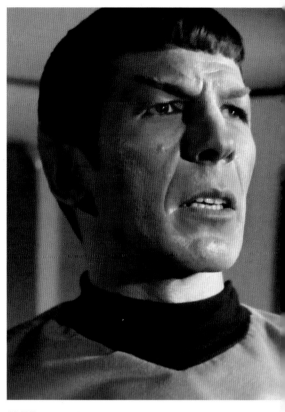

ABOVE: *Spock delivers his catchphrase 'Fascinating' for the first time. Director Joe Sargent suggested that Nimoy should play down any excitement and deliver the line with detached curiosity.*

I don't know how to do that. I'm going to be on one note throughout the entire series,'" the director told *Starlog*'s Edward Gross in a 1987 interview. "I agreed with him, and we worked like hell to give him some emotional context. But Gene said, 'No way, the very nature of this character's contribution is that he isn't an earthling. As a Vulcan, he is intellect over emotion.' Leonard was ready to quit because he didn't know how he was going to do it.

"Humorously enough, after I saw *STAR*

> "What's the mission of this vessel, Doctor? To seek out and contact alien life, and an opportunity to demonstrate what our high-sounding words mean. Any questions? I'll take two men with me. Doctor McCoy to examine and treat the aliens if necessary, and you, Mister Bailey."

> **Captain Kirk**

of dialogue and soon-to-be catchphrase: "Fascinating." According to Sargent, both he and Nimoy originally sought to imbue Spock with much more emotion. "Leonard said, 'How can I play a character without emotion?

TREK IV, I called him and we discussed the ironies of life," Sargent continued. "If he had quit, he wouldn't be anywhere near where he is now. Not only is he a household symbol, he's a very high-priced director."

D R . M^cC O Y
THE PASSIONATE DOCTOR

It took Gene Roddenberry three attempts to find the *Enterprise*'s doctor,
but DeForest Kelley was everything he wanted: a charming Southerner who
convinced as a science-fiction version of an old country doctor.

D eForest Kelley wasn't a doctor, dammit. He only played one on TV and in the movies. But Kelley's character, Leonard "Bones" McCoy, was, is and forever will remain one of the entertainment industry's most popular and most beloved medics – and he's the STAR TREK medic against whom all other STAR TREK doctors are measured. And, in real life, inspired by DeForest Kelley and Dr. McCoy, more than a few STAR TREK fans studied medicine and became doctors or surgeons. The man who played McCoy was, in a word, charming: a soft-spoken, easygoing, and gracious Southern gentleman who beamed aboard the *Enterprise* deep into a modest career punctuated mostly by Westerns whose directors usually cast him as a… villain.

Kelley's trek almost didn't happen. While casting the first pilot, 'The Cage,' series creator Gene Roddenberry and director Robert Butler reportedly considered numerous actors for the role of Dr. Phil Boyce. Among those actors were Kelley (who'd passed on the role of Spock – more on that momentarily), David Opatoshu (later tapped to portray Anan 7 in 'A Taste of Armageddon'), and Malachi Throne (who went on to voice the Talosian Keeper in 'The Cage' and guest star as Commodore

Mendez in 'The Menagerie' two-parter, before playing Pardek in the STAR TREK: THE NEXT GENERATION two-parter, 'Unification'). Roddenberry supposedly preferred Kelley, but Butler fought for Hoyt, and Roddenberry deferred to his director's choice. Eventually, NBC rejected 'The Cage,' but green-lit a second pilot, 'Where No Man Has Gone Before.' By the time cameras rolled on that episode, Hoyt was gone, replaced by Paul Fix as Dr. Mark Piper. That didn't work, and in stepped Kelley as Dr. Leonard McCoy, aka "Sawbones," or more colloquially, "Bones."

How did that all happen? It's complicated. Roddenberry invited Kelley to a screening of 'The Cage' and approached his friend after the lights went up. "'Well, cowboy, what did you think?'" Kelley recalled Roddenberry asking him. "Not being a fan of science fiction, I said, 'Gene, that will be the biggest hit or the biggest miss ever made. It turned out to be a bit of both." As for previously turning down the role of Spock, that's a true story. "It's hard to believe," Kelley acknowledged. "Gene and I had lunch at the studio commissary, when it was called Desilu. Gene said, 'I've got two roles.' He first described this green-painted alien.'" Uninterested in that, Kelley inquired about the

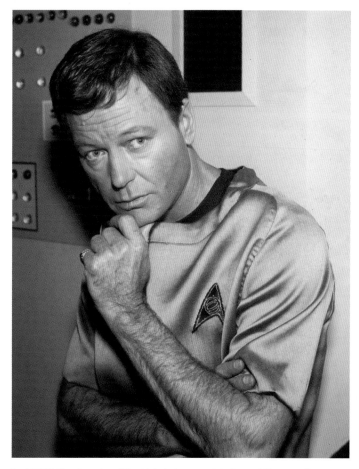

ABOVE: *The character of the ship's doctor came into focus at the same time as Kelley was cast. The 1966 Writers' Guide describes him as an "outspoken character " and a "realist," who is happy to turn his "acid wit" on the captain.*

other option. "He said, 'It's *High Noon*,'" Kelley recalled. "Well, I said, 'I'll take *High Noon*.' I'm glad it turned out that way because I wouldn't have been anywhere near Leonard. He (was) just marvelous."

It's worth noting that, before *STAR TREK*, Kelley appeared in two Roddenberry pilots that failed to secure series commitments. In 1960, '333 Montgomery Street' aired as an installment of the dramatic anthology series, *Alcoa Theatre*. Then there was *Police Story* (1965), a cop show that featured Steve Ihnat (who turned up on *STAR TREK* as Garth of Izar in 'Whom Gods Destroy'), Grace Lee Whitney (*STAR TREK*'s Yeoman Rand), and Malachi Throne, with Kelley in a rare good-guy role as a criminologist, albeit a cranky one.

"I'd known Gene since 1959," Kelley recalled in an interview with *STAR TREK* magazine. "I knew him longer and probably better than anyone in the cast or at Paramount Pictures. I'd done a couple of pilots for Columbia, and they both sold. I was the heavy in them. The producers of those shows decided they were going to do a show, *333 Montgomery Street*, about a

criminal lawyer named Jake Erlich, from San Francisco, and decided to test me for it. Before the test, Bob Sparks, one of the producers, told me he wanted me to go out to Westwood and meet this writer, Gene Roddenberry.

"I went out there, up this flight of stairs, and into this office," he continued. "It was about seven feet by seven feet, and there at this desk was this huge man. It was Gene, and he was sitting behind a typewriter. We had a long talk about the show and the possibility of my doing it. We shot the whole thing in San Francisco and we had the best time we ever had in our whole lives. Gene and I often reminisced about that."

Roddenberry finally secured Kelley for *STAR TREK* after he decided to replace Paul Fix with a different actor as the doctor, when 'Where No Man Has Gone Before' sold NBC on the series. The details are up for grabs. Dorothy Fontana told William Shatner, for his *STAR TREK Memories* book, that "Gene didn't like Paul Fix all that well, and he felt there was a certain vitality missing from the character." Regardless, Kelley was contracted to appear in seven of the first 13 episodes,

though he didn't leap at the opportunity. He'd just costarred with Bette Davis and Susan Hayward in a feature, *Where Love Has Gone*, and felt more movies might be in his future – and *Police Story* still had a shot at going to series. But he accepted the *STAR TREK* job and the rest, as the saying goes, is history.

"How could anyone know that *STAR TREK* would turn into what it turned into?" he asked rhetorically. "I think – I know – its success took everyone ever associated with it by surprise."

The actor went on to play Dr. McCoy for all three seasons of *STAR TREK*, voiced the character in both seasons of *STAR TREK: THE ANIMATED SERIES*, and returned to action for the six TOS feature films. Also, as a thank-you to Roddenberry, the franchise, and its fans, Kelley made a pass-the-torch cameo appearance as an elderly Admiral McCoy in the *STAR TREK: THE NEXT GENERATION* pilot, 'Encounter at Farpoint,' sharing a scene with Brent Spiner, who played the android Data.

"I can only imagine we were thrilled to have DeForest help launch our new *Enterprise*," Spiner noted during a recent conversation. "I don't recall him giving me any advice. Maybe, 'Talk fast and don't bump into the turbolift.' I do recall that he was a very kind gentleman. We met once on the road later on at a convention, and I had dinner with him and his wife, and he regaled me with tales of working in summer stock with John Carradine."

Kelley always judged 'The City on the Edge of Forever' to be the best episode of the series, thought he did his best acting in 'The City on the Edge of Forever' and 'The Empath,' and ranked *STAR TREK IV: THE VOYAGE HOME* as the finest big-screen adventure.

McCoy, truth be told, was a character both well explored and underdeveloped, especially during *STAR TREK*'s three-year run. Other key McCoy episodes include 'Shore Leave,' 'The Trouble with Tribbles,' 'Friday's Child,' 'The Tholian Web,' and 'For the World Is Hollow, And I Have Touched the Sky.' An aborted third-season script, 'Joanna,' would have introduced

McCoy's daughter and explored how he reacted when Kirk engaged in a romance with her. As it stands, when fans think of McCoy, they think of him as a caring, decent human being and an efficient, fast-thinking doctor, as well as a figure with a bit of an edge and a temper, who's easily exasperated by the events, technology (that damn transporter!), and more than a few of the people around him.

His pals aboard the *Enterprise* included Kirk – "Jim" to him – to whom he dispensed wisdom and alcohol, and Scotty, with whom he also shared drinks, as well as an appreciation of beautiful women. However, McCoy's demeanor ignited epic quarrels with Spock, whose fondness for precise details and adherence to pure logic often drove the old country doctor crazy. No one got under McCoy's skin quite like his Vulcan colleague, and vice versa. Spock deemed McCoy almost too human, while McCoy prodded Spock, sometimes cruelly – and possibly even to the point of xenophobia – to embrace his Human half. "Mr. Spock, remind me to tell you that I'm sick and tired of your logic," McCoy barked at Spock in 'The *Galileo* Seven,' to which Spock retorted, "That is a most illogical attitude."

Kirk would often play the bemused referee/observer, and alternately break up or egg on the sparring between the other two sides of the Kirk-Spock-McCoy triumvirate.

"It was always a love-hate relationship [between McCoy and Spock]," Kelley once explained. "Each of them maintained a great deal of respect for the other. I think there's that underlying thing where you realize, 'Gee, Spock really does admire him,' or, 'Gee, McCoy really does admire Spock.' Really, Spock represents everything McCoy hates. In his eyes, Spock is something of a computer. I guess, in McCoy's eyes, he's really what Data is today. Leonard and I were fortunate to be able to build the relationship between our characters over three decades. Not a lot of actors get the opportunity to do that."

ABOVE: Kelley and Nimoy grab something to eat during a break in filming. The two men shared an enormous number of scenes over the years.

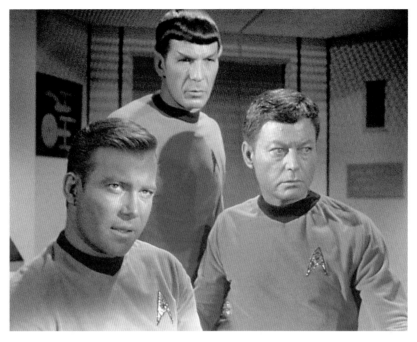

ABOVE: *Spock and McCoy were both voices in Kirk's ear, urging him to take different approaches, with McCoy always favoring the emotional course. Roddenberry told the writers that everyone secretly knew they liked one another, but the scripts should always show them battling.*

Nimoy, in his memoir *I Am Spock*, saluted Kelley's contribution to *STAR TREK*. "De's Dr. McCoy became a very valuable addition, bringing a special chemistry to the show and further helping to define the characters of Kirk and Spock through the acid observations of that good-hearted curmudgeon, McCoy. McCoy and Spock evolved into verbal sparring partners – with the good doctor taking the humanist stance and Spock the side of logic – but there was always a strong undercurrent of friendship and mutual respect. From the very first moment he appeared in 'The Corbomite Maneuver,' De had that special twinkle in his eye; he knew how to approach the character of McCoy. Soon the writers would begin interjecting humor into the scripts by taking advantage of McCoy's cantankerous emotionalism and Spock's ability to take any comment literally. Spock was the straight man – George Burns, if you will, to Dr. McCoy's Gracie."

Kelley never wrote a memoir, and, in fact, was the only cast member not to. "I could very easily do one," he told the *New York Times Syndicate* in 1998. "I've got stories that people might find interesting. But it just seems like such an enormous job to me." Kelley, however, did read all his costars' autobiographies, several of which touched on the famous squabbles between several of the actors. No one ever uttered a bad word about Kelley. To those around him, he was an unassuming man who adored his wife, Carolyn, and preferred spending time at home with her and their pets (including a turtle that may still be alive), lending support to animal-friendly causes, reading poetry, and answering fan mail, than basking in the spotlight.

"It's nice to hear that people think well of you," Kelley said, a year before his death. "The truth is I just always tried to do my job. I knew about the feelings that existed on the set when we did *STAR TREK*, of course, but I just divorced myself from

"I run into people all the time who grew up with it, graduated with it. Many of them became physicians as a result of watching STAR TREK."

DeForest Kelley

that and tried to keep my eyes straight down the road. I've gotten along with people who had reputations for being difficult. I got along with Henry Fonda. There were others, too. I've always tried to do my job without digging into somebody's personal life, without making waves. I'd like to think that served me well."

Kelley understood that when he passed away, obituaries would read, "DeForest Kelley, *STAR TREK*'s Dr. McCoy, dies," and he'd made peace with that. He expressed pride for the show, the character, his work, and the impact of it all on the world at large. "I think that since people have discovered computers, the number of *STAR TREK* fans has just grown and grown," he commented. "*STAR TREK*, and by that I mean the original show and all the new ones, used to seem so futuristic. Reality is catching up with fantasy and I think people appreciate how ahead of its time *STAR TREK* was. My mail, from both here and abroad, has only increased over the years. Foreign countries, especially, hadn't been as exposed to *STAR TREK* as the American audience has. When *STAR TREK* first started in England, they were only doing 13 episodes at a time. Now, another whole generation is seeing *STAR TREK* and enjoying it all again for the first time, if you will.

"It's amazing, just amazing to me, how it continues to grow," continued Kelley, who died on June 11, 1999, at the age of 79. "I run into people all the time who grew up with it, graduated with it. Many of them became physicians as a result of watching *STAR TREK*. It's just an amazing phenomenon. I'm very pleased that *STAR TREK* has created such an audience and that it has been so inspiring to our youth, to push them to go and do good and better things. It's very rare that an actor is able to do something that makes him feel, when he leaves this Earth, as if he'll have contributed something truly wonderful to society."

ABOVE: *Only a handful of* STAR TREK *episodes actually revolved around medical dilemmas, but Kelley rapidly proved himself to be a valuable and popular member of the cast, often providing tension and humor by disagreeing with Spock.*

ENDINGS AND BEGINNINGS

During the filming of *STAR TREK*'s penultimate episode, NASA launched Apollo 8, the first manned mission that orbited the moon. Kelley wasn't sure, but this probably occasioned one of his favorite memories. "We knew we'd be dropped at the end of the season, but we were still shooting the show," he recalled. "There was a television set around and we watched one of the NASA missions. Here we were, standing there in our far-out costumes, filming a show about the future, watching the astronauts walking around – for real. That always amazes me, that memory."

THE VULCANS

SPECIES OF CONTRADICTIONS

The Vulcans were *STAR TREK*'s first aliens, and since Mr. Spock featured in every episode, they were the ones we got to know best. When filming started on *STAR TREK*, exactly what it meant to be Vulcan was still vague – Spock is even referred to as Vulcanian. Roddenberry handed the writers a guide, which told them that Vulcans had an "incapacity for emotion" and he showed them what Spock looked like, but that was all they had to go on. Leonard Nimoy's performance as Spock would define his species, but we always knew that Spock was only half-Vulcan.

Several episodes made passing references to Spock's biology, which was often used to help out with some tricky story points. In 'The Man Trap,' we learned that Spock's blood was different. Thanks to Fred Phillips' makeup we could see that it was green, and in 'Obsession' we finally learned that it was copper-based. In 'Dagger of the Mind,' we discovered that Vulcans had telepathic abilities, when Spock performed a mind-meld for the first time. That episode revealed that the mind-meld was "a hidden, personal thing to the Vulcan people, part of our private lives." In later episodes, it became one of

Spock's defining features and was used again and again.

In 'This Side of Paradise,' Kirk told us that Spock is "much stronger than the ordinary human being," thus adding some real danger to their fight when Kirk sets out to rile him. And at the end of the first season, in 'Operation – Annihilate!,' the writers needed a reason for Spock to recover from the blindness caused by exposure to an enormous amount of sunlight. Their solution was to give him an inner eyelid, which, they explained, protected Vulcans from the brightness of their sun. This in turn suggested the idea that Vulcan was a hot and arid planet. We got proof of this when the *Enterprise* finally visited Vulcan in 'Amok Time.' Picking up on the line from 'Operation – Annihilate!,' Roddenberry suggested that they make Vulcan a desert planet, because arid locations were easy to find near L.A. However, in the end they decided to film all the scenes set on Vulcan on the soundstage. Roddenberry also suggested that the planet should have higher gravity than Earth, which explained Spock's greater strength.

'Amok Time' explored the idea that the Vulcans hadn't always been logical. In 'Balance of Terror,' when he was confronted by the Romulans, Spock had told us that Vulcans had a violent past in which war had been an "imperative." But more than anything, 'Amok Time' established that Vulcans really were alien. Ted Sturgeon's script revealed that every seven years Vulcans enter *Pon farr*, a condition that will kill them if they don't return home and take a mate. Dorothy Fontana was quick to point out that this led to some confusion. "The myth arose," she said, "that Vulcans only have sex every seven years, which is incorrect. It's just that they *have* to have sex every seven

years. The rest of the time it's as they wish." 'Amok Time' also established that Vulcans bond with one another as children, and introduced their greeting "Live Long and Prosper."

Fontana would make the next major contributions to our understanding of Vulcan culture, when she introduced us to Spock's father, Sarek. The script revealed that he was expert in the Vulcan martial art, *tal shaya*, and was quite capable of killing someone if he thought it was logical. It also showed us that for all his logic, he hadn't spoken to his son for 18 years and he was clearly very close to Spock's human mother, Amanda – both of which suggested Sarek had feelings.

"Vulcans are the way that they are," Fontana explained, "because of thousands of years of physical and mental and emotional conditioning. It seems to me that, in the depths of their personal lives, Vulcans do have emotions and show emotions. There was true love there, there was great respect and certainly great caring between the two of them, but expressed, as far as Sarek goes, in a very Vulcan way."

A passing reference in 'Return to Tomorrow' suggested that Vulcan prehistory could be explained if they had originally come from another planet. 'Is There In Truth No Beauty?' touched on how Vulcan philosophy is based on a belief in Infinite Diversity in Infinite Combinations. 'All Our Yesterdays' firmly established that Vulcans were vegetarian, and revisited the idea from 'Balance of Terror' that they had once been a savage race. 'The Savage Curtain' then introduced us to Surak, who had led Vulcan away from violence and into a rational and enlightened future – a goal he achieved by insisting on peace, regardless of how brutal his enemies were.

ABOVE: *Spock's parents made their debut in 'Journey to Babel.' Sarek clearly loved his wife, although he expressed it in a very Vulcan way. The actors Mark Lenard and Jane Wyatt came up with the idea that they expressed affection by touching fingertips.*

YEOMAN RAND
ADMIRING THE CAPTAIN

The captain's yeoman was going to be a big deal: she was a series regular who would join landing parties and provide the captain with an unrequited love interest. But plans change…

"I call her Amazing Grace," Leonard Nimoy wrote in his foreword for Grace Lee Whitney's autobiography, *The Longest Trek: My Tour of the Galaxy*. "She rejects that name and denies that she is amazing, but I insist, because she is." Anyone who met Whitney in her later years can vouch for Nimoy's words. Whitney – who died on May 1, 2015, at 85 – filled a room with her joyous spirit, unflagging energy, and deep belief in God. She'd endured so much – a good deal of it, she'd be the first to admit, problems of her own making – and burst through the other side feeling lucky, enlightened, and eager to share her hard-learned message, especially with STAR TREK fans. That message: if she survived and then thrived, they could, too. And so she left behind a remarkable legacy, both as an actress and as a human being.

Whitney, who was adopted, was raised in Ann Arbor, Michigan. Born with the name Mary Ann, her adoptive parents christened her Grace. She knew, early on, that performing would loom large in her life. "From the time I was three years old and opened the refrigerator and the light went on," she recalled in 2011. "That's when I began to perform. Right in front of the refrigerator, I sang right into the ice cubes. The ice cubes were very impressed. In fact, I melted a few of them. That's how I knew it was the right career."

At 14, Whitney embarked on her life as a professional performer. She sang as part of an *a cappella* chorus for the radio station WJR in Detroit. She eventually moved to Chicago, hooking up with a band called The Prevue, opposite Buddy Rich's band, and then landed a gig opening for Billie Holliday, whom she watched "get loaded every night on heroin." Singing led to acting, with Whitney making her Broadway debut in 1951 in *Top Banana* with Phil Silvers, and also appearing in the movie version of the musical, released in 1954. She then understudied Janis Paige in *The Pajama Game* and played Lucy Brown in *The Threepenny Opera*.

Hollywood came next, with Whitney acting in such shows and movies as *Peter Gunn*, *Some Like It Hot*, *The Untouchables*, and a pilot called *Police Story*, written and produced by Gene Roddenberry, directed by Vincent McEveety, costarring DeForest Kelley, Malachi Throne, and Steve Ihnat, and

ABOVE: The producers experimented with more than one hairstyle before settling on Yeoman Rand's famous beehive. Her hair was actually created by costume designer William Ware Theiss, with a lot of input from Roddenberry, who thought that it looked futuristic.

featuring a score by Alexander Courage. All of them would soon figure into another series called *STAR TREK*.

Whitney received a good news/bad news call from her agent. *Police Story* would not go to series, but Roddenberry wanted to talk to her about a steady role on his next project. She met with him and he filled her in on the role, which he'd developed significantly since the slivers of the yeoman characters that Laurel Goodwin and Andrea Dromm had struggled to give dimension to in the first and second *STAR TREK* pilots. Whitney loved Roddenberry's detailed character sketch of Janice Rand.

"I was supposed to be innocent, dedicated, excellent in my motives for wanting to be on the *Enterprise*, but very green, with no experience," she noted. "Rand was willing to learn to be a secretary to the captain, whom, of course, I immediately had a crush on. But it was unrequited love, like Kitty and Matt on *Gunsmoke*. It could not be consummated. It had to be love from afar, an unrequited love between the captain and me."

> "*I was supposed to be innocent, dedicated, excellent in my motives for wanting to be on the Enterprise, but very green, with no experience,*"

■ Grace Lee Whitney

Whitney appeared in a total of eight first-season episodes: 'The Corbomite Maneuver,' 'The Enemy Within,' 'The Man Trap,' 'The Naked Time,' 'Charlie X,' 'Balance of Terror,' 'Miri,' and 'The Conscience of the King.' Rand was professional in her approach, sporting her trademark short skirt and fabulously high and braided beehive hair. However, despite Whitney's strong performances in 'Charlie X' (in which Rand slaps Robert Walker Jr.'s Charlie Evans) and 'Miri' (in which she seeks solace in Kirk's arms after a group of children tie her up), the character arguably didn't work. That, in large part, was because any spark with Kirk – who acknowledged his feelings for Rand in 'The Naked Time' – stunted the captain's evolution as a character, and his opportunities for further romance. In addition, the show used Whitney like a supporting player, while paying her a series-regular rate. Terminating her contract would free up money that could then be allocated for guest stars. There is also no question that Whitney was drinking and taking pills.

Additionally, as chronicled in both Shatner's memoir, *STAR TREK Memories*, and Whitney's *The Longest Trek*, a powerful figure involved with *STAR TREK* allegedly sexually assaulted her in late August, 1966. Whitney never named the figure, referring to him only as "The Executive." Days later, Whitney's agent informed her she'd been "written out" of *STAR TREK*. She shot one more episode, 'The Conscience of the King,' and then departed the show. Whitney, rocked years earlier by the news she'd been adopted, now lost her *STAR TREK* family, too. Whitney's drinking – already a problem – got out of control.

"It was presented to me that the ship was the wagon train in space and that all of us on the ship were going to have these experiences out there," Whitney recalled, addressing the character-related aspect of her exit. "There was a scene that Shatner and I did – and I remember when it happened – that scared the producers, because they said, 'Uh-oh, they're getting too close. This is getting too hot. We have to remove her, because he's going to look like he's cheating when he falls

in love with other women on other planets.' So, if she's waiting for him on the ship and he's out there cheating, Yeoman Rand would be the sympathetic part on the ship and he'd look like a cad. So, they said, 'Why don't we just remove the yeoman.' Of course, this went on behind the scenes."

As for the sexual assault? "Oh, my goodness," she replied. "Well, I had the sexual assault from someone at Desilu, which I found out later was done by a lot of producers [during that era]. It was before the sexual assault law came into being. I was one of the ones that was a victim. I was fired from the show, but I found later that it was in the works before the assault. I'd been blaming the assault for most of my life, until about [40] years ago, when I got sober.

"When I got sober, I had to go to Paramount and make a lot of amends and talk to a lot of people over there, including Gene Roddenberry," Whitney continued. "I had to make amends to them for drinking. I didn't drink that much [during the show]. Really, I didn't. But I did it [went to make amends] because I needed to stay sober and I needed to get back in their good graces. And, of course, they put me in everything after I went over there. I was in the movies and on *VOYAGER* – and *STAR TREK* was back in my life."

Whitney trod a harrowing road from leaving *STAR TREK* to triumphantly returning to the franchise. In the years between, she drank even more heavily, indulged in drugs, and ultimately bottomed out while in Los Angeles. "And bottoming out means I was sick and tired of being sick and tired, and I had to get help." Fortunately, she hit upon a 12-step program, found God, and reclaimed her life. Her *STAR TREK* homecoming started with conventions, where she reconnected with fans and Gene Roddenberry.

"I'd made amends to him," Whitney recounted, "and he in turn said to me, 'Grace, I've never made such a big mistake in my life as allowing NBC and Paramount to write you out. If I'd only seen my way clear, I could have kept you aboard. You would be the only person, really, who knew the inside story of Captain

ABOVE: When the series started production, one of the first things that happened was that Whitney joined William Shatner and Leonard Nimoy for a photoshoot to promote STAR TREK. These early photographs show her with a very different look.

ABOVE: Grace Lee Whitney and Leonard Nimoy relax during a photo session for publicity pictures. Whitney described Nimoy as her closest friend among the cast. She would often discuss her performance with him and valued the advice that he offered her.

Kirk, and you could have been waiting for him when he came back from the escapades. We would have had a whole new focus for the show and for the character.'

"He said, 'I'm going to put you in the next series,' which of course turned out to be STAR TREK: THE MOTION PICTURE. I came for that and then was in all the movies, except for *II* and *V*."

Whitney went on to reprise her Rand role three more times. First, she joined George Takei in the acclaimed 'Flashback' episode of *VOYAGER*, which aired in 1996, and then in two fan projects. Her memoir, the aforementioned *The Longest Trek*, reached bookstores in 1998. And for the final years of her life, Whitney participated in *STAR TREK* conventions and devoted herself to God and her family.

"I live in California on a 30-acre parcel near Yosemite National Park, with a running creek," she noted. "It's just gorgeous. I still do conventions. I'm dedicated to helping people not drink and not use and... not die. So, I'm completely fulfilled. I have two sons – Jonathan and Scott. They were both in 'Miri,' stealing the communicators, and Scott was in *THE*

ABOVE: Giving the captain a potential love interest among the crew proved problematic. In the first season, Kirk does suggest that he is suppressing the attraction he feels for Rand, but Roddenberry wanted him to be free to romance guest stars, and this was, at least partially, behind the decision to drop Yeoman Rand.

MOTHER OF THE MINIDRESS

Much has been made of the fact that in the first two *STAR TREK* pilots, the female characters all wear trousers, but when the series went into production they were in minidresses. According to Grace Lee Whitney, this wasn't because of the network, or even because of Gene Roddenberry. It was, in fact, her idea. She told author Mark Cushman that she suggested the switch because she was proud of her legs and wanted to show them off. In 1966, miniskirts were the height of fashion and considered a symbol of female liberation. Roddenberry and Theiss embraced the idea and designed a new version of the women's costume. The dress they came up with covered what Whitney described as "red shorts," worn with sheer black stockings that were supplied new every day. It was, she said, a little shorter than she had imagined. It made its debut, along with Whitney, in the first regular episode to be filmed: 'The Corbomite Maneuver.'

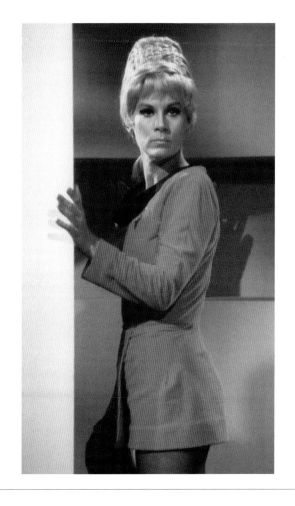

MOTION PICTURE, too – and Jonathan built a home down at the end of my property, where he lives with his family, including my grandchildren. They're going to take care of me as I move through life to my home in heaven. But right now, I take my grandchildren to school and cart them around, and I'm of maximum service to them. I also line dance one night a week and I go to the gym three days a week. So, my life is happy, joyous, free, sober, and saved, and a lot of fun, too," Whitney jubilantly concluded. "I have a lot of fun."

Nimoy was right: Whitney was amazing.

THE ROMULANS

THE OLD ENEMY

STAR TREK's first recurring "villains" made their debut in the series' eighth episode, 'Balance of Terror,' written by Paul Schneider. It was scripted before any episodes had been aired, so when Schneider started work, the series was still very much in development.

Schneider came up with a story about the *Enterprise* being locked in battle with an enemy ship. The episode was inspired by the 1957 film, *The Enemy Below*, which involves an American destroyer chasing down a German submarine. The title 'Balance of Terror' was taken from a phrase coined by Secretary of Defense Robert McNamara in 1962 to describe the threat of Mutually Assured Destruction, and the Romulans were clearly designed to be stand-ins for the North Vietnamese or the Soviet Union.

Roddenberry and Schneider were determined that the story would really be about two captains, both "strong men of honor," who had no choice but to fight. Schneider based the Romulans on the ancient Romans, to the point where one of the officers is a centurion and the commander talks about the senate. According to associate producer John D.F. Black, Roddenberry loved the idea and had a great enthusiasm for all things Roman. He also liked the story because it showed Kirk and the Romulan Commander in a strong light. The revelation that the Romulans were related to the Vulcans was designed to introduce another of *STAR TREK*'s key themes: the importance of rejecting racial bigotry.

From the beginning, the Romulans were hobbled by the cost of putting them on-screen. In Schneider's earliest drafts, their ship doesn't have a cloaking device; it has simply crossed the border to mount a raid. The idea of making it invisible only

ABOVE: *Writer Dorothy Fontana decided to make the Romulan Commander in 'The* Enterprise Incident' *a woman who was every bit Kirk's equal. When Harve Bennett was developing the movie* STAR TREK II, *early versions of the story made it clear that she was Saavik's mother and that she had mixed Spock's DNA with her own.*

came about because showing the ship more than a handful of times was too expensive. Similarly, putting pointed ears on all of the extras would have been too costly, so associate producer Bob Justman suggested that most of them should wear helmets.

The casting of Mark Lenard as the Romulan Commander was widely regarded as one of the series' great successes, and Roddenberry was particularly pleased with the finished episode. The Romulans, however, were never intended to be recurring villains, and the costs associated with their makeup made them problematic. But the production team had invested in a Romulan ship. VFX shots were expensive so it was bound to be reused. In 'The Deadly Years,' the *Enterprise* is surrounded by Romulan vessels, but the Romulans are never seen. The writers considered making them the enemy force arming the tribal people in 'A Private Little War,' before Gene Coon (scriptwriter and producer on the first and second seasons) won the argument and they were replaced with the Klingons.

They did return in the third-season episode, 'The *Enterprise* Incident.' Writer Dorothy Fontana wanted to do a story that was inspired by the Pueblo Incident, when a U.S. spy ship was caught off the coast of North Korea, and thought the Romulans would make more interesting villains than the Klingons.

"At this point," Fontana explained, "we were starting to know a lot about the Klingons, and I wanted to go back to someone we don't know too much about, and that's what brought me back to the Romulans."

Fontana constructed a story that was loosely inspired by another Desilu show – *Mission: Impossible* – and had Kirk and Spock set out to deceive the Romulans so they could steal an improved cloaking device. Her story introduced another significant element to Romulan culture: the leader of the Romulan forces would be a woman. "Rome had a fairly strong matriarchal society," Fontana said. "I was thinking that because the Romulans were loosely based on Rome, a woman could have command. This would be interesting and would be a good face-off for Kirk and Spock – someone strong, a woman character, an equal commander who would be just as efficient and militarily directed as Kirk."

Once again, the episode benefited from strong casting, with Joanne Linville taking on the role of the unnamed Romulan commander. To Fontana's annoyance, the script was given a rewrite that made Linville's character more naïve and the cloaking device considerably larger than she had envisaged, but the episode is one of the third season's best, and firmly established the Romulans as a major species.

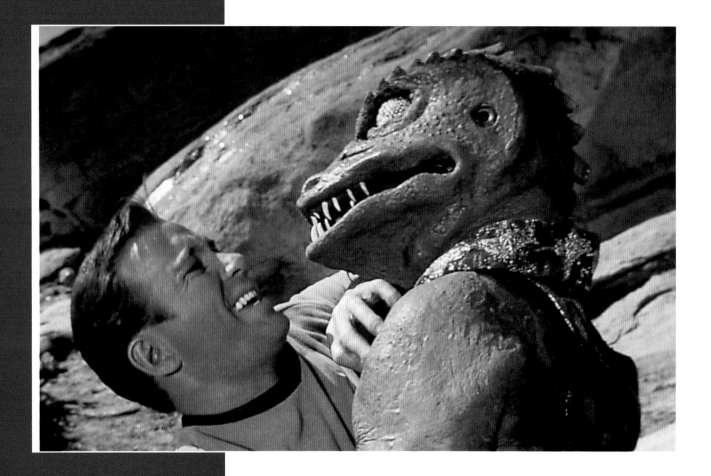

SEASON 1
EPISODE 19
AIR DATE: JANUARY 19, 1967

Teleplay by	Gene L. Coon
Story by	Frederic Brown
Directed by	Joseph Pevney
Synopsis	After the Gorn mount a surprise attack on the colony at Cestus III, the *Enterprise* pursues them, only for Kirk and the Gorn commander to be transported to a planet where they are forced to fight one another.

A R E N A

With *STAR TREK* running out of scripts, Gene Coon produced one of the series' most celebrated episodes: a story that pitted Captain Kirk against a giant lizard, in a tale that was about the importance of mercy.

The episode that introduced the Gorn was responsible for several *STAR TREK* firsts. 'Arena' was the first episode scripted by Gene Coon, who would write many of the series' best episodes; it was the first episode directed by Joseph Pevney, who would tie with Marc Daniels as the series' most prolific director; it was the first time the Federation or Starfleet were named; it was the first time we saw a universal translator; and the first time the *Enterprise* fired a photon torpedo.

'Arena' was written at top speed. Gene Coon had joined the writing team as its new producer in the middle of the season. As the year progressed, there were fewer and fewer scripts that were ready to go into production. If something wasn't done quickly, *STAR TREK* would grind to a halt. Part of the solution was for Coon to write stories himself. He produced the script for 'Arena' in a handful of days. The story about Kirk and the representative of an alien species fighting it out to prove themselves to another, nearly omnipotent, species was enthusiastically received – not least by NBC, who had been asking for more action and stories set away from the ship.

But there was a problem: almost all the elements of Gene Coon's story could be traced to a Frederic Brown short story, also called 'Arena,' which had been published in *Astounding*

Science Fiction magazine more than 20 years earlier, in 1944. Coon had probably read the story and subconsciously retained it. Rather than lose Coon's script, Desilu approached

> **"By sparing your helpless enemy who surely would have destroyed you, you demonstrated the advanced trait of mercy, something we hardly expected. We feel there may be hope for your kind. Therefore, you will not be destroyed."**
>
> **The Metron**

Brown and offered to buy the story from him. He asked to see Coon's script first, but once he did, he signed on the line and received the story credit.

Coon also recommended a new director to the show – Joseph Pevney, who Coon had worked with on *The Munsters*. Pevney was extremely experienced, having directed major feature films in the '50s before moving into television. By this point in the season, *STAR TREK* was over budget, so the producers offered him a deal: if he could film 'Arena' in six days he would get a $500 bonus. As *STAR TREK*'s director of photography, Jerry Finnerman, told the Television Academy, the director was determined to prove himself and this nearly brought the two men into conflict. When they were introduced, Pevney asked him how fast he was in front of the assembled crew. Finnerman was a young man and felt that Pevney was trying to pressure him. "I said, 'I don't know,'" Finnerman recalled, saying that Pevney's response was, "'Well, I'm very fast and we're going to get this show done on schedule.' Like the cameraman is holding this up." Determined to make a point, Finnerman set up the simplest, most basic lighting possible, giving it a fraction of the time he would normally devote to it. Within half a day, Pevney understood what was happening, took Finnerman aside, and said, "I like you. Let's be friends." Finnerman nodded and the basis of a

ABOVE: In Coon's script, the Metrons spare Kirk because he shows mercy, not because he wins.

long friendship was formed. The episode would come in on schedule, too. "I liked Joe Pevney," Finnerman concluded.

The Gorn costume was built by Wah Chang, who actually created two of them. Chang delivered "naked" suits, which William Ware Theiss then dressed in a tunic. Bob Justman warned Coon that working on *The Outer Limits* had proved to him that anybody in

a rubber suit would not move fast, so Coon wrote that into the script. The battle between Kirk and the Gorn was filmed at Vasquez Rocks with three different stuntmen taking turns in the Gorn costume. The opening scenes on Cestus III were filmed at a standing fort set nearby, which had made several appearances in *The Wild Wild West* and *Bonanza*. The fort was dressed by the *STAR TREK* art department and several large explosions were set off, which William Shatner reported left him with tinnitus.

The Gorn's voice was provided by Ted Cassidy, who is best known as Lurch in *The Addams Family* and had already portrayed the android Ruk earlier in the season. The Metron was played by Carole Shelyne, with the voice provided by actor Vic Perrin, famous for being the control voice in *The Outer Limits*.

It was Roddenberry's suggestion that Kirk and the Gorn shouldn't be able to communicate with one another until the Metrons gave them the translation device, and that the Metrons should transmit the events on the planet to the bridge of the *Enterprise*.

Kirk's decision to spare the Gorn would provide *STAR TREK* with one of its key themes: the idea that humankind is on a journey to becoming a more enlightened species.

ABOVE: The episode was largely filmed on location at or near Vasquez Rocks. The weather was cold, but the stuntmen inside the Gorn costume still struggled with the heat.

MR. SCOTT
MIRACLE WORKER

At first Mr. Scott was going to be in roughly half the episodes. For a moment, Roddenberry thought he didn't need him at all, but thanks to Jimmy Doohan's performance, Scotty became indispensable.

"To me, Scotty is Scotty and was already a full human being as soon as I opened my mouth with a Scottish accent," wrote James Doohan, in his 1996 memoir, *Beam Me Up, Scotty*. "I tell people that he's one percent accent and 99 percent James Doohan. Although that might be simplifying it. The way I look at Scotty is, hey, I love engineering myself. I wish I could be an engineer. Scotty may not be so much James Doohan as he is an idealized version of James Doohan. A James Doohan who, as a boy, loved things that 'went' and dreamed of escape. Indeed, how much further can you escape than the stars?"

Doohan loved Scotty, while *STAR TREK* fans cherished both the character and the man who played him. The actor made it seem effortless, and maybe it was. Scotty was heroic, a loyal friend, easygoing, a prolific drinker, honorable, a man of good humor, full of piss and vinegar, and, of course, the *U.S.S. Enterprise*'s resident miracle worker. Doohan, a bit of a miracle worker himself, imbued Scotty with all those attributes, an extraordinary feat considering that Scotty was a supporting character with limited screen time during the show's three-year run.

Born in 1920 in Vancouver, British Columbia, Canada, and of Irish and Scottish descent, Doohan began acting in high school. Canada officially entered World War II in 1939, and the 19-year-old Doohan promptly enlisted in the Canadian army, in part, he always noted, to get away from his abusive father. He rose through the ranks and spent more than five years in England during the war with the 14th Field Artillery Regiment of the 3rd Canadian Infantry Division and other divisions.

After initially not seeing much action, Doohan found himself immersed in harrowing combat several times. Most notably, at Juno Beach on D-Day, six bullets struck him. Four slugs hit his leg, one caught him in the chest, but was stopped by a silver cigarette case his brother gave him, and the sixth so severely damaged the middle finger on his right hand that the digit required amputation. Look closely and in 79 episodes you'll rarely see the fingers on his right hand. He was always careful to keep his missing digit hidden, if he could. After recovering in England, he returned to action in the war, now as a pilot/ flying observer, helping photograph enemy positions and target artillery fire from above. He was, simply, a war hero.

On the conclusion of the war, Doohan started performing

on Canadian radio programs, and then in stage productions, television shows, and movies. He moved to New York in 1946, first studying and later teaching at the famed Neighborhood Playhouse. During those early days, he befriended the likes of Leslie Nielsen, Lee Marvin, Eli Wallach, and Tony Randall.

Then it was back to Canada for several years, before he settled in Los Angeles. Credits – and accents for his roles – piled up, including the 1960 *Encounter* episode, 'The Well' with costar William Shatner, *The Twilight Zone*, *The Wheeler Dealers* (his Hollywood feature debut, with James Garner), and *Hazel* (the first time he used a Scottish accent). Doohan also appeared in *The Outer Limits*, *Bewitched*, *Peyton Place*, and *Voyage to the Bottom of the Sea*, the last of which, he often pointed out, asked him to sign a contract and stick around as the submarine's accent-free engineer.

Scotty entered Doohan's life in 1965. His agent, Paul Wilkins, called him less than two weeks before the second pilot, 'Where No Man Has Gone Before,' rolled camera. "Paul just said, 'Go and read for these people,'" he recalled. "I hadn't heard anything about them, and I said 'What are they?' And he told me it was called *STAR TREK*. So, I went and I did eight different accents for them and, at the end, Gene Roddenberry asked me which accent I liked. 'Well,' I said, 'if you want a chief engineer, he'd better be a Scotsman.' They said, 'Well, we rather liked that one, too.'

ABOVE: *At one point, Roddenberry thought the Enterprise would be so sophisticated that it wouldn't need an engineer. In practice, the writers often found that stories called for the ship to break down and Scotty frequently came to the rescue, performing engineering wonders.*

So that was that." Actually, there was a bit more to the tale. Doohan gave Montgomery "Scotty" Scott his name. His grandfather was called James Montgomery, and right there in the audition Doohan decided that would be the perfect name for Roddenberry's engineer. "I said, 'Good, I'll name him Montgomery Scott,'" Doohan continued. "Gene broke in and said, 'We haven't hired you yet.' I said, 'Oh, well, sorry.'

"Then, once they sold the pilot, I got a letter from Gene saying, 'Well, thanks very much, but we don't think we need an engineer.' I told my agent about this, and he said, 'You got a letter?' I said, 'Yeah.' And he said, 'You just hang in there.' By three o'clock in the afternoon I was back on the show." And, what were the other accents he road-tested during the audition? "There was Irish, and there was cockney and German and Italian, French-Canadian and French," he replied.

"I never got any more guidance, none at all," he continued. "The only thing was that as I created the character, I used an Aberdeen accent because I had the six weeks of [hearing] that [from the soldier] in the cot next to me in Yorkshire [at signaling school during World War II]. The first week of talking to him, I couldn't understand a word he'd say. It was thick. As a matter of fact, Gene Roddenberry twice told me, 'Don't make your accent so thick. They won't understand you.' I disbelieved that, but I cut it down."

Despite Roddenberry's reservations about having an engineer, Mr. Scott nearly became Captain Kirk's best friend. When they were writing the early episodes, the writers had a lot of latitude and could establish relationships between the characters. George Clayton Johnson was hired to write 'The Man Trap.' He figured that the captain would need someone he could "really buddy up with." To his mind, *STAR TREK* was based on the navy, and in the real world the ship's engineer was the one person who could tell the captain that the engines were more important than his orders. At the same time, because the engine room was his domain, the chief engineer would be separate from the rest of the crew and could relax with the captain without it interfering with the chain of command.

In an early draft of 'The Man Trap,' Johnson had Kirk and Scotty go down to the planet where they rushed Professor Crater together. He was delighted with the scene and told Doohan about it, saying that the relationship he had written would give dimension to his part. Roddenberry, however, was

RIDING PAST THE KING

Playing Scotty made Jimmy Doohan famous. Wherever he went, he remembered people would yell out, "Beam me up, Scotty!" According to Doohan, one day he was driving down the road alongside a large, fancy car. He noticed that something was wrong with the front wheel. Doohan pulled alongside the driver to warn him, only to discover that it was Elvis Presley. Somewhat taken aback, Doohan pointed at the car's front wheel and shouted out that Presley needed to do something about it. To his amazement, Presley nodded in agreement and replied, "OK Scotty!"

determined that Kirk would have that kind of friendship with Spock rather than Scotty, so he took the lines Johnson had written and gave them to Nimoy.

Doohan was originally hired to appear in five of the first 13 episodes, but Roddenberry was so pleased with his performance that Scotty ended up factoring into 66 of *STAR TREK*'s 79 episodes. Among the character's best moments, he drank an alien under the table in 'By Any Other Name,' beat up Klingons and cunningly beamed tribbles over to a Klingon ship in 'The Trouble with Tribbles,' stood accused of murder in 'Wolf in the Fold,' and took command of the *Enterprise* several times, including in 'A Taste of Armageddon.' And, of course, Scotty saved the day on multiple occasions, earning his "Miracle Worker" nickname in 'The *Enterprise* Incident,' 'That Which Survives,' and other episodes. Scotty even enjoyed a short-lived romance with Mira Romaine (Jan Shutan) in 'The Lights of Zetar.' Shutan told *Starlog*'s Pat Jankiewicz in 1994 that "James Doohan was an awfully nice guy, very sweet," and that she'd hoped to recur as Mira, only to learn NBC had cancelled the show.

"I accepted whatever they wrote," Doohan noted, adding that he did occasionally adjust his lines. "If it needed a more fluid Scottish treatment, I told the writers about that, and they always agreed with me because I knew what I was talking about." Of Scotty's lack of an active on-screen love life, the actor commented, "It was tough luck for poor old Scotty.

ABOVE: *Doohan makes a brief appearance in the second pilot, 'Where No Man Has Gone Before.' His character was considered important enough to appear in publicity photographs, but Roddenberry only expected him to be in approximately half the episodes.*

Courtesy STAR TREK: Original Series Set Tour/James Cowley

> # "I used an Aberdeen accent because I had the six weeks of [hearing] that [from the soldier] in the cot next to me in Yorkshire [during World War II]. It was thick."

James Doohan

Nothing good ever really happened to him." But, despite being a supporting character, Scotty got his moments to shine. "I kind of felt my character growing in popularity," he noted, "because the writers loved him. It was too bad that [Scotty and the other supporting actors] didn't get more screen time, but the characters were well written with the ideas behind them."

Also, lest anyone forget, viewers occasionally caught a gander of Scotty dressed up in a kilt, like the one he sported in 'The Savage Curtain.' "That was fine with me. I looked good. I was slimmer then than I am now. I don't like the looks of me in a kilt now!" Doohan remarked in 1999, laughing.

During production of the series, Doohan typically arrived at Desilu by 7am, pulling up in his black Mustang. As detailed in *Beam Me Up, Scotty,* he'd often tackle the *Los Angeles Times* crossword puzzle with Nichelle Nichols, or chat with Leonard Nimoy, DeForest Kelley, George Takei, and later, Walter Koenig.

And Doohan considered Marc Daniels and Joseph Pevney the show's best directors.

STAR TREK went off the air in 1969 and Doohan contended with typecasting that severely limited his acting opportunities for decades. Still, he added to his resume roles in such films and shows as *Daniel Boone, Pretty Maids All in a Row, Jason of Star Command, MacGyver,* and *The Duke,* as well as numerous commercials. And he returned to the *TREK* universe for *STAR TREK*: THE ANIMATED SERIES (voicing Scotty and more than two dozen other characters), all six original series-cast features and *STAR TREK GENERATIONS,* as well as the 'Relics' episode of *STAR TREK: THE NEXT GENERATION.*

He also attended countless *STAR TREK* conventions around the globe and remained lifelong friends with Gene Roddenberry. "I got to like Gene after the show had run its three years," Doohan noted. "We'd go sailing together in his

ABOVE: *Doohan's performances were strong, so the writers often put Scotty in their scripts and he became a prominent character. He made a convincing commander and in several episodes, he came out of engineering and assumed control of the ship when both Kirk and Spock were away.*

ABOVE: *When he returned for the third season, Doohan slicked his hair back as he kept it when he wasn't working. The look only lasted a few episodes, but it was used for the season three publicity shoot.*

FROM ONE SCOTTY TO ANOTHER

Simon Pegg tread lightly. Stepping into the role of Scotty for the *STAR TREK* reboot features, the British actor wanted to do right by his predecessor, but not deliver a carbon copy of the cherished character. "Out of respect to Jimmy Doohan, I tried to not make particular reference to him, just because that'd be saying Scotty was him when in actual fact he was playing Scotty," Pegg told StarTrek.com in 2011. "I tried to do what he probably did when he got the script, which was to consider the details on the page and who is he? We weren't making a parody. None of us was tempted to make sly references to the original cast members. Karl [Urban] and Zach [Quinto] were probably the most similar, but they weren't channeling DeForest Kelley and Leonard Nimoy. They were channeling the characters. It was important for us not to seem like we were being wry."

39-footer, and I was a good sailor. I remember he said, 'Boy, I don't have to tell you something twice.' That was great." Frustrated as he grew at times about the "albatross" that *STAR TREK* became, Doohan couldn't help but smile at the recognition the show, movies, and Scotty brought him. Fans told him that he inspired them to pursue engineering degrees and jobs. Once, after receiving a letter from a suicidal fan, he called the woman, met her at a local convention, and then continued to greet her at conventions for two or three years. Eight years later, Doohan received another note, this one thanking him for his kind gestures and revealing that she'd just earned a master's degree in electronic engineering.

Doohan passed away in 2005 at the age of 85, succumbing to Alzheimer's disease and pneumonia, and some of his ashes, quite fittingly, were smuggled aboard the International Space Station. He left behind seven children and his third wife, Wende, and he had long ago made peace with *STAR TREK* and Scotty – and their influence on his life and career. "A great friend of mine, said, 'Jimmy, you are going to be Scotty long after you're dead. So, if I were you, I'd just go with it,'" he told Paul Rosa of The Life Arts Network in 1994. "I saw the sense in that, and I've accepted it and learned to like it. Now, hey, I know very well that I'm one of the terrific characters that came out of *STAR TREK*. And I made him. So, that's lovely for me."

THE KLINGONS

THE GREAT POWER

I f you really want to understand the Klingons, you have to start with the Vietnam War. When Gene Coon sat down to create them in December 1966, in 'Errand of Mercy,' the war was the dominant issue in America. The United States was supporting the South Vietnamese government against the communist North, which was backed by China and the Soviet Union. In Coon's script, the Federation faces off against another great power, as they struggle for control of an apparently primitive planet. As you'd expect from *STAR TREK,* the story ultimately expresses the belief that the two powers aren't so different after all.

The conflict in Coon's story would be expressed through two commanders: Kirk and the Klingon Kor, both vigorous men of action who saw one another as equals. The role of Kor went to

John Colicos, who remembered that the episode was filmed at top speed. He learned his lines on the plane to L.A. and when he arrived at Desilu, he and makeup artist Fred Phillips worked together to create a look for the Klingons, because no one else had had a chance to think about it. The script simply described them as "oriental" and "hard-faced." Clearly seeing the parallels with modern politics, Colicos suggested that Phillips turn him into a futuristic version of Genghis Khan, whose empire had extended from Southeast Asia to Eastern Europe. Phillips dyed his hair black, gave him extravagant eyebrows and an alien skin color. The whole process took two hours.

Colicos's performance would define the Klingons. As *THE NEXT GENERATION* and *DEEP SPACE NINE* writer Ronald D. Moore says, "He wasn't simply a mustache-twirling villain, but

was a guy that relished this military role he had, and he played it with this larger-than-life quality. If Colicos hadn't played Kor in that way, they might not have come back to the Klingons."

Roddenberry and Coon were pleased enough with the Klingons to make them a recurring presence. Like America and its adversaries, the two powers were locked in a cold war, competing with one another as they sought to control or make alliances with planets. In 'Friday's Child,' the Klingons are backing Maab's attempted coup. In 'The Trouble with Tribbles,' they have poisoned the grain destined for Sherman's Planet. In 'A Private Little War,' they are arming the tribes on Neural.

Coon was particularly keen on the idea of making Kor a recurring character. They offered him the role of the Klingon commander in 'The Trouble with Tribbles,' but he wasn't available, so they cast William Campbell instead and renamed the character Koloth. Campbell remembered that Roddenberry told him that they were considering giving the Klingons an even greater presence. "Gene said they were thinking of offering me a 13-episode deal," Campbell recalled. "He said, 'I don't want to have to go to monsters.' But," Campbell continued, "almost within the month, the word came that Gene canceled. He wanted it to be an anthology show."

When *STAR TREK* was renewed for a third season, the Klingons gained a ship. Model company AMT had sold a LOT of *Enterprise* kits and wanted an adversary for the starship, so they worked with Matt Jefferies to design a Klingon battlecruiser. The ship's first appearance was filmed for 'Elaan of Troyius,' when the Klingons pursue the *Enterprise* as they try to gain control of the Troyian supplies of dilithium. Due to changes in the production order, it actually made its on-screen debut in 'The *Enterprise* Incident,' where it is operated by Romulans instead of Klingons. The script called for ships, the budget was tight, so a line was added to the script explaining that the Romulans and the Klingons had entered into an alliance.

The Klingons made their final original series' appearance in 'Day of the Dove.' Jerome Bixby wrote the part of the Klingon commander for Kor, like Coon before him, hoping that John Colicos would return to play the part. Again, Colicos was unavailable. This time the role went to Michael Ansara. Just as it had in Coon's first story, the episode ends with Kirk's crew and the Klingons realizing they are not so very different. When they returned to TV decades later in TNG, things had moved even further and the two great enemies were now uneasy allies, mirroring the way the real world had changed.

ABOVE: STAR TREK *consistently emphasized that although Starfleet was on the brink of war with the Klingons, the two great powers should put aside their differences. In 'Day of the Dove,' the conflict is caused by a non-corporeal entity that creates suspicion and paranoia. Kirk and Kang defeat it by joining forces and literally laughing at it.*

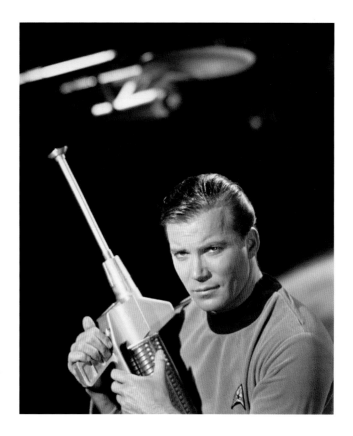

THE PHASER RIFLE

After its appearance in the second pilot, one of *STAR TREK*'s most memorable props disappeared from view for the best part of 60 years.

Gene Roddenberry, Matt Jefferies, and Wah Chang get the lion's share of credit for creating the look of *STAR TREK* and inventing its iconic props. However, there's another crucial figure, a man rarely mentioned in the same breath as the headliners above, who merits recognition. That man is Reuben Klamer.

In 1965, Klamer designed/created the phaser rifle that Kirk wielded in the second *STAR TREK* pilot, 'Where No Man Has Gone Before.' Kirk utilized it to weaken his god-like old friend, Gary Mitchell, and then to topple boulders that buried Mitchell in a grave meant for Kirk. The episode's action – exemplified and amplified by the phaser rifle – helped nudge NBC to commit to *STAR TREK* as a series. Also, in 1966, a few months

before *STAR TREK* premiered, network publicists arranged a photoshoot with Shatner, Nimoy, Grace Lee Whitney, and unwittingly, the phaser rifle. The resultant images stoked viewer anticipation about the upcoming sci-fi series – and triggered a mystery.

After 'Where No Man Has Gone Before,' the weapon disappeared from the show. The prop itself seemed to vanish, too, until it went under the gavel in 2013. It generated 23 bids and fetched $240,625, the highest price ever paid for a hand-held *STAR TREK* prop. The seller? Reuben Klamer.

A veteran inventor and toymaker, he developed the classic board game, *The Game of Life,* and created such products as *Busy Blocks* and Fisher-Price's training roller skates. Klamer's

company, Toy Development Center, Inc., also devised props for the entertainment industry. One such prop, a gun produced for *The Man from U.N.C.L.E.*, wowed audiences – and Gene Roddenberry – and became a bestseller when Klamer licensed a toy version. Roddenberry, deep into preproduction on *STAR TREK*'s second pilot, got Klamer's name from *U.N.C.L.E.* producer Norman Felton.

"I had no clue I was going to get a call from Roddenberry," says Klamer in 2021, aged 99. "I was surprised. He said, 'My name is Gene Roddenberry, and I have this show called *STAR TREK*. I'd like you to come in and talk about an idea we have.' I said, 'Of course, I'll be out there any time you say.' And we met." Roddenberry and Klamer agreed that Toy Development Center would construct a phaser rifle in exchange for the merchandising rights to toy phaser rifles and potentially to other *STAR TREK* products.

Klamer and his design associates, Dick Conroy and Ab Kander, spent two weeks toiling around the clock to build a long, sleek weapon with a trio of transparent tubes in its body and a minisatellite dish at the barrel's end.

"We had to get the looks of it right first, so we worked on that for days," Klamer recalls. "Once we got that right, then we could get down to brass tacks. We did the whole thing in two weeks, but it would've taken two months under normal conditions. I was willing to do it, though, so I could get the merchandising rights. Our *U.N.C.L.E.* products were very successful. One of the guns sold over a million pieces and had its own fan mail."

Everyone loved the rifle, including Shatner, who'd attended an early meeting about the prop. Roddenberry, on seeing the nearly finished version, declared, "This is it!" Next, lawyers negotiated and letters were exchanged, but ultimately, "Gene didn't follow through" with granting Klamer the merchandising rights to the phaser rifle or any other *STAR TREK* toys. "I was disappointed," Klamer concedes, "extremely disappointed."

NBC, unaware the weapon would never be used again, included it among the props that Shatner, Nimoy, and Whitney posed with for a photoshoot. At some point thereafter, the phaser rifle wound up back in Klamer's possession. He kept it in its case at his office in Culver City and then in San Diego. "We'd open the box once in a while to show somebody, but it was perfectly preserved," Klamer says. "The funny thing is we tried to hide the box so that if our office ever got broken into, no one would find it." He watched 'Where No Man Has Gone Before,' and was impressed. "The phaser rifle looked great on-screen, especially with the special effects added," Klamer says. "And I thought Shatner did a really good job."

Decades went by. Finally, one of Klamer's sons suggested selling the rifle. Klamer agreed, and sold it with a design sketch sheet, Polaroid photos, and correspondence from Roddenberry. "I didn't imagine the bidding would hit $240,000," Klamer says. "That was great." Though he no longer owns the prop, he owns something maybe of higher value: a unique place in *STAR TREK* lore. "That prop was more than a phaser rifle and more than a model," he claims. "It looked like something special. It *was* something special. It gave the show some pizzazz."

ABOVE: *Klamer's original sketch for the phaser rifle. At this stage, the design included a shoulder brace, which wasn't part of the final prop. When it wasn't in use, it swung under the main body. Even in 1965, Roddenberry was interested in merchandise rights and hoped the rifle would become a toy.*

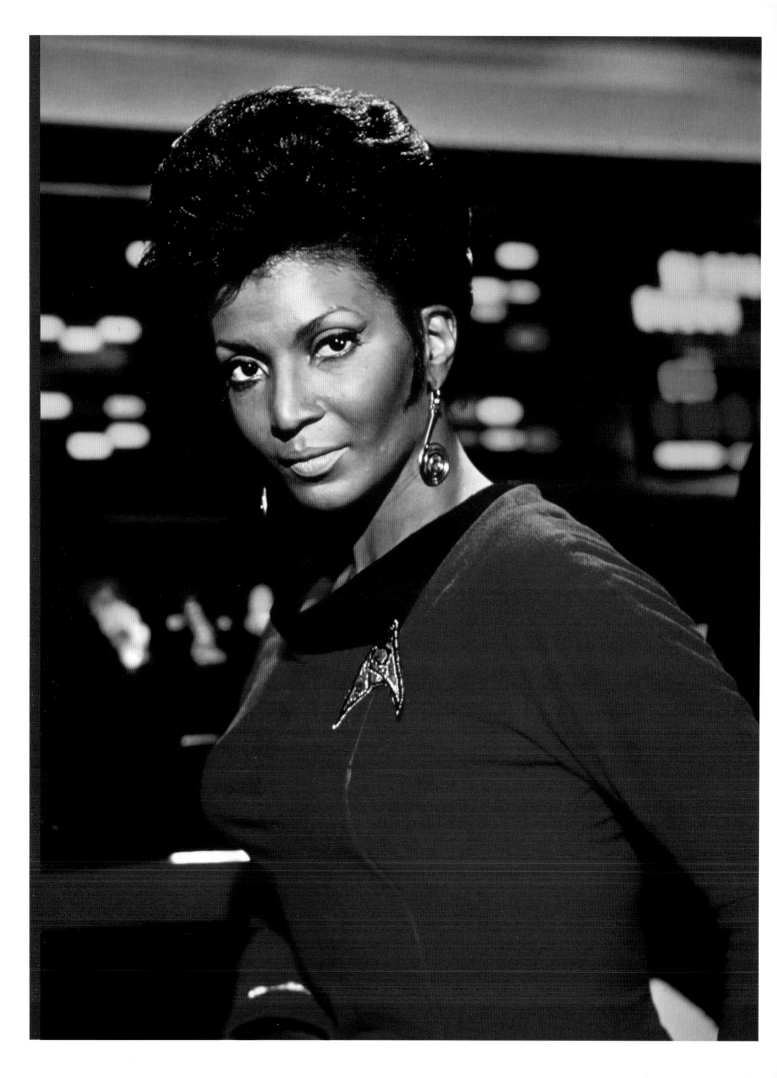

U H U R A
VOICE OF THE SHIP

Uhura was only added to the crew at the last minute but
she became a cultural icon who showed that Black people –
and women in particular – had a place in the future.

Uhura should be dead. We can hear you screaming now: Wait! What?! But she wore a red shirt, and red shirts in *STAR TREK*, especially on the original series, suffered horrible, gruesome deaths. Or so the theory suggests. That supposition has long been debunked; characters in command gold statistically perished at a greater rate (18 percent versus 10 percent) than their shipmates in communications/engineering/security red. But the myth prevails, and by that standard, Uhura sidestepped the grim reaper for decades.

So, did Nichelle Nichols ever fear for Uhura's life? "No! Never!" she insisted. "But there's a funny story. The first time you saw me, I wasn't in a red outfit; the outfit was puke green. The front office hadn't seen that and had no idea I was on the show. When they saw the dailies, they went, 'What the hell? Who is she?' Gene [Roddenberry] said, 'She's the communications officer.' They said, 'What happened to… [Lloyd Haynes]?' Gene said, 'He got a lead role on *Room 222*, and Nichelle is absolutely perfect for it. Isn't she good?' They said, 'Yes, she's good, but… but… but, we can't…' Gene said, 'I told you I was going to make a change on the bridge.'

"They said, 'All you said was you were going to add a little color. We thought you were talking about the costumes!'" Nichols energetically continued. "Gene said, 'You know, you're right. I don't like her in that outfit,' and he had the costumer change it. The next thing I knew, I was in a red costume for the duration of the show. They didn't come up with the idea of the red shirts dying on planets for a little while."

Now, there's a heap of hyperbole in that anecdote, but also a good measure of truth in Nichols' comments. By all accounts, Roddenberry snuck Nichols into the *STAR TREK* mix. She joined the cast at the last minute and, in fact, was the final major piece of the puzzle, not counting Walter Koenig, who beamed aboard the *Enterprise* in season two. However, Nichols was neither a series regular nor a contract player at first. She worked as needed and was paid by the day, much to her frustration, though Roddenberry promised to write her in as often as possible, and was true to his word. Roddenberry's scheme worked, and it actually cost Desilu more to pay Nichols by the day than if they'd offered her a contract.

Roddenberry may have had other motives for regularly calling upon Nichols, but let's rewind. Grace Nichols – the

Nichelle moniker came later – was born in Robbins, Illinois, just south of Chicago; her ancestry included Moorish, Spanish, Welsh, Ethiopian, and Cherokee roots. As a child, Nichols sang, danced, and performed in school plays and recitals. She dreamed of becoming a ballerina, though few, if any, young Black women achieved success in that discipline at the time. Instead, she hit the road, singing and dancing, and by 16 toured with the immortal Duke Ellington and Lionel Hampton. By 18, she was married and a mother, all the while pursuing her career. She sang in clubs, acted in plays, and opened for comedian Redd Foxx.

Nichols made her film debut in *Porgy and Bess* in 1959 and moved to Los Angeles, where she chased roles in TV shows and other features. In 1963, she and Don Marshall guest starred in an episode of Gene Roddenberry's first series, *The Lieutenant*. The episode, 'To Set It Right,' spun a powerful story about racism. It was cowritten by Roddenberry and directed by Vincent McEveety, with Joe D'Agosta handling the casting. Nichols and Roddenberry fell in love but, as Nichols wrote in her 1994 autobiography, *Beyond Uhura: STAR TREK and Other Memories,* they stayed discreet out of respect "for each other and the other important people" in their lives. And, she insisted, "Certainly our relationship was over long before *STAR TREK* began."

A couple of years after her appearance on *The Lieutenant,* her agent reached her in Europe and implored her to return to L.A. to audition for something called *STAR TREK*. To kill time at her audition, Nichols brought along a book, *Uhuru*. She met the producer: Roddenberry. Her agent had never mentioned his name. She read for Roddenberry, Joseph Sargent, Jeff Peters, and Bob Justman. The communications officer role didn't really exist. In fact, Nichols remembered that when she came into audition there weren't even any lines for her to read. "I read for the role of Mr. Spock because there was no Uhura." After Nichols was cast, she and Roddenberry went to lunch and the character started to become more than just the communications officer. Nichols says she and Roddenberry "conceived and created" her together, starting with her name. As she told the story, Roddenberry said he couldn't get the book she was reading out of his mind. "What do you think about using the Swahili for "freedom" as a name?' And I said, 'Well, sure, there are people named Freeman, so it would mean a free person, but 'Uhuru' kind of sounds strong.' And he said, 'I was thinking of an alliteration of it,' so we went through 'Uhurio,' 'Uhuria,' and then we just came to 'Uhura,' almost together. It was so pretty, and I just said, 'That's it.' Then it was a matter of whether it was her first name or her last name. I said, 'I think it's her last name,' and he said, 'Well, what other names in Swahili do you know?' and I said, 'That's about it! But Uhura knows.'"

In 1966, casting a Black person in a notable supporting role wasn't that unexpected. The National Association for the Advancement of Colored People (NAACP) had been campaigning for more representation, and as a result of their work, the studios actively encouraged it. What was unusual was casting a Black woman. Even more unusually, Uhura was no stereoytype. Most Black women in movies and TV were still playing maids. Uhura was a bridge officer and all through the series her race is barely mentioned. "I felt very good," Nichols said, "about being able to create a character that I could feel strongly about and respect, and get into the kind of dignity, that intelligence, that I wanted her to have."

Roddenberry continued to write Uhura into stories. While there's no "Uhura episode" per se, the character figured prominently in 'The Man Trap' (joyously, shamelessly flirts with Spock); 'The Changeling' (memory-wiped, she's reeducated); 'Mirror, Mirror' (disarms Mirror Marlena, turns on the sex appeal to distract Sulu); 'The Galileo Seven' (assumes the science station from Spock, saves the day); and 'The Naked Time' ("protected" by Sulu).

And then there's 'Bread and Circuses' ("I'm afraid you have

ABOVE: Uhura wasn't part of either of STAR TREK's pilots, but made her debut in the first regular episode, 'The Corbomite Maneuver.' In that episode, she wore a gold uniform rather than the familiar red.

ABOVE: Nichols shows off her dancing skills on the STAR TREK sets. Although she was frustrated that she wasn't given a series regular contract, it did give her the freedom to accept other jobs. Uhura's occasional absences were usually because she was unavailable because she had a singing engagement

it all wrong, Mr. Spock, all of you"); 'The Tholian Web' (Kirk's alive!); 'Charlie X' (sings and dances as Spock plays his Vulcan lute); 'The Trouble with Tribbles' (accidentally instigates all the trouble); 'Who Mourns for Adonais?' (saves the day with her duotronic repair tool); and the game-changing 'Plato's Stepchildren,' with its real-world first televised kiss between a white man and a Black woman. Uhura always handled her responsibilities well, shifting tasks and stations on the bridge when necessary, and forged bonds with everyone, notably Spock, whom Nichols considered "Uhura's mentor" because

he was older and more experienced. In some ways, Uhura's race protected her from some of the attitudes toward women that were prevalent in the 1960s. Because of racial sensitivities, Uhura was rarely given any kind of romantic storyline, and as a result. she is never shown being subservient to a male guest star in the way some of her female colleagues were.

Nichols wanted more to do, more to say. Every actor does. Still, Uhura made an impact in episode after episode, and on the other characters in her orbit. STAR TREK would not truly be STAR TREK without Nichols or Uhura. "Most of us, other

> *"Uhura represented womanhood and the breakthrough of cross-racial representation. She represented dignity and intelligence, and no one can take that away from me, or her."*

■ Nichelle Nichols

than the big three guys, weren't used properly," Nichols argued. "I don't know why everyone seems to think it was just me who wasn't used enough. I don't think anybody was used to their fullest in ways that would've been artistically viable, pleasing, and entertaining. Many of Uhura's scenes have been cut out of the reruns in order to put in more commercials. So, there is that sense, I guess, of there being less than what was there, which wasn't enough to begin with. That sense of not enough Uhura is even stronger for people who became TREK fans from watching the series only in reruns.

"STAR TREK made sweeping statements about society and relationships between people at the same time Captain Kirk swashbuckled," she continued. "We never lost sight of the first law of show business: to entertain. We did it and made our statements without preaching. My God, that's such an opportunity. I think that's what Gene intended to accomplish when he specifically cast George Takei and me on the command crew. And he did it. That's why I rather resent it when people say Uhura didn't do anything but say, 'Hailing frequencies open.' That's not true. It demeans my status. Uhura represented womanhood and the breakthrough of cross-racial representation. She represented dignity and intelligence, and no one can take that away from me, or her."

Nichols featured on the cover of *Ebony* in January 1967 and the article inside proclaimed her character to be "a triumph of modern-day TV over modern-day NASA," but during the course of the first season, she grew frustrated. She was angry about the internal politics, at the network and on the set, that resulted in cut lines of dialogue. She was still miffed about her contract status, or lack thereof. Someone told the mailroom staff not to deliver fan mail to Nichols. A gate guard at Desilu refused to allow the actress onto the lot, insisting her name wasn't on his list, and a Desilu executive's assistant, to Nichols' face, claimed that she and not Grace Lee Whitney deserved to

be axed. Nichols strode into Roddenberry's office and quit.

"When I told Gene, I walked away, and as far as I was concerned it was a *fait accompli*," Nichols recalled. "As nice as this little part was – and I loved the people and I loved working on it, and I was getting experience in a new medium – I didn't think twice. Gene said, 'You can't [leave], Nichelle. Don't you see what I'm trying to do here?' I just looked at him, because I was resolute. He said, 'OK,' and I handed him my resignation. He took it and looked at it with sad eyes. He was behind his desk and I was standing in front of him and – I'll never forget it – he said, 'I'm not going to accept this yet.' He put it in his desk drawer and said, 'Take the weekend and think about this, Nichelle. If you still want to do this on Monday morning, I will let you go with my blessings.' I said, 'Thank you, Gene.'"

That weekend, Nichols attended an NAACP fundraiser in Beverly Hills. As she settled into her seat at the dais, an event organizer approached her and said, "Ms. Nichols, I hate to bother you just as you're sitting down to dinner, but there's someone here who wants very much to meet you. And he said to tell you he is your biggest fan." Nichols picked up the story. "I said, 'Oh, certainly.' I stood up and turned around, and who comes walking over towards me from about 10 or 15 feet, smiling that rare smile of his, is Dr. Martin Luther King. I remember saying to myself, 'Whoever that Trekkie is, it'll have to wait because I have to meet Dr. King.' He walks up to me and says, 'Yes, Ms. Nichols, I am your greatest fan.' You know I can talk, but all my mouth could do was open and close, open and close, I was so stunned."

Dr. King informed Nichols that he and his wife, Coretta, allowed their young children to stay up and watch one show: *STAR TREK*. He described to her what the show itself meant to him, how she'd shaped a character brimming with dignity and knowledge. She thanked Dr. King and mentioned how much she'd miss her costars. The smile vanished from his face.

Courtesy STAR TREK: Original Series Set Tour/James Cawley

| **ABOVE:** Nichols in the STAR TREK makeup department, getting ready to go to work as Uhura.

"He said, 'What are you talking about?'" Nichols continued. "I told him. He said, 'You cannot,' and, so help me, this man practically repeated verbatim what Gene said. He said, 'Don't you see what this man is doing, who has written this? This is the future. He has established us as we should be seen. Three hundred years from now, we are here. We are marching, and this is the first step. When we see you, we see ourselves, and we see ourselves as intelligent and beautiful and proud.' He goes on and I'm looking at him and my knees are buckling. I said, 'I..., I...' And he said, 'You turn on your television and the news comes on and you see us marching and peaceful, you see the peaceful civil disobedience, and you see the dogs and see the fire hoses, and we all know they cannot destroy us because we are there in the 23rd century.'"

That changed everything. Nichols drove to Desilu on Monday and shared the story with Roddenberry. "He sat there

behind that desk and a tear came down his face, and he looked up at me," she noted. "I said, 'Gene, if you want me to stay, I will stay. There's nothing I can do but stay.' He looked at me and said, 'God bless Dr. Martin Luther King. Somebody truly knows what I am trying to do.' He opened his drawer, took out my resignation, and handed it to me. He'd torn it to pieces. He handed me the 100 pieces and said, 'Welcome back.'"

This time Nichols was given a contract, guaranteeing that she would appear in nine out of 16 episodes. She remained with *STAR TREK* to the end of its run and then returned for all the feature films, *STAR TREK: THE ANIMATED SERIES*, and a few *STAR TREK* video games and fan films. She also frequented *STAR TREK* and sci-fi conventions around the world. Away from the 23rd century, Nichols appeared in such films and TV shows as *Gargoyles, Futurama, Snow Dogs, Heroes, The Young and The Restless*, and *Unbelievable!!!!!*

In the late 1970s and 1980s, as a result of her *STAR TREK* association, she found herself with a job with NASA, recruiting new candidates, who weren't white men, for space shuttle missions. A mild stroke in 2015 barely slowed her down. Within weeks she was back acting, meeting fans at conventions, and riding aboard NASA's Stratospheric Observatory for Infrared Astronomy, a telescope-bearing airplane. More recently, in 2021, she served as the subject of the acclaimed documentary, *Woman in Motion*.

"That was a very successful venture, very rewarding in my life," she enthused of her time with NASA. "I had a touch with history. The first six women and three Black men, as well as the first Asian and Indian astronauts, are because of me. I felt very proud. Since then, a young woman heard me speak. She was too young to qualify for astronaut status. She believed what I said and was so impressed that she made sure she finished her education and geared it by taking courses that would help her become what she wanted to be. She came to me and told me I was responsible, and she became the first Black astronaut. Her name is Dr. Mae Jemison. She's young and beautiful, and when she came to me, I just fell in love. I have a beautiful son, but if I could choose my daughter, it would be Mae."

In late 2017, during a conversation timed to her 85th birthday, Nichols was asked if she ever contemplated her legacy. "Oh, yeah," she replied instantly. Asked to elaborate, she invited us all to follow in her groundbreaking footsteps. "If you want to do something badly enough, strongly enough, there's nothing that can stop you. So, don't let anything stop you from going there," Nichols implored. "You really will be able to do it if you stay on top of it. I definitely am proof of it."

WHEN ALI MISSED UHURA

In 1969, Craig Thompson looked out of the window in Desilu's postproduction department and saw Muhammad Ali at the studio gates. A few minutes later the two men met in Desilu's reception area. Thompson picks up the story, "'Hey,' Ali said, 'maybe you can tell me. Where do I find the *I, Spy* set?' He'd come to meet Bill Cosby. It was right next to my office, so I said, 'Follow me.' He was friendly and we were chatting away." When they got to the *I, Spy* stage, Cosby was busy, but he told them he'd planned to take Ali over to meet Nichelle Nichols, and asked Thompson to help out. "I had the time to do it, so I said 'Sure.' It was a long walk. As we're walking he's saying, 'What is she like? Do you think she'll mind meeting me?' We finally get up there and walk in, Shatner and Nimoy were there, but it was Nichelle's day off. They held up production to chat, but he never got to meet her."

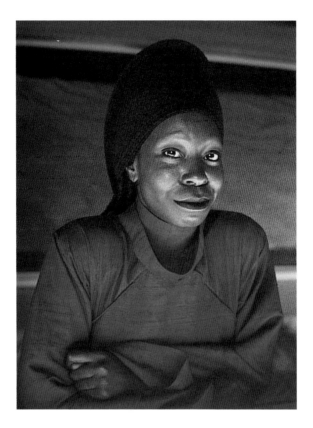

WHOOPI GOLDBERG: INSPIRED BY UHURA

Caryn Elaine Johnson might not have become Whoopi Goldberg were it not for *STAR TREK* and Nichelle Nichols. She was seven or eight, growing up in a Manhattan housing project, when she stumbled upon her mother watching *STAR TREK*. "I had watched all of the sci-fi movies, but when I saw Lieutenant Uhura on *STAR TREK*, it was the first time I noticed that we were indeed part of the future of the world," Goldberg says during a recent conversation. "I was allowed to ask who she was and what she was doing onboard that ship. She was so beautiful, so that wasn't so shocking, but it was only later I realized how unique her presence actually was. It was about seeing us represented in the future."

Goldberg and Nichols formed a long, loving friendship, and Goldberg paid it forward by portraying Guinan on *STAR TREK: THE NEXT GENERATION* and in *STAR TREK GENERATIONS*, and by welcoming Nichols onto the stage to join her during her first-ever convention appearance, in 2016.

"It's an honor and a privilege to know Nichelle and to understand the cost of being her, being beautiful and sexy and smart," Goldberg says. "I'm not sure any of us think about who is watching our films or movies, and the impact we can have on others. *STAR TREK* put that into perspective for a lot of people.

"It's one of the first things I said to Gene Roddenberry when I made it known that I wanted to be on the show and he asked me why. I explained that Nichelle's Uhura gave me the gift of knowing people of color would be in the future. When he asked what I meant, I explained that in all the science fiction I'd ever seen up until *STAR TREK*, there were no people of color.

"When he went back and watched a lot of pre-*STAR TREK* films, he saw what I meant," she continues. "It was as clear as day because he was looking for it. He told me I had the job and that he was shocked to discover that I was correct about our absence, until he fixed a problem he didn't even know we had. That's why I love *STAR TREK* and *THE NEXT GENERATION*. They fixed things no one realized needed fixing."

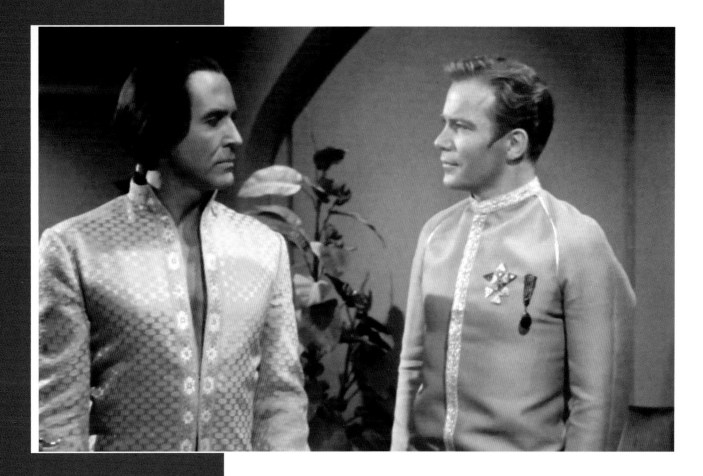

SEASON 1

EPISODE 22

AIR DATE: FEBRUARY 16, 1967

Teleplay by Gene L. Coon, Carey Wilber

Directed by Marc Daniels

Synopsis: The genetically engineered
superhuman Khan Noonien Singh
is awakened from suspended
animation and promptly seizes
control of the *Enterprise.*

SPACE SEED

'Space Seed' introduced us to Khan Noonien Singh, a genetically-
engineered superman played by Ricardo Montalban, but when the
story began, Khan was an ordinary criminal called Ericsson.

When they made 'Space Seed,' no one
had any idea that it would become one
of *STAR TREK*'s most important episodes. This
is the show that set the stage for *STAR TREK II:
THE WRATH OF KHAN,* the movie that righted
the big-screen ship in the wake of *STAR TREK:
THE MOTION PICTURE,* and set the scene for
STAR TREK: INTO DARKNESS.

Veteran television writer Carey Wilber,
making his first and only contribution to *STAR
TREK,* penned the first draft of the story, titled
Botany Bay. His treatment introduced an

antagonist named Harold Ericsson, a powerful
figure of Nordic descent, who was one of
a hundred criminals who had been put into
suspended animation and sent into space.

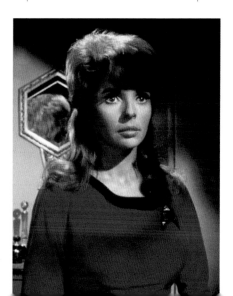

*RIGHT: In Wilber's early drafts of the story,
Marla McGivers (played by Madlyn Rhue) was a
communications officer rather than an historian.*

In Wilber's story, this was a futuristic spin on an old English policy of sending criminals to imprisonment in the colonies.

The writing staff liked Wilber's outline but they wanted changes. Among other things, he had Spock cheating at chess and displaying a wide range of psychic powers; there was far too much expensive action; and Ericsson wasn't much more than a common criminal. Coon suggested that Wilber make him an equal for Kirk.

Wilber produced a couple of subsequent drafts of the script, but Roddenberry was still unhappy. For one thing he felt that sending criminals into space was both expensive and inhumane. He suggested that instead, Ericsson should be one of a group of "super criminals" who had conquered the Earth and fled when they were defeated.

Gene Coon took over writing duties and rapidly produced a revised draft. In his versions, Ericsson became Ragnar Thorwald, but it was Roddenberry who took the final pass and renamed the character Khan.

As casting director Joe D'Agosta remembers, getting Ricardo Montalban was a coup. "He was cast because he was a star. He was presented to us, and I said, 'What about Ricardo Montalban?' I was told, 'Get him.'"

The script called for an extraordinary physical specimen and Montalban definitely fit the bill. "He had a 31-inch waist," D'Agosta says, laughing. "It pissed me off. I had to call him, get his sizes. We got to the waist size. He said, '31 inches.' I said, 'You know, I don't like you.' We laughed about it. By then, my waist had moved from 31 to 32."

Years later, Montalban would say he always assumed his physique is what got him the job, but he was a powerful actor and his Khan is brilliant, calculated, ego-driven, rugged, and superior.

Madlyn Rhue was cast as Marla McGivers, the ship's historian who is obsessed with powerful men. Coon and Roddenberry had both been troubled by the character, who at least temporarily betrays the crew. Between them they suggested giving her a fascination with heroic figures from the past, and made Khan almost mesmerizing. But Khan is downright cruel and misogynistic, and Marla responds to this. In the end, she decides to join him in exile on her own accord.

> **"...the scientists overlooked one fact. Superior ability breeds superior ambition."**
>
> **Spock**

Cameras rolled on December 15, 1966, with Marc Daniels back in the director's chair after having called the shots on several previous episodes, among them 'The Man Trap,' 'The Naked Time,' and 'The Menagerie, Part I.'

Many of Khan's followers were played by dancers so that they would have suitably impressive bodies, but Bill Theiss's costumes were a little too revealing for NBC who insisted that scenes of them stretching on the *Botany Bay* were cut back.

In a borderline blooper, Kirk's phaser detaches from his belt and falls to the ground as he smashes the glass of Khan's cryogenic chamber, prompting Dr. McCoy to look at Khan and then the floor several times. The phaser prop was not intended to come off William Shatner's belt, and DeForest Kelley's reaction occurred in real time, as if he was not sure if Daniels would call for another take of the scene.

The various rewrites had relocated most of the action to the *Enterprise*. Matt Jefferies built a new part of sickbay we had never seen before: the decompression chamber, which would reappear in 'The Lights of Zetar.' He also designed a simple set for the interior of the *Botany Bay*, and Khan's ship itself, which recycled a design labeled 'antique space freighter,' he had come up with when he was designing the *Enterprise*.

'Space Seed' called for effects shots that showed the two ships alongside one another. These were done at Lin Dunn's Film Effects. *American Cinematographer* magazine ran a feature on *STAR TREK*'s effects during the shooting of this episode, and as a result the effects were documented in more detail than usual.

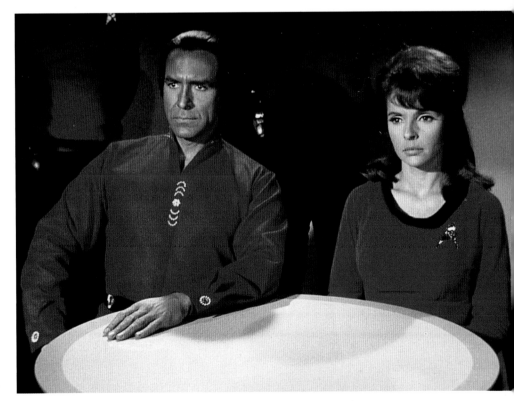

ABOVE: *Even in the earliest drafts the story ended with Kirk sending Khan (or Ericsson) to Ceti Alpha V, expecting it to be a harsh world Khan can make his own. It was an idea that appealed to the writing staff.*

MR. SULU
LEADING THE WAY

Sulu was a reliable presence at the *Enterprise*'s controls, but more than anything, he was a sign of the kind of future that Gene Roddenberry envisaged.

When people talk about *STAR TREK* and anti-racism, they tend to focus on Uhura – but Sulu, the *Enterprise*'s dependable helmsman and occasional commander, was a big deal, too. In 1966, many Americans still thought of Japan as "the enemy," so putting an Asian man in charge of piloting the ship was a bold move. That fact wasn't lost on George Takei. As he recalls, if you were Asian, roles like that didn't come along very often. "Usually," he explains, "it was as an accented servile person, or the enemy, or an insignificant role for Asian American actors. Here, I'd be part of the team, without an accent, playing a leadership role as a full member of the crew. And, it's a series, with regular, weekly exposure to an audience. So, I recognized it as a groundbreaker for Asian American visibility, as well as, for me, steady employment."

Takei had personal experience of American prejudice. When he was a child, his parents Takekuma and Fumiko, were forced from their Los Angeles home and imprisoned in the Rohwer War Relocation Center in Arkansas. Takekuma served as block leader, mediator, and translator, assisting new arrivals, while Fumiko repaired clothes and crafted rugs and curtains.

Five-year-old George played alongside his siblings Nancy and Henry, blessed and distracted by youthful ignorance. He could not possibly realize it then, but amid the myriad horrors of Japanese American internment, Quasimodo and a *Benshi* planted the seeds of what would blossom into his astonishing trek as an actor. "We were in this concentration camp and occasionally they'd show movies," Takei recalls during a recent conversation. "I remember seeing Charles Laughton as the hunchback of Notre Dame. The performance and the makeup were spectacular. They also showed Japanese samurai films, which were silent. Whenever they showed those films, there was a man that came, the *Benshi*. He had an assistant, a boy, and there'd be a small table at the far end of the screen. On a table, he had coconut shells, triangles and wood blocks, different musical instruments. The *Benshi* would provide the dialogue – the magisterial voice of the Shogun, a princess's voice, a samurai's voice – and the boy might play the triangle, creating clashing metal sounds, during a sword fight. It was so fascinating that I was more riveted on the *Benshi* than the movie," Takei continues. "Their artistry stayed with me."

Released in February, 1946, the Takei family lived in L.A.'s

ABOVE: Sulu made his debut as the ship's astrophysicist, but when the series went into production, he was reassigned to the helm.

Skid Row area. Racism remained rampant and money tight. Takei's father unwittingly purchased an item for the house that further nudged his son closer to pursuing his destiny. "My dad bought a small radio, and that was the discovery," Takei marvels. "There were entertainment shows – cowboy stories, gangster stories, mystery stories, science-fiction stories being told on this machine called the radio. A whole new world opened up, with just sounds, voices and my imagination. Voice acting became a part of what I admired."

Takei majored in acting at UCLA and soon secured his first paying jobs: dubbing voices for the monster movies *Rodan* (1957) and *Gigantis the Fire Monster* (1959). He made his on-camera debut in 1959, with the 'Made in Japan' installment of *Playhouse 90*: another step on his path toward the final frontier. "Herbert Hirschman was the director, and the assistant director was a guy named Bob Butler," he continues. "A few years later, Bob got a *Twilight Zone* script ['The Encounter'], and he didn't ask the casting director for help. He called me in directly, and I got that wonderful two-hander with Neville Brand. My first big film was *Ice Palace* (1960), and all my scenes were with Richard Burton. I'm an Anglophile and I love Shakespeare, and Richard loved to talk. It was a really wonderful way to start my career."

Butler, who coincidentally later directed the original *STAR TREK* pilot, 'The Cage,' had recommended Takei to Hoyt Bowers, a casting agent and mentor of sorts to Takei. It was

HIDDEN LIFE

George Takei publicly revealed that he was gay in 2005, but the news surprised few people, including his *STAR TREK* family. "Walter [Koenig] suspected," Takei says. "The morning ritual was we'd get made up, go to the coffee area and chitchat, and then go to our dressing rooms. On one occasion, some extras starting coming onto the soundstage. Walter suddenly started making this gesture, like, 'Look behind you.' I looked behind me and there was this gorgeous guy wearing this tight *STAR TREK* uniform. He had big pecs and a sculpted face. Breathtaking. Then I realized it was Walter that told me to turn around. I looked at him, and he was smiling and he winked. But he was being very sophisticated. He knew if he made a big thing of it, it'd have negative repercussions on me."

Takei, Koenig, Nichelle Nichols, and James Doohan later toured together for a series of Fab Four conventions. One time, inclement weather resulted in them landing in Pittsburgh, where they tracked down two rooms at a mostly sold-out hotel. The men drew straws to determine who'd share a room with Nichols. Takei drew the short straw. "We arrived at our room with our separate luggage, and we each took a few drawers," Takei recalls. "I said, 'Nichelle, you can have the bed. I'll sleep on the couch.' Nichelle said, 'Darling, I know who you are. I'm safe. Get in the bed.' So, I shared a bed with Nichelle Nichols! In those days, we didn't talk about that because... well, because.

"They knew, but they cared about the repercussions on my career," Takei added. "And I appreciated that."

Bowers who invited Takei to read for *Ice Palace*. And then, apparently, Gene Roddenberry heard about Takei from Bowers.

"I met Gene Roddenberry in 1965, to talk about *STAR TREK*," Takei says. "I was expecting to read for Gene. That's what you usually did. Usually, you had other people [producers, a casting agent, and network executives] in the room... But for *STAR TREK*, it was just Gene," continues Takei, who famously referred to him as "Mr. Rosenbury" when greeting Roddenberry's gatekeeper, Dorothy Fontana. "Gene came around from his desk and ushered me over to the side of his office, which was set up with a sofa and a cocktail table. We shot the breeze. It was a wonderful give-and-take about what was going on in the world, and he told me what he envisioned for Sulu, which was tantalizing."

ABOVE: *Takei always tells the story about how he suggested Sulu should fantasize about being D'Artagnan rather than a stereotypical Japanese hero, and relished the chance for some swordplay.*

In his 1994 memoir, *To the Stars*, Takei shared that he told his agent, "Fred, I've got to have that role. I desperately want that role." However, Takei did not elaborate as to why he so passionately yearned to play Sulu.

"The way Gene described it, the idea itself was fantastic, groundbreaking," Takei explains. "All these people of different backgrounds, ethnicities, races, working as a team on this starship. That was a futuristic idea that was also so relevant in the 1960s, especially because I grew up in an American concentration camp. Also, in the 1960s, I was involved with the civil rights movement. So, I knew about the racial issues and what Gene was trying to do with IDIC — Infinite Diversity in Infinite Combinations."

Takei debuted as *Enterprise* physicist Sulu in 'Where No Man Has Gone Before.' The episode, shot first, aired fifth during season one. Sulu then evolved into Lieutenant Sulu, the ship's helmsman. That was no oversight. "Gregg Peters, our assistant director, during a set-side conversation, told me, 'The network people said this guy is interesting. If you're going to have him downstairs, you're not going to see him regularly. Bring him up to the bridge and we'll see him regularly,'" Takei recalls. "I liked that. I'm an actor. I want to be more visible."

Of course, Takei wanted to be even more visible. As a supporting character, however, Sulu received only so much screen time and character development. Takei nevertheless made the most of any opportunity to imbue the helmsman with pride, loyalty, and a flair for the dramatic, and to display his *alter ego*'s unparalleled navigation skills.

No episode shone a better spotlight on Takei and Sulu than 'The Naked Time.' In it, a pathogen unleashes dormant personality traits among the *Enterprise* crew, including Sulu, who bares his glistening chest, brandishes a fencing foil, and promises Uhura, "I'll save you, fair maiden!" Takei routinely cites 'The Naked Time' as his favorite episode, when asked by fans at conventions or journalists.

"Great fun," Takei effuses. "John D. Black wrote that, and about two weeks, three weeks before, we were on set shooting 'Mudd's Women.' He plunked down and said, 'I'm developing a story where this virus affects all of us and breaks down our inhibitions. Sulu grabs a samurai sword and terrorizes the ship.'"

Takei suggested an alternative. "I said a samurai sword would be racially authentic, because I'm of Japanese ancestry, but that when I was a kid, I didn't play samurai," he recalls "I said, 'I saw Errol Flynn's *Adventures of Robin Hood*, and that swept me away.' I had my mother make me a Robin Hood outfit, and I wore that to school for Halloween. I did a pretend

thing in my backyard with a skinny blond kid from the neighborhood as my Friar Tuck. Martha Gonzalez was my Maid Marian.

"I suggested to John, 'Wouldn't it be interesting to put a fencing foil in his hand?'" Takei continues. "He said, 'Interesting idea. This is sci-fi.' What I was trying to do was not make it a stereotype. 'Oh, George is Japanese American. OK... samurai.'"

Evil Sulu hit hard on Uhura in 'Mirror, Mirror,' and tried to kill Spock and Kirk, too, in his effort to commandeer the Enterprise. "It's fun to curl the mustache," Takei comments, "to sink my teeth into bloody red flesh." In 'Catspaw,' Sulu and Kirk went mano a mano. "I was able to bring a lot of truth to my acting," Takei teases.

Scripts arrived on a steady basis, followed daily by different color pages with revisions. "We had the whole rainbow of pages in our scripts," he jokes. And, yes, lines meant for Takei often vanished with each fresh set of pages. "When Sulu's lines disappeared – and they did frequently – I knew why..." Takei says, a barely veiled reference to William Shatner's purported penchant for requesting that Kirk should always be central to the action and therefore be given more lines. "The others were complaining about the same thing, and we all know what the source was."

ABOVE: We didn't learn much about Sulu's background, but 'The Man Trap' revealed he was a keen botanist, giving Takei the chance to pose with some exotic and alien plants.

Takei worked on numerous sets before STAR TREK. It begs a loaded question: was Shatner's purported behavior the norm for a leading man? "On other sets, there were rewrites, and sometimes parts would be enlarged and other times they'd be whittled down," Takei replies. "Usually, for me, it was guest shots. I'd come in for one show and that was it. But on a show where it's a continuing basis, you could start figuring out where it came from, the whittling down of your part.

"I was aware of who has the power, who gets the most fan mail, which is a measure of your worth," he continues. "So, you make suggestions. You do a little lobbying, maybe suggest that

Sulu has a family, or parents, or a love interest. They're not all accepted. Some are accepted, like the fencing foil. That's part of the give-and-take."

Roddenberry listened to Takei's concerns and ideas, and, before season two, he eagerly presented the actor with several scripts for upcoming episodes. Around the same time, Takei flew to Georgia to shoot John Wayne's war film, The Green Berets. Production went way over schedule, forcing Takei to stay down South. Meanwhile, Walter Koenig joined STAR TREK as Chekov, and lines meant for Takei were adapted for Koenig or dropped.

"Gene gave me a batch of those scripts, and I took them with me to Georgia," Takei recalls. "I was fully expecting to be back on time, but I then had to tell Gene we'd be running over. They had to make decisions, and they brought in Walter. I can't imagine what those scripts would be worth. I gave away thousands of dollars' worth of scripts.

"My niece and nephew would visit, and I'd give them these [unused] scripts and boxes of crayons to draw pictures for me when I babysat them," Takei says, shaking his head. "Of course, those wonderful pictures would eventually go in the wastebasket. I realized what I'd done when Jimmy told me, 'Oh, I got $250 for that script at a convention.' I'd say, 'What? You're selling them!'"

By season three, STAR TREK's ratings had dropped. Important behind-the-scenes figures left. Budgets were slashed. Takei reports that the cast tried to stay positive and always did the best they could with material handed to them. "That element of excitement and looking forward wasn't there, but it was still a job," Takei notes. "Actors want to work. We wanted it to be renewed and have a long life."

Takei was on set when the axe fell. "I was disappointed, heartbroken," he says. "I was unemployed! I was immediately on the phone with my agent."

ABOVE: *Sulu's position at the front of the bridge made him one of the most prominent members of the crew. In early episodes he is often given command of the ship, laying the groundwork for his promotion to captain in the movies.*

All pictures courtesy STAR TREK: Original Series Set Tour/James Cawley

"*We thought it was the end. That's it. We scattered to the winds. But here we are in the 21st century...*"

George Takei

STAR TREK eventually returned – and Takei with it. He participated in *STAR TREK: THE ANIMATED SERIES*, the six features with the original cast, ascending at long last to Captain Sulu, as well as numerous video games. Takei even reprised his signature role for the triumphant 'Flashback' episode of *STAR TREK: VOYAGER*. And, he's a favorite at conventions.

And after decades of contending with typecasting, Takei found himself busier than ever as an actor, appearing in *Mulan, Heroes, Supah Ninjas, Hot in Cleveland, The Simpsons,* and *The Terror.* Additionally, Takei has run for office, written books and graphic novels, been the focus of a documentary, married his husband, Brad, emerged as a gay rights activist, served as

Howard Stern's announcer, become an Internet mogul, and more. He also realized the long-held dream of mounting and starring in *Allegiance*, a stage musical inspired by his internment camp experiences.

Through it all, Takei never turned his back on *STAR TREK* or its fans. He was tempted, at times, but stuck it out. "It was a fluky situation," Takei says. "We thought it was the end. That's it. We scattered to the winds. But here we are in the 21st century, in the year 2021. It's what, the 55th anniversary? *STAR TREK* is still going strong with *STAR TREK: PICARD* now. It became, and it still is, a mega-phenomenon. It's a fantastic and totally unexpected phenomenon."

SEASON 1

EPISODE 25

AIR DATE MARCH 9, 1967

Teleplay by Gene L. Coon

Directed by Joseph Pevney

Synopsis Kirk and Spock discover that a seemingly monstrous creature is just a mother protecting her children. Should it live or die?

THE DEVIL IN THE DARK

In 'The Devil in the Dark,' Gene Coon stamped his mark on *STAR TREK*, writing a story that emphasized the importance of compassion and understanding, and insisting that aliens should not be feared.

Sometimes inspiration can take the form of a Hungarian stuntman, acrobat, and creator of creature costumes. In late 1966, Gene Coon was running out of scripts that were ready to be filmed. Janos Prohaska, who had performed as a couple of creatures in 'The Cage,' visited his office and, after impressing him and Bob Justman with a chimp outfit – and an in-character performance – walked out with an agreement that he would craft creatures on spec and, if the producers liked them, they would put them in the show.

Days later, Prohaska was back, scooting around in what Justman described in his book, *Inside STAR TREK: The Real Story*, as

RIGHT: After McCoy heals the Horta with cement, he starts to think he can "cure a rainy day."

"a large pancake-shaped glob of gook with a thickened raised center and fringe around its circumference." Then, depending on whose account you listen to, he laid an egg or had his creature roll over a rubber chicken and spew the bones out the back. "Great!" Justman recalled Coon exclaiming. "It's perfect. Just what we need."

According to legend, Coon was so impressed he promptly went back to his office and wrote 'The Devil in the Dark.' From the first outlines, the story was about a misunderstood alien creature, who Kirk and Spock finally learn is just trying to protect its young. Roddenberry would later say that this was the moment when he and Coon identified one of STAR TREK's core themes: that we should seek to understand new life rather than assuming it is hostile. The Horta is a mom who just wants to keep her children safe and stave off extinction. It doesn't get more primal than that. Up to this point, Herb Solow (Desilu's head of production) felt that Kirk had been more likely to fight aliens than talk to them. In the additional material he recorded for the Sci-Fi Channel broadcast, he said, "Coon came in and said... 'Why don't we go in and find out what they want, why they're there? Maybe they have the right to be there and we don't.'"

Coon's story progressed from outline to script with only minor changes. In his early outline, the Enterprise visits the mining colony because it is in severe need of repairs and, rather than mind-melding with the Horta, the crew use a device that resembles the

writing at speed, and Roddenberry let this script and others that followed, go through without rewriting them himself.

Trivia aficionados note that this is the sole episode with a teaser that features neither any of the ship's crew nor the Enterprise itself. It incorporates a painted backdrop of the mining facility on Janus IV that was reused as a background in 'The Gamesters of Triskelion.'

ABOVE: At first Kirk and Spock assume that the Horta is simply a monster that wants to kill the humans, so they attack it, but they soon realize that things are more complicated.

Director Ralph Senensky was originally slated to make his debut with this episode, but scheduling changes meant 'The Devil in the Dark' was pushed back, so Joe Pevney took charge. Barry Russo, who played Security Chief Giotto, would also play Commodore Bob Wesley the following year in 'The Ultimate Computer.' Chief engineer Vandenberg was played by Ken Lynch.

Filming the Horta, which Prohaska had originally created for The Outer Limits, caused some technical problems. It was hard to make out against the walls, so the crew put

"a kind of sheen" on it to make it more visible, and Pevney told Prohaska to exaggerate his movements. Roddenberry was a little unhappy that the tunnels had such smooth floors, but given that Prohaska was crawling around on all fours throughout the filming, this was a necessity. Pevney remarked that Prohaska probably lost "eight to 10 pounds a day" inside the suit.

William Shatner deemed this his favorite episode. "[It] was a terrific story," he wrote in STAR TREK Memories. "Exciting, thought-provoking and intelligent, it contained all of the ingredients that made up our very best STAR TREKs. However, none of that stuff qualifies it as my favorite." Rather, the actor received word, during day two of production, that his father had died. He insisted on working until he needed to catch a plane to head home for the funeral, and the cast and crew had his back – especially Leonard Nimoy and director of photography Jerry Finnerman. And that, he wrote, "is what made this episode my favorite."

Shatner was back on set the following week, but on the day after he left, Eddie Paskey stepped in to double for him in the scene where Kirk has his back to viewers as he confronts the Horta.

> "The Horta is intelligent, peaceful, mild. She had no objection to sharing this planet with you, til you broke into her nursery and started destroying her eggs. Then she fought back in the only way she knew how, as any mother would fight when her children are in danger."
>
> **Captain Kirk**

universal translator. By now Coon had worked on half a dozen episodes and was making major contributions to the show and helping to define the characters. This episode features the first of DeForest Kelley's famous "I'm a doctor, not..." complaints. Coon was also

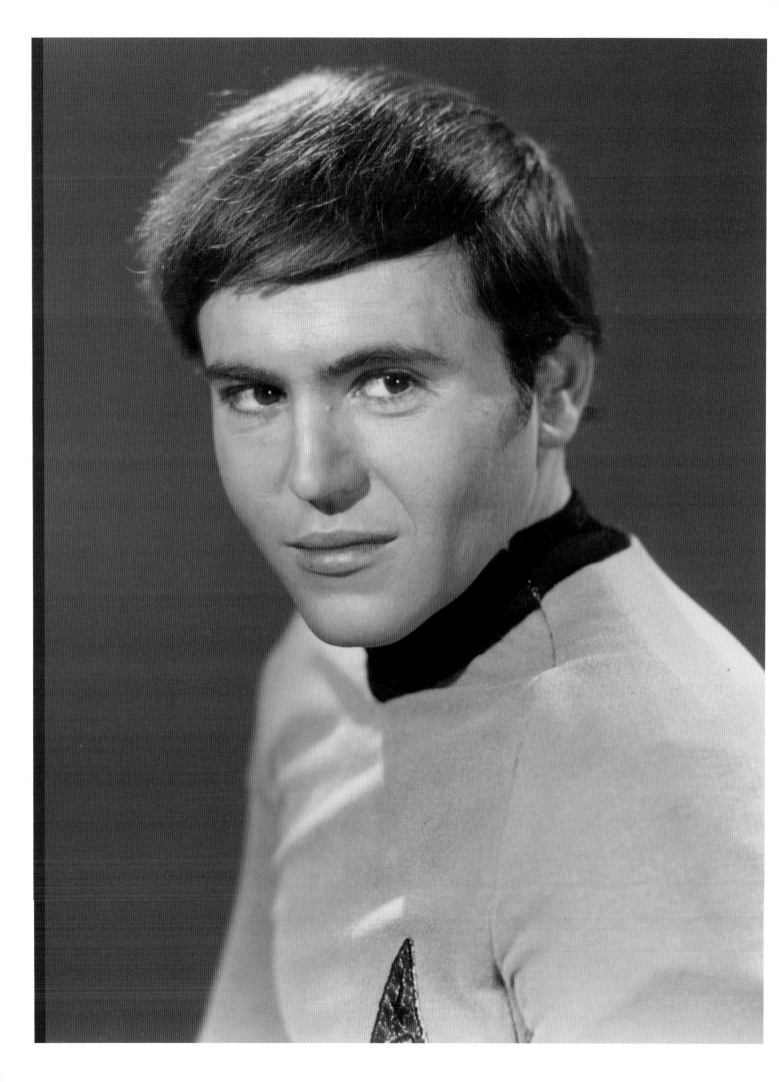

C H E K O V
THE YOUNG ENSIGN

In *STAR TREK*'s second year, Gene Roddenberry introduced a new character who was designed to appeal to younger viewers who had just gone wild for *The Monkees*' Davy Jones.

W alter Koenig scours the universe, searching for the perfect metaphor to define his pre-*STAR TREK* career, and then he finds it: "I'm pretty much a supermarket bag, a plastic bag, that if you abandon it, it floats in the air and lands nowhere that you'd expect."

Quite the phrasing, but also typical Koenig – sly, acerbic, self-deprecating, and always, always honest. Those pre-*STAR TREK* credits included stage appearances in high school, college, summer stock, and at New York City's Neighborhood Playhouse. On moving to Los Angeles, Koenig logged sporadic television work, beginning with *Combat!* in 1963, followed by *The Untouchables, The Lieutenant, The Alfred Hitchcock Hour, Mr. Novak, Ben Casey, Gidget*, and *I, Spy*.

Two of those credits started the ball rolling toward Koenig joining *STAR TREK* in 1967. Gene Roddenberry created and produced *The Lieutenant*, and Vincent McEveety, who directed Koenig's episode, 'Mother Enemy,' went on to direct *STAR TREK*. Meanwhile, Harlan Ellison wrote and Joseph Pevney directed 'Memo from Purgatory,' Koenig's installment of *The Alfred Hitchcock Hour*. Ellison and Koenig later formed a close but sometime fractious friendship, and Pevney called the shots

on numerous *STAR TREK* episodes, including the Chekov-heavy, 'The Apple.'

"I'd gotten some fairly nice roles," Koenig acknowledges. "I'm not a person who is able to map out a life, and say, 'Look, this is where I'll be at this point, and this is where I'll be 10 years later.' I wasn't able to find the way to 'make' a career. My career sort of found me."

STAR TREK eventually snagged Koenig in its tractor beam and never let go. But before season two, the show barely registered on his radar. Passing it while flipping channels, he glimpsed Styrofoam, plexiglass, and "stuff that wasn't real." Digressing for a moment, that never changed: "We had one soundstage for the bridge and the ship, and another soundstage to create planets," he notes. "Of course, the planets were all artificial, and the flowers, whatever we discovered there, were built. I liked being a part of it. I liked working with the other actors, but it seemed a little artificial to me, and it was just a job, until it stopped being just a job."

During his audition, Koenig read lines for producers Roddenberry and Gene Coon, director Joe Pevney, and casting director Joe D'Agosta. He believes that Gregg Peters, then the

unit production manager, was on hand, too. They gave Koenig precious little to go by. In fact, the character in the script he read from was "entirely different than what they were looking for," and the character was named Green or Blue or… Jones.

"I think the character's name was Jones," Koenig says, putting the emphasis on the word think. "It was easy to write 'Jones' and think of Davy Jones, which they all had in mind. But it was a very tense moment in the story. Kirk was on a planet somewhere and they had a second in command who was no one that ever returned, as far as I know. The material seemed self-evident. The ship was going to go down and I had to report the circumstances under which we were operating. So, I went for that. There was no other sane choice, no hidden message I was trying to convey, just that we were in trouble. I read with intensity and a certain degree of apprehension, and when I got done, the room was dead silent. I thought perhaps I'd so knocked them out with my intensity that they didn't know how to respond."

That wasn't the case. The people in the room asked Koenig to repeat the scene – and this time, "make it funny."

"I had no idea what the hell they were talking about," he says. "There was nothing funny in the scene, but I'd gone to drama school for two years. I'd been given some exercises that seemed appropriate to the material in terms of drama, comedy, etc. I knew my responsibility was to do what the director, producers, etc., had in mind. So, I read it entirely differently. I read it very… kind of frivolously, as if crashing a spaceship was something I looked forward to."

Complicating matters, Koenig was about 30 at the time, auditioning for a long-haired, 22-year-old character in the

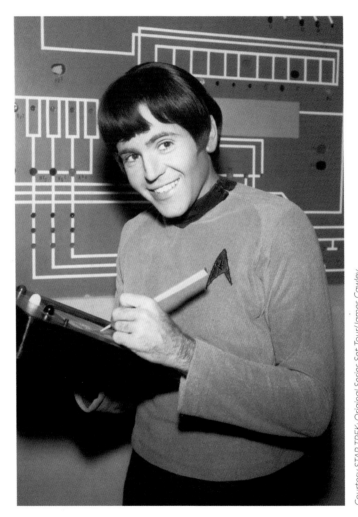

ABOVE: Koenig in an early publicity photograph, complete with Beatle wig. Later on his wigs would fit better...

Courtesy STAR TREK: Original Series Set Tour/James Cawley

mold of Davy Jones, the British member of *The Monkees*. And that character was meant to appeal to kids eight to 14 years old, especially girls. *STAR TREK*'s makeup guru, Fred Phillips, walked by Koenig and famously led the actor off on an expedition to Max Factor on Hollywood Boulevard to track down something called Nestle's Streaks 'n' Tips, and he used it to obscure Koenig's fast-spreading, male-pattern balding. They also picked up four or five wigs of different colors, which sparked an epiphany. "I was actually excited because how often do they take one specific actor and bring him back with all these hairpieces unless they're really interested in him?" Koenig asks rhetorically. "So, I felt I had a pretty good shot at this… if I was ready to wear a woman's wig."

Koenig faced another obstacle to winning the role. Everyone involved in the decision also liked actor Anthony Benson, and it came down to Benson and Koenig. The two had guest starred in an episode of the World War II espionage action-drama, *Jericho*. "He was a hotter actor than I was," Koenig points out. "We'd go in [for auditions)] and I'd see him. Before *STAR TREK*, he got all the roles."

But this time Koenig won out, and he chronicled the story in his 1998 memoir, titled *Warped Factors: A Neurotic's Guide to the Universe*, as well as in *Beaming Up and Getting Off: Life Before and Beyond STAR TREK*, an updated, extended version of which was released in 2020. A topic he broached in neither autobiography: whether or not Roddenberry, Coon, or D'Agosta ever revealed to him why they selected him over Benson to play Chekov.

"I think [they explained why]," Koenig says, less than confidently. "I don't recall, specifically. It may have very well been in the very first audition I had. I caught on pretty quickly

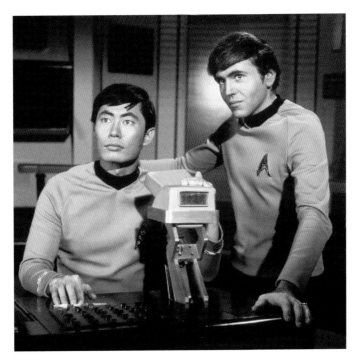

ABOVE: *Chekov was designed to fill the navigator's seat next to Sulu, which had been taken by various actors since Gary Mitchell's death in the second pilot. He was meant to be young and inexperienced, and to offer some humor.*

that they were looking to replicate the success of *The Monkees*, and felt that a character that would appeal to the very young was the way to go. I learned later they actually had a conversation and Gene said, 'Find somebody like the character on *The Monkees*.' So, it was less on my merits than how I looked. That's so frequent in the business. That they're looking for a type for somebody who'll epitomize a character the audience, or some part of it, can relate to. And I got all that mail, canvas bags of fan mail."

Chekov's character was never fully developed on the *STAR TREK* series, but fared better in the feature films, especially *STAR TREK II: THE WRATH OF KHAN*. Still, Koenig made the most of his moments to shine comedically or dramatically. The actor filled in the blanks on his own, devising a backstory that informed his performances. Koenig fancied Chekov to be eager, loyal, a guy who threw himself into his work and thoroughly enjoyed being on the ship, the prestige of serving as an officer, and even his position as an ensign.

"When I understand a character, when I can relate to it, I don't do a lot of self-examination," Koenig shared. "I just go on impulse. 'Oh, this is what he would do.' I don't research it. The only time I'd ever research anything was when I didn't know

"I read it... kind of frivolously, as if crashing a spaceship was something I looked forward to."

■ Walter Koenig

> ## "If you don't have that sense of peril, don't have a lot of conflict, then you're not that concerned if the characters you're rooting for survive."

■ Walter Koenig

how to approach a character. Fortunately, the roles I didn't research worked because they were innately a part of me.

"Once you get a [regular or recurring] role on a show, the directors, who often only do one or two episodes a season, generally leave the regulars alone," he notes. "If they have interpretive conversations with actors, it's with the guest stars. So, nobody really spoke to me about what I was doing. They sort of felt, 'Well, the producers must like what he or she is doing, just leave the actor alone.'"

Back when *STAR TREK* started, suspicions abounded about the Soviet Union, America's sworn enemy in the Cold War. Roddenberry inserted Chekov to further foster his creation's peace-seeking, inclusive nature. Koenig never felt pressure to portray his Russian character in any particular light, nor did he ever contend with viewer pushback or vitriol.

Koenig also debunks the popular theory that Chekov never got the girl. Taking into account that Chekov was a recurring character who didn't join until season two and featured in 36 episodes, he did OK. Ladies he romanced, took a liking to, or was adored by included Sylvia (Bonnie Beecher) in 'Spectre of the Gun,' Yeoman Martha Landon (Celeste Yarnall) in 'The Apple,' Irina Galliulin (Mary Linda Rapelye) in 'The Way to Eden,' and Tamoon (Jane Ross) in 'The Gamesters of Triskelion.'

"Whenever there was an opportunity to get the girl, it was always Captain Kirk!" Koenig says, laughing. "On one or two occasions, I think it was Leonard. On one occasion, it might have been Jimmy [Doohan] or DeForest, but they brought me on to appeal to preadolescent girls, and so, on rare occasions, I did get the girl. I had a meeting with Gene between seasons two and three, and he showed me correspondence he had with these guys at NBC, [Herb] Schlosser and [Mort] Werner, involving me more in season three, and going on planet adventures and being involved with the opposite sex.

"So, 'Spectre of the Gun,' which is my favorite [Chekov] episode, was a reflection of the way Chekov's character would've been if we had not known we were going to be cancelled," he continues. "Once we knew we were going to be cancelled, I knew immediately that Chekov's life was going to change, and there wasn't going to be all this involvement with the opposite sex. I knew it immediately. Jimmy, I think George, and I were on a magazine shoot for *STAR TREK*, and we were on horses. What could be more blissful for a 10-year-old than Chekov, Scotty, Sulu, and horses? That was whipped cream on top of chocolate cake. So, 'Spectre of the Gun' had already been written for the third season, and it reflected the way the character would've gone had we been picked up. We weren't."

BUTTON BASHING

Every time viewers spotted Chekov on the *Enterprise* bridge during the original *STAR TREK* series, he seemed to be at the helm, poking at colorful buttons. Koenig reveals that he winged those moments, but at the same time, he didn't quite push them randomly. "The story I tell is that when I was feeling envious, I hit the green button, and when I was in a rage, I hit the purple button," he says, chuckling. "That was pretty much it. And the buttons didn't move. They didn't push in the way they did when we got to the big screen, and they spent some more money. On the show, they were just pasted into the panel."

ABOVE: *Walter Koenig checking his lines and preparing to film on the bridge set on Stage 9. Koenig typically worked one or two days on every episode, unless he had a featured role, in which case he might be needed for more days.*

Lost to the sands of time are Koenig's memories of the nuts and bolts about the day-to-day of making *STAR TREK*. He can't, for example, remember what time he usually arrived on set, his daily routines on work days, or which writers put the best dialogue in his mouth. Of his costars, Koenig does recall that Nichols was the first to say, "Welcome to *STAR TREK*." A brief, early conversation with Shatner went south fast, with Koenig recognizing Shatner thought him to be "competition," and "I realized he wasn't going to be my best friend."

On a lighter – and louder – note, Chekov screamed a lot on the show and in the movies. Koenig cried out in pain in 'The Deadly Years,' 'Day of the Dove,' 'The Tholian Web,' 'Mirror, Mirror,' and 'The Way to Eden,' as well as *STAR TREK: THE MOTION PICTURE, STAR TREK II: THE WRATH OF KHAN,* and *STAR TREK IV: THE VOYAGE HOME.* Koenig cites "a very specific, pragmatic reason" for Chekov's ongoing caterwauling, since it's not particularly commendable for an *Enterprise* officer to become upset, get hurt, and scream all the time.

"The way to make that more acceptable is to have the youngest, the most vulnerable character have that jeopardy," Koenig insists. "It's unbecoming for Scotty or even Sulu or Uhura to be always crying out in pain. It seemed more acceptable to have it be the youngest member, and at the same time, show that there was jeopardy, that we were in danger, in peril, and that bad things could happen to us. If you don't have that sense of peril, don't have a lot of conflict, then you're not that concerned if the characters you're rooting for survive. It gave me some really good moments as Chekov."

Koenig's connection with *STAR TREK* extends far beyond the original series, the six original-cast feature films, and his short stint with Doohan and Shatner in *STAR TREK GENERATIONS*. Though not included among the voice cast of *STAR TREK: THE ANIMATED SERIES* he scripted the episode, 'The Infinite Vulcan,' Koenig also voiced Chekov for several videogames, such as *STAR TREK: JUDGMENT RITES, STAR TREK: STARFLEET ACADEMY,* and *STAR TREK: SHATTERED UNIVERSE,* as well as the free-to-play MMORPG, *STAR TREK* ONLINE. Several fan films provided "closure" on the character for him, and in 1980, long before his memoirs, he authored *Chekov's Enterprise: A Personal Journal of the Making of STAR TREK: The Motion Picture*. As a crowning achievement, Koenig received his star on the Hollywood Walk of Fame on September 10, 2012. On hand to help him celebrate the long-awaited honor were family, friends, *STAR TREK*'s Leonard Nimoy, Nichelle Nichols, and George Takei, and hundreds of fans.

CAREY FOSTER

THE ORIGINAL SLAVE GIRL

TAR TREK completists out there in the Galaxy view Carey Foster, aka Emmy Lou Parmenter, aka Emmy Lou Crawford, as the franchise's holy grail, missing link, and great white whale all rolled into one. That's because, by all accounts, she is the last living performer to act in 'The Cage' and then on *STAR TREK*, though her scenes for 'The Cage' actually hit the cutting-room floor.

"It's so bizarre and emotional to revisit this," Crawford confesses during a recent conversation. "It really is. I had no idea there was even an interest in the small players involved in *STAR TREK*. It didn't even occur to me that there might be an interest. I guess maybe it should have, but it is truly bizarre. Out of the woodwork!"

Crawford's connection with *STAR TREK* dates back to the early 1940s. Her parents were "close friends" with Gene Roddenberry and his first wife, Eileen, and Carey – who was born Emmy Lou Parmenter – was the first baby born between the couples. "I have pictures of Gene holding me as a baby," Crawford reveals. "Gene always had a special place for me. My family knew them for years through when he was a pilot, flying for the airlines, when he was a writer for the mayor in Los Angeles, and when he started writing for television. He always took an interest in what I was doing. I studied dance. That was my major accomplishment, and Gene followed my career. I started working, and I had an agent, and Gene and Eileen came up to see me in a family stage show I did in San Francisco.

"Gene always wanted to help as much as he could," she continues. "I'd call and talk to him, and he was very protective of me in the industry, because he knew how hard it was for a young woman. I don't know if I got the *STAR TREK* job because of my parents' relationship and my friendship with Gene. It's probably better that I can't absolutely say one way or another, but I do remember my agent indicating that he had to fight for it."

ABOVE: *Crawford takes a moment out during the filming of 'The Cage' to pose for a photograph with family friend Gene Roddenberry. Crawford appeared in the scene where Pike fantasizes about being an Orion trader, but her appearance ended up on the cutting room floor.*

Crawford played an Orion Slave Girl in 'The Cage,' in a scene that, as noted, was cut. Looking back on the shoot, Crawford jokes that three elements stand out distinctly, even 57 years later: Jeffrey Hunter, her makeup, and the exposed belly buttons of the ladies in green. "It was exciting!" she raves. "Jeffrey Hunter was beautiful. I remember his eyes. I was in a scene with him, one scene, and that was it. The makeup was unique. It took a long time to put on and almost as long to get it off. I remember Gene talking about the fact that the powers that be were not happy that belly buttons were shown on television. They argued with him that we needed to cover our belly buttons, and he refused. So, we got to show our belly buttons."

NBC famously passed on 'The Cage,' but the series eventually went on to a three-season run, with William Shatner replacing Hunter as the show's central character. Crawford soon found herself back on the *STAR TREK* set, where she played unnamed and uncredited crewmembers in six – maybe seven – episodes during for the first season. The six definites include 'The Conscience of the King,' 'The Squire of Gothos,' 'The Alternative Factor' (in which she may have even spoken a line that was later cut), 'This Side of Paradise,' 'The Devil in the Dark,' and 'Errand of Mercy.' She wore a science/medical blue uniform in the first four episodes, and engineering/communications red in the latter two installments. As for the other episode she might be in? That would be 'Operation – Annihilate!'

"People tell me I was in some of the best episodes of the show," Crawford marvels. "I was really lucky William Shatner was very personable and friendly… People were respectful, even though you might have a small part. I just found the whole experience very professional, but also very welcoming."

After season one, Crawford focused on dancing and quit acting. She had a family, became a Montessori teacher, and now also runs a dance studio with one of her daughters. But *STAR TREK* lives on for her. She and Roddenberry spoke, "lovingly and affectionately," before his death. An agent contacted her and she plans to rejoin the convention circuit – and is thrilled that a new *STAR TREK* show will soon warp onto Paramount+.

SEASON 1

EPISODE 24

AIR DATE: MARCH 2, 1967

THIS SIDE OF PARADISE

When the crew of the *Enterprise* are infected with psychedelic spores, we get to see a new side of Spock, and the *STAR TREK* writing staff gain a vital piece of the puzzle.

Written by D.C. Fontana

Story by Nathan Butler (Jerry Sohl) and D.C. Fontana

Directed by Ralph Senensky

Synopsis The *Enterprise* visits a planet where alien spores make everyone except Kirk abandon their posts.

It was going to be about drugs and Sulu. After Jerry Sohl finished his first script – 'The Corbomite Maneuver' – he pitched another idea to Gene Roddenberry. What if, he suggested, the crew were all infected with spores that made them peaceful? "The premise of the thing," Sohl told *Starlog*, "was that everyone on the *Enterprise* takes LSD." In Sohl's story, it was Sulu, not Spock, who succumbed to the spores and the advances of an old girlfriend. Roddenberry liked the idea but the process of turning it into a script did not go well. Sohl produced various drafts of the story which changed its name from 'Sandoval's Planet' to 'Power Play' and 'The Way of the

RIGHT: Spock's final heartbreaking scene with Leila, when she realizes he is free of the influence of the spores and can no longer love her.

Spores.' The writing staff, now headed up by Gene Coon, found the story and the script that followed confusing and unsatisfying. Sohl kept reworking it, but the problems didn't go away.

The solution would come from another of STAR TREK's writers. Dorothy Fontana was still working as Roddenberry's secretary, but had already contributed two scripts that had been well received. "We were losing a story editor, Steven Carabatsos," Fontana remembered, "and Gene said, 'If you can rewrite this script and if it satisfies me and it satisfies the network, I'd like you to be the story editor.'"

Fontana looked through the script and thought about what she could do to fix it. As she recalled, the answer was to change the focus. "'You know, the problem with the script, Gene,'" she said, "'is it's a Sulu story, which is not a bad thing, except it should really be a Spock story.' If it was just a Sulu story, and this is no reflection on George, it was then an ordinary love story, whereas if you throw the Spock element into it – how the spores affect him with his half-human/half-alien biology, his mindset – all of these things made it a far more interesting story. It revealed a whole other side of Spock that led to other things later on."

Roddenberry and Coon told Fontana to go ahead and rewrite the script. As she recalled, she wanted to build on a scene in 'The Naked

ABOVE: Director Ralph Senensky originally planned to shoot the scene where Spock finds an emotional Spock in the middle of a field. But it wasn't working so, thinking on his feet, he had Nimoy hang from a nearby tree.

Fontana's script. Leonard Nimoy, however, had concerns. In *I Am Spock*, he wrote that when Fontana told him she was giving Spock a love story, it made him worry. He was finally getting a grip on the character and showing his emotions could undo the work he had done. Sohl was even more unhappy with the rewrite and had his name taken off it.

The episode would be directed by Ralph Senensky, who was making his *STAR TREK* debut. While he was out scouting locations,

dressed her in a simple pair of dungarees, which would turn out to be one of his favorite costumes. It was probably just as well; Ireland was married to Charles Bronson, who Nimoy remembered attending every day of shooting and being extremely protective of her.

Meanwhile, Senensky had decided to film the exteriors at Disney Park. The first two days went well, but when Ireland was needed on the third day, she couldn't make it because she had suspected measles. The production returned to Desilu, where they filmed the remaining scenes, including the fight between Kirk and Spock.

Fortunately, Ireland was fine, but when she returned to work, Disney Park was no longer available, so the production moved to Bronson Canyon. In a moment of good fortune, Senensky spotted some nearby trees. He threw away his original plans and had Nimoy hang from a branch, laughing and smiling as Spock tells Kirk he doesn't want to return to the ship.

The result was an episode that opened the door a crack to show Spock's emotional side and won Fontana her job on the writing staff, giving *STAR TREK* one of its most influential voices.

> "I have a responsibility to this ship, to that man on the bridge. I am what I am, Leila, and if there are self-made purgatories, then we all have to live in them. Mine can be no worse than someone else's."
>
> *Spock*

Time' when we'd seen Spock lose control of himself. "You had a hint of what was there, a hint of the agony that was buried deep underneath. Remember that Spock at this time of his life was approximately 36 years old, so he had all those years of conditioning as a Vulcan. 'The Naked Time' opened that gate a little bit, and I opened it wider in 'This Side of Paradise,' because it allowed not for the agony, but for some joy to come through."

Coon and Roddenberry were delighted with

Roddenberry, Coon, and D'Agosta cast Frank Overton as the colonists' leader, Elias Sandoval, and Jill Ireland as Leila Kalomi. (The name had survived from Sohl's earliest drafts, in which the character was Hawaiian and in love with Sulu.)

William Ware Theiss remembered that Ireland looked anxious when she came in for her costume fitting. It turned out she had seen Sherry Jackson's costume in 'What Are Little Girls Made Of?' – the top part consisted of little more than two straps. Theiss, however,

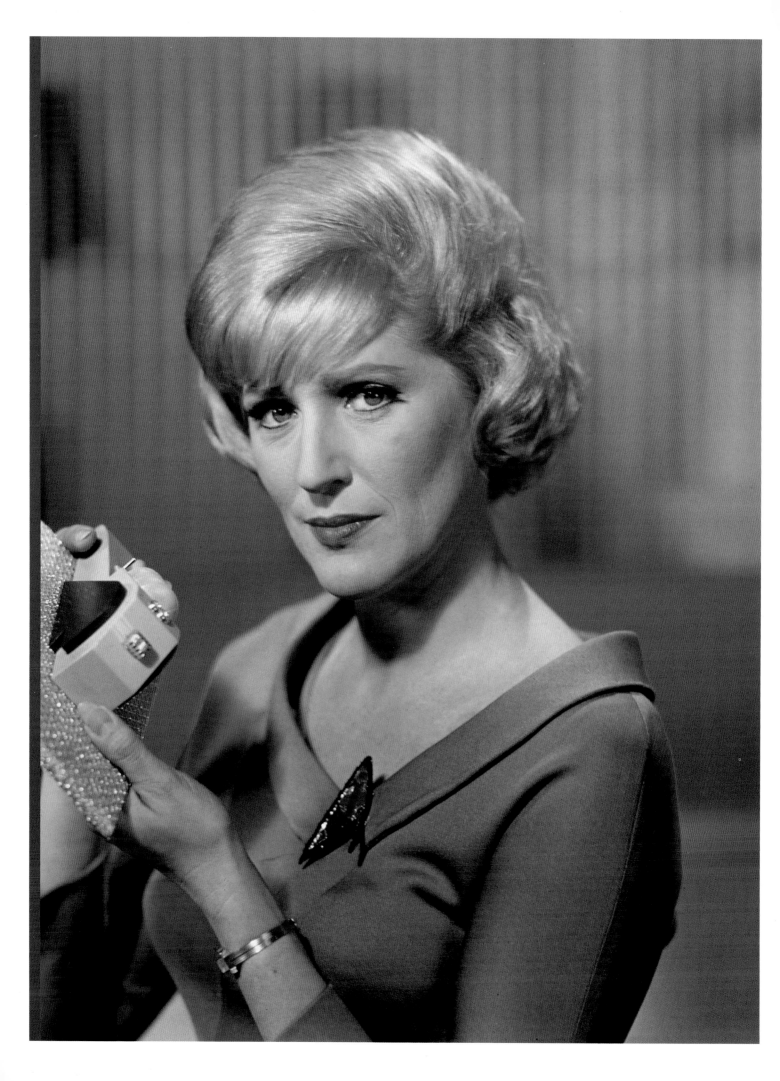

NURSE CHAPEL
THE LOYAL COMPANION

Nurse Chapel appeared in just under a third of *STAR TREK*'s episodes. She was a character marked out by her devotion to her fiancé Roger Korby and for being hopelessly in love with Mr. Spock.

I f Majel Barrett-Roddenberry were alive today, she'd probably suggest that, rather than scrutinizing this present chapter, you watch 'The Cage' and read the chapter in this book about Number One, the character that could have changed the face of science fiction and would have forever altered *STAR TREK*. But since you're here, let's delve into Christine Chapel, the character Barrett-Roddenberry eventually played in *STAR TREK* and in several of the feature films starring the original series cast. None of this is to be negative, but rather honest, like the whip-smart, no-nonsense actress, who passed away in 2008 at 76 years old.

Gene Roddenberry famously lost the battle to keep Number One aboard the *Enterprise* when NBC ordered a second pilot. Back in 1964, audiences "wouldn't tolerate a woman second-in-command of a starship because she'd be too unbelievable," Barrett-Roddenberry said. She was there, in Roddenberry's company because they were dating by then, and around the office at Desilu when the second pilot, 'Where No Man Has Gone Before,' and the subsequent series fell into place. He wanted her on the show. She wanted to be on the show. A

window opened and Barrett-Roddenberry ended up portraying Nurse Christine Chapel across 25 episodes of *STAR TREK*, first in 'The Naked Time,' when the character ached for Spock, and for the last time in the series finale, 'Turnabout Intruder.'

"I was watching each of the scripts coming in because I knew what I was going to do," Barrett-Roddenberry recalled. "They weren't going to keep me out of this thing. It wasn't until about the fifth or sixth script came in that there was a character by the name of Christine. Her name wasn't Chapel. It was something French [Christine Ducheaux]. I had just finished a play using the last name of Chapel, and I liked it so much. I thought, 'Christine Chapel, ah that sounds like Sistine Chapel. There's a little play on words.' When I found the script, it was going to be this doctor going out after her fiancé [Dr. Roger Korby, played by Michael Strong]. The rest of the story ('What Are Little Girls Made Of?') stayed the same.

"After you are canned from a part in a pilot, the network doesn't want to see you again," she continued. "I went and bleached my hair very, very blonde one morning, and I went over and sat in Gene's office talking to his secretary. He came in and nodded at Penny, his secretary, said 'Good morning,' and

walked into his office. I thought, 'Well, that didn't make much of an impression at all. I'm going to lose this battle.' He came out again, gave some papers to Penny, looked at me and nodded again, then turned and went back into his room. Then, the door opened. He said, 'Majel?!' I said, 'Gene, if I can fool you, I can fool NBC.' He said, 'You're right, obviously.' And we pulled it off. We did it. We called me M. Leigh Hudec, which is on 'The Cage' [and 'The Menagerie' two-parter] to this day."

Barrett-Roddenberry liked to say that for three seasons she played Chapel without NBC knowing she'd appeared in the pilot. That's up for debate. It's possible that NBC let it slide to appease Roddenberry. In his book, *Inside STAR TREK: The Real Story*, Desilu executive Herb Solow quoted Jerry Stanley, then NBC's manager of film program, as saying, "Well, well – look who's back." And Solow's coauthor and fellow *STAR TREK* pioneer Bob Justman told Roddenberry that he thought Barrett came across as "awkward," though he blamed the "ill-conceived character," rather than the actress herself. But Justman went on to compliment Barrett-Roddenberry on her recurring performances as Lwaxana Troi, Deanna Troi's "bold and lusty" mother, on *THE NEXT GENERATION* and again on *DEEP SPACE NINE*.

ABOVE: *Majel Barrett, as she then was, played Nurse Chapel and the Enterprise computer throughout the original series run. Barrett was in a relationship with Roddenberry, so would discuss the scripts with him as they came in. This was how she found the part of Christine Chapel, a character who was originally intended to appear in one episode.*

But back to Nurse Chapel. "She wasn't that interesting a character," conceded Barrett-Roddenberry – who also voiced the *Enterprise* computer. "I didn't care for her that much. She was a namby-pamby type of woman... she's a doctor to start, so to go out and find her fiancé, she has to take a demotion, probably as to rank and pay, because there's already a doctor aboard. And when she finds her fiancé, he turns out to be an android, so he's not going to do her much good. Then she signs on to a five-year [mission] with this ship, still with a reduction in rank and pay. This woman's not too smart... We played her out and everything, and there were some great moments, but

each time I used to think, 'Oh boy, if only Number One were here.'"

Nurse Chapel's limited screen time, as Barrett-Roddenberry noted, nevertheless led to several worthwhile moments for the character. She helped reeducate the mind-wiped Uhura in 'The Changeling,' rattled off the great line, "This won't hurt... much," to Chekov in 'The Deadly Years,' and promptly noticed – the first to do so – that the kids from the Starnes Exploration Party shed no tears over their dead parents in 'And the Children Shall Lead.' Chapel also often toiled alongside Dr. McCoy, capably assisting him in 'The Tholian Web,' 'For the World is Hollow and I Have Touched the Sky,' and 'Wink of an Eye,' among other episodes.

"They toyed with the Spock/Chapel relationship for a while," Barrett-Roddenberry observed, referring to such episodes as 'The Naked Time' and 'Amok Time' "Now that I'm producing shows, too, you don't tie up your top people with somebody else, because you know, out there in television land somewhere, somebody's going to think, 'Ah, now he was going with this girl before. Now look at that, he's two-timing her with this other girl...'" she said. "So, you stay away from that type of thing, [because] if they ever got together, there goes your story."

Barrett-Roddenberry later reprised her role as Chapel in *STAR TREK*: THE ANIMATED SERIES, for which she voiced several other characters; *STAR TREK: THE MOTION PICTURE*, with her character elevated to Dr. Chapel; and *STAR TREK IV: THE VOYAGE HOME*. But, as often seemed to happen with Barrett-Roddenberry, at least until Lwaxana Troi entered her *TREK* life, an opportunity passed her by. Chapel was set to be a major figure in *STAR TREK: PHASE II*, but this proved to be a roller-coaster ride that mutated into *THE MOTION PICTURE*.

"I had three different contracts, as did everyone else, and every single one... had to be paid off each time they changed

ABOVE: *Chapel is often associated with Spock, a character she was obviously harboring feelings for. Barrett-Roddenberry remembered that this came out of a story requirement in 'Amok Time,' when the writer needed to show that Spock was being violent and emotional.*

their minds," Barrett-Roddenberry recounted, laughing. "I was delighted they allowed Chapel to come back in. If it had gone as a television series, she would have improved because I was there and knew more about it, and Gene would have taken care of that, anyway. She was going to be a doctor. The ship got bigger, too, so there would have been more than one doctor.

"No sooner did we get going in one direction than a memo would come and they'd say, 'Stop. We're thinking of taking it in another direction. Instead of a series now, we're thinking of making four [telemovies] a year, and making them two hours apiece,'" she continued. "They put us under contract for that. On the next one, it was, 'No, we're going to go back and do a movie, perhaps a movie of the week.' It wasn't until 1977 or 1978 that they decided we're going to make a big-time movie."

STAR TREK has lived long and prospered, both in Barrett-Roddenberry's lifetime and now well beyond it. As late as 2008, Barrett-Roddenberry was providing the voice of the *Enterprise*'s computer. Her son, Eugene "Rod" Roddenberry, coexecutive produces *STAR TREK: DISCOVERY* and *STAR TREK: LOWER DECKS*, plus *STAR TREK: PICARD* and *STAR TREK: STRANGE NEW WORLDS*.

In 2001, Barrett-Roddenberry marveled at the franchise's longevity. "I cannot conceive of a phenomenon like this happening anywhere. It's kind of like having a miracle go on and on and on, where people see things that aren't really there, in religion and so forth, I think, 'Oh, my God, where did it come from? Will it ever go away?' I guess it's not going to go away. Of course, I'm delighted. My personal reaction is, 'Bring 'em on!'"

> *"This woman's not too smart... there were some great moments, but each time I used to think, 'Oh boy, if only Number One were here.'"*

■ Majel Barrett-Roddenberry

SEASON 1

EPISODE 28

AIR DATE: APRIL 6, 1967

Teleplay by Harlan Ellison

Directed by Joseph Pevney

Synopsis: McCoy goes back in time to Earth in 1930, where he saves pacifist Edith Keeler, altering history. Kirk and Spock follow McCoy through a portal, intent on restoring the timeline.

THE CITY ON THE EDGE OF FOREVER

'City' is consistently voted *STAR TREK*'s greatest episode. It combines high-concept science fiction with a heartbreaking decision that has a profound cost for Captain Kirk.

'The City on the Edge of Forever' stuns on every level, and understandably beat out four other classic *STAR TREK* episodes to win the 1968 Hugo Award for Best Dramatic Presentation. Harlan Ellison, who wanted to use a pseudonym for his teleplay screen credit, due to his long-running dissatisfaction with significant rewrites by Gene Roddenberry, Gene Coon, and Dorothy Fontana, won a Writers Guild of America Award in the Best Written Dramatic Episode category.

The story delivers everything *STAR TREK*

aspired to: a smart, time-jumping, science-fiction plot; an effective, heartbreaking development of the Kirk-Spock-McCoy bond;

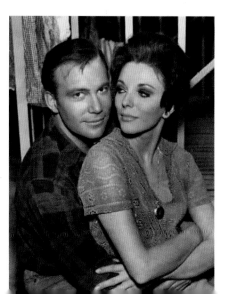

RIGHT: The producers were delighted they could get Joan Collins, who was a big star.

a star turn by Joan Collins as Edith Keeler; and inventive, atmospheric cinematography by Jerry Finnerman. Joseph Pevney's direction also nails the visual elements (especially the Guardian of Forever and the 1930s vibe) and elicits series-best performances from William Shatner, Leonard Nimoy, and DeForest Kelley.

Cameras began rolling on 'The City on the Edge of Forever' on February 3, 1967. The episode took seven-and-a-half days to shoot, a-day-and-a-half longer than usual, and cost $250,396.71, more than any STAR TREK episode. Set designer Matt Jefferies was sick at the time, so art director Rolland M. Brooks designed the Guardian of Forever. According to STAR TREK historians David Tilotta and Curt McAloney, the visual obscurity of the Guardian's time-travel doorway was achieved by means of tubes that pushed carbon-dioxide fog down its backside, and the Guardian's recaps of history were created in postproduction by matting black-and-white film and newsreel footage over the flowing fog footage.

Portions of the episode were shot on the famous 40 Acres backlot in Culver City. Look closely as Kirk and Keeler stroll by a barbershop. That was the Floyd's Barbershop storefront from The Andy Griffith Show, which also filmed at 40 Acres.

Bart LaRue, provided the sonorous voice of the Guardian and proved a go-to talent for STAR TREK. He'd already voiced Trelane's father for 'The Squire of Gothos' and went on to do the talking for Provider #1 in 'The Gamesters of Triskelion' and the Excalbian Yarnek in 'The Savage Curtain.' LaRue also appeared on-screen twice, playing announcers, naturally. He portrayed the Ekosian TV journalist in 'Patterns of Force' and a TV commentator in 'Bread and Circuses.' Decades after his death in 1990, the producers of STAR TREK: DISCOVERY resurrected his voice as the Guardian for the third-season episode, 'Terra Firma, Part 2.'

"Essentially, 'The City on the Edge of Forever' was a motion picture," director Joseph Pevney told Starlog's Edward Gross in 1988. "I treated it as a movie, as I did all television. It was a very honest episode and DeForest Kelley was so

good in it. It was a pleasure working with the actors. They realized their full potential in that one."

> **"For us, time does not exist. McCoy, back somewhere in the past, has effected a change in the course of time. All Earth history has been changed. There is no starship Enterprise. We have only one chance. We have asked the Guardian to show us Earth's history again. Spock and I will go back into time ourselves and attempt to set right whatever it was that McCoy changed."**
>
> *Captain's Log, no stardate*

Most polls and critics rate 'The City on the Edge of Forever' as STAR TREK's best episode. Ellison made his peace with it after publishing,

discovered his work as a result of STAR TREK, something that might not have happened had he gotten his way in 1967 and been credited as Cordwainer Bird.

"Sure, I'm pleased," he said in a 2013 interview. "Look, I have done everything I can do within human bounds to make the distinction between what aired and what I wrote. I did the book and people know the difference. So, having created the Guardian and having created that episode is a high water mark that I can [reach] when I'm good." In a fitting finale to the story, Ellison had his original vision realized in 2015, in the IDW graphic novel adaptation which he was involved in and very pleased with.

Ellison died in 2018 at the age of 84 and, as he predicted in that same 2013 talk, he worked – and stirred the pot – right up to his passing. "I will continue doing this until the road comes to an end and my feet go over the edge of the abyss and I go into whatever niche in posterity they have for me,"

ABOVE: The story ends with Kirk deciding that he must allow the woman he loves to die. This beat was introduced later. In Ellison's earliest drafts of the story, and Spock has to ensure that Edith Keeler dies.

in 1996, The City on the Edge of Forever: The Original Teleplay That Became the Classic Star Trek Episode. By then, he had realized that countless thousands of readers likely

he promised. "I made it into the Encyclopedia Britannica, right between Ralph Ellison and Ellis Island. That's pretty good for a poor little Jew from Long Island."

THE PHASER

STAR TREK's hand phasers were much more than simple guns.
They were carefully designed and thoroughly thought through.

Other TV shows had lasers, but Gene Roddenberry wanted to get it right. When he has developing *STAR TREK*, he sent the scripts to Harvey P. Lynn, a retired physicist from the Rand Corporation. Lynn suggested that in the future lasers would be old hat and that Roddenberry should think up a new, undefined technology. He suggested calling the weapons HEAT, ACE, BEE, or CLEB guns. Unsurprisingly, Roddenberry thought he'd better stick with lasers. But by the time they were filming the series, he decided that Lynn had been right after all and renamed the weapons "phasers." The idea was that phased energy would be more powerful and, since phaser was a made-up term, no one could criticize the show for being inaccurate.

Besides being renamed, the crew's hand weapons were redesigned. The original version had looked like a fairly conventional gun. In some episodes Roddenberry wanted a small unit that could be concealed in the crew's clothing, but in other cases he wanted an obvious weapon that the audience could see from a distance. So Matt Jefferies designed a new weapon that could be split into two parts, and his younger brother John drew up the plans.

In the new design, a small unit, known as the "Phaser I," slotted into the top of a gunlike structure to become the more powerful "Phaser II." The design also made a lot of sense. The Phaser II wasn't an independent weapon, but rather a kind of power pack. Although we never saw it on-screen, the handle

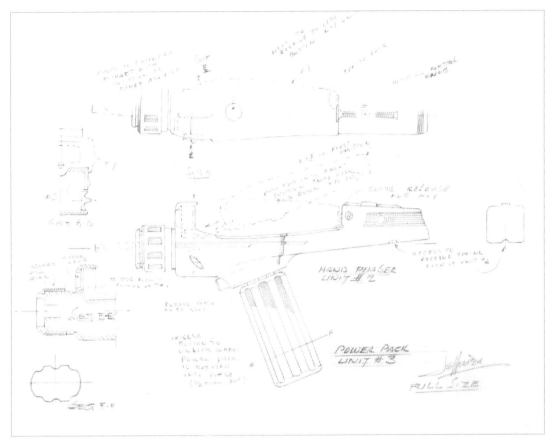

ABOVE: The Jefferies brothers' original drawings for the hand phaser show how it was made up of two independent units. One of Roddenberry's memos refers to an additional piece that would have turned it into a rifle, but this was never built.

was a "battery" that could be removed and replaced by twisting it. There were two different designs of handle: one was exactly like the drawings; the other had a more angular cross section.

Jefferies wanted to give the actors something they could do, so he built various moving parts into his design. The smaller version had two wheels on the top, with the one on the right used to alter the settings. Eagle-eyed viewers will have noticed that when a phaser was set to stun, it produced a blue beam and when it was turned up to kill or disintegrate, the beam turned red. In 'The Enemy Within,' we learned that a phaser could also be set to heat, and in 'The Conscience of the King,' we discovered that it could be set to overload, turning it into an explosive that could "take out an entire deck." The wheel on the left moved the sighting grid up and down, and the phaser could be fired using a button on the underside.

On the larger Phaser II, the barrel could be twisted to adjust the width of the beam. On the left of the unit was a mysterious control that we never saw in use, while more controls at the back could release the smaller unit and supposedly adjust the

power settings. This bigger version of the phaser was fired by pressing a button at the top of the handle.

A fully tricked-out phaser was an expensive thing, so the art department only made four. These hero props were detailed enough to be shown up close. Both sizes of phaser housed batteries and lit up when the user wanted to "fire" them. The beams, of course, had to be added in postproduction by the special effects team. The look of the phasers changed subtly over the lifetime of the series. The earliest versions were completely black, so during the first season Roddenberry had prop designer Wah Chang refurbish them. This resulted in the familiar three-colored version: a black Phaser I, a mid-gray body, and a dark handle.

During the first season, extra plastic and rubber versions of the Phaser II were made for background use. These were later supplemented with improved "mid-grade" phasers made of fiberglass. These were better than the stunt phasers but not on a par with the hero versions. After the show, the various phasers were thrown away or auctioned off.

LIFE AT
DESILU

At Desilu's studios saving the Galaxy, tricking the Russians,
and catching criminals was all in a day's work.

If you arrived at Desilu's Gower Street studios in the middle of the morning, you might have thought the place was deserted. The soundstage doors were all closed and the streets were empty. You might have seen some apprentices carrying cans of film across the lot or actors heading to casting, but that was all. Then at lunchtime, the stage doors would open and people would flood out into the California sunlight. The actors were all in costume, so you'd see aliens and spies and gangsters and even cowboys chatting with one another as they headed to the studio cafeteria.

When *STAR TREK* went into production in 1966, Desilu's Gower Street studios were very much Lucille Ball's empire. The lot where the series was made was the old RKO studios where they had filmed scenes for *King Kong* and *Citizen Kane*. It consisted of 14 soundstages, several of which could be opened up to make even larger spaces.

The lot was on the corner of Gower and Melrose, immediately to the west of Paramount's studios, with only a fence separating the two companies. Lucy and her husband Desi had bought Gower Street in 1957, flush with the money that *I Love Lucy* generated. As well as filming Lucy's sitcoms and

The Untouchables, they rented space out to other productions, including *My Favorite Martian.*

In 1964, they brought in Herb Solow to head up new production. Two years later, Desilu sold *Mission: Impossible* to CBS and *STAR TREK* to NBC. The shows were in production literally alongside one another. Their writers shared a building, with *STAR TREK* on the ground floor and *Mission* on the first. The next year they were joined by *Mannix*. That wasn't everything though. *I, Spy* was filmed on the same lot, which also housed special effects companies Howard Anderson and Linwood Dunn's Film Effects of Hollywood, both of which worked on *STAR TREK*.

The working day on *STAR TREK* was long. The makeup team would open up at 6am, with Leonard Nimoy first in Fred Phillips' chair. William Shatner would arrive a little later, often riding in on his motorbike. As he took his place in Phillips' chair, costumes would be given last-minute adjustments before everyone was called to the set at 8am. The actors rehearsed with the director, while lighting cameraman Jerry Finnerman lit the sets. If they were on the bridge, the entire cast would be assembled, but on most days Shatner, Nimoy, and Kelley were

ABOVE: *Filming* STAR TREK *was always challenging. The schedules were short and the budgets tight, but the crews were professsional and efficient and everyone knew what they were doing.*

working with the guest cast. Meanwhile, on *STAR TREK*'s other stage, Matt Jefferies' construction team would be building something new, perhaps an alien world or a futuristic city. At lunchtime, the producers would gather to look at the previous day's footage in one of Desilu's projection rooms, with Bob Justman checking that everything was on schedule.

The atmosphere on set was friendly and professional. Shatner, in particular, was known to be a joker and would often crack up during filming. Particularly in the first two seasons, everyone describes Desilu as being like a family where everyone knew that their bosses would back them. Roddenberry was fond of practical jokes and was a fan of throwing birthday parties.

After Lucy sold the studio to Gulf+ Western in 1968, the old guard faded away. Those who stayed behind often felt it was a harder era, but for the most part people were happy to be working on a network TV show and knew what a rare privilege it was.

While the actors were filming, Joe D'Agosta, Desilu's head of casting, would be calling people in and having them read for the next episode. As soon as actors were cast, they headed over

to see William Ware Theiss, who would quickly fit them for the costumes he had already designed. Once the guest stars were in their outfits, he'd walk them in front of Gene Roddenberry, who would almost invariably adjust the costumes.

In the editing rooms, three teams would be cutting different episodes of *STAR TREK*, perhaps taking a visit from the episode's director, while another episode was being shown to the producers in one of the projection rooms.

Thanks to union agreements, the day would wrap at 6.12pm. The actors would get out of their costumes and head home. But the work was far from over. Every night, the costumes were sent to be dry cleaned, a process that involved removing any rank insignia and badges, which would have to be sewn back on every morning. After a full day's work, the actors might have a new script to learn for the next week's episode. Every third or fourth day, the camera crew would move their kit to the other stage overnight so that no filming time would be lost in the morning. The writers continued working on scripts, and when he got home, Phillips would pour latex into the molds he kept in his house and bake a new pair of ears for Spock before heading off to bed.

RICARDO MONTALBAN

THE SUPERHUMAN

"**M**y career," Ricardo Montalban said in 1996, "has been... 'Ask not what the role can do for you, but what you can do for the role.'" What a career it was, and what roles he played. Born in Mexico in 1920, Montalban acted on stage and television and in films from the early 1940s until his death in 2009 at the age of 88, amassing more than 200 credits, winning an Emmy, and earning a Tony nomination. He tackled heroes and villains, leads and supporting parts, and men of every and any descent: Cuban, Native American, Argentinian, Italian, Brazilian, French, German, and Greek. As a result of his talent, the refined manner in which he carried himself, and his longevity in the business, Montalban paved the way for many a Latino who followed in his formidable footsteps. Along the way, he breathed vivid life into three indelible characters.

Montalban, to younger audiences, remains beloved as Valentin Avellán/Grandfather in the *Spy Kids* franchise. He spent seven seasons on the television show, *Fantasy Island*, starring as Mr. Roarke. And he stole the show, not once, but twice in the *STAR TREK* universe, first when he portrayed Khan Noonien Singh in the original series episode, 'Space Seed,' and 16 years later, when he reprised the role in *STAR TREK II: THE WRATH OF KHAN*.

"I don't know how I was cast (in 'Space Seed'), except at that time they knew that I had a fairly good physique," Montalban told the Archive of American Television in a touch of epic understatement. "I had been working with weights and everything, and I had big pectorals and good arms and so forth. And perhaps they thought they needed someone young, which I was then, who was in good shape, because he was playing a superman. It had to be a man who had proven he could act, but also that he could have a bare chest and you'd believe he's a super-man. And I believe that's how I was cast. It being Khan, there was no nationality. The accent could be any accent."

The first-season episode introduced Khan, a powerful, authoritarian figure who was genetically engineered and who, from 1992 to 1996, ruled more than a quarter of Earth – and conspired to control the rest of it. Finally overthrown, Khan, with more than 100 followers, escaped on a sleeper ship, the *Botany Bay*, to be discovered in 2267 by the *Enterprise* and its crew.

"When I first played Khan (on television) I really enjoyed it," Montalban told the New York Times Syndicate. "The show was treated with all seriousness by everyone and that spirit got to me... It was a very happy company and everybody was very cordial, very nice. All the regulars were wonderful to me, most helpful, and I loved it." Speaking to *Starlog*, he said, "I

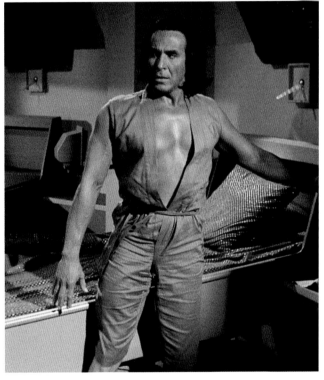

ABOVE: Ricardo Montalban as Khan in 'Space Seed.' Montalban had worked with Roddenberry before and the producers were delighted to cast someone who had starred in movies and who had the presence to go toe-to-toe with Captain Kirk.

thought the character of Khan was wonderful. I thought it was well written, it had an interesting concept, and I was delighted it was offered to me."

THE WRATH OF KHAN fell into place when writer-producer Harve Bennett screened episodes of the show and chose to craft the movie as a sequel to 'Space Seed.' Montalban, then in his sixth year playing the self-possessed, nearly emotionless Mr. Roarke on *Fantasy Island*, itched for a fresh challenge. "I was dying to do something other than Mr. Roarke," he told the New York Times Syndicate. "It was wonderful, because Khan had become so passionate and consumed with avenging his wife's death by getting Kirk." Scheduling issues almost put a stop to Montalban's participation on the movie, but the powers that be worked it out. Montalban then watched 'Space Seed' numerous times, and found his way back into the character.

"Khan was an overly ambitious man that had dimension," the actor told *Starlog*. "Sometimes when you read a villain, he's a villain through and through. But this man had facets. He was genetically engineered with mental and physical superiority, and it's only natural that he uses that superiority and wants to conquer. On the other hand, he falls in love. He takes his girl as his wife when he goes into exile. It was a love that was very real. It humanized the character for me. The dialogue was written interestingly. It fit the character."

Post-*STAR TREK*, Montalban kept working, adding dozens of credits to his resume despite crippling spinal issues that forced him to use a wheelchair. "I don't believe in retiring," he told *Starlog*. "There is a Spanish philosopher who said, 'Rest is not doing nothing. Doing nothing is death. Rest is a change of activity.' Action, be active; that's the thing."

DESIGNING THE
SHIP
INSIDE AND OUT

A NEW KIND OF STARSHIP

T here'd be no boldly going in *STAR TREK* if not for the *Enterprise*, and there'd be no *Enterprise* if not for Walter M. Jefferies. Better known as Matt, he designed pop culture's arguably most iconic fictional starship, and he did so based on the vaguest of instructions from *STAR TREK* creator Gene Roddenberry.

"Gene told me what he wanted," recalled Jefferies (who also designed the *Enterprise* bridge and other interior aspects, the Klingon battlecruiser, and the first handheld phaser), during an interview in 2001. "Actually, about all he said that would help me along was several 'Don'ts'… such as no flames, no fins, no rockets. The one 'Do' was make it look like it's got power. And he walked out."

ABOVE: Roddenberry was very clear about what he didn't want (no flames or flying saucers), so Jefferies began the process by looking for unfamiliar shapes. Even at this early stage, he started to think about how the engines could be kept away from the habitable areas.

ABOVE: One of the most promising designs involved a massive engine ring, with the habitable part of the ship on a spar that ran through the middle of it.

The year was 1964. Jefferies, then in his early 40s, had worked as an art director and production designer on such films and television series as *Bombers B-52, The Untouchables,* and *Ben Casey*. He and Roddenberry, upon making first contact to discuss *STAR TREK*, hit it off immediately, discovering that they'd both fought in World War II and shared a love of airplanes. Faced with a blank page, a tight deadline, and Roddenberry's minimal directives, Jefferies set to work.

Other than a quick decision to take a "practical" approach, Jefferies didn't know how to proceed. The ship needed to be on "the cutting edge of the future," which meant beginning with a basic shape, though that eluded him, too, at least initially. Roddenberry's edict that *STAR TREK*'s central vehicle not resemble a 1960s rocket provided some clarity, as did Jefferies' awareness that Roddenberry fancied the futurist space ships that he'd glimpsed on the covers of pulp science-fiction magazines. So, in addition to "no fins, flames, or rockets," Roddenberry also banned wings and smoke trails.

"Gene described the 100-150-man crew, outer space, fantastic, unheard-of speed, and that we didn't have to worry about gravity," Jefferies said. "To show the fantastic speeds he was talking about on air, I knew we were just going to have flash cuts. You cannot sell speed by holding a vehicle, automobile, airplane, or whatever and moving the background. It just doesn't work. It's going to have to come from infinity to you or the other way. So, I wanted to keep it very simple, but immediately identifiable – a shape that you could instantly pick out."

Jefferies admitted to "floundering" for a while. He drew countless sketches, with Roddenberry liking a little of this one and a bit of that one, but nixing other elements. Jefferies then combined the components that piqued Roddenberry's interest. He also began to incorporate snippets of design elements used in actual ships.

"I did have a lot of material from NASA – work that they were doing and I was a member of the Aviation Space Writers' Association and active as a consultant with the Air Force Museum in Dayton, so I had a source for a lot of what was being thought about," Jefferies explained. "Over a period of about three weeks I was getting more frustrated all the time, but finally I came up with something I thought had possibilities. My thinking was, because of the ship's speed there had to be terrifically powerful engines. They might be dangerous as all get-out to be around, so maybe we'd better put them out of the way somewhere, which would also make them what, in aviation circles, we call the QCU – a Quick Change Unit – where you could easily take one off and put another on.

"Then for the hull, I didn't really want a saucer because of the term 'flying saucer.' The best pressure vessel, of course, is a ball," he said. "So, I started playing with that. But the bulk got in the way and the ball just didn't work. I flattened it out and I guess we wound up with a saucer! I did it in color on black matte board, and by the time I finished I thought we really had something."

Excited at the breakthrough, Jefferies raced over to the studio mill, where his associates crafted the lower hull and dish out of balsa wood. They offered to fashion the engine pods as soon as lathes in use became available, but Jefferies suggested a shortcut: find some birch dowel, assemble it all together, and run a string through a hook up top of what was finally taking shape as the *Enterprise*. Soon, Roddenberry arrived, accompanied by several NBC executives.

"I think there were about eight of them," Jefferies recalled. "They did navigate to the color piece, and I said, 'Well, if you like that, how about the model?' and held it up. Gene took it by the string and immediately it flopped over, because the birch dowels were heavier! I had an awful time trying to un-sell that. And, of course, when our first show hit the air and *TV Guide* came out, they ran a picture of the ship, upside down."

Once everyone signed off on the ship's shape, that rudimentary version of the *Enterprise* then required fine-tuning. What color would it be? White made sense for a variety of reasons, but it wasn't a *fait accompli*. How about the ship's registry number? Jefferies found himself protective of the model, battling with those who sought to add surface details.

"I thought the atmosphere, or lack of it out there in space, might produce different colors, and this gave us a chance to be able to play with light and to throw color on it," he noted. "And I wanted a very simple number that could be spotted quickly. You'd have to eliminate 3, 6, 8, and 9, so I just went for 1701, which, incidentally and coincidentally, happens to be very close to the license number on my airplane – 17701. But I have never really stepped out and squashed the rumor that the number on the *Enterprise* came off my airplane."

Roddenberry also called upon Jefferies to devise the bridge. Again, he took a practical approach to the challenge. He knew from time spent in B-25s, B-24s, and B-17s during World War II that anytime a fresh piece of equipment rolled off the assembly line, it'd be placed somewhere on the plane that would inevitably result in someone bashing his skull on it. That was not about to happen on an *Enterprise* of his design.

"I thought that was kind of dumb," he argued. "So we pushed a chair up against the wall, and my kid brother [John Jefferies], my chief draftsman, drew a line so that when you were sitting, regardless of where you looked, everything had to be at right angles to the eyes and everything was reachable. That's the way we designed the shape of the [bridge] section."

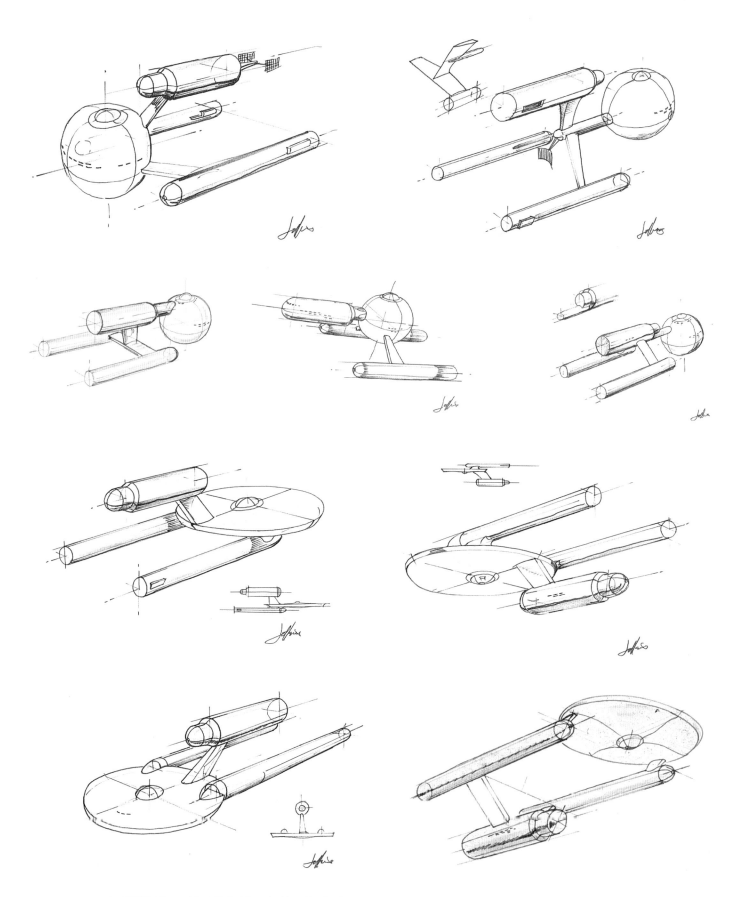

ABOVE: *After a while, Jefferies hit on the idea of having three tubular sections that were connected to one another and a sphere, which he felt was the logical shape for the habitable area. But the sphere was an awkward shape so he flattened it into a saucer.*

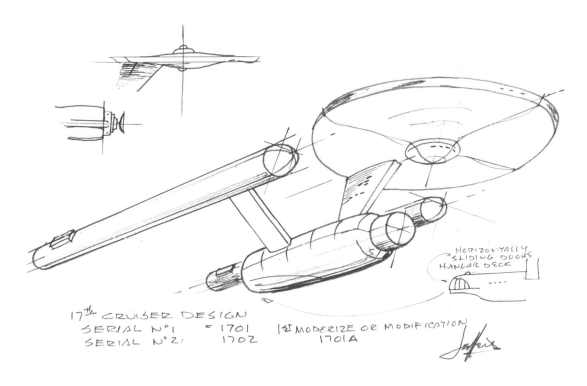

17ᵗʰ CRUISER DESIGN
SERIAL Nº1 = 1701 1ˢᵗ MODERIZE OR MODIFICATION
SERIAL Nº2/ 1702 1701A

ABOVE: *Jefferies finally had the elements he wanted in the layout he wanted. He picked numbers that would be easy to read for the registry number, and then rationalized that this was the first model to be made.*

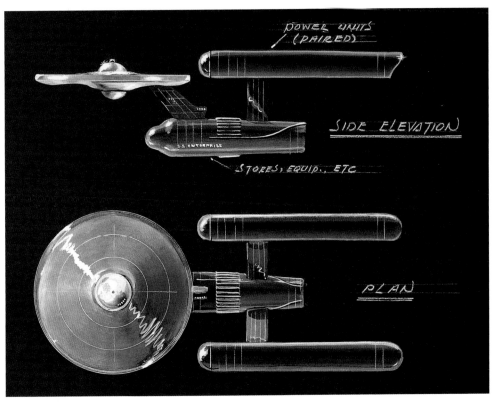

ABOVE: *Once Jefferies was happy with the design he produced this color illustration on black Bristol board.*

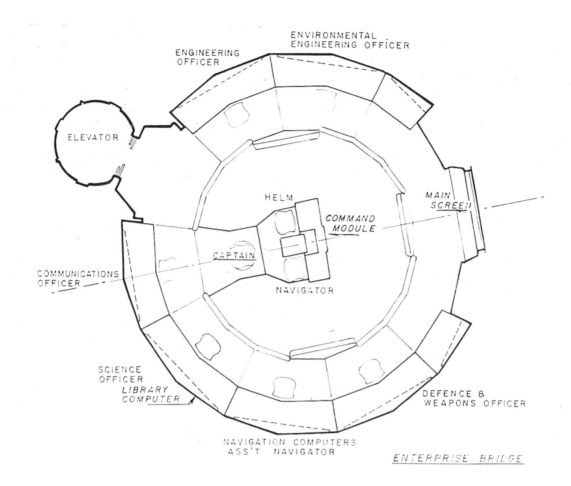

ENGINEERING
OFFICER

ENVIRONMENTAL
ENGINEERING OFFICER

ELEVATOR

HELM

COMMAND
MODULE

MAIN
SCREEN

CAPTAIN

NAVIGATOR

COMMUNICATIONS
OFFICER

SCIENCE
OFFICER
LIBRARY
COMPUTER

DEFENCE &
WEAPONS OFFICER

NAVIGATION COMPUTERS
ASS'T NAVIGATOR

ENTERPRISE BRIDGE

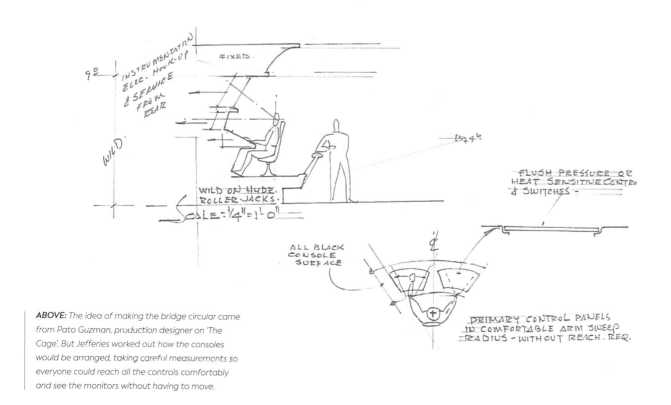

9°

INSTRUMENTATION
ELEC. HOOK-UP
& SERVICE
FROM
REAR

FIXED.

WILD

WILD ON HYDR.
ROLLER JACKS.
SCALE: 1/4" = 1'-0"

FLUSH PRESSURE OR
HEAT SENSITIVE CONTROL
& SWITCHES -

ALL BLACK
CONSOLE
SURFACE

PRIMARY CONTROL PANELS
IN COMFORTABLE ARM SWEEP
RADIUS - WITHOUT REACH. REQ.

ABOVE: The idea of making the bridge circular came from Pato Guzman, production designer on 'The Cage'. But Jefferies worked out how the consoles would be arranged, taking careful measurements so everyone could reach all the controls comfortably and see the monitors without having to move.

And that is where Jefferies' responsibilities ended, at least on the first pilot, 'The Cage.' Everything else – planet sets, devices, etc. – was the domain of "old-time" art director Franz Bachelin and his associate, Pato Guzman. "I went up as acting art director, and we shot the second pilot," Jefferies recalled. "Right after that, I did the pilot for *Mission: Impossible* and then a little Western, one right after the other. Then they loaned me over to Disney to do a staircase for *The Happiest Millionaire.* When I got back and the boss said, 'OK, you're on *STAR TREK*,' I was pleased, and about half-scared."

Jefferies had every reason to be half-scared, or more. He stayed with *STAR TREK* for all three seasons, through the departures of Roddenberry and other key executives, through the tumult of Desilu's purchase by Gulf+Western/Paramount, and through a series of budget cuts that would test the mettle of Jefferies and his crew on a daily basis. He designed the *Enterprise*'s interiors as they came to be revealed, such as the engineering room, first seen in 'The Enemy Within,' along with every other set ever seen on-screen during the show's run.

Many of them were ingenious, allowing for forced perspective shots that convinced viewers they were aboard a massive starship. Sickbay was, is, and will always be a marvel of creativity, practicality, and futurism, particularly the monitors and electronic displays above each bed – and no one ever hit their head on them.

"The panel that we had over the beds in sickbay became a real monster," Jefferies remembered. "Again we were trying to have something that seemed as though it was progressing, so we worked out a thing with a needle that would run up and down a scale. It was a fairly big, bright arrow, which we had to put on 35mm film with sprockets so that Jimmy Rugg's effects people could wind it up and down. To do it cheap, there wasn't any other way."

Jefferies was still smiling decades after the fact, as he recounted how the exercise equipment that he jerry-rigged for 'The Corbomite Maneuver' flummoxed William Shatner. "Captain Kirk was taking a physical in Dr. McCoy's office, and Bill couldn't figure out how that little, short, four-foot exam table was sufficient. We said, 'Well, get your fanny up against the wall and put your feet up, there, Billy.' And I showed him the two handles and said, 'You'll have to hold on to these.' Then, we tripped a lever and it tilted down 30 degrees. He's got to hold on or he's going to slide off on his head. The muscles are really working. And I said, 'Now pump those foot pedals,' and one rehearsal Billy was soaking wet with perspiration. I don't think he's forgiven me for that!"

The cylindrical spaces in which Scotty and other characters occasionally saved the day – and which were later dubbed

THE INFINITE CORRIDOR

Lack of studio space often called for the use of some clever tricks to imply distance. "We needed something that looked a hell of a lot bigger, and we just didn't have room for it," recalled Jefferies, whose solution, in the case of the corridors, was to construct them on a curve. This meant that you could never see the end of the corridor, implying that it could go on forever and that it was part of a curved saucer section. Jefferies designed the main corridor to run around a 90-degree curve from one side of the soundstage to the back of it. He then built various spars that came off it, so characters could turn a corner to go further into the ship. In reality, the doors off the main corridor led to sickbay, the crew quarters (which were most often dressed for Captain Kirk), the brig, the rec room, and a turbolift. The labels by the doors could be changed to show that they opened into different locations, which could be built on the same stage as needed (but not necessarily behind the same door). The shorter corridors that ran off it led to main engineering and the transporter room.

SICK·BAY·EXAM·RM·/

LEFT: Sickbay was designed to create motion wherever possible. The short bed by the door had pedals above it that could be used during medical exams, and the diagnostic biobed could be tilted up and down. Jefferies said that since sickbay didn't feature in that many episodes, it was often folded up so the space could be used for other sets.

Jefferies tubes in canon – helped directors heighten scene tension exponentially.

"Who thought that the thing had to have a name?" he shook his head. "It was a three-foot diameter, solid cardboard tube, used for forms around steel girders when they poured concrete in the supports for freeways, and the steps up the center are so you could have something to push on to back up the thing. We cut a slot where we could throw sparks or light at it, and put a form in front to hide the source of it. Then we took a four-foot wall unit and cut a hole in it, which became an oval since it was angled, and scabbed that on there. I think we probably did the whole thing in a day. The whole [construction] was on rollers so we could push it anywhere in the corridor sections where the company happened to be."

"Necessity made Matt Jefferies the absolute mother of *STAR TREK* invention," Herb Solow wrote in *Inside STAR TREK: The Real Story*. His coauthor, Bob Justman, was more effusive. "Matt Jefferies was the most decent and devoted human being on the production team," Justman stated. "He never lost his cool, never lost his temper. His eyes got watery and he would find it difficult to speak when an over-budget show forced me to take away half his construction money. And

CAPT·KIRK'S QTRS.

RIGHT: There was only one set for the crew quarters, which were divided into working and sleeping areas. The set could be redressed depending on whose room the episode needed to show.

I'd demand the impossible, that he still provide us with believable sets for less money than it should cost... So, Matt would try harder, and he always came through for us."

"The show as a whole was a lot of fun," Jefferies added. "I envy the ones that have been working on the show since my time, when I look at the staff they've got, and the budget, and the time. I'd love the materials they've got today, and the electronic capabilities. I would have loved to have had time to do that kind of thing."

Matt Jefferies passed away on July 21, 2003, at the age of 81. He left behind an extraordinary legacy; his design for the *Enterprise* provided the basis for dozens of ships and his sets established a style that was unmistakeably *STAR TREK*. He was always amazed at the reception his work got. As far as he was concerned, it was "just another job," and he couldn't see what the fuss was about. But his designs were truly iconic and he will always be remembered as the man who designed the *Enterprise*.

RIGHT: *Main engineering got a major upgrade at the beginning of the second season, with Jefferies adding large units in the middle of the floor and a mezzanine level. The engines behind the large mesh screen used forced perspective so they looked bigger than they were.*

THE ULTIMATE ACCOLADE

Jefferies and his *Enterprise* bridge design won the ultimate accolade when the U.S. Navy expressed an interest in his work – and then put it to use in a real-world situation. "Gene (Roddenberry) called me one day and said there were some Navy officers that wanted information on the bridge and why we did it the way we did," Jefferies recalled. "So, they came in... a commander and a lieutenant, senior grade, and we treated them to lunch, and then I showed them the drawing and pulled the blueprints for them. And they got to look at the bridge itself. We got a nice letter the following week thanking us.

"About a year later, another thank-you letter [arrived], saying that the information had led to the design of the new master communications center at NAS [Naval Air Station] San Diego," he continued. "They would like to invite me down to see it, but unfortunately it was classified. I didn't bother to tell them that I still had an ultra-top-secret clearance from work that I had done when I was in Washington before coming out here!"

JOAN COLLINS

KIRK'S TRUE LOVE

R aise your hand if you cried like a baby when Edith Keeler died in 'The City on the Edge of Forever.' We see you, and you... and you, too. Keeler's abrupt, cruel, avoidable, but necessary demise brought tears to the eyes of *STAR TREK* fans everywhere, and the ensuing scene, in which Spock intones, "He knows, doctor. He knows" to Bones after Kirk lets a truck strike Keeler, remains one of the most gut-wrenching moments in all of *STAR TREK*. Joan Collins delivered such a beautiful, nuanced performance as Keeler and shared such palpable chemistry with William Shatner, DeForest Kelley, and Leonard Nimoy – but especially Shatner – that it's hard to believe the raven-haired British actress gained her greatest measure of mainstream fame for embodying vixens and ice queens.

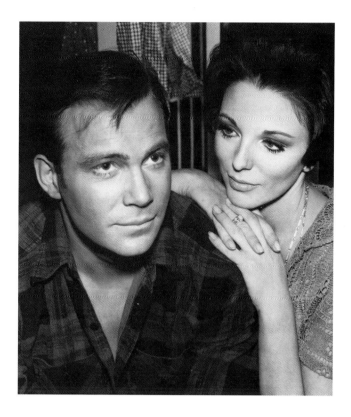

LEFT: *Joan Collins as Edith Keeler in 'The City on the Edge of Forever.' Casting Collins was a coup for the producers, since she had already appeared in several movies, and Edith Keeler would prove to be one of* STAR TREK's *best roles.*

Collins knew nothing about *STAR TREK* when her agent called to discuss the possibility of her guest starring in the show. In fact, she'd never heard of it. Fortunately, her children, Tara and Alexander, who were four and two at the time, respectively, implored her to sign on. "My daughter jumped up and down and said, 'Oh, Mum, you must do it. It's a great show,'" she recalls. "So, that's why I did it."

Even today, though Collins understands and appreciates the fan love for Keeler, the performance and the episode as a whole, she doesn't buy the hype. The grand notion that this wise, big-hearted pacifist must die in order to save millions? "I really didn't think about it very much," she admits. "I just read the script and I thought the script was very good. And I thought it was an interesting premise that this woman could have prevented a world war. So, I just went ahead and did it."

Shooting the episode over four days alongside Shatner, Nimoy and Kelley? "It was fun," she replies. "I did get to know Bill a little bit. We cross paths once in a while, still. Years ago, at my first [*STAR TREK*] convention, he introduced me [to the crowd]... As far as I was concerned, I was starting to do lots of television at that time. I did *The Man from U.N.C.L.E.* I did *The Virginian*. So, [*STAR TREK*] really was just another gig."

Now in her late 80s, Collins remains active on almost too many fronts to count. She's actually Dame Joan now, since in 2015, Her Majesty Queen Elizabeth II elevated Collins to Dame Commander of the British Empire (DBE) for her lifetime contribution to charity work. Collins continues to act; has penned several memoirs, including 2021's *The Uncensored & Unapologetic Diaries of Joan Collins*, and novels; lends her star power and time to a variety of charitable organizations; and toured as recently as 2019 with a one-woman theatrical show called *Joan Collins Unscripted*.

Collins has even attended a few recent *STAR TREK* conventions and autograph shows, and come around to embrace – at least a bit – the reality that 'The City on the Edge of Forever' is a fan favorite that will resonate, well, forever... in large part thanks to her heartbreaking performance. "I didn't even have a clue at the time that we'd made a memorable episode," Collins says. "It was not until several years later. I am pleased. It's nice."

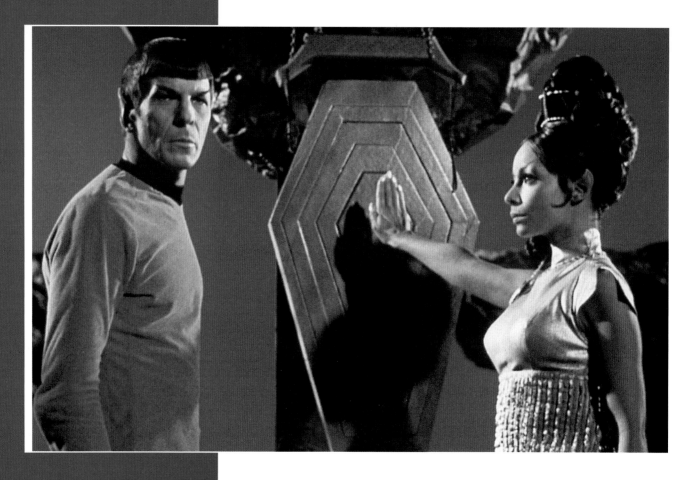

SEASON 2

EPISODE 1

AIR DATE: SEPTEMBER 15, 1967

Written by Theodore Sturgeon

Directed by Joseph Pevney

Synopsis Spock enters the *Pon farr*, a state that will kill him unless he returns to Vulcan and takes a mate.

AMOK TIME

When Spock has to return to Vulcan, we learn just how alien he is. We meet his "wife," learn how Vulcans greet one another and discover that the Vulcans can still be savage.

Everyone wanted to know more about Vulcans. Spock was *STAR TREK*'s breakout character and his alien nature had raised all sorts of questions. Toward the end of the first season, Theodore Sturgeon started work on a story that would take us to Vulcan for the first time and reveal how alien Spock really was. History doesn't record who came up with the idea that Spock's alien nature would force him to return to Vulcan and take a mate every seven years, "not unlike the Earth salmon," but the idea is there from the beginning of Sturgeon's outlines. In those early versions of the story, McCoy examines Spock, who has been behaving strangely and realizes what is happening. Although Vulcans are secretive,

RIGHT: William Shatner poses with a Vulcan lirpa. The story always called for Kirk to fight Spock and appear to die, but he wasn't always aware of the deception that kept him alive.

the Doctor already knows about *Pon farr,* and dodging around the ethics of patient confidentiality, he persuades Kirk to change course and take the ship to Vulcan. When they beam down to the surface, they take Spock to a sacred area of the planet – "a wild and deserted place" where Spock's "bride" T'Pring is hiding among the rocks. At this early stage, T'Pring was the only Vulcan, apart from Spock, that we would see. In Sturgeon's outline, she is rebelling against Vulcan customs and has fallen in love with another man. She stills invokes the ritual combat and still pits Kirk against Spock. But when the fight is over, she is so impressed by Spock that she offers to become his wife.

Sturgeon's outline was enthusiastically received, with everyone feeling that it could be one of the series' best episodes. At NBC, Stan Robertson's immediate response was that he wanted to see more of the planet Vulcan, and this led to the addition of a "marriage" party led by T'Pau.

But Sturgeon had limited experience In writing for television and was not fast. As the end of the first year approached, he was still working on the script, so the decision was made to hold it over to the next season. The script Sturgeon eventually turned in was given a polish by Dorothy Fontana. In this case, she remembered the assignment only involved relatively small changes. "Television and motion pictures are a 'show, don't tell' medium," Fontana explained. "Sturgeon was very experienced, of course, as a prose writer and hadn't done all that much in the visual medium. The initial scenes, where Spock is first starting to show his descent into the *Pon farr,* Sturgeon wrote as McCoy coming up to Captain Kirk and saying, 'You should have seen what just happened with Spock. He did this and he did that.' So, what I did was take it and change it so you see the soup dish coming flying out, and all this anger."

Sturgeon's script had a young yeoman called Maggie trying to help Spock and "mooning" over him. Fontana replaced this unfamiliar character with Nurse Chapel, reinforcing the idea that Chapel had feelings for Spock.

The budget wouldn't allow the STAR TREK team to show much of the planet Vulcan. Roddenberry had suggested making it a

"hot and arid place," because it was easy to find these kind of locations, but in the end the decision was made to film everything on Stage 10, where they could create the Vulcan arena and give the planet a red sky. "We realized we couldn't show a lot of Vulcan," Fontana said. "One of the stipulations for

ABOVE: Leonard Nimoy and Arlene Martel (T'Pring) study their lines on the set of 'Amok Time.'

the script was that it be in a relatively tight area, so that we just get a flavor, a feeling. So you have the ceremonial arena, the temple bits, and so on." The art department's Matt Jefferies told *Inside STAR TREK* that it was a difficult episode to visualize. "What we came up with is actually quite simple in appearance, but straightforward. It looked like something carved from the rim of an extinct volcano. As

Spock himself might say, 'It's extremely logical.'"

The guest cast included Arlene Martel, Lawrence Montaigne, and Celia Lovsky as the

> **" Stonn. She is yours. After a time, you may find that having is not so pleasing a thing after all as wanting. It is not logical, but it is often true."**
> **Spock speaking to Stonn**

Vulcan matriarch, T'Pau. Nimoy and director Joe Pevney came up with the idea that Vulcans would have a special way of greeting one another. Nimoy had always been fascinated with hands, and suggested that they use a symbol that Hebrew priests ("Kohen") made by separating their fingers in the middle to make a V shape. The Vulcan salute was born. Unfortunately, Lovsky couldn't do it, and had to force her fingers apart off-screen before holding her hand up with them already in position. The script also contained the Vulcan greeting "Live long and prosper," a phrase that made its debut here before becoming an essential part of STAR TREK lore.

Pevney felt the fight sequence between Kirk and Spock was one of the best they ever staged. When the episode was edited together, that fight saw the introduction of one of STAR TREK's most famous music cues, which was written by Gerald Fried.

Once the battle is over, T'Pring explains her logic, which Spock finds faultless. This was something that Fontana said she added to the script, because she wanted to give T'Pring a greater sense of logic and agency. Spock's response – that sometimes having is not so pleasing as wanting – was nearly dropped, until Sturgeon, who was particularly proud of the line, saw an early cut and insisted that it was restored.

Finally, Spock returns to the *Enterprise* to discover that Kirk is alive, because McCoy had given him an injection that would simulate death. Nimoy was very reluctant to film Spock's emotional response, suggesting it should be handled a different way, but the writers insisted, Nimoy relented and when he saw the audience's response, admitted that they were right.

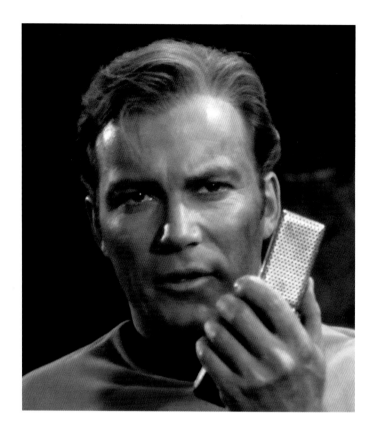

THE COMMUNICATOR

STAR TREK's communicators were made using a plastic pencil
box, Swarovski crystals, and the wheels from a slot car. And
the most sophisticated ones ran on clockwork.

It's a design classic – a simple, effective device that slips into a pocket, or at least it would do if anyone in *STAR TREK* had pockets. Much has been written about how the communicator is the precursor of the modern cell phone. Motorola even designed a real-world phone that was inspired by it. By modern standards it seems a little clunky, but then it can communicate across vast distances without the benefit of a wifi network, and originally, it was going to be even more powerful.

When Gene Roddenberry was developing *STAR TREK*, he was determined to take the science seriously. One of the biggest problems was communication. If the crew encountered new life-forms, they obviously weren't going to speak the same language. His solution was to give the captain and his crew "telecommunicators" that allowed them to understand the aliens they encountered by providing an instant translation. The "telecommunicator" is described as "little more complicated than a small transistor radio carried in a pocket. A simple "two-way scrambler," it appears to be converting all spoken language into English." It could also be used to talk to the ship and to allow the transporter to work out where someone was. Although it was never shown on screen, the communicator's translation abilities were still being referred to in the first season Writers' and Directors' Guide.

When Roddenberry got to make his first pilot, he commissioned the noted propmaker Wah Chang to create several props, including the telecommunicators. The first model Chang produced wasn't the one we're used to. It flipped open and had a grille on the top, but the insides showed a series of transistor-like components encased in a transparent shell. There's no mention of its translation abilities in 'The Cage,' but Pike does use it for communication even when he's onboard the *Enterprise*. The same style of communicator makes a brief appearance in the second pilot, but by the time the series entered production, Roddenberry had decided to revisit the design and order more models.

At this point Wah Chang produced the familiar design, which was a little smaller and more robust. He vacu-formed the body around a template based on a plastic pencil box that he cut down to the right shape. The shells were made from Kydex, the same material that he would later use for the tricorder.

He made brass "flip tops" that covered up three buttons and lights. As was usual for Chang's *STAR TREK* props, he used the wheels from slot cars and Swarovski crystals. Above this was a bezel that contained a moire pattern.

He delivered 10 models to the production team just before filming began on the first episode. At first glance, most of them were the same, but *STAR TREK* needed two "hero" communicators that could be shown in close-up. For these models, Wah Chang added a feature: the moire pattern, which was made of two separate discs, would move. The mechanism was ingenious: the bottom disc was rotated by a stopwatch that was concealed inside the communicator. The winder for the watch poked out from the bottom and could be used to create 30 seconds of movement.

Douglas Grindstaff's sound department created the communicators' final element: the distinctive "chirping" sound, a noise that is every bit as iconic as the rest of the prop.

ABOVE: *Wah Chang made at least 10 communicator props for the STAR TREK production team. Two of them were designed to be shown in close-up, and with the ingenious use of a concealed pocket watch, the moire pattern could be made to move.*

GENE RODDENBERRY

W R I T E R S
OF THE FUTURE

STAR TREK's writers were an extraordinary mix of sci-fi
authors, TV veterans, and newcomers.

Today, TV shows are written by a team of people who sit in a room and work out the details of a story together. It wasn't always like that. On the original *STAR TREK*, there were only ever two or three writers in-house at Desilu, and most of the scripts were written by freelancers.

When *STAR TREK* entered production, Roddenberry always wanted the stories to be about something. He was determined his new show would have ideas and believable characters. As he wrote in the Writers' and Directors' Guide, "Science fiction is not gimmick and gadgetry but, rather like any other story, is best when the main theme involves believable people in believable conflict."

In order to achieve this, he was keen to bring in established science-fiction writers. He went out of his way to court admired novelists and short-story writers Ted Sturgeon, A.E. van Vogt, Philip Jose Farmer and Robert Sheckley, none of whom had a background in writing for television. Only Sturgeon would actually provide stories that worked in the *STAR TREK* format. Next in line was a group of science-fiction authors who had proved they could write for television and had produced

scripts for *The Twilight Zone* and/or *The Outer Limits*: George Clayton Johnson, Richard Matheson, Robert Bloch, Jerry Sohl, and Harlan Ellison. All these writers would produce episodes, but not without disagreements with Roddenberry.

Other assignments were given to established television writers who had no particular background in science fiction. This group included Stephen Kandel, Paul Schneider, Adrian Spies, Shimon Wincelberg, Barry Trivers, and Oliver Crawford. And then there was Dorothy Fontana, a fledgling writer, who was still working as Roddenberry's secretary but who had started to make regular sales. She had had to adopt the pen name D.C. Fontana to disguise the fact that she was a woman.

Roddenberry believed that almost everybody on the list would need to be rewritten. *STAR TREK* was only vaguely defined and everyone was working independently. To help him with the rewriting he brought in John D.F. Black and his secretary (and later wife) Mary. Black was given the title associate producer. His job would be to manage the freelance writers, making sure they delivered their scripts on time and, where necessary, rewrite them himself. Black was

ABOVE: STAR TREK's head writers from left to right: John D.F. Black, Gene Coon, John Meredyth Lucas (with William Shatner), and Fred Freiberger.

never comfortable with this last part. He strongly believed that writers should be able to rewrite their own work. Roddenberry, however, had a reputation for getting his hands dirty and reworking the scripts himself. His logic was that it was the producer's job to make the scripts fit his vision of what STAR TREK should be.

Story ideas would be sent in and read by Roddenberry, the associate producer, the story editor (when there was one), and Bob Justman. They would all write notes about the story, and these were circulated to everyone involved before being sent back to the writer, who would be asked to make revisions.

After a few rounds of changes, the writer would produce a script, which would then go through the whole process again.

The outlines and scripts were also sent to Stan Robertson at NBC, who would chip in with his opinions, frequently calling for the stories to have more action and, wherever possible, to get away from the ship. His views shaped the series in significant ways. This process generated dozens of memos, with the writers only occasionally coming in for meetings.

During the first half of STAR TREK's first season, Roddenberry rewrote almost every script. To his mind, this was completely necessary and played an important part in

ABOVE: Gene Coon joined the series halfway through the first season and is widely credited with developing the relationships between the characters. 'Arena,' his first script, played an important role in defining many of STAR TREK's core themes.

shaping *STAR TREK*. John Black had a different attitude. He felt it showed a lack of respect for the writers, and he and Roddenberry often argued about the changes. Black was particularly unhappy when Roddenberry rewrote his own script for 'The Naked Time.' When his contract came up for renewal after the first 12 episodes, Black "asked for the world," and always said he was delighted when he didn't get it – meaning he could leave the series.

Black was replaced by Gene Coon – a veteran of *McHale's Navy* and *The Wild Wild West* – and *STAR TREK* gained one of its most significant voices. Coon would write or cowrite several of the series' best episodes, including 'Arena,' 'Space Seed,' 'The Devil in the Dark,' 'Errand of Mercy,' 'Metamorphosis,' and 'A Piece of the Action.' He created the Klingons and established many of *STAR TREK*'s core themes, especially the importance of understanding other life-forms. "Gene Coon," William Shatner once said, "had more to do with the infusion of life into *STAR TREK* than any other single person."

Whether it was because he was exhausted or because he had great faith in Coon, Roddenberry stepped back at this point and did less and less rewriting. Instead, Coon would polish the scripts. It was Coon who identified the relationship between Kirk, Spock and McCoy as central to the series, and embraced the idea that the show could have purely comedic episodes. By all accounts, he was gruff and had no time for niceties, but he was extremely well liked.

ABOVE: *Lucas was brought in after his script for 'The Changeling' was well received. He remembers that many of his stories focused on war themes, which were very current in 1968.*

When Coon came on board in August 1966, he was given a story editor, Steven Carabatsos, who would help to review and rewrite the scripts. Carabatsos had little love for science fiction and was never that good a fit. He left after five months, turning in one last script, 'Operation – Annihilate!,' which he remembered being from an idea Roddenberry gave him.

His place was taken by another of *STAR TREK*'s most important voices. When the series began, Dorothy Fontana was still working as Roddenberry's secretary, but she was making a name for herself as a writer. Roddenberry had commissioned her to write a script that became 'Charlie X.' It was well received, so when she suggested that the troubled script for 'This Side of Paradise' should feature Spock instead of Sulu, Roddenberry and Coon offered her the chance to rewrite it. They told her that if she did a good job, she could then become the series' new story editor. The script Fontana submitted proved to be one of *STAR TREK*'s most beloved installments and played a major role in developing Spock's character. Fontana joined Coon on the writing staff, and would review or rewrite every script from this point until she left at the end of the second season.

As *STAR TREK* approached the end of the first season, the writing staff was as strong as it would ever be. Coon was running the show on a day-to-day basis, with Fontana contributing notes and helping him to rewrite the scripts. Roddenberry was overseeing everything. That run would continue into the second season, which featured many of the show's best-regarded episodes.

The series continued to use celebrated science-fiction authors, with Sturgeon returning to write 'Amok Time,' which took us to Vulcan for the first time. Robert Bloch wrote two episodes, 'Catspaw' and 'Wolf in the Fold,' and Norman Spinrad contributed 'The Doomsday Machine.'

Notably, the series also offered opportunities to aspiring young writers. David Gerrold had just graduated when he sent in a pitch that turned into 'The Trouble With Tribbles,' and the next year Judy Burns contributed 'The Tholian Web.'

The workload, however, was exhausting, and by the middle of the second season Coon had had enough. He pulled one of the writers, John Meredyth Lucas, who had scripted 'The Changeling,' into his office and asked if he would like to take over as the series' producer. "Gene told me he was leaving because of health matters," Lucas remembered. "I had been the producer of *Ben Casey*, so he asked if I would like to take over."

Roddenberry was unhappy about losing Coon and only agreed to let him go if he continued to contribute scripts, but by the middle of the season Lucas was in place. Unlike Coon, who always wanted to concentrate on the writing, he was happy to involve himself in every aspect of the production. He

recalled that although *STAR TREK* was extremely hard work, it was a "functioning operation." By this stage, Roddenberry was relatively hands off, although he still contributed story ideas and commented on drafts of scripts. Most of the day-to-day work was done by Lucas and Fontana.

Then, at the end of the second season, *STAR TREK* was almost canceled. We'll probably never know exactly why it was renewed, but the ratings were marginal at best. When the show came back for the third season, the perception inside Paramount (who had meanwhile bought Desilu) was that something needed to be done to change things.

Part of the answer was to bring in a new producer. Fred Freiberger, who, like Coon, was well regarded for his work as a producer on *The Wild Wild West*, joined the series at the beginning of the season, with Arthur Singer as his story editor. He was instantly confronted with problems.

Roddenberry, who had been dismayed that the show was being given the 10 o'clock slot on Fridays, was busy with other projects. Dorothy Fontana had handed in her notice as story editor to pursue other writing opportunities. The budget was being slashed, leaving Bob Justman, who had wanted the executive producer's job, unhappy. And the network told Freiberger that the show needed to do better with women.

Freiberger didn't change the show's format, but he adopted a very different approach from that of his predecessors.

To save money, he decided that roughly every fourth show would be set solely aboard the *Enterprise*. To broaden the audience, he played up the romance. He also embarked on more stunt casting, giving roles to lawyer Melvin Belli and – more reasonably – to *Batman* actors Frank Gorshin, Yvonne Craig and Lee Meriweather.

For the most part, Freiberger used the same writers, with Jerome Bixby, Margaret Armen, and John Meredyth Lucas all returning. Freiberger received scripts from Coon and Fontana, too, but Coon was busy elsewhere and his scripts were not his best. Fontana was never happy with the rewrites that Freiberger and Singer did on her work, and felt the new regime didn't want to make the kind of *STAR TREK* that she knew and loved.

It's fair to say that Freiberger put more emphasis on action and less on high-concept ideas and consistent characterization. This was an era when *Batman* and *Lost in Space* had become big hits, and Freiberger pushed *STAR TREK* to be more like them. In the event, his change of approach made no noticeable impact on the ratings, while the scripts from the last season are unarguably weaker than the ones that preceded them. However, the season is still littered with great ideas and even great moments. As the future would prove, the *STAR TREK* format was strong, and even when the show was canceled in 1969, there were still hundreds of stories worth telling.

ABOVE: *Despite Freiberger's efforts, 'Turnabout Intruder' would be the last episode of* STAR TREK's *third season. The story involves a vengeful woman swapping bodies with Captain Kirk. Shatner cites it as one of his favorite episodes and Freiberger was delighted with the script.*

CELESTE YARNALL

THE WOMAN WHO OFFENDED VAAL

The young yeoman formed part of a landing party in her only *STAR TREK* appearance, bewitching Ensign Chekov on a planetary paradise.

C eleste Yarnall wore many hats in her uncommon life and career: actress, model, author of books about holistic health care for pets and humans, Miss Rheingold (1964), realtor, scream queen, entrepreneur, producer, convention favorite, wife, mother and, of course, *STAR TREK* guest star, having portrayed Martha Landon in 'The Apple.' She wore all those hats with aplomb.

The second-season episode found Chekov and Yeoman Landon engaged in a budding romance while on Gamma Trianguli VI. Their public displays of affection, however, stoked the ire of Vaal, the planet's 'god,' who forbade his people from indulging in love or marriage, and literally rattled the ground beneath them to make his point.

"I was cast by Gene Roddenberry, Joe D'Agosta and Gene Coon personally," Yarnall, who passed away in 2018, recalled in 2013. "They'd been looking for something for me to do as a guest starring role. They wanted something perhaps a bit more exotic than Yeoman Martha Landon, but they brought me in and said, 'Do you like the part, Celeste? If you like it, it's yours. We were hoping to find something more exotic for you…' I said, 'Oh, no. I love this part.' As actors, we're always worried about paying the mortgage, you know?"

Yarnall, who shot her scenes at Desilu over the course of a week in July 1967, acknowledged that she knew little about STAR TREK. But, after the costume department altered one of Grace Lee Whitney's Rand costumes to fit her, she leapt into the action and bore witness to apocryphal anecdotes in STAR TREK history, including the infamous hiding of Leonard Nimoy's bike.

Yarnall shared most of her scenes with Walter Koenig and described that as a "very special experience." Koenig, in a recent conversation, returned the compliment and revealed an amusing actorly tale about their major scene. "I saw Celeste frequently at conventions," Koenig says. "Very sad that she passed away. She was extremely pretty and, although she denied it, I distinctly remember, during a camera smooch, she turned me around so that it was my back in the camera lens and her gorgeous face (facing the camera). Makes sense to me!"

Despite the fact she made only the one guest shot in 'The Apple,' Yarnall years later found herself embraced by the STAR TREK faithful. She ranked (and still ranks) at or near the top of polls listing STAR TREK's most beautiful women, and made numerous convention appearances celebrating STAR TREK and also Elvis Presley, who serenaded her in Live a Little, Love a Little. Likewise, she attended many a horror convention in order to meet aficionados who revered her performances in the cult classics Velvet Vampire, Eve, and Beast of Blood.

"Life is just a blessing and a gift," Yarnall said. "I've been on what I call a celestial Trek, and it's wonderful that fans keep us (people involved in STAR TREK) alive in their memories and with their good wishes."

"STAR TREK was one of her favorite credits," notes Yarnall's husband, the artist Nazim Nazim. "But, even more, she loved the fans and welcomed every opportunity to meet them. She considered them more than fans. To her, they were friends. Celeste was always inspirational and to her, nothing was impossible, especially for women. That's the message she always shared with her STAR TREK friends. STAR TREK meant the world to Celeste and I can't tell you how much it means to me that she lives on in repeats of the show and in the hearts of people all over the world."

ABOVE: Chekov romances Yeoman Landon on the beautiful – but hostile – planet, angering the Vaal entity that maintains the Eden-like world.

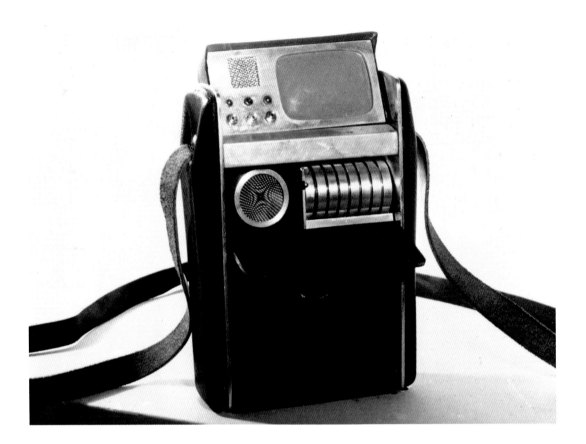

THE TRICORDER

The tricorder started out as a kind of sophisticated recording device that was used by landing parties before becoming an incredibly powerful scanner.

fficially, they invented the tricorder in 2017. In 2012, the Qualcomm Foundation decided that a medical tricorder would be so useful that they sponsored the Tricorder XPRIZE, offering $10 million to anyone who could make one. They even licensed the term "tricorder" from CBS. Five years later, they declared that Final Frontier Medical Devices (and, yes, they really are called that) had cracked it. The terms of the XPRIZE called for a scanning device that could take a wide range of readings using "noninvasive" technology. In STAR TREK, the tricorder's functions are a little more vague. Over the series' three years, it evolved into an

impressive device that could scan almost anything, access the ship's library computer, and record events for future study.

When Roddenberry first invented it, the tricorder was intended purely as a piece of kit that could be carried by the captain's yeoman. As he wrote to Bob Justman in an April 1966 memo, he wanted to expand the yeoman's duties and give her a useful role on landing parties. So he suggested that she might carry "some sort of neat, over-the-shoulder recorder-electronic camera, via which she can take log entries from the captain at any time, make electronic moving photos of things, places, etc." Roddenberry wraps up by adding that although he hasn't

thought about it much, he thinks it could make a good toy.

Less than 10 days later, Roddenberry wrote another memo, in which he describes the tricorder as "a device which acts sort of as a portable secretary-recording-photographic unit capable of taking down any information the Captain wishes at any time he is away from his bridge."

Wah Chang was commissioned to design the tricorder, which at this point was still very much conceived of as a recording device. His design reflects this. The head tilts open to reveal a metal panel, with a small grille that presumably worked as a microphone for recording log entries, and a screen for playing back information. To the right of the screen there were three buttons (in reality the wheels from an Aurora slot car) with different colored lights above them. Underneath this was a short flap that could be opened to reveal a series of recording discs and a circular screen with a moire pattern. A larger flap underneath this could also be opened, though this was rarely seen on-screen.

When the tricorder made its on-screen debut in 'The Naked Time,' it was being carried by Sulu rather than Yeoman Rand, although she does have one slung over her shoulder even when she's on the bridge. The medical tricorder made its debut in the next episode to be filmed, 'The Man Trap,' with McCoy using the external scanner for the first time.

In the episodes that followed, the tricorder gained more and more abilities as the script called for them. Spock uses his tricorder to scan almost everything the crew encounter and even to display what must be a massive historical database when he and Kirk travel back through time in 'The City on the Edge of Forever.'

The tricorder was so useful that the art department decided to have more than two made. The original models were taken apart and used as the basis for new fiberglass models. Around this point, they lost their recording discs and the circular screens. Neither of these featured on the new fiberglass versions, either. From now on, both flaps were kept firmly shut. Finally, more copies were made with leatherette bodies.

By the time it was seen in the final season, the tricorder had become an important part of STAR TREK lore. The third season Writers'/Directors' Guide describes it as "a remarkable miniaturized device, it can be used to analyze and keep records of almost any type of data on planet surfaces, plus sensing or identifying various objects. It can also give the age of an artifact, the composition of alien life, and so on."

It is, in short, an extremely useful thing. So much so, that we had to invent one.

ABOVE: *Wah Chang's original sketch for the tricorder. At this stage, its main function was recording data, and the row of discs was meant to be a form of storage.*

SEASON 2

EPISODE 10

AIR DATE OCTOBER 6, 1967

Teleplay by Jerome Bixby

Directed by Marc Daniels

Synopsis A transporter glitch sends Kirk, McCoy, Scotty, and Uhura to a parallel universe where they encounter ruthless mirror versions of Spock, Sulu, and Chekov.

MIRROR, MIRROR

'Mirror, Mirror' gave us a dark reflection of Kirk's crew and opened the door to countless stories, posing the question of how we would behave in a fascistic regime.

Like 'Space Seed,' 'Mirror, Mirror' is a *STAR TREK* episode with a lasting impact. The parallel universe/evil counterpart plot device later factored into *STAR TREK: DEEP SPACE NINE, STAR TREK: ENTERPRISE,* and *STAR TREK: DISCOVERY.*

Noted science-fiction novelist Jerome Bixby was keen to write for STAR TREK, even going so far as to submit a spec script in the first season. That story got him through the door, even though it didn't sell. When the second season was confirmed, Roddenberry and Coon asked him for other ideas. Bixby suggested

doing something based on his own short story, 'One Way Street,' which had been published in the December 1953/January 1954 issue of *Amazing Stories.* It involves a parallel universe, alternate versions of people, and a character

RIGHT: Kirk is posed with a dilemma: will he kill innocent people or lose his own life?

sporting a goatee – but who is vastly different.

Gene Roddenberry, in his famous 1964 "*STAR TREK Is...*" document, had also proposed a "story springboard," which he called 'The

> **"The ship is subtly altered physically. Behavior and discipline have become brutal, savage."**
>
> *Captain's Log, no stardate*

Mirror.' Here the *U.S.S. Yorktown* has a "near collision with another *Yorktown* on an exact opposite course. Not only is it the same cruiser, it is manned by exactly the same crew. Could you face yourself after discovering survival depends upon killing yourself?"

In Bixby's original story outline, Kirk was the only member of the crew who was transported to the other universe, where he discovers that the crew are at war with a species called the Tharn and that he is married to a woman called Anna. Kirk suffers from dizzy spells because he has been transplanted between universes. In the pivotal moment, he discovers in this universe that the Federation has never developed the phaser. He helps them with the necessary technology so they can win the war.

Roddenberry, Dorothy Fontana, and Gene Coon each made suggestions as 'Mirror, Mirror' evolved into the story we know, where we see the effect living in a fascistic society had on familiar characters. As the outline puts it, "there are countries ruled by fascism or military juntas, which exist and evolve just as efficiently as other countries, which are ruled democratically."

It was Roddenberry who suggested that they make more use of the regular cast. One of the episode's most successful elements is the way familiar characters are twisted. Chekov, a nefarious smile plastered on his face, can't kill Kirk fast enough. Sulu – who sports a massive facial scar, lasciviously ogles Uhura, and brandishes a knife with fiendish glee – also out of ambition recognizes the value of a dead superior officer.

"The alternative universe image of Sulu as a

dark villain in 'Mirror, Mirror' showed something interesting about his human side, and in 'The Naked Time,' he was crazed," George Takei observed. "Ironically, we only got a chance to see Sulu when he is not Sulu."

While impressed with the teleplay Bixby produced, the writers felt it was confusing. Gene Coon therefore took a final pass. Marc Daniels was in the director's chair, in the rotation with Joe Pevney.

Because almost all of the episode was set on the *Enterprise*, the budget was kept under control. Matt Jefferies designed the symbol for the Terran Empire – a sword through a planet – and William Ware Theiss got to create more extreme versions of the familiar uniforms. The outline described them as having "a savage, military, splendid flair – broad belts, a dagger appears in a spiral galaxy symbol on

> **"So you die, Captain, and we all move up in rank. No one will question the assassination of a captain who has disobeyed prime orders of the Empire."**
>
> *Mirror Chekov*

brass, short dress swords, perhaps headbands wearing the same fierce symbol."

BarBara Luna was delighted to find herself chosen as the Captain's woman. Her heritage meant that she was often cast in ethnic roles, but here that was utterly irrelevant. Mirror Chekov's henchman, the guy phasered into oblivion, was played by Bobby Clark, one of the stuntmen inside the Gorn costume in 'Arena.' Vic Perrin, who portrayed both versions of Tharn, had previously voiced the Metron in 'Arena' and Nomad in 'The Changeling.' Perrin was probably best known as the Control Voice on *The Outer Limits*.

ABOVE: George Takei relished the chance to play a more extreme version of Sulu. When he clashed with Uhura, Nichelle Nichols also got to show a more aggressive side to her character.

Those who pay close attention to the finer details of *STAR TREK* episodes will note that the *I.S.S. Enterprise* orbits in the opposite direction to the *U.S.S. Enterprise*, and that the characters aboard the Mirror ship position their phasers in different spots from their prime counterparts. The sculpture of a metal head seen in Spock's quarters belonged to Dr. Adams in 'Amok Time' and Marla McGivers in 'Space Seed.'

'Mirror, Mirror' was nominated for a Hugo Award in 1968, but lost to 'The City on the Edge of Forever.'

JOE D'AGOSTA

CASTING
THE GALAXY

To be on *STAR TREK*, an actor had to be a well-rounded
performer with a strong presence.

"My philosophy as a casting director is a little different than most casting directors'," Joe D'Agosta reveals. "Basically, I aim to cast through the director's eyes, because it's his vision I'm trying to satisfy. He's the storyteller. What does he want? Need? My job was to find the best actor available for the role, for the right money. I like to think that because a show or movie had me, I could make their script, their show, a little better."

D'Agosta, an actor himself, hired numerous key performers for *STAR TREK*, from leads to supporting players to guest stars. He only consulted on 'The Cage,' but assumed the position full-time for 'Where No Man Has Gone Before' and beyond. Before delving into the nitty-gritty of D'Agosta's *STAR TREK* casting contributions and experiences, a few more nuggets about casting follow:

"Sometimes, the most important part of casting is not great acting, but personality or… presence."

"There are a lot of good actors, more bad actors, and very few brilliant actors. We don't always get the opportunity to cast the brilliant actors."

"Stock actors, as I called them, worked a lot in supporting roles. They came in prepared, did whatever job was required. Directors knew exactly what they'd do."

"Every casting director says they love actors, and some of them don't. Actors were my comrades, because I thought I was more of an actor than a casting director. I was only casting until I could act. Acting never quite happened for me. Still hasn't, but I'm still at it!"

D'Agosta and Gene Roddenberry connected when D'Agosta worked at MGM as a casting clerk, responsible for ordering extras for every show on the lot. He also assisted respected casting director Don McElwaine. One show on the lot was Roddenberry's *The Lieutenant,* and when the usual casting director fell ill, D'Agosta filled the void. "What sold me to Gene was that the former casting director wasn't disciplined about getting actors to get military haircuts for a show about Marines," D'Agosta recalls, laughing. "Well, I didn't let an actor go on set unless they got a military haircut. So, Gene liked me, not because I was a great casting director, but because I could deliver actors with military haircuts. Anyway, the

casting director came back. Gene fired him and kept me."

By 1964, D'Agosta was based at Twentieth Century-Fox. Roddenberry called, grousing about complications casting his new pilot, *STAR TREK*, and requested D'Agosta's assistance. "I said, 'Gene, I've got a job,'" he recalls. "Gene says, 'Well, that's OK. You give us the names and your preferences, and we'll interview them and make the deals.' It was a volunteer job. I wasn't going to get paid. First, we went through the ship's crew. Secondly, we went through guest stars, then supporting players. It took a couple of weeks. Gene sent me a check: $750. I didn't ask for it. $750 was a lot of money for me.

"When *STAR TREK* sold, Gene told Herb Solow that Desilu now had three different shows on the air – *STAR TREK*, *Mission: Impossible,* and *The Lucy Show* – and that they needed a head of casting," D'Agosta continues. "He said, 'Joe D'Agosta needs to run it.'" Assorted producers signed off. Lucille Ball and her husband, Gary Morton, consented. D'Agosta got the gig.

For the record, D'Agosta did not cast Jeffrey Hunter for 'The Cage.' Roddenberry, NBC, and Herb Solow at Desilu handled that hire. D'Agosta oversaw "all of it below Hunter," starting with Leonard Nimoy. "I'd hired him for *The Lieutenant* and Gene liked him," D'Agosta says. "Leonard was a good actor. He was one of Gene's first thoughts for Spock, according to Dorothy Fontana's recollection. But I sent him in because what we needed was an Abraham Lincoln-ish guy, tall, thin. That physicality. So, Leonard was on my list. I didn't necessarily think he was first choice. I thought this other guy, Mark Lenard, was more right for it.

"I sent in Leonard and Mark, and maybe two others," he continues. "I believe my recommendation was Mark Lenard, who I ended up casting as a Vulcan later on. The reason I didn't push Leonard was he'd played a lot of gangster parts I was familiar with, so I had that in my mind as what he fit best. Leonard created Spock. He created it beyond what was on the page in terms of the raised eyebrow, the finger split, the monotone delivery and such. I really hand it to him, because he contributed a lot to that role."

While Nimoy crafted a character for the ages, a story circulated for decades that Martin Landau rejected the Spock role. D'Agosta insists that though Landau might have been "considered," he never brought him in to audition. "Dorothy Fontana, when Gene had her read the script, asked, 'Who are you going to get for Spock?' Gene handed her a photo of Leonard. Also, Bruce Geller wrote *Mission: Impossible* for Landau. He'd gone to Landau's acting classes, to learn how to work with actors, and they were good friends. So, they could've thought about him [for Spock], but I'm almost positive Herb would've said, 'Sorry, Bruce wants him.'"

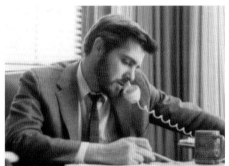

D'Agosta can't remember much more in the way of specifics about casting 'The Cage,' as he was still at Fox at the time. "Majel Barrett was Gene Roddenberry's girlfriend," he notes. "Susan Oliver was a top guest star, so that was just a matter of the director and us agreeing, calling the agent, sending Susan the script, making the deal, and her accepting. As far as the others [were concerned], I probably brought them in for interviews.

"Everybody thinks they're a casting expert," D'Agosta continues. "Everybody has ideas. Gene had an assistant named Morris Chapnick. He was always pushing actors, so some of the actors who got on the show might've been pushed by him. Some might have been thought of by [director] Bob Butler. He knew actors, and I'm sure he had ideas."

NBC rejected 'The Cage,' which "didn't shock" D'Agosta, since networks "do what they want to do." He was more surprised they gave the go-ahead to shoot the second pilot, 'Where No Man Has Gone Before,' directed by James Goldstone. The network and Roddenberry, not D'Agosta, selected William Shatner – who had just wrapped another series and "was tagged as The Next Big Thing" – to play Kirk. However, D'Agosta brought in most of the regulars who surrounded Shatner on the *Enterprise* bridge.

ABOVE: *Mark Lenard was D'Agosta's first choice for Spock, but he was beaten to the role. D'Agosta brought him back in to play the Romulan Commander in 'Balance of Terror' and Spock's father Sarek.*

"I believe Jimmy Doohan was the boyfriend of Gene's secretary," D'Agosta recalls. "So, I guess you could say Gene's secretary cast Doohan, though Goldstone had worked with him before [and valued Doohan's flair for accents]. DeForest Kelley had worked with Gene already, and they got to know each other. I think Gene wanted DeForest for the doctor all along. Gene liked him a lot. I probably cast Paul Fix [as Dr. Piper in 'Where No Man Has Gone Before'] and NBC probably said he's a little too dry, or the chemistry wasn't right between him and Shatner. As I remember it, Sam Peeples [who wrote 'Where No Man Has Gone Before'] was unhappy with Fix, too. He thought Fix was too old.

"I cast Nichelle," he continues. "She had wowed me on *The Lieutenant*. George [Takei] worked a lot before *STAR TREK*, and he was on three shows I'd been involved with. I may have shown Gene film of him. Grace Lee Whitney, she was a hot-looking woman that everybody knew. That's all. I don't know who suggested her. Could've been me. Could've been a director. She became a recurring character, as I recall."

Shatner and Nimoy were contracted for the first season's full run. Kelley, Takei, Doohan, and Whitney had "seven out of 13" deals. Nichols, the final actor hired, was paid a sliding-scale rate with no guaranteed episode minimum.

Walter Koenig arrived in season two as Chekov. He represented *STAR TREK*'s attempt to attract younger, female viewers. "They wanted somebody to be like Davy Jones, which I never thought Walter was," D'Agosta notes. "As an actor, I'd done a little movie with Walter called *Strange Lovers*. Walter and I became friends. We still are. I brought him in for *STAR TREK*. I was always looking for something for him. It was a role I didn't even think he'd take, because Chekov only had two lines. Gene liked him, and then he was a regular."

Meanwhile, *STAR TREK*'s guest stars fell into place for the standard reasons: talent, name recognition, price, perfect for a role, knowing the right person, another actor falling through, the popular guest actor of the moment. Some guest stars received direct offers and others auditioned, meeting with some combination of D'Agosta, Justman, and Roddenberry, etc. D'Agosta would start casting guest stars after receiving finished scripts for upcoming episodes.

"Roger C. Carmel was on my list of actors who worked all the time, and he was perfect for Mudd," D'Agosta states. "Melvin Belli, the lawyer, was Gene's idea. I think Gene knew him. I knew when Leonard was chosen to play Spock that we'd want Mark Lenard for something else, and he was perfect for [the Romulan Commander and Sarek]. A lot of TV shows had a common guest star list. You'd see the same actors on cop

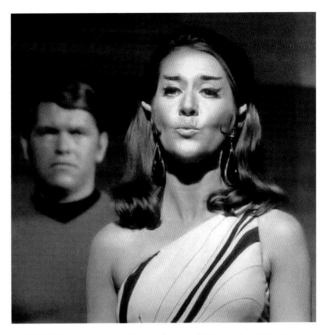

ABOVE: *D'Agosta was particularly pleased with the casting of Joanne Linville as the Romulan Commander in 'The* Enterprise *Incident,' even though she was second choice for the role.*

shows, medical shows. *Mission: Impossible* and *STAR TREK* were different. *Mission*, it was mostly people who could be mid-Atlantic foreign adversaries, you know?

"On *STAR TREK*, all the characters were different," he continues, referring to aliens and humans from various cultures that, presumably, would be readily accepted in the future. "So, we had a range of actors we could go after. Since the show itself was basically a theatrical piece more than a cinematic piece, really good actors were demanded to be the adversaries. Joanne Linville was a great actress, but she wasn't first choice [for the Romulan Commander in 'The *Enterprise* Incident']. Lee Grant was. Number two often gets the job. Lee Grant was, I think, not available. These were both superb actresses, both right for the role. It was the same for a number of roles, where we required well-rounded actors, because they weren't playing cardboard characters. By the way, Joanne Linville later became my acting coach, and she made sure to remind me she wasn't first choice."

Was there anyone D'Agosta couldn't get? "Oh! I'll tell you one. We had a Hercules character, a god," he replies, referring to Apollo in 'Who Mourns for Adonais?' Michael Forrest landed the role over D'Agosta's choice, William Smith. "Bill did a lot of motorcycle pictures later on, but I'd known him,"

D'Agosta says. "He was handsome. He was one of the few people in those days who worked out in a gym. I pushed for him because he was a real decent guy and a really good actor. I didn't think Michael Forrest was as good as Bill. I fought, and I lost. Bill actually cried because he knew that was his role."

D'Agosta maintained personal and professional relationships with many of the *STAR TREK* producers and actors he worked with, though he's never seen a *STAR TREK* feature or done more than flip through the subsequent spin-off series. He continued to cast shows and features, adding *The Courtship of Eddie's Father*, *Transylvania 6-5000*, *Noble House*, and *The Year of Living Dangerously* to his resume. "I pushed hard for Linda Hunt," D'Agosta says, "and she won an Oscar for *The Year of Living Dangerously*." He also served twice as head of worldwide casting at MGM, first under Herb Solow and then Freddie Fields. Now in his mid-80s and "still trying to be an actor and writing a book," D'Agosta can only marvel at the "phenomenon" that is *STAR TREK*.

"Well, I did have a nice hand in it," he concludes. "I thought, at age 28, *STAR TREK* was a stepping stone. It turns out to be the highlight of my career. All my other credits fade compared to *STAR TREK*. But the truth is I'll be able to sleep at night if that's my legacy."

ART
DEPARTMENT
MAKING STRANGE NEW WORLDS

Matt Jefferies and his team invented the look
of the future and dozens of alien worlds, but
they had to be quick and easy to build.

The problem with strange new worlds is that they have to be made from scratch. In the 1960s, even Hollywood had no ready supply of alien props and architecture, so art director Matt Jefferies had to imagine what they looked like and then build the sets in no time for next to no money. "The biggest challenge," Jefferies insisted, "was coming up with ideas."

For Jefferies, the process started in the first preproduction meeting. Sometimes there wouldn't even be a script, just a brief outline, but he would run through it with the producers identifying what needed to be made, often with Bob Justman

shaking his head as he imagined the cost. Even in the meeting, Jefferies would be sketching out ideas. "If I could come up with something real quick," he remembered, "and if I could convince Roddenberry that that's what we ought to have, then I was free to run with it."

In fact, Jefferies was keen not to get too involved with the details of the scripts. At any one point he could be working on seven different episodes, so all he needed was to boil each one down to a list of things he needed to make. "You're responsible for the one that you're shooting and maybe elements of two that have been shot. You're in the construction and painting

EXT TRELAINE MANOR
STAR TREK 18

JADE GREEN
LACQUER —

GREENS

+20'

+14'

+11⁶

+8⁶

STAGE FLR. STG.10

VAAL
"THE APPLE" 038

CLIFF.
24 WIDE
24 HIGH

12° R

BKG.

5'6" ±

30° 30°

4'-6"

WHITE BKG.

DIRT & SAND

WILD FOREGROUND
PCS 8-14 HIGH.

TO STG. 9

20'
CLEAR FOR
EQUIPMENT.

FOR MAX. DEPTH -OR
DISTANCE EFFECT.

ALL SHOTS INTO CORNER.
CURBED BY FOREGROUND
PCS —
ALL EASILY SHIFTED.

TENTATIVE
LAYOUT
STG. 10
PLANET SET

INT. CAVERN
"WHAT LITTLE GIRLS ARE MADE"
#10

+10

THIS PAGE: *Most of the alien worlds that the Enterprise visited were built on Desilu's Stage 10. Jefferies often built caves on the set, using boatbuilder's foam around wood to create a solid structure, then wrapping tin foil around the lower parts and spray-painting it. A door connected the set to Stage 9, where the shipboard sets could be found.*

ABOVE AND LEFT: *Foam was often used to make set pieces, such as the ruins in 'The Man Trap.'*

stage on the next one that's coming up and the next one after that, hard line designing on the one after that, and preliminary thinking on the one after that."

The time pressures meant that Jefferies had relatively little time to actually design things. "That's why I usually worked Saturday, because the rest of the time they had me running too much. The most I ever had was a two-man staff. The cameraman Al Francis was a dream because he would frequently come in Saturday to see what I was doing. Then all of a sudden, something would take hold and it would become something. Al loved reflections, he loved shooting with white. He was a genuine gem to work with."

Under normal circumstances, *STAR TREK* only had two stages. Stage 9 was set up with the *Enterprise* interiors. The

bridge, the main corridors, transporter room, and crew quarters were normally left standing, but the other sets, including sickbay, were often folded up against that wall so Jefferies could use the space to build whatever the script called for. Stage 10 was set up as a "swing set," where alien planets could be built and torn down in short order. Very occasionally, Jefferies could get access to another stage, but it was only used when absolutely necessary, for example, in 'The Gamesters of Triskelion' when he had to build a circular set for the disembodied brains that could be shot from above.

There was always an episode in production, so it was important to work out when he could get into the stages to build something new. The company would normally spend three to four days filming on each stage. This gave Jefferies'

ABOVE AND RIGHT: *Jefferies used perspective tricks to make the sets seem larger, and beams to cover up the lighting rig in the ceiling.*

ROLLER BASE
12º x 16º

ENTIRE UNIT
WILD ON ROLLERS

FRONT ELEV.
THRONE.

033

team the chance to build new sets on the stage that wasn't being used. When the set was ready, they would move all the lighting and camera equipment over there at night so they could start shooting the next morning. "Otherwise," Jefferies explained, "you may lose an hour when you start the next day, and that was almost as much of a no-no as going over budget."

As soon as the company had moved to the new set, Jefferies' team would move in to the stage they had vacated and start building there. Since parts of the *Enterprise* were often

unavailable, Jefferies built a small model of the shipboard sets that he could show to new directors, along with a series of film clips that he rescued from the editing rooms.

Making new sets for the *Enterprise* was a well-oiled process. To get things moving as quickly as possible, Jefferies built a series of four-foot pieces that could be slotted together to make most of the new rooms that were needed on the *Enterprise* or Federation bases. When they weren't in use, they were tied together and leaned up against the walls. Laughing, Jefferies

THIS PAGE: Apollo's temple in 'Who Mourns for Adonais?' was a separate unit that was on wheels so it could be easily moved into position.

ABOVE: *Zefram Cochrane's home in 'Metamorphosis,' a design that Jefferies pointed out didn't include a door....*

ABOVE: *Jefferies also designed any spaceships or stations that were needed. This is an alternative design for K-7 in 'The Trouble with Tribbles.'*

ABOVE AND RIGHT: *The grain storage was designed so the team could dump hundreds of tribbles on Captain Kirk.*

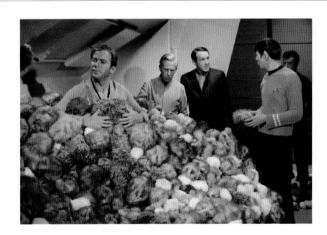

remembered that sometimes it was easier to build more of these pieces than to untie them. In some cases, sets like this didn't even need drawing up. "I knew how much room we had. We'd draw them on the floor with the toe of your boot."

The more complicated sets were built on the planet set. "When you were putting together the alien stuff, you had to be fairly ingenious to make it look different every week with very few resources. But there was nobody to say I was wrong – they hadn't been there, either! We were very limited on 'outdoor' sets, because all we could do to really make it different was to try to light in a different color sky."

When the series started, Stage 10 was completely empty, and Jefferies had to build everything. On the rare occasions that the script called for a familiar piece of Earth architecture, he'd be able to find some existing pieces from the Desilu scene dock, but many of these pieces were so heavy that he couldn't afford the staff needed to move them.

Instead, Jefferies was able to make a lot of things out of wood which could then be faced with a new kind of foam. "We found out about this foam material that the boatbuilders were using," said Jefferies. "It's a two-part composition, shot with a spray gun. You put a quarter of an inch layer on and in about 20 seconds it's up to two and a half inches and it's dry. So we found a boatbuilder that did that."

Jefferies' team would build a set piece, such as the ruins in 'The Man Trap,' out of wood. Then they called in the boatbuilder, who filled it with foam. As soon as it was dry, they would tilt it upright and paint it. The resulting piece was ready in a day and was so lightweight that a team could move it around by hand without the need for machinery. They used the same technique for smaller pieces, which could be taped to the wall.

The technique was so effective that it was easier than using

RIGHT: *Jefferies was always looking for ways to make the planet set look different. In 'For The World is Hollow and I Have Touched the Sky,' the tubes were meant to lead down into the asteroid's interior.*

SURFACE - INNER CORE
ASTEROID SPACE SHIP
065

existing set pieces. "Paramount had a lot of large rocks, like 10, 12 feet high, made in fiberglass and plaster, on a steel frame, on rollers. It took a tractor to move them. We built up stuff that size and foamed it in. It was strong enough to walk on. Six men could pick it up and walk off with it."

The same material was used to make the caverns in 'What Are Little Girls Made Of?' Whenever people didn't have to walk on parts of a set, Jefferies had another go-to solution. "Tin foil was a marvelous material," he remembered. "The painter used to tease me. He said, 'Here comes Matt, give him a spray gun.'

What I did was, I said everything that shoots in that direction and up, we'll do in green lacquer, and everything going the other way and down, we'll do in blue lacquer, so the metallic comes through it. As they'd move around, the wall would change color. Some of the caverns were done with Reynolds Wrap. As soon as we were through with it, it was so damn fragile that we'd ashcan it."

There were, of course, times when more traditional techniques made sense, and Jefferies remembered that he was able to call on some extraordinary craftsmen from Hollywood's

NATIRA'S QTRS.
065.

LEFT: *New locations such as Natira's quarters often reused set pieces from other episodes.*

ABOVE AND LEFT: *Jefferies designed this unusual torture device for 'The Cloud Minders.'*

EAT ROCKS

As Matt Jefferies remembered, not all of the new materials he experimented with worked out – in some cases for the most unexpected reasons.

"A company had come up with foam rocks. They looked like granite and weighed damn near nothing. If anyone dropped one, it would bounce like a damn tennis ball. So we borrowed a bunch of them to shoot the episode about the Gorn. All of a sudden we found the remains of one of them. Dogs liked it and they had torn it up. The owner of that stuff wanted us to pay for it. We said, 'You didn't tell us it was loaded with dog food!'" Jefferies laughed. "We didn't use their stuff any more."

golden age. "The head of the plaster shop was a marvelous artist. The studios used to have a lot of 'em like that – people who could do sculptures and stuff. We could knock together a rough, 10-foot-wide, 10-foot-high fireplace and hearth out of plywood and I'd say I want it to look like slate. In a couple of hours he's got it done."

There were, however, times when old techniques and new materials didn't work well together. "We had several dungeon sets," Jefferies recalled. "On one of them he used to keep two men busy mixing plaster. He'd load a hod and go up the ladder and be doing this sculpting as he went. One day, they sprayed silicone over the top of the stuff. He took the hod, went up there, put it on the wall, came back down for the next one. Here comes that load sliding down the wall. Finally, with everybody laughing, I figured out what was wrong: with that silicone in it, it wasn't going to stay on the wall."

Stage 10 wasn't as big as it looked and Jefferies was careful to design sets that could make use of perspective. As he explained, the planet set "covered one end and the whole long side of the stage. The other long side and the butt end, where the big doors were, we kept – I think it was 15 feet of that – clear of dirt, because of the camera tracks. It was always shot into that corner." In order to create the illusion that the sets were bigger than they were, Jefferies would make a "cutting piece" – often a piece of rock – that could be put close to the camera. "To achieve the effect of distance, you've also got to have something up close as a comparison. You get something that will cut your shot, that's close to the camera, then you've magnified the distance to the far end."

Not everything had to be built on the soundstage. Sometimes the script called for the crew to visit planets that showed familiar architecture. When this happened, they could film on the back lot where the Desilu 40 Acre studio and Paramount, which was next door to Gower Street, had permanently constructed streets that were normally used for New York or European exteriors.

Once the sets had been built, they had to be dressed. Again, it wasn't easy to find existing props in the stores that could simply be wheeled out. This was always a challenge. "The first two men we had in that job were not tuned to it," Jefferies recalled. "They were used to going to the storage building and pulling furniture, and that couldn't be done here. But [set decorator] John Dwyer came aboard with an imagination and the energy to go with it. When you were working with him, that was an area you did not have to be concerned with."

"Matt was great to work with," Dwyer remembered. "He was so busy he didn't have time to worry about what I was doing! But you have to be a team, there's no doubt about that." The average budget for an episode was $500, just enough to "rent a couple of props," Dwyer continued, "or I could have a couple of props made, as long as I didn't do anything that was too electrical. Every once in a while, we'd have a ship show, and I'd end up with 500 bucks and nothing to spend it on, so I would go out and buy materials."

Dwyer spent whatever time he could looking for strange products. For the first show he worked on – 'The Trouble With Tribbles' – he found a company that made unusual fiberglass chairs he could use. He decorated the shelves behind the bar with pieces of volcanic glass, while the walls were decorated with Masonite that was cut into keystone shapes and covered in self-adhesive Mylar. For the Fabrini in 'For the World Is Hollow And I Have Touched the Sky,' Dywer worked out that he could use the same foam that Jefferies was using to make large set pieces, but this time he made a mold for a small piece, trimmed it into a shape and carved hieroglyphs in it.

Other times, he would take an existing product and convert it into something unexpected. "For one episode, 'The Cloud Minders,' I found a guy who was welding up futuristic freeform bases for coffee tables," he remembered. "You put a piece of glass on top of them and you had a coffee table. I chose some and said I would rent them and bring them back next week. He said, 'OK, but should I figure in the glass?' and I said, 'No' and he said, 'Why not?' and I said, 'Because I'm going to hang them on the wall!'

That summed up the STAR TREK art department's approach: wherever possible find new and unexpected materials that let you create something quickly and inventively. Then tear it down and do it all again...

ABOVE: Jefferies often built curved sets so that you couldn't see how big a room was. The idea for the library in 'All Our Yesterdays' was that it was a vast facility packed with records.

ABOVE: The fountain in 'Wink of an Eye' was one of the few set pieces Jefferies regretted building. He liked the way it looked, but the sound team hated the noise made by the water.

| ABOVE: *The body-swapping machine from 'Turnabout Intruder' was one of the last things Jefferies designed for STAR TREK.*

INDESTRUCTIBLE PROPMASTER

The *STAR TREK* art department were tough guys, who took pretty much everything in their stride. Jefferies himself was a World War II veteran and however hard work on *STAR TREK* seemed, there was no comparison. As he liked to tell people, propmaster John Dwyer was also made of stern stuff. For 'The Gamesters of Triskelion,' they had borrowed a small stage they didn't normally use. "It was a full circular set. It was to be a shot with a camera mounted up in the rafters." Dwyer picks up the story. "Jimmy Rugg [special effects] had come up with this brain-like cover that he could pulse and light from the inside, and I had come up with the domes because I'd found them in a scrapyard. Matt came up with the shape of the rest of the thing, and we put it all together. Jimmy Rugg and I were putting the cover over the brains when the lens fell off the camera and hit me on the head." Jefferies was amazed that despite being "knocked out flat as a rug," Dwyer barely broke stride. "They rushed him off to the hospital for a couple of stitches and by the time he got back we still didn't have a replacement lens!"

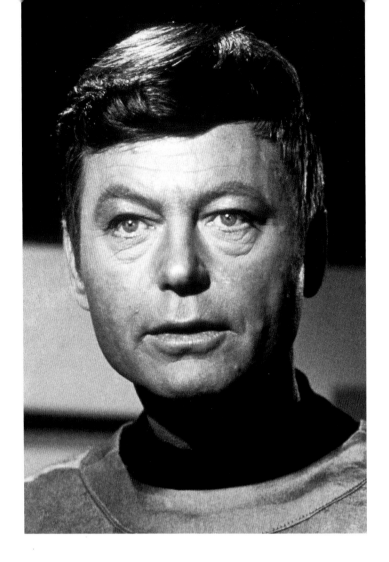

I'M A DOCTOR, NOT A...

STAR TREK was responsible for more than one catchphrase. Ironically, some of the most famous were never actually used on-screen, but in one running gag Dr. McCoy was always happy to remind people what he wasn't...

Dr. McCoy's job was to heal people, and he did it admirably, but he could also kill with a look or a caustic comment, the latter usually fired in the direction of his green-blooded frenemy, Spock. Many of Bones' most quote-worthy lines, though, were uttered in something resembling protest, when he felt he'd been asked to do the impossible, and Kelley delivered them with the utmost conviction. And thus was born what today would be an "I'm a doctor" meme, a running verbal gag that carried over to Dr. Bashir, The Doctor, and Dr. Phlox on the *STAR TREK* series that followed, as well as to Karl Urban's iteration of McCoy in the *Kelvin* Timeline films.

Writers worked the line into the script at key points, with variants making it into the show a dozen times.

"What am I, a doctor or a moon shuttle conductor?"
('The Corbomite Maneuver' Season 1, Episode 10)

"My dear girl, I'm a doctor. When I peek, it is in the line of duty."
('Shore Leave' Season 1, Episode 15)

"I don't know. I'm a doctor. If I were an officer of the line, I'd…"
('A Taste of Armageddon' Season 1, Episode 23)

"I'm a doctor, not a bricklayer."
('The Devil in the Dark' Season 1, Episode 25)

"I'm a surgeon, not a psychiatrist."
('The City on the Edge of Forever' Season 1, Episode 28)

"I'm a doctor, not an engineer."
('Mirror, Mirror' Season 2, Episode 4)

"Look, I'm a doctor, not an escalator."
('Friday's Child' Season 2, Episode 11)

"I'm not a magician, Spock, just an old country doctor."
('The Deadly Years' Season 2, Episode 12)

"I will not peddle flesh. I'm a physician."
('Return to Tomorrow' Season 2, Episode 20)

"I'm a doctor, not a coal miner."
('The Empath' Season 3, Episode 12)

PLANET EDEN
075

THE SHUTTLECRAFT

The *U.S.S. Enterprise* was always meant to have shuttles, but finding an affordable design was challenging. Model company AMT provided a solution, but only when Matt Jefferies abandoned his original ideas.

Equipping the *U.S.S. Enterprise* with shuttles was an idea that occurred when Gene Roddenberry was designing the ship with Matt Jefferies and *STAR TREK*'s first technical consultant, Harvey Lynn. "The *Enterprise* was never supposed to sit on a planet's surface, so we needed something other than the transporter room," recalled Jefferies. "We should probably have had a shuttle like a city bus, because several times a script came up that called for more people than we had seats for!" Lynn suggested that the *Enterprise* could carry a variety of "smaller shuttles, taxis, and tugs," so Jefferies designed the fantail at the back of the ship to accommodate such craft. Yet the expense in time and money of constructing even a single shuttle meant that it could

not be included in a script – that is, until the stranded shuttlecraft central to 'The *Galileo* Seven.'

A solution to the construction conundrum presented itself. Modelmakers AMT approached Desilu for the rights to make model kits of the *Enterprise*. The studio agreed, in exchange for AMT building a model shuttlecraft and a full-size exterior and interior. Now Matt Jefferies could at last get to work on the design – though the process went through many permutations.

"I was going to do a teardrop thing," Jefferies said, and "the whole side panel, the outside door, would slide back, and you could just step right off on the ground." He then favored a design with a gull-wing door, with the bottom folding down into steps. This shuttle had twin warp nacelles on outriggers

*curved shape,
too expensive*

SHUTTLECRAFT

ABOVE: *Jefferies' original design for the shuttle had a teardrop shape that echoed the familiar curves of the Enterprise. It turned out to be too impractical for AMT to make, so they had to opt for something simpler.*

that formed legs for planetary landing, but AMT reported that sadly this design was too expensive to make in the time, and subcontracted it to Gene Winfield, an automotive designer. Winfield in turn could not physically build it in the time – so Jefferies asked him to come up with a design that he could build. Winfield involved a San Francisco company, where Thomas Kellogg sketched an idea that Jefferies approved, with modifications. Jefferies concluded, "…it was a good solution, and it worked, obviously."

Winfield recalled having 30 days to build the full-size version, from plywood fitted around a metal frame. Landing gear came from an aircraft supplies company, and the nacelles were tubes from a well-drilling firm. He also created a separate set for the shuttle's interior, with either wall being removable for filming. His team produced a 22-inch wooden model for the visual effects. This was finished off by Richard Datin, who had made the model of the *Enterprise*.

The shuttle made its onscreen debut in 'The Menagerie,' where it "played" a shuttle from Starbase 11. The miniature version was used for the shuttle taking off and landing from the *Enterprise*'s hangar deck – itself a scale model built by Datin. The *Galileo* shuttlecraft was destroyed in 'The *Galileo* Seven,' (which was filmed before 'The Menagerie') but the model was just too good to waste and appeared, unchanged, in several episodes, including 'Metamorphosis' and 'Journey to Babel.'

Galileo

NCC-1701/7
U.S.S. ENTERPRISE

NCC-1701/7

STAR TREK

SCALE IN FEET

SHUTTLECRAFT - LEFT SIDE

HARRY MUDD

THE ROGUE ELEMENT

STAR TREK fans squabble about the original show's greatest guest star, an argument that usually boils down to Ricardo Montalban or Joan Collins. But there's no disputing the funniest guest star and the only one who came back for a second appearance… Roger C. Carmel

Dressed like a pirate, shiny from flop sweat, eyes a-bulging, and sporting the Galaxy's cheesiest mustache, Carmel delivered humor and menace in equal measure as Harcourt Fenton Mudd, first in 'Mudd's Women' and then in 'I, Mudd.' The character epitomized the villain everyone loved to hate, and hated to love; hapless, mischievous, relatable, and almost sympathetic, despite treating women as cargo, pushing the illicit "Venus" drug, leaving the *Enterprise* crew to die, and reselling stolen alien technology.

Born in Brooklyn, New York City, in 1932, Carmel embarked on his acting career in the late 1950s. Early credits included *The Power and the Glory* and *The Irregular Verb to Love* on Broadway, and such shows and films as *The Defenders*, *A House Is Not a Home*, *The Dick Van Dyke Show*, *The Alfred Hitchcock Hour*, *The Man from U.N.C.L.E.*, and *Gambit*. One fateful day in 1966, STAR TREK casting director Joe D'Agosta phoned Carmel out of the blue.

"I'd done some other guest shots for Joe," Carmel told *Starlog*'s Dan Madsen in a rare interview conducted in the early 1980s. "He called me in to read, with other actors as well, and I guess they liked my reading the best. That's how I got the first one, 'Mudd's Women.' It was a pretty big success, and they got a lot of positive reaction. So, they wrote ['I, Mudd'] especially for me the next season. By then, the part was mine, so to speak, so I didn't have to read. They told me during the third season they were going to write another one for me for the [fourth)] season, but of course, there never was a next season."

Carmel spoke of happy days on set while making his episodes. He described William Shatner as "at heart, a very crazy kind of comic." Their playful banter on-screen, the actor noted, led to amusing moments – Shatner tugging on Carmel's mustache, for example, then mugging for the camera – featured in the famous *STAR TREK* blooper reels. The only negative? A "wonderful, long" monologue deleted from 'Mudd's Women,' in which Mudd tried to seduce Uhura into taking the Venus drug. "It was just too long," he said. "I remember being very disappointed because I felt the monologue was very effective and very much to the point of the show's philosophy. Years later, you don't remember the disappointments. You remember the good things."

Post-*STAR TREK*, Carmel added dozens more movies and TV credits to his filmography and lent his voice to such cartoon projects as *STAR TREK: THE ANIMATED SERIES* ('Mudd's Passion'), *The Transformers*, and *DuckTales*.

Carmel, who died in 1986, lived long enough to hear the appreciation *STAR TREK* fans felts for him – and Mudd. "They're terrific!" he raved. "How can you say anything bad about somebody who comes up to you and tells you they love you?" He expressed to *Starlog* that he considered Mudd one of his favorite roles. And, according to the actor, there might have been more for fans to love. He ran into Gene Roddenberry at a goodbye party for Herb Solow at Desilu, and Roddenberry commented, "It's a shame that series thing for you never worked out. I said, 'What series thing?'" Carmel recalled. "He said, 'Oh, didn't you know?! Well, after the successful Harry Mudd episodes, NBC wanted to know if I'd develop a spin-off series for you, starring the Harry Mudd character. A space pirate, intergalactic conman kind of thing.' 'My God, Gene, I didn't know anything about that. What happened?'

"He said, 'Well, the writers didn't have enough time to develop it,'" Carmel continued. "Of course, you couldn't blame Gene. He didn't want to let somebody take it off in a direction he didn't approve of. Since he didn't have time to handle it all, the Mudd series project died. What a great chance that would have been for me to star in my own spin-off series."

MUDD REBORN

Fifty years after Roger C. Carmel last played Harry Mudd, actor Rainn Wilson stepped into the role on *STAR TREK: DISCOVERY*, guest starring in 'Choose Your Pain,' when Lorca and Tyler are imprisoned alongside Mudd on a Klingon ship, and in 'Magic to Make the Sanest Man Go Mad,' when Mudd manipulates time, reliving events until they work out in his favor. The last story ends with us being introduced to a young version of Harry's terrifying wife, Stella.

Wilson, best known for *The Office*, returned for 'The Escape Artist,' an installment of *STAR TREK: SHORT TREKS* that he also directed. "I stole a lot of things that I loved from [Carmel's] performance, and then added a lot more of my own," Wilson says. "So, it's a testament to [Carmel] – what an interesting actor he was. You can't take your eyes off him... So full of light, and has a wonderful light and dark quality that the original writers brought to him."

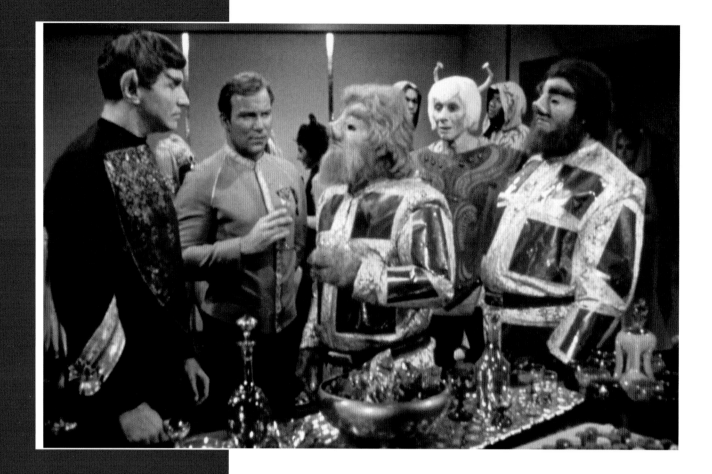

SEASON 2

EPISODE 10

AIR DATE: NOVEMBER 17, 1967

Written by D.C. Fontana

Directed by Joseph Pevney

Synopsis The *Enterprise* is transporting a group of diplomats when one of them is killed. Suspicion falls on Spock's father Sarek, but not everyone is who they appear to be.

JOURNEY TO BABEL

The *Enterprise* is transporting delegates to the Babel Conference, but the real story is about Spock and his parents. We discover that his father didn't approve of him joining Starfleet.

According to Dorothy Fontana, 'Journey to Babel' had its origins in a line she wrote in 'This Side of Paradise.' "Spock," she explained, "says, 'My mother was a schoolteacher, my father was an ambassador.' We needed to see the family background that Spock was raised in. What's going on with him truly personally?"

For Fontana, exploring Spock's background and how he came to be the man he was, was the real point of the story, but *STAR TREK* was an action-adventure series, so she still needed a plot. What she came up with was a story in which the *Enterprise* picks up various delegates who are heading for a peace conference. One of them is murdered, and suspicion falls on Spock's father. "The A-line is the journey to

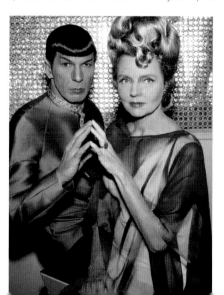

RIGHT: Leonard Nimoy poses with the actress Jane Wyatt, who, casting director Joe D'Agosta laughs, was known for playing mothers.

Babel," Fontana recalled. "It was the first show we had done with a number of different aliens all together in one place with some goal in mind. Bringing in the whole murder and the whole political background was a lot of fun. That was the main story, but personally I was more involved, in terms of interest as a writer, with the personal story of Spock and Sarek and Amanda, which actually takes up very little room – and yet that's the part of the story that everyone remembers."

Fontana decided that Spock should be estranged from his father, who is an impressive and imposing figure. "This was the first mention," she said, "that he and his father had been estranged. Well, why? What's with his mother? What feelings does she have in this particular triangle between husband and son? And what kind of a woman was she to marry a Vulcan, go to Vulcan, live like a Vulcan, raise a half-Vulcan son? What was all that about?"

Casting would be key to the episode. We had seen Vulcans earlier in the season, in 'Amok Time,' but they had barely been developed. For Sarek, the producers called back Mark Lenard who had once been considered for Spock and had played the Romulan commander in 'Balance of Terror.' He was only seven years older than Leonard Nimoy, but the producers reasoned that Vulcans aged more slowly and put a little gray in his hair. Spock's mother, Amanda, was played by Jane Wyatt. Reggie Nalder and William O'Connell rounded out the cast as the Andorians Shras and Thelev respectively, with John Wheeler playing the Tellarite Gav.

The show was set entirely on the *Enterprise* with the producers deciding to pour their budget into makeup and extras, so much so that they had Sarek and Amanda arrive by shuttle to save the expense of a transporter effect. 'Journey to Babel' features more alien makeups than any other episode of the original series, and introduced the Andorians and the Tellarites, who we would later learn were founding members of the Federation. The Andorian makeup included antennae that Fred Phillips attached directly to the wigs he gave them. The tips of the antennae were made from thread spools that he cut down. The Tellarite makeup was a single piece of latex that was glued to Wheeler's face. By modern standards, it was primitive and he had to tilt his head back to see out of the eye

> **"You don't understand the Vulcan way, Captain. It's logical. It's a better way than ours. But it's not easy. It has kept Spock and Sarek from speaking as father and son for 18 years."**
>
> **Amanda speaking to Kirk**

holes. Director Joe Pevney credited Phillips with doing a "fabulous job" and making the greatest contribution to the episode.

When Lenard and Wyatt were cast, they sought out Leonard Nimoy to ask his advice about Vulcans. "They came to me and asked me if there was anything specific about other to indicate that.' They did it by extending two forefingers and walking with those two forefingers touching, rather than hand in hand."

Mark Lenard decided that Sarek had a profound belief in the superiority of the Vulcan way and that he was disappointed that his son had chosen to go out into the universe. His wife, Amanda, was more sympathetic to her son. Fontana saw her as a more reserved person than the version who appeared in the final script, and believed it was Roddenberry who added the scene in which Amanda tells Kirk about Sarek's relationship with his son, which Fontana felt was too revealing. She did, however, believe that Sarek loved Amanda. "She was a breath of fresh air in his life. There was true love there, there was great respect and certainly great caring between the two of them, but expressed, as far as Sarek goes, in a very Vulcan way."

With the introduction of new alien species and, more importantly, Spock's family, the story established several significant elements

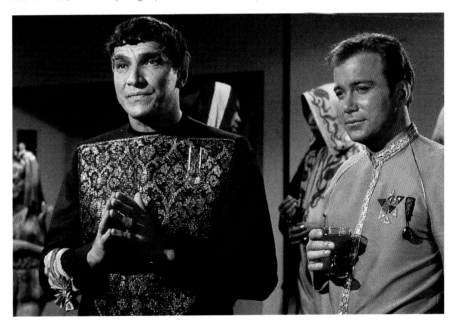

ABOVE: *Mark Lenard tackles his second* STAR TREK *role, as Spock's father Sarek, a character who would return in the movies and in* STAR TREK: THE NEXT GENERATION.

Vulcans," Nimoy remembered. "Mark particularly asked me what specifically there was about Vulcans I'd like to impart to him. I said, 'I think of them as a very hand-oriented people and I think you might find some lovely, interesting way of using your hands with each of *STAR TREK*'s mythology. Both Sarek and Amanda would return in the animated series and the movies, with Sarek even making an appearance on *STAR TREK: THE NEXT GENERATION*. The *STAR TREK* family had gained some important new members.

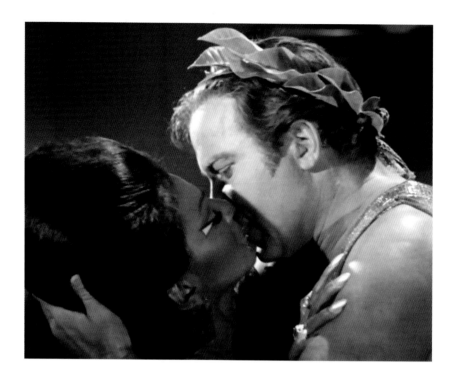

THE KISS

In its third season, *STAR TREK* made history by having a Black woman and a white man kiss for the first time on US network television.

Captain James T. Kirk and Lieutenant Uhura, compelled against their will by the cruel and psychokinetic Platonians, locked lips in the third-season episode, 'Plato's Stepchildren.' The scene – written by Meyer Dolinsky, directed by David Alexander, and, of course, performed by William Shatner and Nichelle Nichols – troubled executives at NBC. A white man kissing a Black woman? On network TV? In primetime? During a period of horrific racial strife, just months after Dr. Martin Luther King's assassination? How might viewers react, especially down South? All involved feared angry calls, protests, boycotts, and perhaps violence.

It turned out that hardly anyone noticed, or cared. The network apparently fielded few, if any, calls or letters of complaint. Nor did the kiss impact the world at large or the entertainment business by opening the floodgates to more such interactions between characters. But that kiss has a place in history.

To be a little more accurate, it was the first lip-to-lip kiss between a Black woman and a white man on US television. There had been interracial kisses before – even in *STAR TREK* Kirk kisses the part-Filipino BarBara Luna (Marlena Moreau) and the part-Vietnamese France Nuyen (Elaan) – but when 'Plato's Stepchildren' was aired in 1968, sexual relationships between Black and white people were definitely a sensitive issue. *STAR TREK*'s executive producer, Fred Freiberger, was determined to address issues of prejudice. Dolinsky's first

versions of the story actually had McCoy kiss Uhura, but under Freiberger's guidance, story editor Arthur Singer rewrote the scene so that it was Kirk not McCoy. Freiberger knew that would cause some alarm. "The network at that time was very nervous," he recalled. "They thought we'd lose the whole southern audience and all of that stuff. I had quite a big battle with what they call program practices, which was censorship. I felt I had won the battle, but without me knowing about it, they had called Gene down and tried to make some kind of compromise. They said, 'Why can't it be Nimoy who kisses her, instead of Shatner?' I said, 'For the reason you want it to be – because he's a Vulcan and it's going to be acceptable to everybody that the Black girl is kissed by a Vulcan. I want it to be Shatner, it's got to be him.'" Roddenberry agreed wtih Freiberger and the Kirk-Uhura kiss stayed.

Back in 2010, via StarTrek. com, a fan asked Nichols if she and Shatner understood while filming 'Plato's Stepchildren' just how important the scene could be. "No," Nichols replied. "To tell you the truth, we were so happy to have a script that was unique and was taking a grand step forward, but we weren't thinking about it [in a historical context]. I think [the producers] were sensitive to it. They saved our scene to be shot when no one

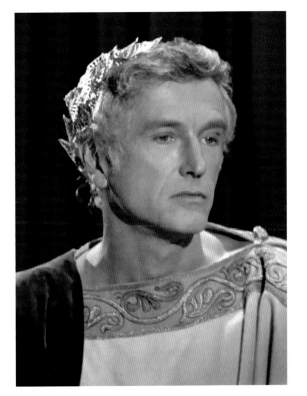

ABOVE: *Despite Freiberger's and Roddenberry's politics, Kirk and Uhura don't kiss willingly. They are forced to do it by the psychokinetic Parmen.*

else was around, at the end of the last day, an hour before the end of shooting."

Details about filming the scene are clouded not just by the passage of time, but also by the occasionally contradictory memories of Shatner and Nichols. Nichols, in her 1994 memoir, *Beyond Uhura*, asserted that the first script draft paired Uhura and Spock, at least until Shatner demanded that Kirk be the one to kiss Uhura. On the set, the day of the shoot, Nichols wrote, director David Alexander "panicked," questioned if they should do the scene, and approached the powers that be. Roddenberry calmed the network brass by offering a compromise. "We'll shoot it both ways," Nichols quoted him as saying. "We'll go right up to the kiss in one take, and then

they'll fight it; then we'll do the kiss in the other take, and then we'll see which one we use." She added: "Of course, Gene knew exactly which one he was going to use, and Bill did, too."

Shatner, in 1993's *Star Trek Memories,* reported that the producers visited him in his dressing room and asked if he'd mind kissing Nichols. His version of events posits that the scene was shot two ways, one in which they "actually kiss on camera," and another that positioned Shatner's back to the camera, creating "the illusion of kissing without ever touching lips." Both Nichols and Shatner noted that network executives watched it all unfold on the set, heightening the pressure of the situation.

The two accounts differ most when it comes to what actually ended up on-screen. Shatner insisted that the non-kiss made the final cut. Nichols, however, wrote: "The next day they screened the dailies, and although I rarely attended them, I couldn't miss this one. Everyone watched as Kirk and Uhura kissed and kissed and kissed. And I'd like to set the record straight: although Kirk and Uhura fought it, they did kiss in every single scene. When the non-kissing scene came on, everyone in the room cracked up. The last shot, which looked okay on the set, actually had Bill wildly crossing his eyes. It was so corny and just plain bad it was unusable.

"The only alternative was to cut out the scene altogether, but that was impossible to do without ruining the entire episode," she continued. With modern technology you can watch the scene frame by frame, and as the shot draws to a close you can see that their lips do touch. *STAR TREK* had earned a special place in history.

NBC were still nervous and didn't advertize the fact that the episode included the kiss. Freiberger, however, took out ads in *Variety* drawing attention to the fact that *STAR TREK* was breaking a taboo, which he – and the ads – described as ridiculous. The greatest triumph is that today a televised kiss between a white man and a Black woman is commonplace. *STAR TREK* may have been first, but it wasn't the last.

MAGGIE THRETT

MUDD'S WOMAN

By the time Diane Pine turned 20, she'd already graced the cover of *Harper's Bazaar* as a model, recorded and released a couple of singles produced by Bob Crewe (famous for his work with the Four Seasons), and guest starred as Ruth Bonaventure in the *STAR TREK* episode, 'Mudd's Women.' Oh, and Pine had changed her name to Maggie Thrett.

"It was," Thrett termed it succinctly, "a whirlwind."

Though she quit the business in 1970 and chose to lead a quieter life, Thrett's entertainment legacy remains impressive. A tall, shapely, dark-haired young woman blessed with bright blue eyes, she convincingly slipped into characters of various ethnicities, including Native Americans and Mexicans. She made memorable appearances in two episodes of *The Wild*

Wild West, the film *Dimension 5* (starring Jeffrey Hunter and released two years after he shot 'The Cage'), and the cult feature, *Three in the Attic*. But it was 'Mudd's Women' that secured Thrett her place in pop culture history. In the episode, Kirk and his crew beam to the ship captained by devious rascal Harry Mudd (Roger C. Carmel). Onboard are three ladies – Ruth, Eve (Karen Steele), and Magda (Susan Denberg) – whom Mudd refers to as "cargo," and to whom he supplies a Venus drug that supposedly maintains their beauty. Spoiler: It doesn't, though the women, for a moment, age horrifically.

"I find it fascinating that people are still so interested in the fact that I was on *STAR TREK*," Thrett marvels during a recent conversation. "I'm still getting fan mail! I get a few letters every week. I got one from Germany, from Nova Scotia, from England. In fact, somebody sent me a five-pound note to cover postage, but the cost of converting is more expensive than the actual postage. So, I kept that as a souvenir.

"It's interesting," she muses. "There are things I appreciate, like old movies with Humphrey Bogart. And even now, I'm still interested in them. So, I get it. *STAR TREK* is one of those things that's kind of classic."

ABOVE: *Maggie Thrett poses with Leonard Nimoy for a publicity picture during the filming of 'Mudd's Women.' Thrett was cast before a single episode of STAR TREK had aired and remembered the cast and crew being happy and friendly.*

Thrett vaguely remembers auditioning for the role of Ruth, and thinks Gene Roddenberry, casting director Joe D'Agosta, and director Harvey Hart, were in the room as she read her lines. She actually auditioned for *Mission: Impossible* the same week and wanted that job more. Why? Neither *STAR TREK* nor *Mission: Impossible* had premiered yet, but *Mission* boasted a better buzz. The *STAR TREK* production team made an offer first, and got their woman.

Contemplating what still stands out most about her 'Mudd's Women' experience 55 years later, Thrett pauses for a moment

and then spiritedly announces, "The makeup, the aging makeup, for the conversion, to make us look old. I had six coats of surgical glue on my face. It shrunk up my face. It took about two hours to apply it and about an hour to get the stuff off. And it hurt! But it worked. It's kind of camp, but that kind of thing is always campy, I think. They knew what they were doing, especially for the time.

"Also, everyone in the cast was very nice," she adds. "They were nice people, all of them. I had no complaints whatsoever. William Shatner was charming. Leonard Nimoy was very nice, but I remember him saying he was in pain all the time from his [Spock] ears. The girls were nice. And I already knew Roger Carmel because he lived in my building. He was a very good actor, very believable and enjoyable, carefree to be around. Everyone was good to one another, and that made it very pleasant."

What else can Thrett reveal? Though most people would consider 'Mudd's Women' sexist by today's standards, she didn't – and doesn't – sweat it. "There might have been some eye candy, but at the same time, I didn't feel like eye candy," Thrett insists. "It was a role, and that was the way to play it. How much can you put in a woman who goes to outer space looking for a husband?" Thrett also confirms reports that she and Roddenberry clashed about overtime pay, which she said he initially denied her and then tried to convince her to sign over the residuals to a charity, a request she rejected.

As for the colorful Venus drugs? "They were Jujyfruits!" Thrett shares. "You know those little glycerin candies? That's what they were. That's what you saw sparkling in our hands. That was our magic drug!"

DRESSING
FOR THE FUTURE

UNEXPECTED EXPOSURE

STAR TREK's costumes made ingenious use of materials and often revealed unexpected areas of flesh.

William Ware Theiss was a smart man. He was always immaculately dressed, rarely seen without a tie or an ascot, and famously sported an impressive mustache. *STAR TREK*'s costume designer was known for his inventiveness, his ability to create something out of the most unexpected materials, and for the sharpness of his tongue. He could be famously abrupt to the point of rudeness.

Theiss's no-nonsense attitude could be forgiven, because in *STAR TREK*'s costume department, time was always a problem. Unlike most TV shows, *STAR TREK* couldn't rely on costume hire companies. It was true that some scripts, such as 'Spectre of the Gun' or 'Return of the Archons,' called for familiar clothing that could be found and rented, but most stories required alien outfits that were unlike anything we had seen before.

Theiss would be one of the first people to see the scripts. He read through quickly, looking for new characters that would need new costumes. As soon as he found one, he would start sketching, sometimes straight onto the cover of the script, other times on a napkin or whatever came to hand, or occasionally even in an art pad. As Theiss sketched, he would be thinking about the practical requirements of the costume – did it need to keep the wearer warm or offer protection?

ABOVE: *Theiss was particularly pleased wtith the Greek outfit he designed for Leslie Parrish, who played Carolyn Palamas in 'Who Mourns for Adonais?' The gown had no visible means of support and depended on Parrish's good posture and the weight of the material to hold it in place.*

One of Theiss's biggest challenges was designing something that looked stylish in a contemporary way and also at home in the future. His approach was to take 1960s fashions and see how much further he could push them; hence many of *STAR TREK*'s characters wore miniskirts, kaftans, and go-go boots.

Examining the history of clothing, he saw that it had become less and less bulky as fabrics became more and more advanced.

He theorized that in the future, fabrics and society would be so sophisticated that they wouldn't need to offer the same kind of protection, either "physically or morally." Roddenberry was clear that he wanted the female costumes in particular to be as revealing as possible, but the network censors were extremely cautious. So Theiss developed an approach whereby the women's costumes would expose unexpected areas of the

ABOVE: *Theiss designed these costumes for the Vulcan guards in 'Amok Time.' Like many of his creations, the style was deceptively simple and was easy to make in the short time available.*

ABOVE: *The Romulan uniforms were made from ribbon fabric, which Theiss sprayed gold, silver, and purple. (Right) Joanne Linville wearing Theiss's design for the Romulan* Commander *in 'The* Enterprise *Incident.' We had seen male versions of the Romulan costumes before, but the female version with its thigh-high boots was specially designed for this episode.*

actress's body – often the midriff or back – while preserving their modesty. In addition to this, it was often difficult to see how the costumes could possibly stay on. Theiss famously believed that an outfit would be sexier if it seemed there was a risk of it falling off. In theory, this could be because of futuristic fastenings. In reality, a lot of double-sided tape was involved.

This approach led to two of Theiss's favorite costumes: Andrea's in 'What Little Girls Are Made Of?' and Carolyn Palamas's Greek-inspired dress in 'Who Mourns for Adonais?' In both cases, the outfits showed off the actors' bodies in unexpected ways. In Andrea's case, the legs of the pants extended to form a cross-shape that covered her breasts. Palamas's outfit only stayed up because of the weight of the fabric that was thrown over her shoulder.

Theiss was constantly searching for materials that looked futuristic, and he often worked out the most unexpected solutions possible. The Romulan costume was made of black ribbon fabric sprayed gold or silver. He used upholstery fabric in 'A Taste of Armageddon,' and on the same show sprayed fabric with metallic paint, using geometric lace as a stencil. Nothing was off-limits and he would employ the most unlikely materials. For

example, the Klingon belt buckles were bubble wrap sprayed gold. The faceplates of the helmets for the crew's environmental costumes were made of the mesh from a screen door, and in 'Elaan of Troyius,' the Elasian guards had place mats stuck to their tunics.

As soon as Theiss had a concept and had chosen a fabric, he needed to get basic approval from the producers. All of this happened before casting. As soon as actors had been selected, they were rushed into Theiss's office where measurements were taken. Theiss's concept drawings were then handed on

RIGHT: *The costumes for the guards in 'Elaan of Troyius' incorporated plastic place mats. This wasn't done to save money – it was more about adding something unexpected.*

ABOVE: Theiss's sketch for Lenore Karidian's outfit in 'The Conscience of the King.' Theiss always wanted his designs to be inspired by contemporary trends that he could project into the future.

ABOVE: The costume Theiss designed for Spock's mother Amanda, who appears in 'Journey to Babel,' could have come straight off the catwalk in 1967. He also designed a coat for her that was worn over this dress.

ABOVE: Theiss's design for Lethe in 'Dagger of the Mind.' Theiss was a fan of kaftans and made use of them on more than one occasion. The dress incorporates some metal panels.

ABOVE: STAR TREK had a running battle with the network censors who were uncomfortable about showing a woman's navel. When Theiss designed Losira's outfit, he used an unusual approach to deal with the issue.

ABOVE: *Theiss embraced the opportunity that 'Elaan of Troyius' gave him to put the Dohlman of Elas in different outfits, and he created several designs for the actress France Nuyen.*

to Geneva Kurd, who would cut the pattern for the costume.

The team rarely had more than five days to create a costume, from Theiss's first thoughts to a design perfectly fitted to an actor as they walked on stage. There was barely enough time to make the costumes, and certainly not if Theiss stuck to the letter of the union agreements, which restricted the number of hours people could work and imposed costs that challenged *STAR TREK*'s limited budgets. Theiss's solution was to set up a nonunion sewing team in an office a block away from the studio, where the costumers could stitch through the night, delivering their outfits through the Desilu windows on Gower Street.

Once a costume had been cut and sewn together, it was fitted to the actor. Roddenberry made a point of seeing every outfit and would frequently request changes at the last minute, often asking for a hemline to be raised or a little more skin to be exposed. Alterations were made at speed, with the final costumes often being delivered hours before the cameras turned over.

From this point on, men's costumes would be looked after by Kirk Templeman, and women's by Andrea Weaver. If necessary, they would sew their charges into their costumes and would be on hand to make repairs if – as they often were – the costumes were damaged on set. Every night, they were sent to be dry-cleaned, returning the next morning for yet more repairs and another day's filming.

DRESSED BY STARFLEET

Gene Roddenberry saw the *Enterprise* as a 'shirtsleeves environment,' a semi-military operation as on a destroyer or a submarine, where the crew were busy at work rather than in uniforms that were meant for formal display. When he looked at most contemporary visions of the future, he always thought the outfits sounded like "long underwear." He didn't want that, so he told Theiss to design something that came in two practical pieces, adding that in the future there would no visible buttons, zippers, or pockets. Roddenberry gave his costume designer another stipulation: he wanted three different colors for the *Enterprise*'s different divisions, and those colors had to be obviously different on both color and black-and-white TV sets.

The budget on 'The Cage' was tight, so Theiss found shirts and pants that he could buy and adapt. The shirts were velour and he managed to find three colors that matched Roddenberry's requirements: a gold, a blue, and a brown. The pants were a dark navy. Theiss also designed the *Enterprise* badge – which has three different symbols in the middle – and the rank insignia, and sewed them on. In 'The Cage,' he also provided the crew with jackets that they could wear when they beamed down to a planet.

These costumes were left unchanged for the second pilot, 'Where No Man Has Gone Before,' because there was no money for anything extra, but Roddenberry wanted changes. He told Theiss that he imagined the crew would have what we would now call 'smart fabrics' that could adjust to the conditions on any planet, so the jackets were unnecessary and were abandoned.

ABOVE: *Roddenberry always wanted a futuristic-looking fabric for the uniforms and different colors for the different divisions. Theiss found velour shirts, which he altered, but the red uniforms were not introduced until 'The Corbomite Maneuver.'*

When *STAR TREK* was picked up to series, the producers revisited the uniforms and upgraded the design, with countless voices chipping in from the production team, Desilu, and the network. Theiss was not a fan of the process and always felt that the end result was designed by committee. For the revised uniforms, he sewed on black collars and updated the rank insignia. The brown shirts were abandoned in favor of a new red version. According to Grace Lee Whitney, she lobbied for the chance to wear a miniskirt rather than pants. The idea was embraced by Roddenberry, so Theiss designed a female version of the uniform. He was also called on to design

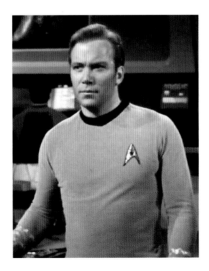
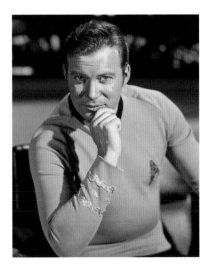

ABOVE: *The uniforms evolved throughout the series. In the second pilot, the color of the collar matched the rest of the shirt. When regular production started, Theiss added black collars and revised the rank insignia. In the third season, the design stayed the same but the material was changed.*

ABOVE: *This early Theiss sketch shows an unused concept for Kirk's uniform.*

like a belt and holster from a Western, so it was replaced with a black version before this was abandoned in favor of simply sewing some Velcro into the pants for the equipment to stick to. During production, the Velcro could often be heard as a phaser or communicator was pulled free of it.

Union regulations meant that the uniforms had to be dry-cleaned every night. This involved removing the badges and rank insignia and sewing them back on once the uniform was clean. As a result, both elements moved around a little from scene to scene. The dry-cleaning process also meant that the uniforms shrank, so the fit changed over the course of the series and eventually led Theiss to replace them in the third season with polyester double knit in matching colors.

Years later, Theiss would be amazed that people were still interested in the uniforms, insisting that he would have designed something more futuristic had he been given the chance. The committee design, however, has stood the test of time, becoming one of Theiss's most familiar and iconic designs.

Rand's haircut, which Roddenberry thought looked suitably futuristic.

These uniforms made their debut in the first episode of regular production, 'The Corbomite Maneuver,' but they were still evolving and the collars were visibly wider. Since the episodes were broadcast out of production order, the uniforms make unexpected changes in the first season.

Initially, the crew were given belts to hold their phasers and communicators. The first version was brown, but this looked too much

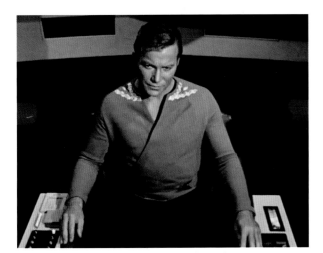

ABOVE: *Roddenberry and Theiss gave the captain a different uniform to make him stand out from the rest of the crew. He wore this in the first season, but it was replaced by a wraparound shirt in the second season.*

Courtesy STAR TREK: Original Series Set Tour/James Cawley

ABOVE: *Grace Lee Whitney claimed that she convinced Theiss and Roddenberry to introduce the minidress so she could show off her legs.*

MARK LENARD

ROMULAN AND VULCAN

H
e was nearly Mr. Spock. *STAR TREK*'s casting director Joseph D'Agosta actually recommended him for the part. It turned out Roddenberry already knew he wanted Leonard Nimoy so Mark Lenard missed out, but everyone was impressed with him, so it was inevitable he would be brought back for another role. In the end he would play two of *STAR TREK*'s most memorable characters: the Romulan Commander in 'Balance of Terror' and Spock's father Sarek in 'Journey to Babel.' Lenard would prove to be one of *STAR TREK*'s most important guest stars. He was the first Romulan and played an important role in giving them a sense of dignity and honor. As Sarek, he would help to define what it meant to be Vulcan, and years later he would return in the movies and in *STAR TREK: THE NEXT GENERATION*.

"I've always been surprised, moved, and excited by the *STAR TREK* phenomenon," Mark Lenard told the New York Times Syndicate in 1995. "But after all this time and all the *TREK* incarnations, I've gotten pretty used to it being a part of my life and to the idea of it possibly going on forever. Many people say my first appearance, as the Romulan Commander, was one of the better *STAR TREKs*, and maybe my best performance. I love Sarek and got to do some good things, but I'd have to say my best acting opportunity was 'Balance of Terror.'

Lenard – a man of regal bearing, with a voice to match – also played the lead Klingon in *STAR TREK: THE MOTION PICTURE* and holds the distinction of being the only *STAR TREK* actor to slip into makeup and costume as a Vulcan, a Klingon, and a Romulan. "Aliens are sort of wish fulfillment," he once said. "It's really getting outside all that we can cope with. I like character roles anyway. I can do anything but play a human, I guess." While he relished the acting challenge inherent in the Romulan Commander, it was Sarek with whom he became most associated. Brilliant, forthright, fully Vulcan and utterly logical, Sarek, Lenard explained, "taught Spock, but he doesn't have any of the human frailties that make Spock so endearing." Still, Sarek clearly possessed a soft spot for humans. He married one, Amanda (Jane Wyatt, whom Lenard called "awfully sweet"), and helped raise their half-human, half-Vulcan son, Spock. Father and son clashed, often and harshly, but Sarek – as Spock eventually learned via a mind-meld with Jean-Luc Picard – loved and was proud of Spock.

The actor played Sarek over such a span of time, Lenard told *The Official Star Trek Fan Club,* that he started to consider himself an actual Vulcan. "Leonard Nimoy said in his book, *I Am Not Spock*, 'If I'm not Spock, who is?'" he recounted.

ABOVE: *Mark Lenard as Spock's father Sarek in 'Journey to Babel.' Lenard had originally been brought in for the part of Spock, then played the Romulan Commander in 'Balance of Terror,' before finally landing on the part that he is best known for.*

"We've taken over the personas of these characters because we are them. They don't exist anywhere else. It isn't literature or something; they only exist on the screen and within us.

"I find that there is more interest in Vulcans, and I have it, too," he continued. "I think the possibilities are unlimited for the Vulcans. As I watch some of the old episodes, whenever something comes up, the Vulcans usually have a way to cope with it. Spock seems to be able to mind-meld with just about anything. I'm just fascinated by the fact that there was so much interest in them. I get a very spirited reception wherever I go, and it seems to be growing."

Lenard passed away on November 22, 1996. He left behind his wife, Ann, and their two daughters, Roberta and Catherine, as well as millions of *STAR TREK* fans around the world. He'd always appreciated the fans, the opportunities *STAR TREK* afforded him, including occasional work and steady convention appearances, and the fact that *STAR TREK* endured – and endures. "I have asked all over the world what is there about *STAR TREK* that made it unique among science-fiction shows," the actor commented to *Starlog* in 1991. "People say different things; nobody seems to know. It's a fine science-fiction show and stands for high ideals, and that struck a chord with many people. It's hard to run across someone who doesn't know of *STAR TREK*. There's something in the chemistry of the characters and concepts that made it unique and a particular success.

"Ultimately," Lenard continued, "I don't know what the deal is. I know that the late 1960s was a strange time and people's involvement with self-discovery attracted them to Vulcans and Spock. It was a time to be antiestablishment but cool. *STAR TREK* had a particular meaning, and it was the right time for that meaning."

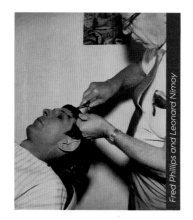

Fred Phillips and Leonard Nimoy

MAKEUP
DEPARTMENT
FIRST IN, LAST OUT

STAR TREK's legendary makeup artist created alien races with the clever use of greasepaint and prosthetics.

STAR TREK's working day began in the makeup department. Some time around 6 o'clock every morning, Fred Phillips would open the small room on the edge of Desilu's Stage 9, make himself a cup of coffee, roll a cigarette, and lay out a pair of Vulcan ears. By 6.30, Leonard Nimoy had arrived and taken a seat in one of the three barber's chairs. One of the production assistants would take breakfast orders and head over to the commissary, while Phillips started the work of transforming Nimoy into Spock. Half an hour later, at 7 o'clock, William Shatner would arrive, and the joking would begin as Nimoy and Shatner exchanged puns. A little later, De Kelley would join the conversation, and so on.

The makeup room was one of *STAR TREK*'s innovations. When they filmed 'The Cage,' the normal practice at Desilu was for makeup to be done on portable tables at the edge of the soundstage. As Roddenberry discovered, this cost the production

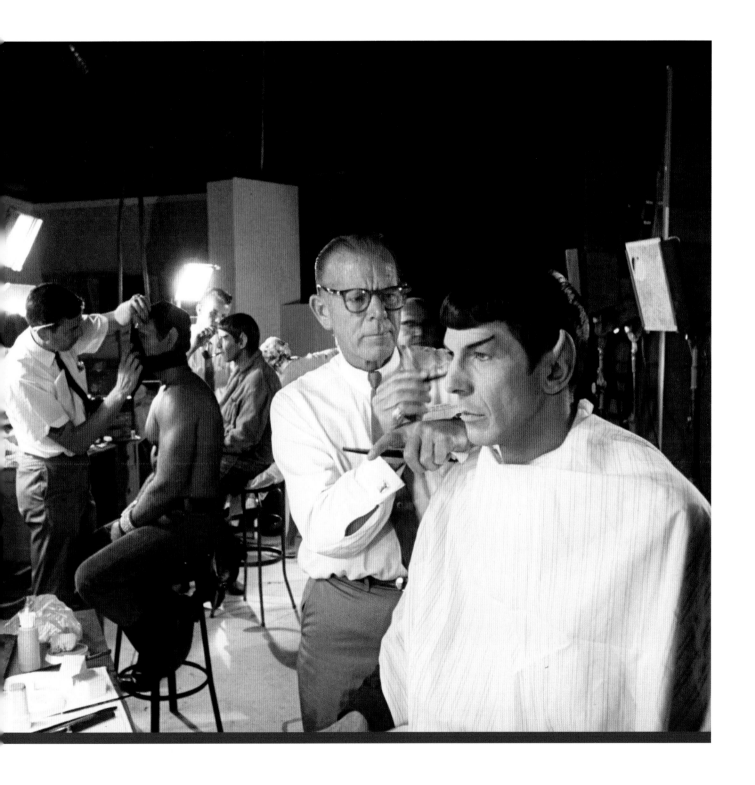

ABOVE: *Fred Phillips puts the final touches to Spock's Vulcan makeup during the filming of 'Amok Time,' while his assistants make up other Vulcan characters. STAR TREK's makeup room was on the edge of Stage 9, which housed the Enterprise sets. It was introduced so that Phillips could work in a well-lit, professional environment.*

MAKING IT GREEN

One of *STAR TREK*'s big selling points was that it was in color. Roddenberrry wanted to take advantage of this by giving some of his aliens strange hues. Most memorably, the Orion slave girl would be green. Phillips got a head start by doing some makeup tests with Majel Barrett. It was important to find a tone that looked good on a color TV and on the black-and-white sets that were in most homes. So the next day, the team assembled to look at the footage they had shot. To their surprise, Barrett had an almost normal skin tone. So they tried again, this time with a stronger colored makeup. The results were much the same, so they tried a third time. Once again, the footage came back and Barrett was not green. In bemusement, they called the lab where the film was being processed, to discover that the technicians had been working overtime to correct Barrett's skin tone. They sighed with relief and told the lab not to bother.

ABOVE: *Majel Barrett tries out the green skin and a variety of other techniques in a test shot for 'The Cage.'*

RIGHT & FAR RIGHT: *Fred Phillips applies makeup to Susan Oliver during filming. Applying grease paint to her body was harder than just covering her face, since it cracked when she moved and had to be constantly touched up.*

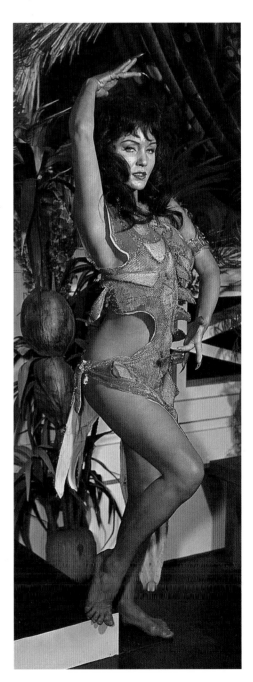

ABOVE: *Clint Howard as Balok. The makeup was designed to make him look very different from a human child, so he was given a bald cap and large bushy eyebrows.*

ABOVE: *Nimoy and Kelley in* STAR TREK's *makeup room shortly before filming. Shatner and Kelley normally arrived an hour before they were needed on set.*

valuable time. Some of the makeups were complicated and the edges of the stage weren't properly lit, so problems with the more complex makeups only came to light when they were ready to film. So when work started on the second pilot, Roddenberry wrote a memo calling for the construction of a makeup room with "white walls and ceilings, hot and cold running water, adequate lights, hair dryer, shampoo basin and any other equipment usual for complicated makeup and hairstyling jobs."

The memo was almost certainly written after consultation with Phillips, who had worked on 'The Cage,' but the first person to benefit from it would be Robert Dawn, who supervised the makeup on 'Where No Man Has Gone Before' because Phillips was unavailable. When the series went into regular production, everything was relocated to Desilu's Gower Street lot, next door to Paramount, Phillips returned and the permanent makeup room was established.

Roddenberry always had reservations about traditional science-fiction monsters. They would appear on *STAR TREK*, but as the Writers' and Directors' Guide made clear, most aliens would be created with the clever use of makeup. As the guide says, "some modification of form, color, and hair distribution

ABOVE: *Makeup was used to create the mottled skin pattern that was caused by the Salt Vampire in 'The Man Trap.'*

ABOVE: *Arlene Martel admires her Vulcan ears and hair for her role as T'Pring. This was the first time she had worn any kind of prosthetic and she was delighted with the result, even though it took two hours to get her ready.*

LEFT: *Ted Cassidy as Ruk in 'What Are Little Girls Made Of?' Cassidy was a giant of a man, and Phillips gave him a bald cap, covered his eyebrows so they were invisible, then painted on very strong shadows to exaggerate his striking bone structure, making him look distinctly alien.*

can be accomplished without undue strain." Phillips was well qualified for this role. He had headed up the makeup team on *The Outer Limits* and had solved the problem of how to create convincing ears for Spock when it was beginning to look impossible. Most aliens would be realized by changing skin tones, adding wigs, and reshaping eyebrows. Occasionally some, such as the Vians in 'The Empath,' would require a latex head. Vulcans, Romulans, and the Tiburon Dr. Sevrin would get an extravagant ear.

The more extreme alien creatures, such as the Horta, the Gorn, the M-113 "Salt Vampire," and the Excalbians would be created by Wah Chang's Projects Unlimited or Janos Prohaska, who, like Phillips, had worked on *The Outer Limits* – but the rest was left to Phillips and his team.

In addition to his reservations about "rubber suit" monsters,

Roddenberry warned against giving aliens complicated hands, by adding fingers or entire glass hands, for example (both effects that had featured on *The Outer Limits*). He advised that, when complex prosthetics were called for, the team should make molds of the actors' heads so they would have time to experiment with different appliances without needing the actor. Finally, he said that rather than relying on the prop shop or prop suppliers such as Projects Unlimited, they should commission specialist makeup labs to make prosthetic appliances.

Spock's ears aside, on most episodes Phillips' time was taken up with "ordinary" makeup. In fact, the first problem he faced was what to do about the regular cast's haircuts. Roddenberry wanted the hairstyles to be futuristic in some way. Leonard Nimoy agreed to Spock's bowl haircut, but guest stars would not be so accommodating. They were, after all,

MAKING UP MR. SPOCK

Applying the Spock makeup took roughly 90 minutes. The first stage was to clean Leonard Nimoy's ears before applying a layer of spirit gum to them. Next, Phillips would slip the latex ears he had made the night before over Nimoy's own ears and use pieces of double-sided wig tape to stop them sticking out comically from the side of Nimoy's head. Phillips then applied a plastic sealer to cover the joins with Nimoy's ears and to keep the color consistent. After this, he applied Rubber Mask Grease to change the color of the ears to a warm yellow.

A similar colored cream was used to make the color of Nimoy's face, neck and hands match. Finally, Phillips applied gray-blue eyeshadow before penciling in the line of Spock's pointed eyebrows, which were made from yak hair glued on with more spirit gum.

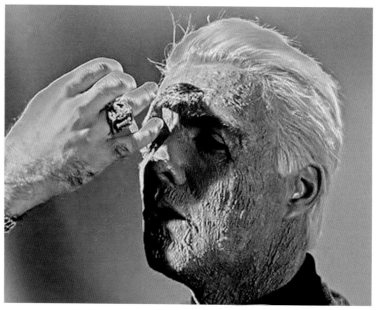

ABOVE: *Sean Kenney is made up to look like someone who has suffered severe radiation poisoning. On the first tests, his hair was dyed completely white but this looked wrong, so it was given a little yellow.*

ABOVE: *For the Vians in 'The Empath,' Phillips was able to reuse prosthetic heads that he had made for the pilot of* The Outer Limits. *The rubber heads' look took three hours to apply.*

working actors and changing their look for a few days' work on *STAR TREK* wasn't an option. The solution was to give all the men pointed sideburns. The actors could grow their hair to have these appear naturally or, if necessary, they could be touched in with a makeup pencil. In the 1960s, most women wore their hair long and this could be restyled by Virginia Darcy, who looked after all the hair in the first season, or by Pat Westmore, who replaced her for the rest of the series' run.

Complex hairstyles could mean that it took much longer to get an actress ready than her male counterparts, so when a show had heavy makeup requirements, Roddenberry recommended that most of the guest cast and extras should be men.

Once the morning makeups had been done, Phillips and his assistant, Jack Stone, would be on hand for touch-ups during production and start work on any actors who had been called to the set later in the day. Whenever Phillips got a chance, he

ABOVE: *'Journey to Babel' called for more aliens to be seen in one place than any other episode of STAR TREK. Phillips created most of the alien diplomats with a combination of skin makeup and exotic hair. The Andorians were blue-skinned and we saw two gold-skinned delegates from an unidentified species.*

Black & white photographs courtesy STAR TREK: Original Series Set Tour/James Cawley

ABOVE: *These rare photographs show makeup tests for the Tellarite, who wore a prosthetic, and for various delegates who milled around in the background.*

would read through the scripts for upcoming episodes and start sketching ideas in an art pad. A typical day was 13 hours long, and it didn't end when Phillips left the studio. When he got home at around 8 o'clock, he would fill the molds for Spock's ears with latex and put them in the oven, taking them out at midnight so they could cool overnight and be applied the next morning.

Phillips always said that he enjoyed creating "fantasy makeups" most of all. Over the course of the show's three years, he brought various alien species into being. When a young Clint Howard came in to play Balok, Phillips asked if he'd be willing to have his head shaved. When his dad said 'No,' they decided to give him a bald cap and bushy eyebrows that would be out of place on a human child. A similar approach was used for Ted Cassidy (best known as Lurch in *The Addams Family*), who played the android Ruk. Once again Phillips used a bald

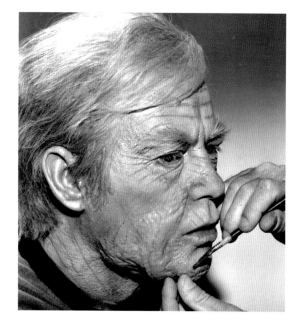

cap but this time there were no eyebrows at all. Instead Phillips gave him an unusual skin color and painted strong shadows on to his skull to enhance his bone structure.

The two-part story 'The Menagerie' was designed to reuse the original pilot, 'The Cage.' John Black wrote a framing sequence in which Spock rescues a critically injured Captain Pike in order to return him to Talos IV, where the Talosians had the power to let him live a full life in his mind. Jeffrey Hunter was unavailable, so the plan was to make up Sean Kenney to look like a badly disfigured Pike. In his memoir, *Captain Pike Found Alive!*, Kenney remembered that Phillips and Ray Sebastian created the makeup together. Per Roddenberry's notes, they began by taking a cast of Kenney's face and from this they made a model to use for designing the makeup. Rather than creating a prosthetic, they decided on several treatments that could be applied directly to Kenney's face. They covered it with spirit gum and stippled white cotton and latex on it to create a rough texture. Then they taped the corners of his eyelids down. When rehearsals began under the hot studio lights, the dark scar on the side of Pike's face started to melt. Sebastian's solution, Kenney remembered, was to cut a piece out of his jeans and stick it to Kenney's face. The denim fabric was reapplied every day.

A similar technique, in which latex was applied to the actors' faces, was used to age the cast for 'The Deadly Years,' an episode that required them to grow old during the course of the story. This was one of the biggest challenges Phillips faced. Designing five sets of old-age makeup should have taken six weeks. Phillips had 11 days – so he called in as many makeup artists as he could.

The first stage of the aging process was accomplished by adding highlights and shadows with ordinary makeup. For the second and third stages, the makeup team used a technique known as stretch and stipple. One makeup artist would pull the actor's skin tight, while another applied liquid latex. It was dried quickly and the skin was released. The latex creased, forming realistic-looking wrinkles. For the fourth stage, which showed the actors in extreme old age, the makeup artists added foam jowls and eye bags before applying the

Black & white photographs courtesy STAR TREK: Original Series Set Tour/James Cawley

LEFT: *The old-age makeup needed in 'The Deadly Years' was extremely challenging. Kelley and Shatner both spent hours in the makeup chair with three people working on them, applying latex to their skin and adding prosthetic jowls and eye bags.*

stretch and stipple technique. The process took up to three hours with three different makeup artists working at the same time. On one particularly frustrating day, Shatner's makeup was completed just in time – only for everyone to discover that the shooting day couldn't be extended because of union deals.

On two occasions, Phillips gave alien characters antennae. In both cases (the Andorians and the people of Vaal), they were attached to the wigs the actors wore rather than directly to their heads. The people of Vaal also had tattoos drawn on their faces, a technique that was repeated for Sevrin's followers in 'The Way to Eden.'

'Journey to Babel' called for a host of alien ambassadors, which Phillips created in next to no time. Famously, the episode featured the blue-skinned Andorians and the pig-faced Tellarites, but it also included a dozen or so extras with unusual skin tones and hair.

The Vians in 'The Empath' were among STAR TREK's most obviously alien species. With little time or money, Phillips was able to repurpose some full-head masks that he had used on The Outer Limits.

In the third season, Phillips had to transform Melvin Belli's Gorgan as Kirk exposes his true nature. He took a full-face cast of Belli, again for use in designing the makeup. When it came to filming the scene, Belli was supposed to transform as he melted in front of our eyes. Those few seconds took half a day to film. Belli's head was locked into place with a clamp. He delivered a few seconds of action. He was released from the clamp, and went to makeup where Phillips added prosthetics, building up his nose and making his jowls melt. Then Belli returned to the bridge set, where his head was put in the clamp to make sure it was in exactly the right position.

Half a century later, Phillips' work stands up remarkably well, and it established an approach that would benefit future generations of STAR TREK. Phillips went on to work on series such as The Man From Atlantis, and his film credits include One Flew Over the Cuckoo's Nest, but he will always be remembered as the father of STAR TREK's aliens.

ABOVE: *Phillips' design for Gorgan in 'And The Children Shall Lead' is the only one of his makeup sketches we know to have survived. It was reprinted in 'Inside STAR TREK: The Real Story.' Every time a new version of the makeup was applied, Melvin Belli's head had to be clamped back in place on set.*

BARBARA LUNA

THE CAPTAIN'S WOMAN

"When I'm at autograph shows – not just *STAR TREK* conventions, but autograph shows – and I have all my photos out, fans will be at the table looking at the photos," BarBara Luna shares. "They'll look at the photos and say, 'Oh, did you meet Frank Sinatra? Oh, did you meet Henry Fonda? Wonderful. But let's talk about *STAR TREK*…'"

There's a good reason people want to talk about *STAR TREK*: Luna made an indelible impression as "captain's woman" Lieutenant Marlena Moreau in 'Mirror, Mirror.' The actress remembers feeling a bit shocked when she was offered the role. And she felt that shock not over the direct offer – "There was a point when I'd already earned the right to be offered a script rather than having to go and read for it" – but as a result of the role itself.

"I thought, 'My gosh,' because almost all of the roles I portrayed were Hispanic or Japanese or Chinese or Vietnamese or Indian," she recalls. "Because of my ethnicity, which I always thank my parents for, you couldn't really pin down my look. If you see all the characters I played you know exactly what I'm talking about. Marlena was surprising because there was no accent involved. I thought, 'Gee, I love this role because she's just a woman. No accent. Just a woman.' When I was offered Koori on *Buck Rogers*, it was the same thing. She was a bird… [laughs], but still.

"That's one of the things that's so intriguing about the sci-fi world," Luna continues. "You can be hired just as an actor or an actress and not for any particular ethnicity. Things are much better today. It's quite wonderful because things are not as stereotypical anymore. I had many arguments with producers where I'd be hired for a role and they'd change the character's name to a more Hispanic name. I'd march up to the producer's office and say, 'We can't do this!' So, I feel that many of us paved the way for actresses like Jennifer Lopez and Cameron Diaz and Salma Hayek, who are hired only as actresses and not because they speak with an accent."

Luna and Shatner, whom she called "wonderful," hit it off She told *Starlog,* he was "a good kisser" and ranked him right behind Michael Landon and Robert Hays among her on-screen smooch partners. Asked more recently what stood out most about her days shooting 'Mirror, Mirror,' Luna immediately cites Lieutenant Moreau's massive hair and Mirror Moreau's slinky, belly-baring costume.

"When I want a good giggle, I always look at Lieutenant Moreau when she comes in at the end with her hair piled up to the ceiling," Luna says. "Those hairdos, they were so funny. But, actually, something awful happened. The story is

ABOVE: *BarBara Luna as Marlena Moreau in 'Mirror, Mirror.' In the Mirror Universe, the captain had certain privileges, including a "captain's woman." The character of Marlena proved that people in the Mirror Universe weren't inherently evil and Kirk returned to discover her counterpart on his own version of the* Enterprise.

kind of known. I woke up with a strep throat and a very high fever after filming for four days. Of course, I couldn't call the studio and say, 'I'm sick. I'm not coming in.' So, I got into my car and drove to work. They took one look and sent me to the medic, and he said, 'Oh my God, she's so contagious.' The scene we had left was the scene in the cabin, the kissing scene with Shatner. I barely had a voice. The decision was to send me home and go on to the next scene. I went back a month later and completed the show. I guess while I was recuperating, I lost several pounds," she continues. "So, when I arrived on set in the costume that was made for that scene, Roddenberry said, 'Oh, my gosh, that's awful. No.' Bill Theiss, the costumer, came out, and genius that he was, he put me in a bikini and wrapped this material around me. And what you see is that beautiful caftan in the cabin scene."

Luna – as her friends call her – settled into retirement in the 1990s, though she popped up in a couple of episodes of a *STAR TREK* fan series and remains a popular convention guest. She's also been a longtime volunteer with the charitable organization Thalians, which raises funds to "educate and enlighten the world" about mental illness.

If there's one thing missing from Luna's impressive resume, it's a second episode of *STAR TREK.* Fans query her about it all the time and the thought has crossed her mind as well. "Many people ask me why they didn't do more with Moreau, why there wasn't a sequel, because it seems, when she appears at the end, that there could be a continuation," Luna explains. "I don't know. This is only conjecture on my part, but if they had any plans, when I got sick, it probably nixed the idea. But they may have never had plans at all."

INSIDE
THE MONSTERS

Some of *STAR TREK*'s most misunderstood monsters were brought to life by a trio of talented stunt performers.

G ene Roddenberry never wanted *STAR TREK* to be a "monster show." Even when we did see so-called monsters, they were often misunderstood and *STAR TREK*'s message was (almost) always that there was something more complicated going on. But the truth is people remember the monsters. They were unmistakably alien, and they stuck in the mind whether it's the M-113 "Salt Vampire" sucking the life out of a crewman, the lizardlike Gorn overpowering Captain Kirk, or the Horta shuffling across the ground to protect her young.

And so, we are forever indebted to Bobby Clark, the most recognized of several stuntmen who played the Gorn; Sandra Gimpel, the stuntwoman concealed deep within the Salt Vampire; and Janos Prohaska, who embodied several monsters, including the Horta, the Mugato, and a birdlike creature that the Talosians imprisoned alongside Captain Pike.

Bobby Clark likes to say he was "Gorn to *TREK*," and that just might be true. He performed countless stunts in countless movies and television shows, often – even usually – going uncredited. He made his mark on *STAR TREK* when, for 'Arena,' he stepped into Wah Chang's Gorn costume and fought Captain Kirk. The exact details are lost to history, but it's understood that Clark and

Behind-the-scenes photographs Courtesy Gerald Gurian

THE FATE OF THE GORN

After they were used in 'Arena,' the two Gorn costumes had pride of place in the writers' office, where they stayed until STAR TREK was canceled. On the last day, a young apprentice editor named Herb Dow remembers walking past the STAR TREK sets for the last time. "They threw all the props in a dumpster by the stage. So I took home two boxes of tribbles, the charts from sickbay, the 3-foot Enterprise model, and one of the Gorn suits. Can you imagine me cycling across the lot with the Gorn costume to my car? I kept the charts and the tribbles in my garage. A leak developed – the charts were just chalk and the tribbles got ruined, so I threw them out. Eddie Milkis asked for the Enterprise back when they were trying to make the new TV series in the '70s. I used to wear the Gorn suit at Halloween. That thing was really hot. I remember wearing it when we drove to a party across the valley. I put the head on and I remember people on the Ventura freeway backing up to get a look. A friend of mine called me and said, 'Do you still have that Gorn suit? I'll give you a thousand dollars for it.' So I sold it to him. I found out later he sold it for fifty!"

D. C. FONTANA GENE COON

Gary Combs did the Gorn's stunts, William Blackburn donned the Gorn head for close-ups, and Ted Cassidy recorded the character's voice.

It all began when director Joe Pevney phoned Clark, with whom he'd worked before, and said, "I've got a show for you." To Clark's questions, Pevney simply replied, "Bobby, you'll like it. Take my word for it. It'll be good, and it'll be good for you." Clark's answer was likewise simple: "All right, sure. I trust you." He then headed over to the Desilu wardrobe department.

"I got to the room they sent me to and looked around, and I didn't see any wardrobe," recalls Clark, now in his mid-80s and sharp as a tack. "I'm used to seeing cowboy clothes, or gangster clothes, or something like that. And I didn't see anything that said Bobby Clark on it." Finally, he says, "I came across an old pipe rack, and there's this big rubber suit hanging over it. I didn't see the head at the time. I thought, 'What am I supposed to do with it?' I figured out I was supposed to be some sort of creature. The costume wasn't made for me. It was made for the size of me. Later, I get called to go to the Vasquez Rocks, to shoot the episode. The wardrobe guy had the head there, and I knew I was in for something of a big surprise. Even during shooting, Joe didn't say I was the Gorn. He just said, 'You're a reptilian that moves rather slowly.'"

On set, the crew zipped him into the suit, attached the head, and strongly advised him not to drink much coffee. To answer the question of a million fans, "Yes, it was pretty darn hot in the costume." Shatner and Clark worked out the fight choreography. "I had a good time with Bill," he says. "The crew was great. I got along with everyone." Clark also collaborated with Shatner's stunt double, Dick Dial.

After the big fight, Pevney called upon Clark to "lumber around a lot," as the Gorn and Kirk stalked each other. "The suit was cumbersome and not easy to maneuver around in," he explains, "especially because I was walking through the bush and not on concrete, and the feet were pretty big." So, who did what between Clark and Gary Combs? "Gary and I were off and on in scenes, in the costume," Clark replies. "It's hard even for me to tell just exactly what he did and what exactly I did."

Clark returned to STAR TREK for three other episodes and continued to perform stunts in shows and movies for 25 years. Thanks to the recommendation of one of his sons, Clark has been a favorite on the STAR TREK convention circuit since 2000. In a full circle moment, the STAR TREK: ENTERPRISE stunt coordinator, Vince Deadrick Jr., invited Clark to visit the set of 'In a Mirror Darkly, Part II,' the show's Gorn-centric episode. "It made me feel a little honored to have somebody invite me there," Clark notes. "I'm sitting in this chair, watching, and it was pretty different from when I was working with cameras.

Mugato photo Courtesy Gerald Gurian

ABOVE: *The many monsters of Janos Prohaska. From left to right: an alien bird creature that was imprisoned alongside Pike in 'The Cage'; the Mugato in 'A Private Little War'; and the rocky Excalbian in 'The Savage Curtain.'*

Now they have all this technical stuff, and they were doing the Gorn [with CGI]. I watched the director watch the screen of the scene being shot. It was really something to go there and see that."

Janos Prohaska's STAR TREK journey covered five years, beginning in 1964 with 'The Cage' and concluding in 1969 with one of the show's last installments, 'The Savage Curtain.' Born in 1919 in Budapest, Hungary, Prohaska began as a Hollywood stuntman, but quickly found his niche portraying – and creating – elaborate costumes for creatures. He'd already played chimps and gorillas when he stepped into the humanoid bird and arthropod ape built by Wah Chang for 'The Cage.'

When the series went into regular production Prohaska, who had played all manner of creatures on *The Outer Limits*, figured that STAR TREK would probably be in need of monsters – and he was right. He struck a deal with Robert Justman, with whom he'd worked on *The Outer Limits*, and Gene Coon: Prohaska could devise creatures and if one felt right for a script, they would rent the costume and hire him to play the character. A week later, the story goes, Prohaska unveiled a blobby organism, and demonstrated what it could do by scuttling over a rubber chicken before throwing bones

ABOVE: *Prohaska's most memorable performance was almost certainly as the Horta. Gene Coon wrote the script because he was impressed by the costume Prohaska had designed and wanted to create a story around it.*

ABOVE: *The true face of the Salt Vampire. Gimpel removes the creature's head while filming the scenes in Kirlk's quarters for 'The Man Trap.'*

out the back. He was soon before the camera, portraying the deadly but misunderstood Horta in 'The Devil in the Dark,' although it's worth noting that Prohaska simply tweaked his costume – a massive microbe – from *The Outer Limits*' final episode, 'The Probe.'

In their book, *Inside STAR TREK: The Real Story*, Justman and Solow described Prohaska as follows: "Although small in stature, he was muscular and possessed incredible strength. When not working, Janos was a sweet man, mild, modest, and unassuming. But once inside a costume, he 'became' the creature and showed a much darker side of his nature."

Speaking to *TV Guide* in 1969, Prohaska observed, "From

the whole block, children in my neighborhood know when I've finished a monster, and they all come around me, taking pictures... I do not know how they know when I have finished a new one, but they know. Most of the time I don't want to be frightening. I did a show with Lucille Ball. I like that. I'd like to be a candy monster. I would like to do a children's series... I'd rather do something funny, not killing."

A petite ball of energy and sunshine, Sandra "Sandy" Gimpel is the sweetest and most vibrant lady on the planet. So, it's ironic and requires a grain of salt to accept that the stuntwoman/actress/dancer played the M-113 entity in 'The Man Trap.' The creature, glimpsed in human form as Dr.

Courtesy Gerald Gurian

ABOVE: *Sandy Gimpel in full Salt Vampire costume attacks Captain Kirk. It was impossible for her to see what she was doing, so she rehearsed the action of grabbing his head until she could do it blind.*

McCoy's former love, Nancy Crater (Jeanne Bal), and other characters, soon revealed its true visage: ghastly face, white/purplish hair, sparse, jagged teeth, and suction-cupped hands. It literally sucked the salt out of its victims, leaving them dead.

Though shot fifth, 'The Man Trap' – thanks to its effective sci-fi premise and terrifying shapeshifting monster – launched STAR TREK on September 8, 1966. Similarly, 'The Man Trap' wasn't Gimpel's first STAR TREK gig. A member of stunt coordinator Paul Stader's squad of stuntpeople, Gimpel popped up as an ethereal, pulsing-headed Talosian in 'The Cage.'

"I worked on everything Paul did – *Lost in Space, STAR TREK, Time Tunnel, Land of the Giants, The Poseidon Adventure, The Towering Inferno…*," Gimpel recalls during a recent conversation. "He knew I could handle the makeup and prosthetics, that I wasn't allergic to anything. The [Salt Vampire] costume was custom-made by Wah Chang. I had fittings. I think they did a cast of my head and made the creature's head for me. The only problem was the suckers were a good eight inches beyond my own fingers. And the eyes were slits. I had no peripheral vision. I rehearsed in full costume and couldn't figure out where Shatner was. When I'd reach for him, the suckers were beyond his head. They had to remove the head for us to rehearse. So, I'd take the head off, figure out where to stand to get the suckers on his face, and then I could do it blind, with the head on. That's when they got the picture of me holding the head."

Gimpel, who is still working today, reports that she barely interacted with Jeanne Bal, because "the scenes were so technical that we just had to get them done, especially when I had to get shot, fall backward and hit the wall, then slide down it. They had to make sure Jeanne was in exactly the same position I was. Everything had to line up so that one person would morph into the other. It's so different today. It was a crude way of doing it, but the only way they knew how."

Gimpel hit it off with director Marc Daniels and came away impressed by Shatner. "I worked a lot with Marc after that," she says. "I loved him. For 'The Man Trap,' he told me basically what I was supposed to do, how to react. I listened and did what he told me. Bill and I didn't talk much, but he was professional… If you're doing a scene with someone, but the director is shooting a close-up of them, it's only courteous to stay and do your side, to help the other person. Bill did that for me. I used to teach karate at a gym in Studio City where Bill would come in and work out," Gimpel continues. "I actually talked to him more then than any time before or after! So, I told him I was the Salt Vampire. We had nice conversations."

Though frightful and lethal, the M-113 creature provided companionship to Robert Crater and didn't kill for thrills or out of malevolence, but purely for survival. Fans felt compassion for it, just as they would later in season one, when 'The Devil in the Dark' introduced Prohaska's Horta. "The Salt Vampire was the last of its kind, and people were supposed to be sad that we were killing it off," Gimpel asserts. "They were going to be extinct. The only way they could survive was to have salt, and humans have salt in their bodies. It was, 'Here's someone who has salt, and this is what I need.'"

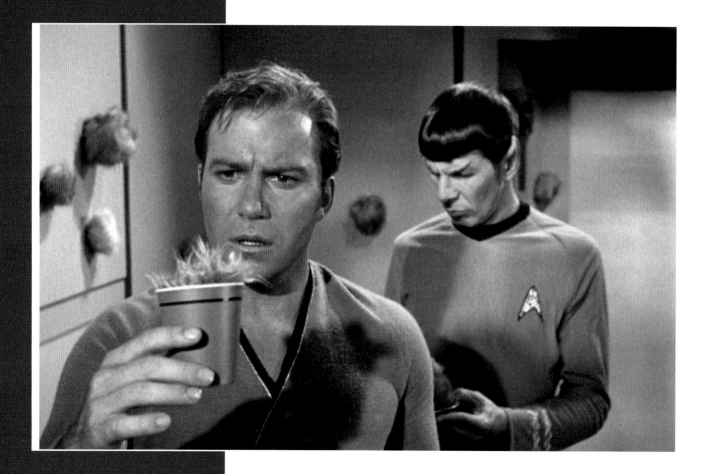

SEASON 2

EPISODE 13

AIR DATE: DECEMBER 29, 1967

Teleplay by David Gerrold

Directed by Joseph Pevney

Synopsis A shipment of quadrotriticale grain aboard the *Enterprise* becomes catnip for cute but dangerous little furballs called tribbles, which eat and reproduce at an alarming rate and really don't like Klingons.

THE TROUBLE WITH TRIBBLES

STAR TREK makes a rare foray into all-out comedy when the ship is infested by thousands of adorable tribbles – living balls of fluff that are born pregnant.

The *STAR TREK* format is incredibly flexible. It can embrace high-concept science fiction, romance, drama and comedy. Arguably, no episode of *STAR TREK* is funnier than 'The Trouble with Tribbles,' the story that was David Gerrold's first contribution to the franchise. When he graduated from college he sent a spec script in to *STAR TREK*. They didn't buy it – according to Gerrold, it would have cost millions to film – but Gene Coon liked it enough to invite him into the office, where he explained the kind of story they might buy, and told him to come back with some ideas. Gerrold pitched three story ideas, one of which was titled 'The Fuzzies.' In that first

RIGHT: William Campbell felt Roddenberry missed a trick by not having Koloth return to plague Kirk.

version of the story, a corporation is trying to prevent a competitor from growing grain on a particularly fertile planet. Their scheme is exposed when a horde of fuzzies eat the grain seed, revealing that it has been poisoned. Right from the beginning the fuzzies were small, purring balls of fluff that replicated at an incredible rate.

Coon liked the idea and told Gerrold to work it up, but insisted that he eliminate the idea of an evil corporation, which he felt didn't belong in *STAR TREK*. Gerrold suggested using the Klingons instead, and was delighted when Bob Justman also suggested setting the whole thing on a space station. He was even more pleased that Coon mentored him, helping him rework the story and giving him the chance to write the teleplay.

Researcher Kellam de Forest then pinpointed a few problems in the script. First, the name 'fuzzies' was out because it was too close to a book called *Little Fuzzy*, and the idea of a pet that bred at incredible speed was too similar to Robert A. Heinlein's flat cats from his story, *The Rolling Stones*. The second problem was dealt with when the producers called Heinlein and asked him if he was OK with the similarities – he was. The first meant that a reluctant Gerrold had to rename his creations. He rejected 'shaggies,' 'goonies,' 'puffies,' and more than a dozen other names before settling on tribbles.

ABOVE: Gerrold reported that the production team had to bury William Shatner in tribbles eight times before they got it absolutely right. Tribbles were still being dropped on him as he delivered his lines.

him. But if somebody went to kill him I wouldn't let them do it, because if anybody's going to kill him, I'm going to kill him. And I want to annoy the hell out of him.'"

Campbell was joined by William Schallert as the infuriating bureaucrat Nilz Baris. Charlie Brill, a stand-up comic and friend of Leonard Nimoy's, was cast as Arne Darvin. Stanley Adams, who had once worked with Schallert in a comedy act, came aboard as Cyrano Jones, with Whit Bissel playing Mr. Lurry. Gerrold had originally written scenes for Yeoman Rand and Mr. Sulu, but Grace Lee Whitney had left the

of tribble. The most sophisticated, which could 'walk,' were made by removing the heads from motorized toy dogs and covering what remained with fur. Breathing tribbles were made by filling the fluffy sleeves with balloons that could be inflated and deflated. A handful of tribbles were filled with beans so they had enough weight to sit in a corner. But the vast majority were just filled with cotton.

The fate of those 500 tribbles has been a source of speculation. William Campbell remembered that he took at least some of them home. "I had lunch with Michael Wayne [son of John Wayne] and I passed the soundstage where we had all the tribbles. They were lying on the floor, so I got a plastic bag and threw about 40 of them into it. I gave them to the kids in the nearby neighborhood."

Emmy Award-winning sound editor Douglas Grindstaff combined the sounds of a screech owl, a squeaking balloon, and murmuring doves to give the tribbles their "voice."

Although Coon and Pevney loved the episode, Roddenberry was less certain. He worried that it pushed the series too far into comedy. But the fans adored it and 30 years later, it would be given a sequel when Captain Sisko and his crew traveled back in time and inserted themselves into the action in 'Trials and Tribble-ations.'

> **"One million seven hundred seventy one thousand five hundred sixty one. That's assuming one tribble, multiplying with an average litter of ten, producing a new generation every twelve hours over a period of three days."**
>
> **Spock**

Joe Pevney was handed the directing assignment and embraced the chance to do some outright comedy. Coon wanted to bring John Colicos back as Kor, but he wasn't available so instead they turned to William Campbell, who had played Trelane in the previous season. As Campbell remembered, he saw Koloth as a nemesis for Kirk. "Gene [Roddenberry] asked me what I thought of the relationship between Kirk and Koloth. I said, 'Well, as far as I was concerned I respected him as a captain, although I hated

show and George Takei was filming *The Green Berets*, so the scenes were given to Uhura and Chekov instead.

How many tribbles were onboard? According to Spock... 1,771,561. How many tribbles were physically produced for the episode? Per Gerrold, that'd be 500, designed by Wah Chang and sewn by Jacqueline Cumere, who earned $350 for her efforts. John Dwyer, who had just joined the series as its propmaster, remembered there were four different kinds

APRIL TATRO

STAR TREK'S BIGGEST MYSTERY SOLVED

April Tatro turned out to be the answer to one of *STAR TREK*'s enduring mysteries: who played the human form of the cat Isis in 'Assignment: Earth'?

For decades, fans believed that Victoria Vetri portrayed the sleek black cat, a no-dialogue role that merited no on-screen credit. Vetri, in 2010, publicly revealed that she didn't play Isis. Nearly another full decade passed before *STAR TREK* historian Larry Nemecek assembled the pieces (including production and extras call sheets), solved the puzzle, and tracked down Tatro. And she had a remarkable story to share. She'd made her living as an actress, dancer, model, and professional contortionist. She earned $84.51 for her day's work on *STAR TREK* and never gave it another thought. And more than 50 years after the fact, Tatro found herself at conventions posing for photos with fans and signing autographs.

"It's kind of amazing!" Tatro enthuses during a break from meeting fans at a convention in England, her first official *STAR TREK* event. "All of this, it's mind-boggling to me. The people I'm seeing here, they say, 'Where have you been? Why did it take so long?' I also hear a lot of 'We're so glad you came' and 'Welcome to the family,' which is lovely. Who expects anything in their life like this, especially after so many years?"

Back in early January of 1968, central casting rang Tatro and instructed her to drive over to the Paramount lot. There, on January 5, the *STAR TREK* team weaved their magic.

"Most of the time was spent gluing a costume on me, and doing my makeup and hair," she recalls.

STAR TREK extras at the time earned $29.15 per day, though Tatro made another $55.36 thanks to the role's distinct makeup and hair requirements. As for Tatro's big scene, it involved her, as Isis, "sitting and looking strangely at Teri Garr," who guest starred as Roberta Lincoln in the backdoor pilot, the events of which transpired entirely in 1968.

"They told me to look strangely at Teri, and she was looking at me strangely," Tatro says, laughing. "That was basically it. They cut out a part where I walked across the room and came back. I did that a couple of times."

ABOVE: *On a mission to Earth, 1968, Kirk and crew meet Gary Seven and his black cat, Isis. Seven is an Interstellar agent known as Supervisor 194, and his cat has a human form.*

"One (other) thing I remember vividly was the eyelashes," she laughs. "They put these eyelashes on me and I could hardly hold them up because they were really long, and they came up above my eyebrows. I was blinking a lot. They said, 'Are you OK?' I said, 'Well, the eyelashes are a little much, but it's fine.'

"I worked mostly with Teri, and I saw most of the cast, just briefly. But I met William Shatner, of course, and he asked me to lunch. I was quite naive. I was going to get married in two weeks, and I thought, 'What the hell would lunch matter?' He called me, on a different day, and we went to lunch. And then at lunch I'm thinking, 'My goodness, maybe I should cancel the wedding. He's awfully cute.' But I didn't. I got married. And I was booked, as a contortionist, for a tour of the Hawaiian Islands, to raise money for a police association.

"My husband couldn't go with me because of his business, and so he ended up staying back, and I went on my honeymoon alone," she continues. "I was gone for about two weeks and, while I was gone, William Shatner called the house, and said, 'Hello, is April there?' My husband said, 'Well, no. Who is this?' 'William Shatner. Who is this?' He said "This is her husband." So, of course, it was a real quick click."

Tatro actually met Victoria Vetri, who people for ages thought played Isis. They chatted while appearing, separately, at an autograph show in Los Angeles. "She had told people, 'It can't be me. I have brown eyes and she has blue eyes, and no, I never did *STAR TREK*,'" Tatro recalls. "At least she was honest. When we met at The Hollywood [autograph] Show, I thought she was a very sweet lady. She said, 'I told them it wasn't me!' And so we took a picture together, and I'm holding up a photo of Isis that I inscribed, 'Victoria – It's me!' That was pretty fun."

Tatro's life and career extend far beyond her few seconds of screen in 'Assignment: Earth.' She worked with comedy legend Milton Berle, serving as his act's headline dancer, and was a Copa Girl at the Sands Hotel, where she also danced for members of the famed Rat Pack, specifically Dean Martin, Jerry Lewis, and Sammy Davis Jr. Later, Tatro taught health and physical education at L.A. City College, Palomar College, L.A. Valley College, and Pierce College. And, currently, she offers Pilates lessons at her own studio.

"I've got a very nice life," Tatro says. "What's happened with *STAR TREK*, it's still brand-new to me. A couple of years ago, a friend of mine called me and said, 'It's on the Internet that this Victoria Vetri, they think she played the cat. Didn't you play the cat?' I said, 'Yes.' She said, 'You should tell somebody.' I said, 'Who am I going to tell? What difference does it make, really?' Then, Larry touched base with me. And now I know what difference it makes. It's this fresh wrinkle for the fans, a discovery after all this time, someone new for them to meet. And it's a whole new world for me. I love it."

Marc Daniels

DIRECTORS

MEN OF VISION

Directing *STAR TREK* called for an impressive combination
of decisiveness, tact, discipline, and artistry.

arc Daniels, Joseph Pevney, Ralph Senensky, and
Vincent McEveety directed a combined 41 episodes
of *STAR TREK*, or 42 if you count 'The Menagerie'
as two separate installments. Either way, between them
the quartet called the shots on more than half of the show's
79 episodes across three seasons. Among those are some of the
absolute best ('The City on the Edge of Forever,' 'Space Seed,'
'Balance of Terror,' and 'Metamorphosis') – and one of the worst
('Spock's Brain').

Pevney and Daniels hold the record as *STAR TREK*'s most
prolific directors, having helmed 14 episodes each, and they
alternated episodes for most of season two. Senensky directed
seven episodes, or six-and-a-half, depending how one regards
'The Tholian Web,' because he was replaced midproduction
by Herb Wallerstein and is not credited. McEveety directed
six episodes.

What was it like to direct *STAR TREK*? Daniels, Pevney, and
McEveety passed away in 1989, 2008, and 2018, respectively. The
man to quiz is Senensky. Born in 1923 and in his ninth decade,
he is long retired, but his memory of his time on the show is

phenomenal. Senensky is also refreshingly straightforward and
unsentimental about his *STAR TREK* output. "I worked a total of
90 days on the seven shows, spread out over a couple of years,
and I was paid $3,000 per episode," Senensky says. "I did more
episodes that I esteem of *The Waltons*, but the *STAR TREK* fan
base turned it into something else. It's only been in recent years
that the ones I did gained some acclaim. They did not at the
time. The show itself didn't gain all that attention until it grew in
syndication, probably a decade afterward.

"Now, I'll tell you something," he continues. "Directors in
episodic television, in that period, dealt with a caste system.
Agencies had agents handling television and agents handling
features, and features were far more prestigious. So, when I left
Hollywood, I'd done all that work, but I have more attention
now, and more acclaim, than back then when I was doing it, for
STAR TREK and *The Waltons*, and also *The Twilight Zone*, *Dan
August*, the *Dynasty* pilot, *Hart to Hart*, and *The Paper Chase*."

In late 1966, Senensky's agent called to gauge his client's
interest in directing an episode of *STAR TREK*, then in its
first season. Senensky believes Gene Coon, with whom he'd

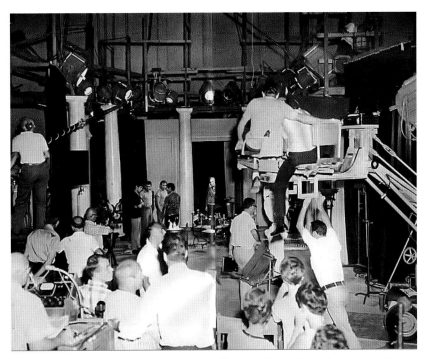

ABOVE: *Senensky's crew prepare to film a scene in 'Bread and Circuses.' Senensky remembers that both Gene Roddenberry and Gene Coon were still rewriting after he had started work.*

worked on *The Wild Wild West*, recommended him to Gene Roddenberry. He was initially assigned 'The Devil in the Dark,' but Pevney ended up in the director's chair, while Senensky debuted with 'This Side of Paradise.'

"I had no discussions about any of it," Senensky recalls. "A lot of this is stuff I figured out since. Gene Coon might have assigned 'Devil' to me because he liked what I did on *Wild Wild West*. The change was made, I think, because they thought it was too difficult for somebody coming in, who hadn't done the show yet. Marc and Joe were the main directors, and the producers brought in others to fill the gaps. It wasn't until I read one of Mark Cushman's *STAR TREK* books that I found out, after 'Metamorphosis,' my second show, I was considered the third of the triad."

Directors today communicate with each other and often serve as director-producers to maintain story and character continuity, but Senensky "never" interacted with Daniels or Pevney. Senensky sometimes met with a producer, associate producer, or the story editor responsible for an episode's rewrites. Even then, he only ever encountered story editor

Dorothy Fontana twice. "I respected the scripts," Senensky says. "If something needed to be changed on the set, or an actor wished to improvise, I picked my slots where intelligence prevailed. Good actors can make good writing even better."

When it came to the actors, the show's regulars knew their characters inside and out. Thus, Senensky gave notes only when he felt strongly about something. Though he "kept a closer eye on guest stars," he says, "I wasn't going to tell Leonard Nimoy how to play Spock." The cast liked that Senensky ran a "quiet" set and also that, though he shot scenes until satisfied, he usually accomplished that in two takes.

"The actors could come in and act, and not be ordered, 'Now stand here, and say this line,'" he explains. "I never did that." Commenting specifically on Nimoy, William Shatner, and DeForest Kelley, he says, "Bill and I had a good rapport, but he was probably, of the trio, the most distant. Bill was a classically trained actor. There was some ego there, but again, we had a good relationship. Leonard, when he got out of the makeup chair, was Spock. He stayed Spock. It was wonderful. After 'Paradise,' Leonard wrote me a lovely note, thanking me, and

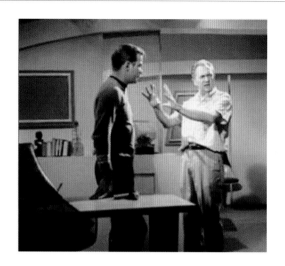

MARC DANIELS

"Right from the beginning, it was easy to see that [STAR TREK's] characters were extremely well drawn," Marc Daniels told Starlog's Ed Gross in 1987. "There was some trial and error with the peripheral characters, but the three main ones – Kirk, Spock, and McCoy – were excellent. With that many characters, it was difficult to give each their due. It was a very good contrast, because you didn't have the same thing going on between any two of them."

Daniels' greater challenges were technical: massaging footage from 'The Cage' and a mute, disfigured Captain Pike into 'The Menagerie;' depicting Khan turning someone upside-down in 'Space Seed;' manipulating three Nomad props in 'The Changeling;' and filming multiple sets of twins in 'I, Mudd.'

By season three, Daniels contended with a bigger issue: a new producer. According to Daniels, he and Freiberger "didn't agree on what the director's role was. There are many writer-producers who don't consider the director a partner. They consider him, shall we say, an employee. This is particularly true in episodic TV. They just want you to do the work, get the shots. The problem with the third year is that Gene [Roddenberry] didn't give the series his full attention. He was doing other things, and we needed his guidance badly."

Despite the headaches, Daniels sounded pleased to have helped secure STAR TREK's place in entertainment history: "We had a feeling we were working on something very 'important, although I don't think anybody ever dreamed STAR TREK would have the longevity it has had."

liking the work we did together. And, DeForest was DeForest. When he was Doc McCoy, he was the just the same as DeForest Kelley. That's the secret. If you're acting, do it so it doesn't seem that you're acting."

Leaving the actors "to do what they do" freed Senensky up to concentrate on the look of his episodes, to "stage" them, and to complete each one on time and within budget. His partner in much of that was director of photography Jerry Finnerman, who he describes as "a master at lighting." Among other ideas and innovations, Senensky credits Finnerman with suggesting that a nine-millimeter fisheye lens be used in 'Metamorphosis' for the long shots of the Galileo shuttlecraft on the asteroid's surface. Senensky later utilized that same wide-angle lens in other episodes to convey insanity.

"Jerry and I had never worked together," Senensky says. "In those early years, directors of photography were so fine at their jobs. They'd all been trained, and first operated cameras for the big screen's great cinematographers. Jerry worked for Harry Stradling as his operator, and Stradling not only helped Jerry get STAR TREK, but insisted he do it. Just as I came in and had to adapt to the director of photography, the director of photography had to cope with new directors coming in. Somehow, Jerry and I clicked. On the fifth day, we did the ['Paradise'] scene where Spock first gets sprayed by the spore, and the love scene ends with 'I can love you.' After we did it, Jerry told me, 'That was when I knew I wanted to work with you more.'"

Production on STAR TREK became more complicated and

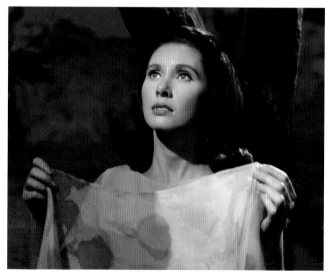

ABOVE: One of Senensky's favorite shots is in 'Metamorphosis.' In the story, an energy being called the Companion has fallen in love with Zefram Cochrane. After it merges with Nancy Hedford, it looks at Cochrane through her scarf. The pattern of her scarf replicates the pattern made by the Companion.

nerve-racking, Senensky asserts, following Gulf + Western/ Paramount's purchase of Desilu. Suddenly, bigger-picture matters of authority shifted from Herb Solow to Doug Cramer, with Gene Coon feeling the squeeze, which then impacted the directors. Episodes of most series at the time took six days to shoot, but *STAR TREK* typically averaged six and a half days. The new management tightened budgets and demanded that episodes wrap in six days.

"Not only that, Gulf + Western said, instead of quitting at 7 at night, we were quitting at 6:12," Senensky recalls, shaking his head. "I figured out that if we stopped at 6:12, that was 48 minutes a day we were losing. Multiply that by six, and that was just shy of half a day. So, episodes literally had to be done in five and a half days. It was just insanity."

Reflecting on his episodes, Senensky picks 'Metamorphosis' as his favorite. 'Is There in Truth No Beauty?' ranks as the most disappointing, since, to his thinking, he handed in a solid director's cut "ruined" by the hands of others. "If [Fred] Freiberger hadn't done the stuff he did to it in postproduction, with the green light and animation, it was as different and potentially as important to the story as 'Metamorphosis,'" he says. "Both had the same kind of character. 'Metamorphosis' had this cloud that seemed evil, but it wasn't evil. It was an enemy, yet it was a gentle soul. And in ['Is There in Truth No Beauty?'], here was this creature. It was in the box, yet it was a sympathetic character. The creature was the Ambassador, and was really an ambassador of peace. The stuff they did in postproduction, they turned it into an evil character." Senensky felt powerless. He didn't view the master cut until the episode premiered. And even if he knew sooner of Freiberger's changes, directors did not argue with producers. "If I'd gone in like that," Senensky points out, "I'd have been fired."

Freiberger actually did fire him during production of his next, and final, episode, season three's 'The Tholian Web.' Senensky "immediately" asked that he not be credited as codirector, even if his name went first. Roddenberry phoned Senensky the next day to apologize, but the damage was done.

It wasn't until years later that fans discovered Senensky's involvement in the episode. His early scenes "set the tone" for the rest of 'The Tholian Web,' and "the way it worked out when it came to light, it worked in my favor," he says. "I didn't plan that, but that's what happened. That was my last one, but again, the fan base changed everything, and the show, and my episodes became esteemed in a way I never imagined.

"*STAR TREK* became something very special in the business," Senensky concludes. "And I'm happy to be whatever part of it I am. Young people have told me that *STAR TREK* changed their lives, and that's a very meaningful thing to hear."

JOSEPH PEVNEY

Joe Pevney directed 14 episodes of *STAR TREK*, from 'Arena' to 'The Immunity Syndrome.' He was the man who introduced Roddenberry to Walter Koenig and to camera operator Al Francis, who he championed to replace Jerry Finnerman as director of photography. Highlights of his *STAR TREK* directing career included 'The Devil in the Dark,' 'Amok Time' (in which he helped to introduce the Vulcan salute), 'Journey to Babel,' and 'The City on the Edge of Forever.' He told Allan Asherman for *The STAR TREK Interview Book*, that 'City' played a major role in getting *STAR TREK* renewed for a second season. "[Roddenberry] was quite convinced that at the time that my work helped... He wrote me a letter which I'm very proud of... congratulating me on my work and the extra special contribution he said I made to *STAR TREK*."

In the same book, Pevney stated that Roddenberry had "a touch of genius about him," though he would later add that Roddenberry's weakness was that he didn't impose enough discipline on the cast. "The producer's function," he told *Starlog*, "is to be the stern father who punishes for misbehavior. Gene Roddenberry could never do that."

Pevney's favorite episode was 'The Trouble With Tribbles,' in which he relished the chance to inject more comedy into the series – something that, he told Asherman, Roddenberry had reservations about. "The show was successful, and I was very happy about that. I was proven right, that you can do comedy if you don't kid the script and if you don't kid *STAR TREK*. If you stay in character, you can have wonderful fun with *STAR TREK*, and the kinds of things you can do with it are endless."

Behind-the-scenes photographs Courtesy Gerald Gurian

DON MARSHALL

INDEPENDENT OFFICER

Don Marshall considered himself blessed. Back in 1966, when he played Lieutenant Boma in 'The *Galileo* Seven,' African American performers found opportunities tougher to unearth than a cache of dilithium crystals. "There wasn't much at all," Marshall noted. "I was very grateful to get the opportunities I got, and it made me work very hard on each part, to make sure whatever I was doing was right and that the characters I played were strong people. I tried to bring out the best in the person I played."

STAR TREK presented several strong Black characters during its run, often in guest starring roles, including Commodore Stone (Percy Rodriguez), Dr. Richard Daystrom (William Marshall), and Boma, and sprinkled in other African American actors in smaller roles.

Boma, throughout 'The *Galileo* Seven,' challenged Spock's dogged adherence to logic, even though Spock was his superior officer. To use modern vernacular, he compelled Spock to think outside the box – and it saved lives. Marshall deemed it "beautiful" that his character's skin color was of no significance. "That was Gene Roddenberry, and I'd worked for him before," Marshall commented. "I did an episode of *The Lieutenant.* That's the way the guy was. He didn't see color. He saw situation and he had a vision, more so than most people. You could really see that with *STAR TREK.* People learned from *STAR TREK.* This guy created something special."

Marshall recalled that Roddenberry phoned him personally and invited him to play Boma. Soon after, when Marshall stopped at the studio to pick up the script, he ran into his old acting coach, Robert Gist. The two talked and were "shocked" to realize they'd be collaborating on 'The *Galileo* Seven,' with Marshall as guest star and Gist as director. It didn't go well – at least not until Leonard Nimoy graciously stepped in to support Marshall.

"I'd left Bob's [acting] class before this," Marshall pointed out. "I'd left because he was into the James Dean-type of acting," and he felt this kind of naturalistic acting seemed out of place in *STAR TREK.* "I was playing an astrophysicist, and on the set it was getting a little rough because he wanted me to act like James Dean, to lean against walls and things like that. It didn't really jibe with what I thought of the character. Leonard noticed I wasn't very happy. He came over and said, 'What's the matter, Don?' I told him, 'Bob wants me to play this like a James Dean-type of character, and this character is

ABOVE: *Don Marshall as Lieutenant Boma (right) in 'The Galileo Seven.' Boma was one of several officers who questioned Spock's decisions when the crew of a shuttlecraft are stranded on a hostile planet. Marshall was delighted that his skin color wasn't an issue for the character or the producers.*

an astrophysicist. It's not going to work, and it's really driving me crazy.' Leonard said, 'OK, I'll tell you what. You go ahead and play the character the way you see it and I'll handle the director.' I said, 'Whooah, OK.'

"He actually did that, and the director said nothing else to me after that, as far as what I was doing," Marshall continued. "Because of Leonard interceding, it gave me all the freedom in the world, and if you see the scenes between Leonard and I, they sparkled. Whenever it's us, it's big and alive and honest. So, it was because of Leonard that show came out so strong."

Two years after his appearance in 'The *Galileo* Seven,' Marshall starred as one of the main characters on the Irwin Allen series, *Land of the Giants.* The series lasted two seasons, from 1968 to 1970, after which he appeared in 20 more shows and films, including the B movie, *The Thing with Two Heads,* a cult classic. When Marshall retired from acting, he produced television commercials and documentary films, and attempted to mount a *Land of the Giants* reboot. By the time Marshall passed away on October 30, 1990, at the age of 80, he had also attended numerous *STAR TREK* and sci-fi conventions.

"I loved it," Marshall enthused of his *STAR TREK* convention appearances. "It was good seeing the fans. They were very generous to me. It's amazing that people are still excited to see all of us who were a part of the show. I did my episode years ago. You never expect something like this, for people to come to these shows, for some of them to remember every little thing you said, every movement you made. It's like, 'Wow.' People are really paying attention, and it makes you feel good."

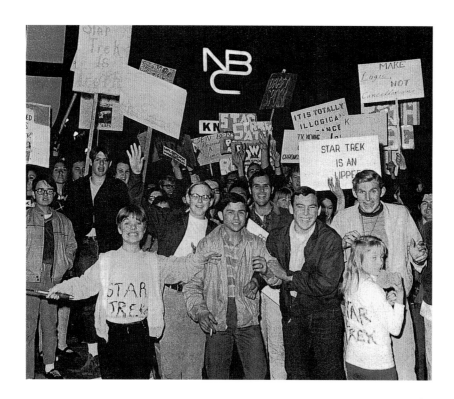

THE CAMPAIGN

When it looked as if NBC would cancel STAR TREK after the second season,
the fans stepped in and started a campaign to save the show.

If *STAR TREK* changed the world, as Bjo Trimble always says it did, then she and her husband John altered its trajectory. They led the grassroots "Save *STAR TREK*" letter-writing campaign in 1967–68 that helped to convince NBC to renew the series for a third season. The additional 24 episodes made the show a viable syndication property, and in syndication, *STAR TREK* – in Bjo's words, "the show everybody said would fail" – exploded into a juggernaut that inspired everything since. John describes how, "55 years later, people are still watching *STAR TREK* reruns, and now those reruns are streaming, which didn't exist in 1966. Fans all over the world love it. Phrases that are part of normal life, that are in the language, came from *STAR TREK*."

The petite and vivacious Bjo was crowned "The Woman Who Saved *STAR TREK*." John, tall and erudite, was there from the start, but reporters focused on the "little housewife at home who spoke up," as Bjo puts it. This frustrated her. "We were a team on the letter-writing campaign, and everything else… People should know John was a major mover on the campaign. It's all John's fault anyway."

John relates how they had visited the *STAR TREK* set and were chugging back home to Oakland in their Volkswagen Bug. "I remember discussing how everyone on set thought *STAR TREK* was over, and I said to Bjo, 'It's sad… There's got to be something we can do.' Now, I should've known better than to say that to her. We spent the rest of the trip working out the 'Save *STAR TREK*' campaign."

The Trimbles – longtime science-fiction aficionados – had

befriended Gene Roddenberry and approached him with their idea. Roddenberry later professed that he'd just left a staff meeting wondering aloud how to reach fans, when the Trimbles fell into his lap. "I'm not sure that's true," John says, chuckling. "Gene could be pretty apocryphal, but he liked the idea."

By talking to secretaries at businesses in Hollywood and elsewhere, Bjo learned why they might trash a letter they received, answer it themselves, or put it on their boss's desk. In this way, she assembled a list of letter-writing do's and don'ts. Letters had to be sent as bulk mail to minimize costs, so John studied postal guides to understand zip codes and bundling. To reach potential letter writers, they pulled return addresses off fan letters to Paramount, procured convention lists, and secured the names of fan club leaders and fanzine publishers.

Save STAR TREK letters then had to be copied, so John hand-cranked them on a mimeograph machine. Next, envelopes needed to be stuffed, labeled, stamped, and bulk mailed. To facilitate that, Bjo arranged gatherings at their home, which, John says, "often turned into potluck dinners and weekend work parties," fueled by pots of beans, stew, or spaghetti.

STAR TREK's actors knew nothing of the Trimbles' efforts. Roddenberry supported the campaign but the couple insisted he couldn't actively participate. Says Bjo, "I told Gene, 'If you do so, NBC can say you're the one who started it and ran it. That won't be good for the campaign.' He was pretty good. For one of our work parties, he sent over a catering truck with large trays of cold cuts and other food."

"We held enough work parties during that campaign," John says, "that, years later, when we sent out party invitations,

people would say, 'Is this a real party or a work party?'"

NBC received between 14,000 and a million letters (depending on the source) and fans lobbied at NBC's Manhattan and Burbank headquarters. It paid off, as NBC picked up STAR TREK for a third season. Roddenberry was "appreciative," John says, but beyond that, the Trimbles received little public recognition. Years later, most of the actors, including William Shatner, Leonard Nimoy, and George Takei, thanked the Trimbles in their respective autobiographies.

The couple worked for a while for Roddenberry, helping launch Lincoln Enterprises. Bjo and John returned to letter-writing action in the mid-1970s to convince President Ford to name the first space shuttle Enterprise. Bjo wrote an official book, STAR TREK Concordance (1969), and a memoir, On the Good Ship Enterprise (1983), and was a fan extra in STAR TREK: THE MOTION PICTURE. The couple still occasionally appear at conventions, and CBS honored them at the official 50th anniversary event in Las Vegas in 2016.

John explains why STAR TREK inspired their devotion. "[It] was the first show that tried to do science-fiction well. It wasn't a kiddie show. It portrayed real people doing real things."

Bjo agrees. "…It wasn't, 'There's an alien, let's kill it!' It spoke about humanity getting together and actually doing something. The crew, you didn't think, 'Oh, he's Asian,' or 'She's black…' It was people doing their jobs, which was wonderful. And we both loved Gene's main theme, that the human spirit will prevail. I grew up in a contentious family. The show's togetherness and positive sensibility appealed to me. I think that drew a lot of people to STAR TREK."

ABOVE: Bjo and John Trimble still attend STAR TREK conventions and are widely credited with saving the show. They organized a massive letter-writing campaign that encouraged countless fans to write to NBC asking them not to cancel STAR TREK.

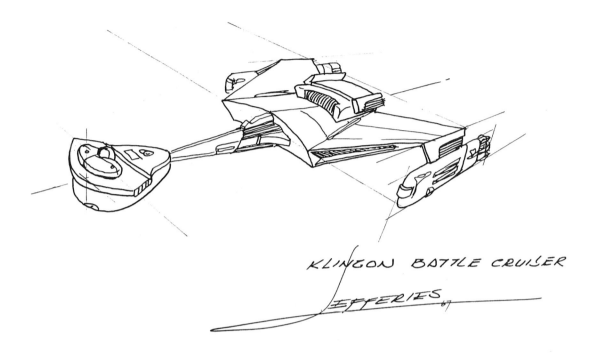

KLINGON BATTLE CRUISER

JEFFERIES 67

THE KLINGON SHIP

New spaceships were an expense that *STAR TREK* could rarely afford,
but AMT was doing well selling model kits, so they offered to fund
the creation of a Klingon battle cruiser.

When production began on the show's third season, the budget belt was cinched tighter than ever. So no one expected to build a warship for the sporadically recurring Klingons. But, having produced a successful model kit of the *Enterprise*, AMT approached Desilu, to ask if they could give it an adversary. They explained that they were happy to fund the creation of a Klingon ship in return for the rights to the kit. The producers agreed, but as Matt Jefferies explained, "I designed it at home because there was neither the time nor the money to do it at the studio. Gene pretty much left me on my own. Primarily it was done for AMT, but it was something that would fit the show and we did use it."

Jefferies wanted the design to reflect the Klingons' nature, "I wanted their ship to have something of a killer potential that would look wicked. Naturally, I thought it had to look as far out as we thought the *Enterprise* did." It was not easy, though. A hundred attempts ended up in the trash, until he evolved the idea of an egg-shaped head and neck attached to a body resembling a manta ray, to suggest both viciousness and grace of movement. He finally handed AMT "a full engineering drawing" that was scaled relative to the *Enterprise*.

He supervised AMT's work and was delighted with how closely they followed his design. They made two "tooling" master models, about 18 inches across, from which the steel

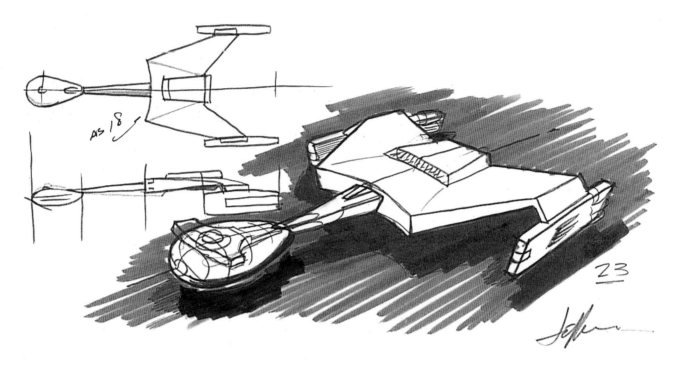

ABOVE: *Jefferies' design for the Klingon ship followed the same basic principles as the* Enterprise, *with twin warp nacelles and a two-part body, but this time the body was based on a manta ray.*

molds were made. Jefferies described how, "a stylus traced its way over the master model, and the other end of it carved out the same shape in tooling steel, which became the mold they built the kit from."

Then, from 2 o'clock one night, they began running out the first models and tweaking them minutely. Jefferies recalled that "it was about 10 o'clock [next morning] when the first one came out they said was perfect. They ran maybe another half a dozen, and checked those out. Then the machine was put in operation and after that one came out every 20 seconds." The model was on sale about a month before the battle cruiser made its screen debut.

Dorothy Fontana visualized the ship's layout as follows: the bridge was in the "top front of the bird-like head," which also contained "quarters, labs and armament control." Weapons were located on the underside of the head, where they were combined with a sensor, and along the leading edge of the wings, which contained "storage, fuel, power source, environmental control units, etc."

Meanwhile, Jefferies had taken one of the tooling masters for filming. He painted it with a shark's coloration, "a grayish-green on top and a lighter gray underneath." His Klingon

symbol made its first ever appearance on the top of one of the wings. "The logo had to be something small and compact that you could recognize quickly," he remembered.

Howard Anderson's visual effects team shot the model, first for 'Elaan of Troyius,' which became the 13th episode of the season to be broadcast. The battle cruiser actually entered the scene at episode two, 'The *Enterprise* Incident' and the footage was used five episodes later, in 'Day of the Dove.' After the original model retired from the fray, it found a final resting place in the Smithsonian collection.

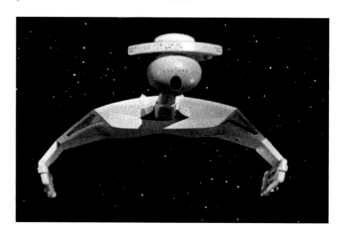

VFX
DEPARTMENT
MAKING THE IMPOSSIBLE REAL

STAR TREK's visual effects were ambitious and inventive, and used everything from sophisticated models to sparklers.

T oday, visual effects are commonplace. They are used to do things you'd never expect – to replace a sky, or extend a building, or cover up the join in someone's wig. In a science-fiction show there can be hundreds of shots in a single episode. In 1966, things were very different. Hardly any TV shows used visual effects routinely, and even fewer needed spaceships and phaser blasts on a weekly basis. It's easy to forget it now, but *STAR TREK* was ambitious. The effects were cutting-edge and were produced by some of Hollywood's most famous effects artists.

ABOVE: *The* Enterprise *fires its phasers. For shots like this, the model of the ship was filmed against a blue screen. The blue background was then removed and the ship was combined with the stars in an optical printer. The phaser beams were created by drawing on top of the image frame by frame, which involved another pass through the optical printer.*

The effects were so demanding that they involved several different companies. Most of the work was done by The Howard Anderson Company, Film Effects of Hollywood, Inc., the Westheimer Company, and Van der Veer Photo Effects, with Cinema Research Corporation picking up extra shots as they were needed.

The effects shots for the pilot and the first few episodes were handled by the The Howard Anderson Company, who were conveniently located on the Desilu lot, where they had worked on *The Lucy Show*. The company had been founded in 1927, during the silent movie era. By 1964, it was run by brothers Howard and Darrell Anderson, who had taken over from their father. Darrell handled their *STAR TREK* business but both men would meet with Gene Roddenberry, who Howard Jr. remembered having a clear vision of what he wanted, often saying that shots should be smaller or faster.

The Anderson Company was responsible for commissioning the original models of the *Enterprise* itself and for filming the space shots. They also came up with the transporter effects. Because of their involvement with the *Enterprise*, they started work long before anyone else and spent the best part of 1964 and 1965 working on the pilots, months before the show made its on-screen debut.

In one of their first meetings, Matt Jefferies presented them with a four-inch scale model of the ship that the studio shop had made out of wood. Although the model was only meant to show the shape, it ended up in the titles, where it was used for shots where the *Enterprise* was far in the distance, and in 'The Corbomite Maneuver,' when the team needed to show a tiny *Enterprise* in front of Balok's giant ship.

The Andersons set about making a three-foot study model, again out of wood, which was built for them by Richard Datin. This model would end up being used in publicity shoots, where Kirk and Spock can be seen holding it. It was never intended to be used for the visual effects shots, but inevitably it turned up in several episodes. For the show's main effects, Datin built a large, 11-foot model. It was the Andersons who pushed to add lights to the ship after the second pilot and as a result, one side was open to allow for the lighting. This meant that the *Enterprise* was only ever filmed from one side. When the team needed to show the ship flying the other way, they would simply replace the decals with versions that faced the other way and flip the film.

Making the ship look as if it was moving fast was probably the biggest challenge the company faced. Up to that point, most spaceships had been seen floating in space. The

ABOVE: *All the energy beam effects were done in the same way, with the beam being drawn on top of a projected image, then filmed again.*

ABOVE: *This early version of the transporter effect was created for 'The Cage,' but was rejected because Roddenberry didn't like the way it looked.*

ABOVE: *When the crew beamed down to a planet, the scene was filmed both with and without them. If the team were filming in a dusty area, the ground had to be swept so that you couldn't see the actors' footprints.*

ABOVE: *The effects team created a matte – basically an empty silhouette where the actors had been – and filled this shape with some film they had shot of aluminum flakes being dropped in front of a strong light.*

Transporter test and sweeping photographs Courtesy Gerald Gurian

Anderson team wanted the ship to have a sense of movement. Their solution was to film the *Enterprise* and the space behind it separately and to make them both move. By this point in time, blue screens were in use, so different elements could be filmed separately and then combined using an optical printer – a device that combined different pieces of film by projecting separate elements and photographing them again to make a single image. The *Enterprise* was mounted on a rig, with most of the sense of motion being created by moving the camera. This was fairly standard, but the Andersons' trick was to make the sky move, too.

They painted black stars on a white background and then used the negative in their state-of-the-art optical printer. By manipulating the sky they were able to make different stars move at different speeds and distances from the camera. When they added the *Enterprise* to the shots, this created a real sense of the ship traveling through space, not just in front of it.

The realities of optical printers meant that individual pieces of film were replicated several times, and every time this happened there would be a loss of quality. Even though they used very fine film stock, the end result could still look soft and blurry by modern standards, with visible film grain, but in the 1960s, there was little chance anyone would spot this, even on the most expensive television.

The Anderson team also designed the transporter effect. They didn't want people to simply pop into existence or vanish,

both of which would have been relatively easy to accomplish. Instead, they came up with a system whereby the person transporting would be overlaid with an energy field that would gradually materialize or dematerialize.

The camera would be locked off so it was completely static. Then the actors would step into or out of the scene, depending on whether they were arriving or leaving. Anderson now had an image of the scene with and without the actors. They duplicated a frame of the film and painted the actors out to create an empty space, known as a matte.

They could then fill the matte with the transporter effect, which was made by filming aluminum dust that was dropped in front of a very bright light. This gave them a person-shaped piece of film with the energy effect. To show someone beaming out, they would start with the person in the shot, then replace them with the illuminated dust. They would cut out the frames in which the actors walked out of shot, and join the film up with a shot of the empty room. They discussed showing a visible beam coming from the *Enterprise* to indicate that people were being transported, but in the end it was decided that this was an unnecessary expense and the idea was quietly put to one side.

RIGHT: *Colored light played a big role in STAR TREK's visual effects. Sometimes characters were cut out and colorized to show them disintegrating or disappearing. In other cases, film was treated and then superimposed to create the effect of an ethereal projection. Some aliens such as the Companion, the Organians, and the entity that feeds on negative emotions in 'Day of the Dove' were made by filming unusual elements, including light shone through different media, to create clouds that appeared to be alive.*

LEFT: *Shots of the Enterprise in orbit around a planet were designed so that they could be reused. The planet and the Enterprise were filmed separately, so the planet could be replaced or recolored to represent a new world.*

ABOVE: *The planet itself was a painted sphere mounted on a stand that rotated. The mount restricted the angles from which the planet could be shot.*

Planet shots were achieved by filming spheres that had been painted and then spun around on an axle. Phaser blasts were visualized by creating mattes on the optical printer and filling them with animated light.

The original plan was for the Anderson Company to deal with all of *STAR TREK*'s effects, but it soon became clear that this wasn't practical. By the time they were filming 'The Corbomitve Maneuver,' Darrell Anderson was working so hard that he ended up in a hospital with exhaustion. Things were in danger off getting out of control, until Eddie Milkis was brought onboard to supervise postproduction at Desilu. One of his first decisions was to split up the effects work between different companies.

When Roddenberry's team came to film the show's seventh regular episode, 'Balance of Terror,' they brought in Linwood Dunn's Film Effects of Hollywood. Dunn was also based on the Desilu lot. When this had been the RKO lot in the '30s, Dunn

ABOVE: *The tiny study model of the* Enterprise *was used for some shots in 'The Corbomite Maneuver.' For those showing the* Enterprise's *sister ship, the U.S.S. Constellation, the team used an AMT model that could be suitably damaged without any long-term consequences.*

ABOVE: *For the* Botany Bay's *appearance alongside the* Enterprise, *the two ships were built in scale with one another and filmed together. Filming them separately and then compositing them would have involved another pass through the optical printer and another loss in quality.*

ABOVE: *In 'The Immunity Syndrome,' the* Enterprise *encounters a giant spaceborne creature that resembles an amoeba. It was simulated by filming liquid sandwiched between two pieces of glass. This footage was then combined with the* Enterprise *in an optical printer.*

had filmed shots for the 1933 version of *King Kong*. Now 62, he was widely regarded as one of the best special effects men in the business, and he had been responsible for the design of the optical printer. The *Enterprise* models were packed up and sent over to his larger stage, where Dunn's team also filmed the new ships for the first season, including the Romulan bird-of-

prey, Khan's sleeper ship (the *Botany Bay*), and the *Enterprise*'s shuttle. The last involved building a larger scale model of the flight deck (or hangar bay as we now know it). The shuttle miniature itself was moved like a puppet by means of wires connected to a special rig high above the hangar.

Dunn's team specialized in the unusual phenomena the crew

ABOVE: *Linwood Dunn filming the 11-foot model of the* Enterprise *against a blue screen. In Hollywood, Dunn was a legendary figure who had worked on* King Kong *and invented the optical printer. The* Enterprise *model was also filmed by other companies throughout the run of the series.*

encountered, and employed a variety of bizarre techniques to produce strange, glowing lights. Some of the "churning, weaving forms and masses hanging in space" were created by using a cloud tank – a process best explained as putting dye and a lot of salt into a fish tank and filming the resulting patterns.

The Westheimer Company spent most of their time devising transporter shots, phaser beams, and disintegration shots, and adding images to the various viewscreens around the ship. They also created planets, and colorized them so they could be reused. Their staff included a young Richard Edlund, who would go on to work on *Star Wars* and form his own company, BOSS films. He remembered his first job was to create the text in the titles, which he hand-lettered. Like Dunn, Westheimer were often called upon to simulate mysterious light effects, which they gradually built into a library. Edlund remembers that the light display used when the Metrons "appeared" on the main viewer was achieved by filming light shone onto a pan of mercury, which they hit with a hammer. On other occasions, they filmed cornflakes and light reflecting from plastic or through Vaseline. His colleague Joseph Wilcots recalled creating another effect by putting 4th of July sparklers in a film can, heating it from below and filming the results. Phaser shots

LEFT: *The effects team reused shots whenever they could. As a result, the* Enterprise *would occasionally revert to the version that appeared in 'The Cage,' before the design was refined. Shots like this can be seen in 'By Any Other Name,' when the* Enterprise *crosses the Galactic barrier.*

235

WINDOW TO THE PAST

In 1966, *American Cinematographer* magazine ran a piece on *STAR TREK*'s visual effects. LInwood Dunn singled out as particularly interesting the moment when the Guardian of Forever shows the landing party the past. "An intriguing time roll-back device was created when our space travelers stepped through a wall of smoke emanating from the inside of a rocklike frame, which glowed in modulation to the voice of a 'master spirit.' Inside this frame, time was rolled back before the eyes as scenes from the past streaked by, pausing momentarily at significant eras." The lights built into the Guardian were practical, as was the smoke, but the footage showing the past had to be added optically. It was black and white, purely because color footage was more expensive.

were done by making mattes on an animation stand. They would either use a "slot gag" technique, creating the entire phaser beam and then revealing it by sliding a piece of paper over it, or they would hand draw the beam growing.

In the second season, Van der Veer Photo Effects started to take on more of the effects work. Their most impressive shots included the giant space amoeba, which was made by sandwiching colored liquid between two sheets of glass and then sliding the glass to convey a sense of life, and the Tholian web from the episode of the same name. The latter shot

LEFT, ABOVE AND BELOW: *Matt Jefferies produced a basic design for Stratos, the Cloud City. His team then cut the model out of foam and glued the pieces together to create the city. They wrapped cotton around the bottom to make the clouds it was sitting on. At first they tried to hang it from the ceiling, but this didn't look good enough, so they filmed the model against the orange backdrop, then painted over the clouds to make it look more convincing. This was then optically added to a shot of Kirk and Spock looking up at the orange sky on Stratos.*

was made with a similar approach to the phasers, but was extremely involved. It was created by a young man called Mike Minor, who would go on to play a major part in *STAR TREK*'s future as art director on the abandoned 1970s TV show and on the first movie.

The Anderson Company and Linwood Dunn commissioned matte paintings from Albert Whitlock Jr., a legendary figure who is widely regarded as one of the greatest matte painters in history. He created the paintings on glass, with blank areas where live-action footage could be added to the scene, giving the impression that the crew were in vast environments, rather than on the confines of a Hollywood soundstage.

Together, the companies made the impossible look real and as a result, every year that *STAR TREK* was on air, the visual effects were nominated for an Emmy. The show never won, but the people and companies who worked on it would go on to win more than a dozen Academy Awards. Their work, performed at incredible speed and on a weekly basis, showed that a TV show could have high-quality effects and laid down a marker that would not be surpassed for decades.

MATTE PAINTINGS

Matte paintings are done on glass – or often, Masonite – then combined with filmed elements to give the illusion that a set is far bigger than it actually is. On *STAR TREK*, Matt Jefferies would give Al Whitlock an initial sketch and build the small set piece that was filmed in the studio. Then Whitlock would create the painting that extended the scene before the two elements were combined.

SEASON 3

EPISODE 4

AIR DATE: SEPTEMBER 27, 1968

Written by D.C. Fontana

Directed by John Meredyth Lucas

Synopsis Captain Kirk starts to behave erratically and takes the *Enterprise* into the Neutral Zone, where it is surrounded by Romulans. After Spock appears to kill Kirk it is revealed there is a secret plan to steal a cloaking device.

THE ENTERPRISE INCIDENT

In its third season *STAR TREK* revisits the Romulans, establishing how powerful Romulan women can be, and turning the crew into spies on a mission to steal technology.

At the end of the second season, Dorothy Fontana handed in her notice as *STAR TREK*'s story editor, but she continued to contribute scripts. The first idea she pitched after her departure would turn the Romulans into a recurring adversary (rather than an intriguing one-off) and establish several important elements of *STAR TREK* mythology.

In January 1968, an American spy ship was caught off the coast of North Korea, in what became known as The Pueblo Incident. As Fontana watched the news unfold, she thought

it could be the basis for a story that took the *Enterprise* behind enemy lines on a secret mission, and would give her the chance to

RIGHT: In early versions of the story, Kirk and McCoy were both transformed into Romulans.

use elements from *Mission: Impossible*, which was being filmed on the stages next door to *STAR TREK*. For the story's villains she wanted to return to Romulans, who at that point had made a single appearance in the first season.

> "It would be a great achievement for me to bring home the Enterprise *intact*."

The Romulan Commander

The initial story Fontana came up with had the *Enterprise* taking Spock's father, Sarek, on a mission to the edge of Romulan space. The Romulans surprise them, capturing the ship with the aid of a new version of the cloaking device. Kirk and McCoy fake their own deaths, then board an enemy ship disguised as Romulans and steal the cloaking device. Fontana's working title for the story was 'Ears,' and there was a fair amount of humor in it as McCoy was transformed into someone who looked just like a Vulcan.

Despite some concern about NBC's response to an episode that was based on embarrassing present-day events, Roddenberry and *STAR TREK*'s new producer, Fred Freiberger, liked the story. When it turned out that NBC wasn't worried, the story was renamed 'The *Enterprise* Incident,' and pushed to the front of the production line in the hope that the real-world events would still be fresh in people's minds when it aired in the fall.

There were changes to Fontana's idea. The most obvious was the removal of Sarek, whose place was taken by Spock. The Romulan Commander also became a woman, with Fontana reasoning that the Romulans were based on Ancient Rome, where women had often risen to positions of power.

The first drafts of the story established that the Romulans had acquired new Klingon battle cruisers. There was a practical reason for this. "The ship that we showed in 'Balance of Terror,'" Fontana remembered, "was really just a wood form knocked together and painted... it wasn't a terribly good model." At the same time that Fontana had been working on her story, Matt

ABOVE: *Fontana originally conceived of the cloaking device as technology that Kirk would have been able to slip into his pocket. In the end, it turned into something larger that we could see Scotty fitting in engineering.*

Jefferies had been working with AMT, who had offered to make the show a Klingon battle cruiser in return for the rights to sell kits of it. The availability of a new ship was too good to resist, so the story incorporated an alliance between the Romulans and the Klingons.

With Freiberger's arrival, *STAR TREK* was under new management. He knew he had to improve the ratings and was determined to put more emphasis on romance, so he and his story editor, Arthur Singer, reworked Fontana's script to introduce a passionate love scene between the Romulan Commander and Spock. Fontana was not impressed; the way she saw it, Spock was behaving in a very non-Vulcan way and the Romulans looked gullible. "There was enough that the Romulans would have known,"

ABOVE: *Joanne Linville established a tradition of women being in command of Romulan ships.*

she said, "based on their previous history, that they could have projected and understood about the Vulcan way of life." She also felt that the Romulan Commander lost credibility because she allowed herself to be swayed by her attraction to Spock. "I would certainly be suspicious if a captured prisoner suddenly came on to me," Fontana complained. The scenes were rewritten but the intent remained the same and Fontana was never convinced.

The episode would be directed by another *STAR TREK* veteran: John Meredyth Lucas. By now budget cuts seriously restricted what was possible. The interiors of the Romulan ship were filmed using wall panels that had been designed for the *Enterprise*.

Respected stage actress and acting teacher Joanne Linville was cast as the Romulan Commander and everybody was delighted with her performance. She had very clear ideas about the character, seeing her as a strong military woman who was direct and honest. She was delighted with the way director of photography Jerry Finnerman lit her, and he would cite the episode as one of his favorites.

The impact of 'The *Enterprise* Incident' would be significant. It established the Romulans as a major presence, introduced their alliance with the Klingons, and showed that in *STAR TREK* a woman could be every bit as powerful as Captain Kirk.

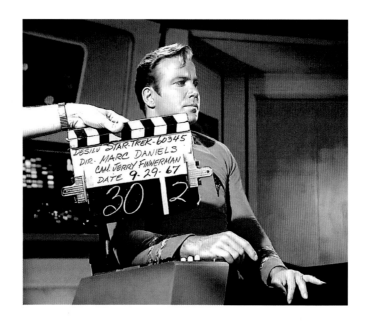

POST
PRODUCTION
PUTTING IT ALL TOGETHER

here was still a lot of work to be done after an episode had been filmed. At the end of each day, the camera assistant would box up the film and send it to the lab. All being well, there would be something like 45 minutes of film made up of different takes. The next morning, one of the apprentice editors would cycle around the lot to collect the film and deliver it to the editors. In 1966, Herb Dow was one of those apprentices. "In the morning," he remembers, 'you would get the boxes of sound from Glen Glenn Sound. Then about 9 in the morning you'd get the film from CFI. You'd take that over to the assistant editors, who would put the dailies together, matching the picture and the sound."

By midday, the "dailies" – all the footage shot the previous day – were ready to be screened, so an apprentice would come back to the editing room to pick them up, then cycle over to one of the screening rooms, where the STAR TREK producers would look at the day's work. "When they were through screening dailies," Dow continues, "you'd deliver it back to the assistant and the editors would cut it."

STAR TREK ran three editing rooms, each one working on up to three shows at a time. "Fabien Tordjman, Don Rode, and Bruce Schoengarth cut most of them," Dow recalls. "Fabien was a fastidious Frenchman. He was a little guy, he was really neat. Don was a regular guy. Just normal editors.

It's a strange craft. I didn't know Bruce as well. I just remember he wore glasses!"

As soon as the editors got the footage, they would start to edit it together. Because they had to wait for the film to be delivered, the editors would always be two days behind the filming. "You'd have the show in your room for just over a month," Dow explains. "You usually had three of them in your room at one time. The first show might be in sound effects. There's one you're waiting on network notes on and there's one you're cutting."

At this stage the editors would be working without any input – or depending on how you looked at it, interference – from anyone else. Laughing, Dow brings up a story about *Mission: Impossible,* which was being shot and edited at the same time as *STAR TREK.* "One day I was coming in the building with a stack of film. I heard yelling. Then I saw this editor, Bobby Watts, come storming out of his room, down the hall, past me and out the door. I looked back and here comes the director out of the cutting-room door with a white editing glove in his hand. What had happened was the director had been in there giving Bobby instructions. Bobby eventually turned to him, said, 'You shot this shit. You cut it!,' handed him the glove and went home. [Producer] Bruce Geller drove to Bobby's home, and promised him that if he came back he'd never let another director in his editing room."

The typical working week for an editor was 54 hours, so they routinely worked Saturdays. "The assistant editor keeps the accounts – the notes about the effects that were being done by Anderson or Linwood Dunn. He is cutting those in as they turn up. The other thing the assistant would do is sometimes shoot inserts – say you needed a hand on the table or something like that. As an apprentice you might run notes over to the stage, to give them to the director. I remember George Takei was always friendly and he'd stop and talk to you."

The director would only be invited in after the editor had completed their first cut of the episode, which would normally be a few days after the episode had finished filming The director would then make any adjustments he wanted, but in most cases these were pretty minimal. The editors knew what they were doing, and because of the way the show was filmed, they didn't have that much choice. *STAR TREK* was shot at speed, so there was rarely time to film many extra takes or alternate angles.

At this point, everyone hoped that the episode would be running slightly longer than the final version. Dow says the directors never took anything out, only asking for shots to be put back in. Once they had had their say, an apprentice would pick up the film and take it over to be screened for the producers. "You'd run everything through Bob Justman, Roddenberry, whoever the other producers were. They'd make some changes, but we had good editors so there shouldn't be many. Once you'd made their changes, you'd run it for Herb Solow. Then make his changes. Then it would go to the network."

The version seen by the producers and executives was still far from polished. By the time the episode was sent to the network, the editors hoped the effects shots would be in, but there would be no music or sound effects – and that included the sound of doors

ABOVE: Effects shots (or opticals) were among the last things to be cut into an episode. The assistant editors would keep track of what was needed and liaise with the effects houses.

opening and simple, unobtrusive effects, such as footsteps or something being put down. These were only added once the network had signed off on the final cut.

"After they'd approved it," Dow explains, "you could cut the negative and create a dupe for sound, which was mixed at Glen Glenn Sound. Doug Grindstaff was the sound-effects guy and Bob Graff was the music editor. They did all the sound effects. They were just up the other end of the street from editing. The music was recorded on Stage M."

Finally, the apprentices would get their moment of glory, as they cut the commercials in before the film was sent out to be broadcast. "It was a happy camp," Dow remembers. "They were good jobs working with really creative people. It was a wonderful time."

MUSIC
DEPARTMENT
OPERA IN OUTER SPACE

TAR TREK and music have always gone hand in hand. Gene Roddenberry's '*Wagon Train* to the Stars' was accompanied by a sweeping, soaring astral symphony, the work of a handful of gifted composers creating a highly recognizable aural identity for the series from the opening seconds of every episode.

Music formed a crucial foundation for Roddenberry in selling his science-fiction adventure series to a mainstream audience. Despite a 1960s vogue for electronic music and experimentation, *STAR TREK*'s creator feared his audience would be alienated if an episode's score veered too much into the science territory of science fiction. "… for the first time on television, I was going to have situations and life-forms that were totally unlike what the audience was accustomed to," Roddenberry stated in a 1982 interview. "And I thought, my God, I had better keep as many things as possible very understandable to my audience. I was afraid that if, on top of bizarre alien seascapes, I had beep-beep-beep music, then I would be in trouble."

In the same interview, Roddenberry went on to say, "I wanted very Earthlike, romantic music. Almost – and I think I used the term with Sandy Courage – Captain Blood: a seagoing feeling of adventure, human adventure."

Sandy Courage was Alexander Mair Courage, a former orchestrator and arranger for MGM Studios in the 1950s, who by the mid-1960s was composing for television shows such as

Sandy Courage

Wagon Train, The Untouchables, and *Voyage to the Bottom of the Sea.* During the production of 'The Cage,' Courage's name was on a list of potential composers to score *STAR TREK*'s first pilot. That list included future *STAR TREK* movie composer Jerry Goldsmith, John Williams, Elmer Bernstein, and Lalo Schifrin, among others. On the recommendation of Desilu Studios' musical director Wilbur Hatch, Courage won the job of composing the score for 'The Cage' and the series' theme tune. For the book, *The Music of Star Trek*, Courage recalled in 1999 receiving a directive from the series' creator. "Roddenberry told me, 'Listen, I don't want any of this goddamned funny-sounding, space, science-fiction music. I want adventure music.'"

Courage's name is synonymous with *STAR TREK*, yet he would compose just six full episode scores for the series, including both pilots. Much of his scoring work for *STAR TREK* would be reused as stock cues throughout the three seasons, but in composing the series' original theme tune, Courage made an indelible mark not only on *STAR TREK*, but on television history.

Combining Roddenberry's required adventurous spirit with an exotic backdrop from the opening of season two (sung by *coloratura* soprano Loulie Jean Norman), Courage's iconic theme took its inspiration from a Hebridean tune. "I wanted something that had a long, long feel to it, and I wanted to put it over a fast-moving accompaniment to get the adventure and the speed and so forth," he said in a previous interview.

From the opening 'pings' (achieved with the use of an early synthesizer (played by musician Jack Cookerly) to the heroic refrain of the *Enterprise* fanfare and the fast-paced main theme, Courage created one of the world's most recognizable screen standards. The composer even stepped up when the production team were struggling to establish a sound for the passing *Enterprise,* as he recalled in a 2009 interview for the Television Academy. "I said, 'Look, this won't cost you anything. Give me a microphone and give me a picture.' So I went out on the stage and as it went by, I just went 'Whooosh!' And that's what they used."

Courage's original *STAR TREK* theme has endured for decades and is still heard in the musical DNA of *STAR TREK'*s subsequent incarnations. However, it was perhaps the cause of Courage's reluctance to return to the series after his initial assignments. A disagreement with Roddenberry over a split of royalties, after the producer penned a lyric for the theme, soured his relationship with *STAR TREK,* although a schedule clash on the movie *Doctor Dolittle* may also have been a contributing factor. However, Courage would return to score two episodes of season three, and he would later collaborate with Jerry Goldsmith as orchestrator of several *STAR TREK* movie scores. In 2009, Courage downplayed the supposed argument with Roddenberry, adding "...it's a shame, because actually, if he'd written a decent lyric, we could have both made more money."

More than anyone else, Fred Steiner established the musical heart of *STAR TREK*, his work being heard on 53 episodes of the series, either as original compositions or stock cues. Like Courage, Fred Steiner was recommended to the *STAR TREK* production team by Wilbur Hatch. His scoring work on another science-fiction staple, *The Twilight Zone,* made him a perfect candidate for *STAR TREK.* He had also composed 'Park Avenue Beat,' the distinctive theme for the hugely popular legal drama *Perry Mason.* "*STAR TREK* was very heavily scored with library music," he recalled in a 2003 Television Academy interview. "Bob Justman, the line producer, had things rigged to use mostly library, but when there was a certain new character or

some new twist to the story, that would demand new music. So for my first assignment, there was writing special music for three different episodes in one session. That was quite a way to break in."

Steiner rerecorded Courage's main theme partway through production of season one, while also establishing variations on the *Enterprise* fanfare to accompany hero shots of the *Enterprise* in space. He also created a theme for Captain Kirk, tinged with a melancholy to emphasize the loneliness of command. "Fred Steiner was kind of like the John Williams of his time," associate producer Bob Justman said in a 1999 interview for *The Music of Star Trek.* "Broad, sweeping themes, a very melodramatic style of music. My first choice, always, unless there was a particular reason, was Fred, who caught the inner being of *STAR TREK.*"

ABOVE: *STAR TREK's most famous love theme, "Ruth," was written by Gerald Fried for 'Shore Leave' and features a flute and strings. It was used again in 'This Side of Paradise' and 'The Apple.'*

When Steiner described the approach to scoring on *STAR TREK* as "Wagnerian," he meant that, as in opera, individual characters and situations would be given themes. These themes would be written for a specific episode, but Justman and the editors often had the composer record a different version that could be added to a library of music cues that could be used again and again. Gerald Fried contributed three of *STAR TREK'*s most memorable themes. The love theme (Ruth) first appears in 'Shore Leave' when Kirk meets his old girlfriend, but may be most memorable for its use in 'This Side of Paradise.' Fried also wrote the battle theme ('The Ritual/Ancient Battle/2nd Kroykah') for 'Amok Time.' To his amusement, years later he discovered that it was quoted so heavily in *The Simpsons* that he got royalties for it. 'Amok Time' also saw Fried introduce a theme for Spock that featured a bass guitar.

Alongside Courage, Steiner and Fried dominated the *STAR TREK* scores, but the series also features impressive work by George Duning, Jerry Fielding, Sol Kaplan, Samuel Matlovsky, and Joseph Mullendore. Together they crafted the romantic heroism of the *Enterprise'*s epic mission and established a musical legacy that would be loved and quoted for decades to come.

NEW LIFE
CONVENTIONS

W hen the *U.S.S. Enterprise* ended its five-year mission prematurely, fading to black in 1969, *STAR TREK* fans wanted more – and they got it. In the 1970s, the show was reborn as a major convention experience, where fans could gather, watch old episodes, and meet the stars. They came in the thousands, helping to convince Roddenberry, and ultimately Paramount, that *STAR TREK* had a future. The faithful could celebrate *STAR TREK* at conventions such as New York's Lunacon or Philcon, but before January 21, 1972, there had never been a convention dedicated entirely to *STAR TREK*. That changed when The Convention, the first major con, with guests, dedicated exclusively to Gene Roddenberry's creation, took place at the Statler Hilton in Manhattan.

It all started in 1971 at the Brooklyn home of Devra Langsam, who, in 1967, edited and published (with Sherna Comerford)

the first all-*STAR TREK* fanzine, *Spockanalia*. "Roddenberry used to give out *STAR TREK* clips from the cutting room," Langsam recalls. "Elyse Rosenstein and I were sorting through slides that he'd given to Bjo Trimble, who distributed them to fans, and one of us said, 'It would be so nice to have a convention that was just *STAR TREK*,' because when you'd go to a regular science-fiction convention, they tended to look down a bit on *STAR TREK* fans. This was just talk, but two or three days later, Elyse called, saying, 'I've got us a hotel and a printer.'"

Langsam and Rosenstein based their proposed event on the Lunacon/Philcon model: panels, guest speakers, art show, dealers' room, and a costume presentation. They recruited friends and relatives – Al Schuster, Eileen Becker Salmas, Joan Winston, Debbie Langsam (Devra's cousin, who picketed NBC during the "Save *Star Trek*" campaign), Joyce Yasner, Steven Rosenstein (Elyse's ex-husband), Regina Gottesman, Stuart

Hellinger, Thom and Dana Anderson, Ben Yalow, Maureen Wilson, Linda Dencroff, and Allan Asherman – to hone the concept and share responsibilities.

Collectively, they were "the Committee." Official paperwork, for legal protection, referred to them as Tellurian Enterprises. The team spent countless hours lining up guests, dealing with vendors, coordinating volunteers, handling crowd control, and so on. Joan Winston, a secretary in CBS and ABC's contracts departments, had major entertainment industry connections. "Joan made contact with the actors and Roddenberry," Langsam says. "She got us an exhibit from NASA, with moon rocks. Between us, we had a lot of friends who loved STAR TREK, so we contacted them and they said, 'Yes, we're coming!' We sold about 800 memberships before the convention, which was quite a lot because science-fiction conventions were not that big. We ended up with about 3,400. The space wasn't rated for that many, but we managed. We don't know exactly how many people came because at the end of the last afternoon, we weren't even charging anyone. People wrote their names and addresses and put them into a box, and somebody stole the box! Our best guess was 3,200–3,400. And we ran out of everything. Everything."

That first convention's guest list featured Roddenberry, Bjo Trimble, Majel Barrett, and Dorothy Fontana, as well as authors Isaac Asimov and Hal Clement. A modest admission fee also covered autograph sessions and photo ops on a fan-built Enterprise bridge, plus screenings of the STAR TREK blooper reel and 15 episodes, including 'The Cage.'

"With naivete and enthusiasm, we'd approached Gene and Majel, and they agreed to come," Becker Salmas says. "We reached out to NASA and they sent that exhibit. We contacted Paramount and they sent episodes. Gene brought the bloopers and original pilot. That was the first time a blooper reel was ever seen outside of cast and crew. Our asks were so unique and new that everyone said, 'Yes.'"

The Committee staged four more events in Manhattan. The 1973 convention featured George Takei and James Doohan, with an unannounced Leonard Nimoy making his first convention appearance. Approximately 10,000 fans attended. The 1974 event welcomed DeForest Kelley, Takei, Nichelle Nichols, Walter Koenig, Dorothy Fontana, David Gerrold, makeup artist Fred Phillips, authors Asimov and Clement, as well as surprise guest Mariette Hartley. The turnout? 10,000-14,000 fans.

The 1975 iteration, with approximately 8,000 attendees, greeted Roddenberry, Shatner, Takei, Barrett, Robert Lansing, Theiss, Gerrold, Asimov, and Clement. And the final event, in 1976, had Roddenberry, Barrett, Kelley, Nichols, Doohan, Gerrold, Theiss, Asimov, Clement, and Howard Weinstein on hand. Roughly 5,000 fans joined in the fun, including actress Anne Meara and her young son, Ben Stiller, while many of the Committee fell ill with the flu.

Interestingly, the organizers knew in advance that the 1976 con would be their last. Other entrepreneurs were mounting events in various markets. Talent costs increased, fans had more options to choose from, and the Committee splintered, with Al Schuster spearheading competitive cons.

It was "surprising and amazing," Langsam notes, when STAR TREK's marquee names participated for free in the first event. They subsequently requested remuneration, hotel costs and airfare. "It was only reasonable because they had to think about their rent, children's dental bills, retirement," Langsam notes. "They had to make money while they could. But it started to get expensive. And, for the Committee, the time commitment grew and grew. There was a while that I was spending every Thursday evening and a lot of Saturdays at Ben Yalow's house, inputting the names and addresses of people who wrote for information about the convention, and doing progress reports.

"We loved it…" Langsam says, laughing. "If you look at who attended the conventions, you'd understand that the average STAR TREK fan is not a teenage male geek with pimples who lives in his parents' basement. An awful lot of fans are adult women with brains and writing and art skills and good judgment, and are not living in their parents' basement, either. At the end, it was too much work to be a hobby and too little money to be a job."

The Committee disbanded, but conventions blossomed. Several surviving members of the Committee reunited at Star Trek: Mission New York, held in 2016. Hellinger organized that reunion panel. "We were incredibly impressed by the crowd size in the room, made up of both older and younger fans," he says. "The overall audience reaction was amazing. When it was over, I was left with a great feeling, especially as some of us made new friends and contacts that day."

Putting everything in perspective, Langsam believes that the Committee's early STAR TREK conventions forever impacted fandom. "Several of us produced magazines because we loved the show so much and couldn't wait for a professional to write other stories," she says. "Then we had to share them with our friends. So, we printed them, sold them, exchanged them. The conventions were like that, too. I don't know whether our conventions led the way to Comic-Con. I just know we did them, especially the first one, because we wanted to get together, talk about STAR TREK, and show each other the things we'd done. Really," Langsam concludes, "everyone did it out of our love for STAR TREK."

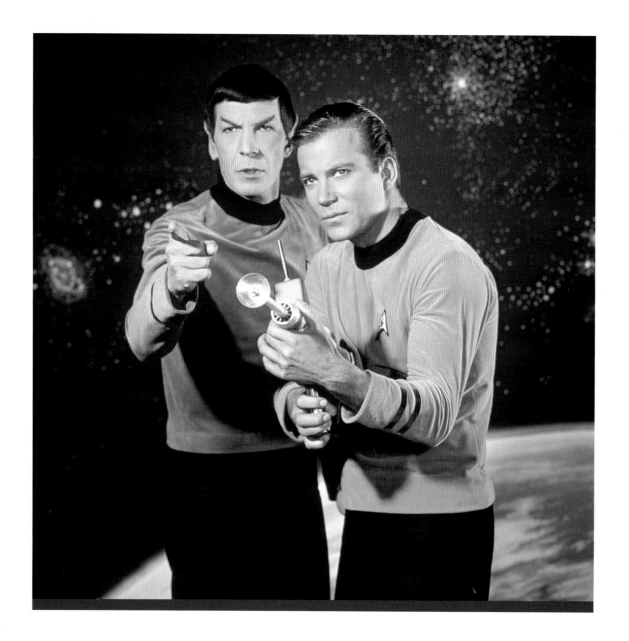

S E A S O N 1

STAR TREK debuted on September 8, 1966, two and a half years after Gene Roddenberry submitted his *STAR TREK Is...* proposal and almost two years after completion of the initial pilot, 'The Cage.' Many viewers immediately embraced the series and became lifelong fans. However, not everyone jumped on Roddenberry's "Wagon Train to the Stars." *Variety* declared, "*STAR TREK* obviously solicits all-out suspension of disbelief, but it won't work. Even within its sci-fi frame of reference it was an incredible and dreary mess of confusion and complexities." Leonard Nimoy laughed raucously while reading excerpts from that review to thousands of fans at a 25th anniversary *STAR TREK* convention.

The show quickly found its footing, with Kirk, Spock, McCoy and the rest of the *U.S.S. Enterprise* crew exploring strange new worlds, seeking out new life and new civilizations, and boldly going where no man had gone before. Along the way, they formed a family – and forged a phenomenon.

1.1 THE MAN TRAP

Dr. McCoy's former love, Nancy Crater, hasn't aged a day since he last saw her. That's because she's actually a shapeshifting, freaky-looking, and murderous Salt Vampire.

1.2 CHARLIE X

The *Enterprise* saves Charlie, a young man stranded alone for years on an alien planet. Now on the ship, and with extraordinary mental powers granted him by the Thasians, he'll do anything to win Rand's affections.

1.3 WHERE NO MAN HAS GONE BEFORE

Kirk's old friend Gary Mitchell attains godlike powers and quickly develops a superiority complex, as well as glowing eyes. Dr. Elizabeth Dehner tries to help him, but becomes equally powerful, doubling the trouble for Kirk and crew.

1.4 THE NAKED TIME

The Psi 2000 virus strikes the *Enterprise* crew, unleashing the deepest desires of those affected. Sulu brandishes a foil, Spock reveals his human side, and Kirk expresses love-hate for his ship.

1.5 THE ENEMY WITHIN

A transporter malfunction results in duplicate Kirks, one good, one bad, neither able to survive without the other. Meanwhile, Sulu and his landing party will freeze to death on Alfa 177 if Scotty can't repair the transporter.

1.6 MUDD'S WOMEN

The *Enterprise* rescues intergalactic conman Harry Mudd and three beautiful women. Kirk and some miners, with whom Mudd cut a deal, discover the ladies take the illicit Venus drug to attain their beauty. Or do they?

1.7 WHAT ARE LITTLE GIRLS MADE OF?

The *Enterprise* locates long-missing biologist Dr. Roger Korby, who was also Chapel's fiancé. Only he's now building android duplicates of people and plans to save mankind by replacing humans with androids... starting with Kirk.

1.8 MIRI

On an Earth-like planet, an *Enterprise* landing party meets centuries-old children, survivors of a plague unleashed by life-extension experiments gone wrong.

1.9 DAGGER OF THE MIND

Spock mind-melds with Dr. Simon Van Gelder and learns he was turned insane by a terrifying device called a neural neutralizer. Dr. Adams then uses it on Kirk, forcing the captain to believe he's in love with Dr. Helen Noel.

1.10 THE CORBOMITE MANEUVER

The *Enterprise* is trapped by a huge ship, the *Fesarius*, and its fearsome-sounding commander, Balok. Kirk discovers that Balok is a childlike being gauging the crew's true intentions.

1.11 & 1.12 THE MENAGERIE, PARTS I & II

Spock kidnaps his former commander, Captain Christopher Pike, who is now paralyzed, disfigured, unable to speak, and uses a wheelchair, and charts a course to the off-limits planet Talos IV.

1.13 THE CONSCIENCE OF THE KING

Is Anton Karidian, an actor in a traveling theater troupe, actually Kodos, the figure responsible for ordering the deaths of countless Tarsus IV inhabitants, including the family of Lt. Riley?

1.14 BALANCE OF TERROR

Kirk determines that he must destroy a Romulan ship equipped with cloaking technology. Meanwhile, Spock contends with prejudice.

1.15 SHORE LEAVE

Kirk and his crew enjoy shore leave on an Earth-like planet. The captain battles an old nemesis, Finnegan. Sulu takes on a samurai. Spock dodges a tiger. The fun stops, however, when a black knight kills Dr. McCoy.

1.16 THE GALILEO SEVEN

When the *Galileo* shuttlecraft crash lands on Taurus II, Spock takes command of the situation, but much of the group questions the Vulcan's leadership and logic-based decisions.

1.17 THE SQUIRE OF GOTHOS

Kirk and Sulu disappear from the *Enterprise*, setting the stage for the crew's interactions with Trelane, a flamboyant, unpredictable, music-loving, and powerful man-child alien.

1.18 ARENA

The *Enterprise* chases an enemy ship, only for both vessels to enter Metron territory. There, the Metrons pit Kirk and a Gorn commander in a battle to the death.

1.19 TOMORROW IS YESTERDAY

Thrown back to the 20th century, the *Enterprise* becomes a UFO and beams up Air Force pilot John Christopher. His son will eventually be important, meaning Kirk and crew must return Christopher to his place in time. But how?

1.20 COURT MARTIAL

Ben Finney appears to die when his pod is jettisoned off the *Enterprise* during an ion storm, prompting Commodore Stone to start court-martial proceedings against a "negligent" Kirk.

1.21 THE RETURN OF THE ARCHONS

While trying to determine what led to the disappearance of the *U.S.S. Archon* a century earlier, the *Enterprise* crew finds a powerful, enigmatic figure who "absorbs" people... and just absorbed Sulu.

1.22 SPACE SEED

The *Enterprise* comes upon an ancient sleeper ship, the *S.S. Botany Bay*, and finds its crew in suspended animation. Upon being awakened, its leader, genetically enhanced superhuman Khan Noonien Singh, plots to steal the *Enterprise* and conquer the galaxy.

1.23 A TASTE OF ARMAGEDDON

Kirk and company are dispatched to Eminiar VII to foster diplomatic relations. There, they discover that Eminiar has been at war for ages with the nearby planet Vendikar, a war fought by computer.

1.24 THIS SIDE OF PARADISE

Everyone on Omicron Ceti III should be dead, but they're alive, well and impossibly happy, thanks to plants that spray life-altering spores. Nearly everyone is affected, including Spock

1.25 THE DEVIL IN THE DARK

An unseen creature that effortlessly cuts through stone is killing miners on Janus VI. Kirk and Spock discover the creature is a Horta mother – the last of her kind.

1.26 ERRAND OF MERCY

The dangerous Klingons, led by Kor, prepare to invade Organia, yet the planet's five leaders don't share Kirk and Spock's concern.

1.27 THE ALTERNATIVE FACTOR

On a dead planet, Kirk and Spock meet Lazarus, or, more accurately, two beings named Lazarus. They're from separate dimensions and adamant about destroying each other.

1.28 THE CITY ON THE EDGE OF FOREVER

A crazed Dr. McCoy steps through a time portal that sends him to 1930, where he meets pacifist Edith Keeler. Kirk and Spock follow, and learn that Keeler's actions will change the world... if they occur.

1.29 OPERATION – ANNIHILATE!

Death, pain, and insanity caused by alien creatures on the planet Deneva hit home for Kirk when they claim his brother's life.

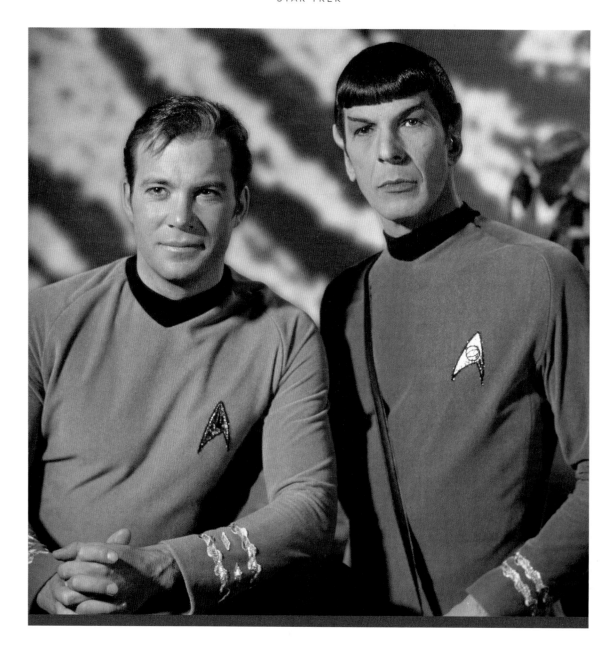

S E A S O N 2

NBC debuted season two of *STAR TREK* on September 15, 1967, and its 26 episodes ranged in quality from good to great. Directors Marc Daniels and Joseph Pevney, who'd established reputations for working fast, efficiently, and within budget, alternated shows for most of the season, while Ralph Senensky helmed four episodes. Gene Coon, though he'd stepped down as producer, contributed several notable scripts, including 'Metamorphosis' and 'A Piece of the Action.'

Fans at home enjoyed the evolution of the characters and their relationships. The Kirk-Spock-McCoy troika proved particularly popular, while Scotty, Uhura, and Sulu remained key members of the *Enterprise* family. Gene Roddenberry had big plans for George Takei's Sulu, but the actor's stint on the John Wayne film, *The Green Berets*, dragged on so long that scenes and dialogue meant for him were instead given to Walter Koenig, who had joined the show as Pavel Chekov.

2.1 AMOK TIME

Spock experiences the effects of *Pon farr*, the Vulcan mating urge, prompting Kirk to order that the *Enterprise* warp to Vulcan. There, Spock's betrothed, T'Pring, chooses another Vulcan, which results in a to-the-death battle between Spock and... Kirk.

2.2 WHO MOURNS FOR ADONAIS?

A massive hand in space reaches out and grips the *Enterprise*, stopping the ship in its tracks. That hand belongs to an alien entity that presents himself as the Greek god, Apollo, who demands fealty from his new subjects.

2.3 THE CHANGELING

The computer/space probe Nomad has destroyed the Malurian System and its four billion inhabitants, and sets its sights on the *Enterprise*. Nomad mistakes Kirk for its creator, providing a window of opportunity for the captain to save the day.

2.4 MIRROR, MIRROR

Transporter issues send Kirk, McCoy, Scotty, and Uhura to a parallel universe and *Enterprise* where treachery and barbarism are the norm, while "mirror" versions of the quartet arrive on the "normal" *Enterprise*. Spock must resolve the crises in both universes.

2.5 THE APPLE

Gamma Trianguli VI is far, far from the Garden of Eden-like planet that an *Enterprise* landing crew initially believes it to be. And the inhabitants' deity, a giant serpent's head, isn't what it appears to be, either.

2.6 THE DOOMSDAY MACHINE

Commodore Matt Decker loses his mind after a massive cone-shaped alien machine/weapon consumes his ship, the *Constellation*, and its crew. He then tries to steal the *Enterprise* in an ill-advised effort to seek vengeance.

2.7 CATSPAW

A creepy, haunted castle on Pyris VII is home to the aliens Sylvia and Korob, who take the form of a witch and a warlock, respectively. Scotty, Sulu, and eventually McCoy are transformed into "zombies," but Spock seems unaffected.

2.8 I, MUDD

Super-sophisticated androids aspire to help save humans from themselves, and taking control of the *Enterprise* is just part of that effort. Complicating matters, the androids are led by a familiar foe/nuisance, Harry Mudd.

2.9 METAMORPHOSIS

Kirk, Spock, and McCoy, aboard the *Galileo*, are bringing ailing Assistant Federation Commissioner Hedford to the *Enterprise* for treatment. A cloud creature then puts them in the presence of Zefram Cochrane, the presumed-dead creator of warp drive.

2.10 JOURNEY TO BABEL

The *Enterprise* hosts conference-bound alien ambassadors. Only, some ambassadors aren't getting along. Then a mysterious ship starts to follow...

2.11 FRIDAY'S CHILD

Kirk and crew arrive at Capella IV to thwart an alliance between the Klingons and Capellans. Kirk stops the ritual execution of Eleen, the deposed Capellan High Teer's pregnant wife, heightening tensions between the Klingons, the landing party, and the Capellans.

2.12 THE DEADLY YEARS

Radiation poisoning causes Kirk, Spock, McCoy, Scotty and Lt. Galway to age rapidly. An increasingly cranky McCoy races to find a cure.

2.13 OBSESSION

A cloud being that killed Captain Garrovick and half of the *U.S.S. Farragut*'s crew, but spared a young Kirk, returns and threatens the *Enterprise* crew, which includes the late captain's son. Kirk is determined to thwart it.

2.14 WOLF IN THE FOLD

On Argelius II, Scotty, recovering from a head injury, is accused of murdering several young women. Did he do it, or did Redjac... aka Jack the Ripper?

2.15 THE TROUBLE WITH TRIBBLES

The *Enterprise* protects a shipment of the grain quadrotriticale on K-7. The task is complicated by the arrival of Captain Koloth and his Klingons, and then by Cyrano Jones, whose fluffy tribbles devour grain, hate Klingons, and multiply rapidly.

2.16 THE GAMESTERS OF TRISKELION

Kirk, Uhura, and Chekov are kidnapped, brought to the planet Triskelion, and forced to fight as entertainment for "the Providers."

2.17 A PIECE OF THE ACTION

An *Enterprise* landing party discovers that the Iotians base their society on a book about 1920s mobsters. So, Kirk and company deal with rival gangs, sport suits, and brandish machine guns.

2.18 THE IMMUNITY SYNDROME

A single-cell life form best described as a giant amoeba destroys the *U.S.S. Intrepid* and its all-Vulcan crew, as well us the Gamma 7A system. The *Enterprise* must stop the amoeba.

2.19 A PRIVATE LITTLE WAR

Kirk returns to a peaceful planet after more than a decade, and learns that the Klingons are creating conflict amongst its inhabitants.

2.20 RETURN TO TOMORROW

The disembodied aliens Sargon, Thalassa, and Henoch seek to "borrow" the bodies of Kirk, Spock and Dr. Anne Mulhall in order to devise android bodies that can contain their minds.

2.21 PATTERNS OF FORCE

The *Enterprise* seeks to determine the fate of John Gill, Kirk's friend, teacher, and Federation cultural observer. It turns out he introduced a Nazi-like regime to the people on Ekos, which is now attacking their neighbors, the Zeons.

2.22 BY ANY OTHER NAME

The Kelvans, led by Rojan, conquer the *Enterprise* and turn everyone except Kirk, Spock, McCoy and Scotty into easily destroyed tetrahedron cubes. The foursome plot to reclaim the ship by exploiting the Kelvans' unfamiliarity with their new human bodies.

2.23 THE OMEGA GLORY

Exposed to a virus that's killed the *U.S.S. Exeter*'s crew, Kirk, Spock, and McCoy look for answers on Omega IV. There, they meet Captain Tracey, who, seeking eternal youth, introduced weapons into a Yangs /Kohms conflict.

2.24 THE ULTIMATE COMPUTER

Dr. Daystrom, aiming to restore his reputation, watches his new computer system, the M-5 – bolstered by his own mental patterns – get a test run on the *Enterprise*. Everything goes well, initially...

2.25 BREAD AND CIRCUSES

Searching for the missing *S.S. Beagle* and her crew, Kirk, Spock, and McCoy arrive on 892 IV, a planet with 20th-century technology, but a civilization that resembles ancient Rome.

2.26 ASSIGNMENT EARTH

Earth barely avoided destruction in 1968, and the *Enterprise* goes back to that time to learn how. There, Kirk and Spock meet Gary Seven, a mysterious humanoid who they suspect plans to initiate World War III.

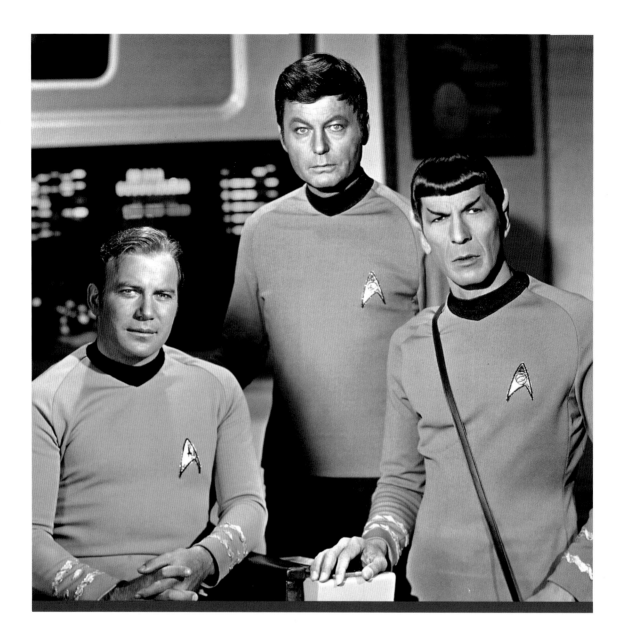

S E A S O N 3

The *STAR TREK* fans saved their favorite show via the legendary letter-writing campaign championed by Bjo and John Trimble, resulting in a third season that for months seemed like an impossible dream. Unfortunately, season three for the most part fell short of expectations due to producer and writer departures, several lackluster scripts, massively slashed budgets, and a notorious kiss-of-death timeslot, Fridays at 10 p.m. To put the problems in perspective, season three kicked off with the much-maligned 'Spock's Brain.'

Nevertheless season three gave us such memorable hours as 'The Paradise Syndrome,' 'Is There in Truth No Beauty?' 'The Tholian Web,' 'For the World Is Hollow And I Have Touched the Sky,' and 'Day of the Dove.'

And importantly, the season's 24 episodes pushed the show count to a total of 79, just enough to make *STAR TREK* a feasible syndication candidate. And it was in syndication that Gene Roddenberry's "failed" series blossomed into a global phenomenon.

3.1 SPOCK'S BRAIN

Kara, an Eymorg, steals Spock's brain in order to power her planet. The Vulcan's body can only survive 24 hours, sending Kirk, Scotty, and McCoy on a race against the clock to locate Spock's brain and make him whole again.

3.2 THE ENTERPRISE INCIDENT

Kirk appears to have lost his mind, steering the *Enterprise* into Romulan territory, and he is killed by Spock, using a Vulcan death grip. However, it's all a ruse to obtain a Romulan cloaking device.

3.3 THE PARADISE SYNDROME

Suffering amnesia on a planet inhabited by a Native American-like tribe, Kirk falls for Miramanee, who becomes pregnant with his child. Meanwhile, Spock and McCoy bicker about finding the captain and stopping an asteroid headed for the planet.

3.4 AND THE CHILDREN SHALL LEAD

The *Enterprise* comes across a group of children who seem unaware that their parents are dead. Aboard the ship, Kirk and crew contend with both the powerful kids and their "friendly angel," an evil entity named Gorgan.

3.5 IS THERE IN TRUTH NO BEAUTY?

The *Enterprise* welcomes Dr. Miranda Jones, a telepath; Kolos, a noncorporeal Medusan that can't be looked at by mortals; and Lawrence Marvick, a designer of the starship's engines, who loves Dr. Jones and envies Kolos. Trouble ensues.

3.6 SPECTRE OF THE GUN

Ignoring a warning buoy, the *Enterprise* heads into Melkotian space. Provoked, the Melkots deposit Kirk, Spock, McCoy, Scotty, and Chekov in an Old West recreation, in time to participate in the infamous gunfight at the O.K. Corral.

3.7 DAY OF THE DOVE

The crews of the *Enterprise*, captained by Kirk, and of a Klingon battle cruiser, led by Kang are manipulated into fighting each other by an energy being that feeds on aggression. Can everyone stop fighting and save themselves?

3.8 FOR THE WORLD IS HOLLOW AND I HAVE TOUCHED THE SKY

A dying McCoy joins a landing party visiting Yonada, an asteroid that's actually a spaceship destined to smash into a planet. A computer, the Oracle, guides/controls Yonada's inhabitants. McCoy and the Oracle's high priestess, Natira, fall in love.

3.9 THE THOLIAN WEB

Kirk becomes stranded aboard a ghost ship as it slips into a parallel dimension. Spock's last-ditch effort to rescue the captain is doomed by the Tholians, who wrap the *Enterprise* in an energy web.

3.10 PLATO'S STEPCHILDREN

An *Enterprise* landing party meets the Platonians, powerful telepaths who lack resistance to diseases and thus want McCoy to stay with them. When the doctor refuses, the Platonians force Kirk, Spock, McCoy, Uhura, and Chapel to participate in humiliating acts.

3.11 WINK OF AN EYE

Males on Scalos are sterile, leading the planet's beautiful queen, Deela, to use a metabolism-revving drug to kidnap Kirk – and later quite possibly all the *Enterprise*'s men – with the intent of repopulating her world.

3.12 THE EMPATH

Kirk, Spock, and McCoy investigate when Federation researchers Linke and Ozaba go missing. The trio then come across the aliens Lal and Thann, who torture them, and Gem, a mute empath who can absorb the pain of others.

3.13 ELAAN OF TROYIUS

Peace between Elas and Troyius depends on Kirk delivering Elaan, the Dohlman of Elas, to Troyius for her wedding. Only, she's arrogant, socially graceless, and sheds tears that make her irresistible to Kirk. Plus, the Klingons are lurking.

3.14 WHOM GODS DESTROY

Garth of Izar, posing as Donald Cory, governor of the last existing asylum for the mentally ill, conspires to steal the *Enterprise*. He soon poses as Kirk, leaving Spock to decide which man standing before him is his real captain.

3.15 LET THAT BE YOUR LAST BATTLEFIELD

Loki and Bele are both half-black and half-white, with the colors on opposite sides of their faces. So intense is their – and their people's – hatred for each other that it nearly engulfs the *Enterprise* and her crew.

3.16 THE MARK OF GIDEON

Arriving at potential Federation member planet Gideon, Kirk vanishes in an apparent transporter accident. Everyone aboard the *Enterprise* thinks he's disappeared, while he believes he's on the ship without his crew, though accompanied by a mysterious woman named Odona.

3.17 THAT WHICH SURVIVES

Whoever's name the solid holographic projection Losira says aloud... dies. And the *Enterprise* crew encounters the lethal Losira several times aboard the ship and on a Kalandan outpost.

3.18 THE LIGHTS OF ZETAR

A fast-moving energy storm takes possession of Scott's love interest, Mira. The energy is actually the life force of the Zetarans, who've existed as lights since the destruction of their planet, and they plan to stay in human form.

3.19 REQUIEM FOR METHUSELAH

Kirk, Spock, and McCoy, on Holberg 917-G seeking ryetalyn to treat a shipboard outbreak of Rigellian fever, meet a lonely immortal figure named Flint. Kirk and Flint's ward, Rayna, fall in love. The problem: she's an android.

3.20 THE WAY TO EDEN

Dr. Sevrin and his peace-loving followers, having just stolen a ship, scheme to hijack the *Enterprise*. Sevrin and the group are trying to reach the mythical planet, Eden, where they hope to lead a wondrous, more idyllic life.

3.21 THE CLOUD MINDERS

Seeking zenite, Kirk and company head to Ardana, becoming entangled in a class struggle between the Troglytes, who mine zenite on the inhospitable surface, and the planet's elite, who live high above. Meanwhile, Kirk and Spock both find romance.

3.22 THE SAVAGE CURTAIN

The *Enterprise* welcomes Abraham Lincoln, one of Kirk's heroes. Kirk and Spock then beam down to Excalbia, where the rock creature Yarnek demands they participate in a battle of good vs. evil that includes Lincoln, Genghis Khan, Surak, and Kahless.

3.23 ALL OUR YESTERDAYS

Sarpeidon's sun is going nova, and the *Enterprise* crew visits to warn its inhabitants. There, Kirk, Spock, and McCoy come across a vast library, a mysterious librarian, and a time machine that sends them into the past, where Spock meets Zarabeth.

3.24 TURNABOUT INTRUDER

Kirk's ex-flame, Dr. Janice Lester, who is jealous of his captaincy, swaps minds with him. When she assumes command of the *Enterprise*, her behavior sets off alarm bells for Spock, McCoy, and the bridge crew, who try to intercede.

Creator James Cawley in the captain's chair

STAR TREK: ORIGINAL SERIES
SET TOUR

When *STAR TREK* ended in 1968, the sets were dismantled and thrown in a dumpster. But it wasn't quite the end. In a work of incredible dedication, one man has made a dazzling recreation of the old Desilu soundstage.

If this book has you yearning to step back in time and visit the *STAR TREK* sets, it's not as hopeless as you might think. You can visit the *Enterprise* sets in New York where they have been recreated in amazing detail by James Cawley.

"The idea is to make visitors feel like they're working on the show," Cawley says. "When you walk in, you're on Stage 9, with the *Enterprise* bridge and everything on it: Kirk and Spock's quarters, sickbay, engineering, a Jefferies tube, the transporter room, the bridge. Fans can sit in the captain's chair. They can peer up a Jefferies tube. We've made it as interactive as possible."

Cawley worked with blueprints he was given from costume designer William Ware Theiss, and built the tour – with a growing range of memorabilia – from there.

"As you go, you start looking at things in more detail," Cawley says. "'OK, what is that thing? What did they use? Where did it come from?' And we start digging. Of course, the internet has become this massive tool. Plus, we go to swap meets ... where antiques are sold. We have a whole group of people who are doing this all over the world. We've got a lot eyes and ears out there ... constantly trying to make it better."

Of all his achivements, Cawley is especially fond of the corridors, shaped – as on the show – so that they appear far longer than they really are.

"You get a sense of déjà vu, even though you've never been on the sets before. It's just that you've seen these corridors a million times and think you've been there. You know them intimately. I've seen grown men cry walking through the corridors," says Cawley. "It's like they're... home."